Further Adventures of the Celestial Sleuth

Using Astronomy to Solve More Mysteries in Art, History, and Literature

Donald W. Olson

Further Adventures of the Celestial Sleuth

Using Astronomy to Solve More Mysteries in Art, History, and Literature

 Springer

Published in association with
Praxis Publishing
Chichester, UK

 PRAXIS

Donald W. Olson
Department of Physics
Texas State University
San Marcos, TX, USA

SPRINGER-PRAXIS BOOKS IN POPULAR ASTRONOMY

Springer Praxis Books
ISBN 978-3-319-70319-0 ISBN 978-3-319-70320-6 (eBook)
https://doi.org/10.1007/978-3-319-70320-6

Library of Congress Control Number: 2017962323

Cover design: Jim Wilkie

Printed on acid-free paper

This Springer imprint is published by Springer Nature
The registered company is Springer International Publishing AG
The registered company address is: Gewerbestrasse 11, 6330 Cham, Switzerland

Dedication

To Marilynn and Christopher

Preface

What do the following examples from art, history, and literature all have in common?

Claude Monet watches as the orange disk of the setting Sun sinks behind the towers of the Houses of Parliament, with the sky above colored by light passing through the smoke and fog of the London metropolis. Vincent van Gogh rides the last train of the day to a small town in the Netherlands and then hikes for miles across a rural landscape under a starlit sky. Viking graves surround Edvard Munch as he observes the full Moon and a sparkling column of light reflected in the Oslofjord. In the opening days of World War II, a German U-boat commander has the mission of penetrating the secure home harbor of the British fleet and making a surprise night attack. The crowd in Times Square celebrates on the day of the end of World War II, as the afternoon Sun casts shadows on the surrounding buildings and Alfred Eisenstaedt captures an iconic photograph of a sailor kissing a woman in white.

During one of the most arduous campaigns of the Korean War, Marines anxiously await the end of a snowstorm and spot a single "star" in the night sky as the clouds begin to clear. Characters in the novel *Don Quixote* and in Shakespeare's plays determine the time at night by observing the positions of constellations in the northern sky. Edgar Allan Poe writes an apocalyptic tale about an encounter with a comet that ends all life on Earth. A meteorological observer in Le Havre makes written notes about the state of the sea and the sky and the direction of the wind at the same time when, in a hotel window nearby, Claude Monet paints the Sun rising into the mist over the harbor.

The common theme is that astronomical analysis can solve long-standing mysteries about these and other similar topics, as explained in detail in the chapters of this book.

My previous book (*Celestial Sleuth*, Springer Praxis, 2014) detailed how astronomy could be applied to solving dozens of mysteries drawn from art, history, and literature. The connections between science and the humanities have ensured that there would be no shortage of similar projects for this book. Artists throughout the centuries have created drawings and paintings depicting the heavens. Astronomical factors can also affect historical events, especially in military history, where moonlight and tides can be important. Poets, novelists, and playwrights from every era have described the sky, and their

references are of special interest when we can make a convincing case that an actual celestial event inspired the literary passage.

The chapters in this book are arranged in four parts.

Part I includes projects applying astronomy to art. These chapters describe the analysis of night sky and twilight paintings by Claude Monet, J. M. W. Turner, Ford Madox Brown, Édouard Manet, Vincent van Gogh, Caspar David Friedrich, Canaletto, and Edvard Munch, along with new results for photographs by Alfred Eisenstaedt and Ansel Adams.

Part II focuses on historical events influenced by astronomy. These are ordered chronologically, from a thirteenth-century battle in Scotland through the eighteenth-century events in France, to a remarkable meteoric event in the early twentieth century, and finally to important battles of World War II and the Korean War.

Part III analyzes astronomical references in literature. These chapters are also ordered chronologically and discuss a mystery regarding the motion of the Moon as described in Chaucer's *Canterbury Tales*, an enigmatic passage in *Don Quixote* about telling the time of night by observing stars in the northern sky, descriptions of celestial timekeeping by the stars and the Moon in two of Shakespeare's plays, a spectacular twilight sky observed by Lord Byron, the paths of comets in a short story by Edgar Allan Poe, and a moonlit encounter in *The Woman in White* by Wilkie Collins.

Part IV makes a departure from "celestial sleuthing" and describes two projects undertaken as a "terrestrial sleuth." The first project involved J. M. W. Turner's painting *Rain, Steam, and Speed—The Great Western Railway*. Railroad timetables from 1843, meteorological archives, memoirs, and other clues helped to provide an explanation for the origin of this important work. The second terrestrial project studied another British painting and solved a long-standing mystery regarding the ancient oak tree that was the inspiration in 1852 for the setting of *The Proscribed Royalist, 1651* by the artist John Everett Millais. We also discovered a surprising connection between this centuries-old tree painted by Millais, the celebrated painting of *Ophelia* created in 1851–1852 by the same artist, and the dramatic moonlit scene near the beginning of the Wilkie Collins novel, *The Woman in White*.

August 2017

Donald W. Olson
Texas State University, San Marcos, TX, USA

Foreword

Welcome to this fresh set of probes into paintings by the masters, turning points in history, and passages from great literature—all with a view toward explaining things that were unclear, ambiguous, or downright baffling until now. Just as in the book's predecessor, *Celestial Sleuth,* the key often comes from an unexpected corner of human wisdom, astronomy.

For the past quarter century, Donald W. Olson has taught an honors course at Texas State University, and from this course, much of the present material is drawn. He once told me that coming up with a topic is by far the hardest part of any project. The subsequent work is more straightforward, though he's often unsure where each investigation will lead. Students accompany him on research trips, and the whole class shares in the analysis. Quite often, the novelty of their findings makes news around the world.

A surprising lesson for me, reading these pieces, is how often a renowned artist paints exactly what he or she sees. Like most people and even some art historians, I'd assumed artists felt free to rearrange scenes to suit their emotional state or their sense of composition. "I'll put the rising Sun over there," an artist might think. In a night sky, jabs of the brush could add stars here and there.

Or so I thought. Perhaps some artists work that way, but very often true masters like Claude Monet place elements in their paintings just as they see them. Their genius lies not in rearranging nature but in searching out natural scenes that resonate with their intended message. They document their excitement faithfully, and this precision is what provides Olson grist for his projects.

In this book he draws on clues from canvas details and astronomy to work out the exact dates when Canaletto created two well-known night scenes in Venice. For Caspar David Friedrich's *Two Men Contemplating the Moon,* he resolves questions about the date, identifies a "star" near the Moon, and learns just where in Germany the artist was situated at the time.

When it comes to dating Monet's *Impression, Sunrise,* Olson employs tides, weather records, the Sun, the positions of ships, and even the presence (or absence) of lights and known harbor structures—all to show that Monet most likely worked from a particular

hotel window in Le Havre on a certain morning in November 1872. (And this for a scene so vague and dreamy, it launched the Impressionist movement!) Olson first described his penetrating study of *Impression, Sunrise* in the catalog of a Monet exhibition at the Musée Marmottan, Paris. He took part in the press conference held when the event opened in September 2014.

Olson's interpretations of astronomical evidence often correct misunderstandings without losing sight of the importance of the human record as well. In his moving account of a Korean War campaign, we read how the US Marines became surrounded and hunkered down in the town of Koto-ri near the Chosin Reservoir. After frigid and snowy nights, they at last through an opening in the clouds spotted a single star, raising hopes for improved weather and air support to make their breakout possible. Following the war, this fondly remembered "Star of Koto-ri" was incorporated into the emblem of those veterans, who call themselves the Chosin Few. Olson points out that what they saw that night was actually a bright planet and not a star, but his chapter stresses that the importance of the celestial scene is that the "star" stands as a permanent reminder of the Marines' courage and commitment during this epic campaign.

Quite often these research projects correct widely held "truths" or invalid assertions by various authorities that have echoed down the ages. One example involves Alfred Eisenstaedt's 1945 photograph of a sailor kissing a random young woman in Times Square, New York, on the day President Truman announced victory over Japan. In the years since that iconic image was made, many newspapers, magazines, and at least one book have purported to identify the couple. But Olson makes clever use of shadows, old maps, and building records to fix the exact time to the minute when Eisenstaedt snapped the shutter, thereby ruling out some of the most widely accepted claimants.

Another case looks at eighteenth-century comet hunter Charles Messier and the Ring Nebula in Lyra, which is numbered 57 in his famous list of targets for small telescopes. Messier seemed to credit another astronomer with discovering it, and many books follow suit, but Olson demonstrates that it was Messier himself who first spotted the Ring Nebula. This result became the cover story of the June 2017 *Sky & Telescope* magazine.

I've been fortunate to watch the Texas team in action on some of the research trips for this book, including their sally into the dense woods of West Wickham Common in search of the real "Millais Oak." We all came away convinced. The tree traditionally pointed out to park visitors cannot be the one John Everett Millais painted in one of his best-loved works.

While the group was in faraway Orkney in 2015 to study the harbor's access channels and the World War II sinking of HMS *Royal Oak*, an email arrived from back in Texas. The Texas State University system had just named Don Olson a Regents' Professor, its highest honor. Only a year earlier, he had earned the American Association of Physics Teachers' prestigious Klopsteg Memorial Award for his skill in explaining science to the public.

With his students, we can sit back and marvel at the scope and depth of this research. Here, in essence, are some of the finest examples we'll ever see of what twentieth century English writer Philip Guedalla called "the busy spade of modern scholarship."

Sky & Telescope Roger W. Sinnott,
 Cambridge, MA, USA

Acknowledgments

The chapters will often refer to "our Texas State group." Marilynn Olson of the Department of English and Russell Doescher of the Department of Physics worked with me on almost every project. Margaret Vaverek, research librarian at our Alkek Library, provided especially valuable assistance by locating primary sources, difficult-to-find articles and books, maps and aerial photographs, and any other documents that we needed for our research.

Roger Sinnott of *Sky & Telescope* has been a valued colleague and has become an honorary member of "our Texas State group." Roger checked numerical calculations and participated in a half dozen of our research trips.

Many helpful consultations about astronomy and the humanities took place over the years with Brad Schaefer of Louisiana State University.

Special thanks go to Laurie E. Jasinski, a coauthor on several projects, for her careful reading and editing of each of the chapters in this book.

Several scholars provided key ideas that helped to guide the research methods of our Texas State group. Owen Gingerich of Harvard University inspired us to use computers not just to predict celestial events in the future but also to understand the skies of the past. The books by astronomical computing expert Jean Meeus provided algorithms to calculate the positions of the Sun, Moon, stars, and planets at any time in history and at any place on Earth. Dennis di Cicco of *Sky & Telescope* gave us the idea of taking modern comparison photographs of the heavens from precisely the same places used in the past by artists and photographers.

My sister, Karen Hasenfratz, was the first to suggest that we try to find a Vincent van Gogh site. The projects described in this book benefited from information gained on research trips to locations employed by Claude Monet and J. M. W. Turner in London (Chap. 1), Monet and van Gogh in France (Chap. 2), Caspar David Friedrich in Germany, Canaletto in Venice, Edvard Munch in Norway (Chap. 3), and Monet in Le Havre, France (Chap. 4). We also visited the site of a thirteenth century battle at Stirling in Scotland (Chap. 6) and the locations of World War II events in Scapa Flow and in Normandy (Chap. 7). Our Texas State group walked along the same road in northwest London as did the characters in the dramatic opening installment of *The Woman in White* (Chap. 9), and we

traveled to the town of Hayes, southeast of London, to solve the mystery of the actual site of an ancient oak painted by John Everett Millais (Chap. 10).

Since 1994, I have taught an Honors College course titled "Astronomy in Art, History, and Literature." Ron Brown, the director of the Honors College in 1994, encouraged me to develop this course. Students who worked with me on the projects described in this book include Julie Adamson, Kellie Beicker, Shaun Ford, Amanda Gregory, and Ava Pope.

I am also grateful for the research assistance from the following local history experts and individuals at museums, archives, and research institutions: John E. Thornes, Jacob Baker, and Soraya Khan at the University of Birmingham, UK; Paul Sutherland of skymania.com in Walmer, Kent, UK; local history experts Marius Broos, Walter Geerts, Toon Gouverneur, and Cor Kerstens in the Netherlands; Dr. Wilfred Niels Arnold at the University of Kansas Medical Center; Charles Whitney of Harvard University and the Smithsonian Astrophysical Observatory; local history expert Frank Richter in the Saxon Switzerland region of Germany; Francine Carraro at the Wichita Falls Museum of Art at Midwestern State University, Wichita Falls, Texas; editor Trond Erik Hillestad at *Astronomi* magazine in Norway; Lasse Jacobsen and Frank Høifødt at the Munch Museum in Oslo, Norway; Géraldine Lefebvre at the Musée d'art moderne André Malraux in Le Havre, France; Edwin L. Piner at Texas State University; Bruno Rambaldelli and Norbert Aouizerats at Météo France; and Steven Kawaler and Lee Anne Willson at Iowa State University. Barbara Baker Burrows, director of photography at Life Books, granted permission to reproduce the Eisenstaedt images and provided much expert advice about the career and the methods of that remarkable photographer. Additional research assistance for the VJ Day project came from Russell Burrows, Daniel Okrent, Lawrence Verria, Robert Sullivan of Life Books, Rebekah Burgess at the Life picture archives, Leica camera experts Jim Lager and Jonathan Davis, and the staffs of the University of Wisconsin-Milwaukee Library, the Avery Library at Columbia University, and the Map Division at the New York Public Library. The author is also grateful to Claudia Rice at the Ansel Adams Publishing Rights Trust; Leslie Squyres at the Center for Creative Photography in Tucson, Arizona; Jon Paynter at Denali National Park, Alaska; William D. Liddle at Texas State University; Giovanni Maria Caglieris of the Circolo Astrofili di Milano in Italy; Steve Hutcheon of the Astronomical Association of Queensland, Australia; Wolfgang Gloeden, Birgit Gloeden, and Gudrun Rosenhagen of Deutscher Wetterdienst in Germany; the staff of the Orkney Library and Archive, Kirkwall, Orkney, UK; U-boat expert Jerry Mason of uboatarchive.net; the staff of the Mémorial Pegasus museum in Bénouville, France; Marine historian Colonel Joseph H. Alexander; the staff of the Edgar Allan Poe House and Museum in Baltimore, Maryland; Andrew Gasson and Paul Lewis of the Wilkie Collins Society; Rolf Sinclair for suggesting the project about Turner's *Rain, Steam, and Speed*; Arthur Holden at the Bromley Local Studies and Archives, Bromley, Kent, UK; and Ranger Luke Barley at West Wickham Common, Bromley, Kent, UK.

I remain forever grateful for seminal conversations with two Texas State University faculty members, English professor Edgar Laird and history professor James Pohl, who first asked me to combine science and the humanities for research projects about Chaucer's astronomical passages and the mystery of the tides at the Battle of Tarawa in World War II. None of the projects described in the previous book or the present volume would have occurred without these two initial conversations with Edgar Laird and James Pohl.

Contents

Part I
Astronomy in Art

1

Monet in London, J. M. W. Turner, and Ford Madox Brown

During the 1890s Claude Monet created his series depicting haystacks, poplars, and Rouen Cathedral. For each of these French motifs he painted the same subject repeatedly to explore variations in weather, season, time of day, and atmospheric conditions. Near the turn of the century, after being inspired by the works of J. M. W. Turner and James Abbott McNeill Whistler and especially by their paintings of scenes along the River Thames, Monet continued his series method but with subjects in England.

During trips to London in 1899, 1900, and 1901, Monet worked on three different series. From the balcony of his room in the Savoy Hotel, Monet painted Waterloo Bridge in the morning. Near midday he looked from the hotel balcony toward Charing Cross Bridge. In the late afternoon he worked from a location inside St. Thomas's Hospital, directly across the Thames from the Houses of Parliament, and depicted sunsets behind the towers of Parliament.

The task of determining the location of Monet's viewpoint for the Parliament series seemed daunting, because the St. Thomas's Hospital complex extended for 1,700 feet and had more than a hundred river-facing windows and more than two dozen terraces with spectacular views. Could we determine the precise hospital location where Monet set up his easel? On what modern dates could we photograph celestial bodies setting behind Parliament? Could we employ astronomical analysis of our modern photographs along with study of nineteenth-century maps, the artist's letters, and meteorological archives to determine the dates and precise times when Monet was inspired to create his paintings of the Sun setting among the towers of Parliament?

J. M. W. Turner, early in his career, exhibited the painting *Moonlight, a Study at Millbank* at the Royal Academy summer exhibition of 1797. The canvas shows the River Thames with a full (or nearly full) Moon in the twilight sky and a bright star or planet nearby. Could we use eighteenth-century maps and other clues to determine Turner's precise "Millbank" location along the Thames in London? Would our result agree or disagree with the locations given in the existing literature? Did Turner's view look toward the eastern or western horizon? Did he observe the Moon rising or setting? Could we identify the object near the Moon? Was it a bright star? Was this object actually a planet, and, if so,

© Springer International Publishing AG 2018
D.W. Olson, *Further Adventures of the Celestial Sleuth*, Springer Praxis Books,
https://doi.org/10.1007/978-3-319-70320-6_1

could we determine whether it was Mercury, Venus, Mars, Jupiter, or Saturn? Could we use astronomical computer programs to find a date and precise time when the sky matched the configuration in the painting? Could the analysis make a convincing case that an actual celestial event inspired Turner?

The British artist Ford Madox Brown, a leading figure in the Pre-Raphaelite movement during the middle of the nineteenth century, created several paintings that included full (or nearly full) Moons. The spectacular canvas titled *Walton-on-the-Naze* features the Moon inside a rainbow that arcs high in the sky above a coastal town, while his *Carrying Corn* and *The Hayfield* depict Moons over rural landscapes. Could we use the lunar phase and position, distinctive landmarks in the foreground, the artist's letters and diary, the geometry of rainbows, and other clues to determine dates and precise times when Ford Madox Brown observed these scenes?

Monet in London: Sunsets Over Parliament

Claude Monet traveled to London and stayed at the luxurious Savoy Hotel, facing onto the Thames, for painting campaigns during September and October of 1899, February and March of 1900, and January through March of 1901. The artist worked on three series of canvases. One comprised views from his hotel balcony toward Waterloo Bridge and the industrial district beyond (Fig. 1.1, top). A second group from this balcony depicted Charing Cross Bridge, with Westminster Bridge and the Houses of Parliament visible in the distance (Fig. 1.1, bottom). For a third series, begun in 1900, Monet worked from a location inside St. Thomas's Hospital and looked across the Thames to observe the Sun setting behind the towers of Parliament (Fig. 1.2).

Some of the Parliament paintings bear dates of 1903 and 1904, but Monet began these canvases in the years 1900 and 1901, respectively, and completed them with finishing touches back in his studio in France. During May and June of 1904, thirty-seven of the London views appeared in a major exhibition titled *Claude Monet, Vues de la Tamise à Londres* at the Durand-Ruel Gallery in Paris.

The opening chapter of my previous *Celestial Sleuth* book described how an astronomical analysis, along with other clues, determined that one of Monet's paintings from Étretat on the Normandy coast depicted a setting Sun on February 5, 1883, at 4:53 p.m. local mean time. (Olson 2014, pp. 3–25) Our Texas State University group wondered whether we could use similar methods to deduce the dates and times in 1900 and 1901 of the original scenes that inspired Monet's Parliament sunset paintings.

W1602 and W1604

Daniel Wildenstein prepared a complete catalog of Monet's works and letters in 1974, with a revised edition appearing in 1996 (Wildenstein 1974, 1996). Ever since, art historians have identified each Monet canvas by its number in these Wildenstein catalogs. For example, the Parliament series includes nineteen sunset paintings numbered from W1596 through W1614.

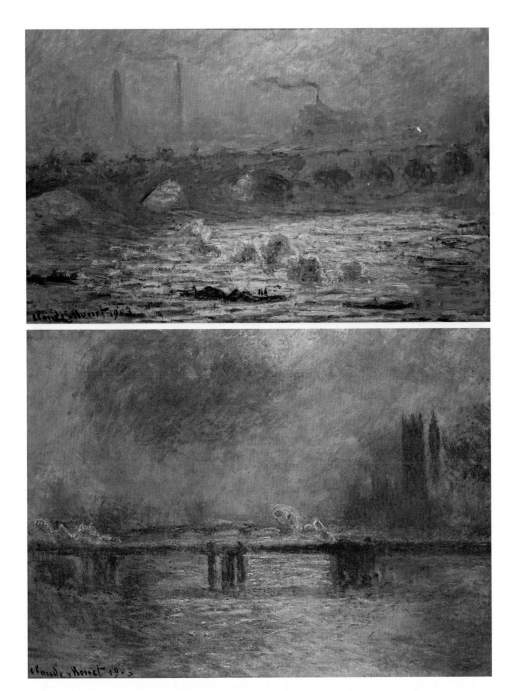

Fig. 1.1 (top) Claude Monet, *Waterloo Bridge, Sunlight Effect* (W1565). The positions of the Sun and the glitter path in the Thames indicate that Monet observed this scene near 8:40 a.m. (bottom) Claude Monet, *Charing Cross Bridge, the Thames* (W1536). The positions of the Sun and the glitter path in the river correspond to a time of 12:40 pm

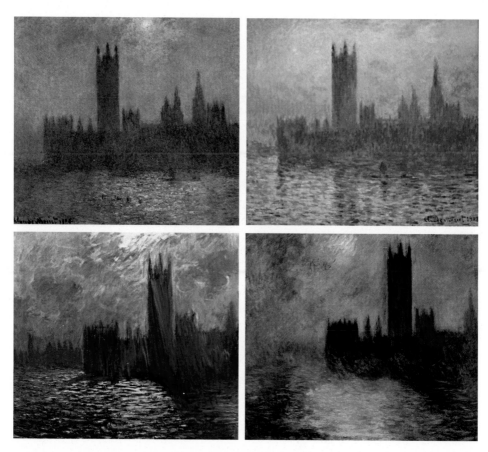

Fig. 1.2 Monet worked from a terrace in St. Thomas's Hospital and looked across the Thames to create a series of nineteen paintings depicting various sunsets behind the towers of Parliament. These four examples from the series include: (top left) *Houses of Parliament, Effect of Sun in the Fog* (W1596), (top right) *Houses of Parliament, Sunset* (W1598), (bottom left) *Houses of Parliament, Reflections on the Thames* (W1606), (bottom right) *Houses of Parliament, Sunset* (W1607)

Some of these show just a late afternoon or twilight glow and provide only a vague indication of the Sun's position in the sky. We realized that two examples, numbered W1602 (Fig. 1.3) and W1604 (Fig. 1.4), would be the most straightforward to analyze, because in each of these Monet clearly depicted the disk of the Sun among the towers of Parliament.

As a first step in the analysis, we needed to know the exact location inside St. Thomas's Hospital where Monet set up his easel to capture these views of Parliament.

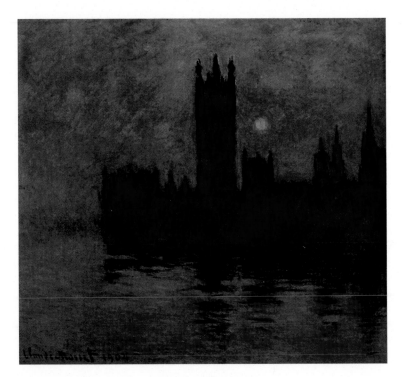

Fig. 1.3 Claude Monet, *Houses of Parliament, Sunset* (W1602)

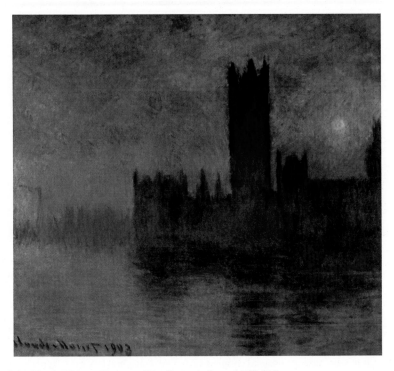

Fig. 1.4 Claude Monet, *Houses of Parliament, Sunset* (W1604)

St. Thomas's Hospital

The nine buildings of St. Thomas's Hospital extended for 1700 ft along the Albert Embankment, directly across the Thames from Parliament. The numbering system for the buildings ran from north to south. Block 1 served as an administrative building immediately adjacent to Westminster Bridge. Blocks 2, 3, and 4 contained patient wards. Block 5 included the public entrance hall and the chapel. Blocks 6, 7, and 8 held more patient wards. Farther south and farthest from Westminster Bridge was the medical school building with its distinctive tower (Fig. 1.5).

The hospital complex had more than a hundred river-facing windows and more than two dozen terraces with spectacular views of the Thames and Parliament. The task of determining the location of Monet's viewpoint therefore seemed daunting at first.

We began by comparing the paintings with the abundant tourist photographs posted online. By studying the way that the towers of Parliament overlapped one another, we could see that Monet must have set up his easel somewhere near the north end of St. Thomas's Hospital and not far from Westminster Bridge.

Fig. 1.5 This illustration from the 1893 edition of *Old and New London* shows the nine buildings of St. Thomas's Hospital extending for 1700 ft along the Albert Embankment, directly across the Thames from Parliament. Block 1 served as an administrative building immediately adjacent to Westminster Bridge, visible in the background of this view. Blocks 2 through 8 contained patient wards along with a public entrance hall and a chapel. Farthest from Westminster Bridge was the medical school building, visible here with its distinctive tower at the lower left. The task of determining the location of Monet's viewpoint seemed daunting at first because the hospital complex had more than a hundred river-facing windows and more than two dozen terraces with spectacular views of the Thames and Parliament

Monet's Letters

In his letters written from London, Monet himself provided clues that determined his precise location in the hospital. Between his arrival in London on February 9, 1900, and his return to France during the first week of April 1900, he wrote forty-six letters that were collected and numbered in Wildenstein's catalog. Monet's correspondence described the progress of his work and also included much detailed weather information. (Wildenstein 1974, pp. 340–347)

Writing on February 12, 1900, Monet explained how he had arranged with St. Thomas's Hospital so that he could work from "a covered terrace" adjacent to an "immense reception room." (Letter 1505 in Wildenstein 1974, p. 341)

In a letter composed at 9 p.m. on February 14, 1900, the artist complained that bad weather, including dense fog and snow that developed into a snowstorm, had prevented any work on February 12th or 13th. However, on the afternoon of February 14th Monet made his "beginnings at the hospital" to capture "a superb setting Sun, in the mist," a scene that was "beautiful from this terrace." He described his location as above the residence of the hospital's treasurer, who greeted Monet warmly and supplied the artist with a welcome "cup of tea, slices of bread, and cake" while he was working in the open air on the terrace. (Letter 1507 in Wildenstein 1974, p. 342)

These details prove that Monet set up his easel on the terrace of the Block 1 administration building, immediately adjacent to Westminster Bridge. This building included both the treasurer's residence and the hospital's large reception room called Governors' Hall. Between Block 1 and the Thames, a flight of steps ascended from the Albert Embankment pedestrian walkway up to Westminster Bridge (Fig. 1.6).

Towers of Parliament

The view looking from the administration building across the Thames toward Parliament was a favorite scene depicted on dozens of postcards produced circa 1900. The postcard photographers used exactly the same terrace selected by Monet. The postcards invariably showed part of Westminster Bridge and the north end of Parliament in order to feature the Clock Tower with the famous "Big Ben" bell. Perhaps surprisingly, Monet did not include the Clock Tower in any of his Parliament series paintings. He instead looked toward the south end of Parliament to observe the setting Sun near Parliament's Victoria Tower and Central Tower (Fig. 1.7).

World War II

The Block 1 administration building no longer stands in London. The German bombing attacks known as the London Blitz began in September 1940. At 2:30 a.m. on September 9, 1940, a bomb exploded at Block 1, collapsed three floors, and killed a half dozen of the medical staff. After the war's end in 1945, the remnants of this structure were finally demolished. Today a park with gardens, modern sculptures, and a fountain stands in place of the building from which Monet painted his views of Parliament.

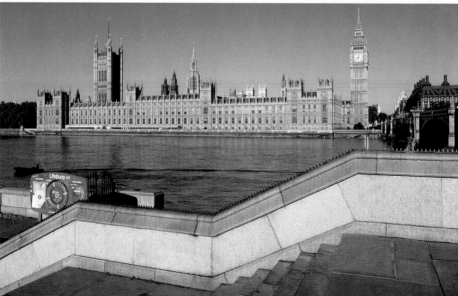

Fig. 1.6 (top) This nineteenth-century woodcut from the *Illustrated London News* shows the Block 1 administration building, adjacent to Westminster Bridge. The upper red dot marks Monet's terrace, from which he looked across the Thames to the Houses of Parliament. Our

However, the flight of steps leading up to Westminster Bridge still remains just as it was in 1900 (see Fig. 1.6 earlier). Our Texas State group was able to determine the exact position of Monet's terrace, relative to these steps, because detailed plans of the Embankment and St. Thomas's Hospital appeared in nineteenth-century architectural journals. (Anonymous 1865, p. 556; Currey 1871, pp. 61–78)

Research Trips: Sun and Moon Over Parliament

Monet looked generally toward the southwest to observe the setting Sun over Parliament. To determine the direction of view more precisely, our Texas State group hoped to obtain modern photographs taken from as close as possible to Monet's terrace location and showing celestial objects setting between the towers of Parliament.

From measurements on detailed maps and also from Google Earth we estimated that the Sun would set between Victoria Tower and Central Tower during the third week of October, about two months before the winter solstice, and during the third week of February, about two months after the winter solstice. The Moon would set between these Parliament towers during two periods of every lunar month.

We then contacted Paul Sutherland, an experienced astrophotographer living in London, and at our request he traveled to Westminster on several occasions. On April 13, 2006, Sutherland took a series of photographs between 3:54 a.m. and 4:56 a.m. British Summer Time as the full Moon passed over Victoria Tower and then set behind Central Tower (Fig. 1.8).

On October 21, 2006, Sutherland captured an especially valuable series of photographs between 4:56 p.m. and 5:14 p.m. British Summer Time as the Sun sank between Victoria Tower and Central Tower (Fig. 1.9). The Sun on this October date followed almost exactly the same path seen by Monet in February.

Our Texas State University group took our own comparison photographs during a research trip in August 2007. We did additional photography during a second research trip in October 2016 (Fig. 1.10).

Because the administration building no longer exists, all of us took our comparison photographs from the flight of steps leading from the embankment up to Westminster Bridge. Compared to our positions on the steps, Monet's terrace was somewhat farther back from the river and higher in elevation. For example, to capture the sequence of the setting Sun on October 21, 2006, Sutherland set up his camera tripod on the lowest of the

Fig. 1.6 (continued) modern photographs were taken from the position marked by the lower red dot on the flight of steps that ascends from the Albert Embankment up to Westminster Bridge. Block 1 was bombed during World War II and demolished shortly after the war, but the flight of steps still remains just as it was in 1900. (bottom) This photograph from the steps nearly matches the view in Monet's Parliament paintings from Block 1. From left to right, the three tallest towers of Parliament are the massive Victoria Tower near the south end, the sharp-pointed Central Tower near the center, and the famous Clock Tower with the "Big Ben" bell. (Photograph by the author)

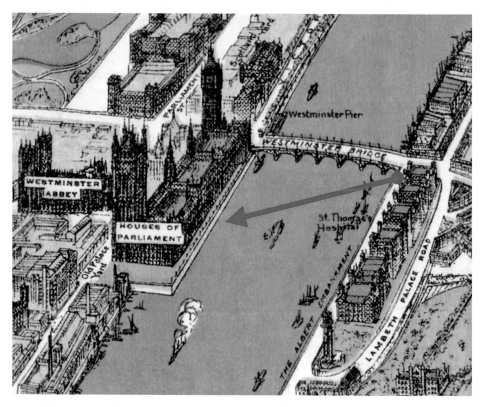

Fig. 1.7 The red dot marks Monet's position in the St. Thomas's Hospital Block 1 administration building, adjacent to Westminster Bridge. The red arrow indicates his direction of view toward the towers at the south end of the Houses of Parliament. This detail is taken from the 1911 edition of Baker's *Pictorial Plan of London*

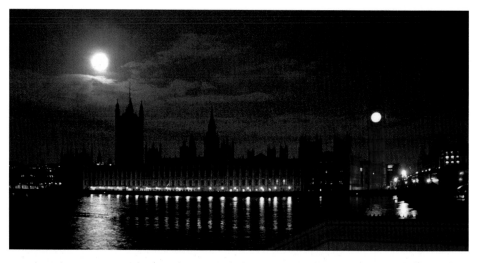

Fig. 1.8 This night scene is the first in a series of photographs taken on April 13, 2006, a date when the full Moon passed over Victoria Tower and set behind Central Tower. (Photograph by Paul Sutherland. Used with permission)

Fig. 1.9 This composite of five photographs from October 21, 2006, shows the Sun's path as it set among the towers of Parliament. Because dense London fogs like those experienced by Monet no longer occur, a solar filter was employed for four of the images in order to provide clear outlines of the Sun's disk. (Photographs by Paul Sutherland. Used with permission)

three landings on the steps. Compared to this tripod position, Monet's location on the hospital terrace was about 20 ft farther away from Parliament and 35 ft higher in elevation above the embankment. We used trigonometry to allow for the difference in viewpoints. The required corrections were relatively small because Parliament was so far away: Central Tower and Victoria Tower were about 1180 and 1480 ft distant from Monet's position, respectively.

Based on the modern photographs, we created a coordinate grid for the towers of Parliament, as seen from Monet's terrace location. Astronomers use altitude to indicate the height of an object above the horizon and employ azimuth to express compass directions numerically, with azimuth progressing around the horizon from 0° at due north, 90° due east, 180° due south, and 270° due west.

We all made sure to set our digital cameras' internal clocks accurately to the correct time, plus or minus 1 s. Because we knew the exact time of each digital photograph, we could use computer astronomy programs to calculate precise values for the Sun's or Moon's altitude and azimuth at that time. When the Sun or Moon passed over a Parliament tower, we could use the known coordinates of the celestial body to deduce the precise coordinates of that tower.

We determined that, as observed from Monet's terrace location, Victoria Tower extended from 235.4 to 239.5° in azimuth, and the adjacent small square tower on the façade facing the river extended from 239.9 to 242.3° in azimuth. The next two small spires were centered at azimuths of 245.5 and 246.7°, while the top of Central Tower had azimuth 249.5°. All of these compass directions are in the southwest, the expected direction for the setting Sun during the month of February.

Fig. 1.10 Ordinary clouds of exactly the right density occasionally allowed our Texas State group to capture images like this one, showing the disk of the Sun setting behind the Parliament towers on October 25, 2016. Our photographic analysis used the known path of the Sun to determine precise coordinates for the direction of Monet's view to each tower. The dark silhouette at the left is the base of the immense Victoria Tower, which stands at the extreme south end of Parliament and appears in all of Monet's paintings from this series

Using detailed plans of Parliament and our comparison photographs, we could likewise determine the altitudes for each of the towers. Monet would have observed the top of Central Tower extending about 10° above the horizon, while the highest point of Victoria Tower (excluding the flagpole) had an altitude of about 11°.

Dating W1602

Using the coordinates of the Parliament towers as a reference, we determined that the center of the Sun's disk in the W1602 canvas (Fig. 1.3) stood near azimuth 241.4° and altitude 6.2°. Astronomical computer planetarium programs showed that the setting Sun reached this position at 4:28 p.m. Greenwich Mean Time on February 16, 1900.

Dating W1604

Compared to the Sun's location in W1602, the solar disk in the W1604 canvas shown earlier (Fig. 1.4) was setting somewhat farther to the north (to the right), suggesting a calendar date slightly later in the year. A comparison with our modern photographs showed that the Sun in W1604 had a position near azimuth 243.7° and an altitude of 6.3°, corresponding to the celestial scene at 4:35 p.m. Greenwich Mean Time on February 20, 1900.

Meteorological Confirmation

Although Londoners generally expect bad weather during the month of February, we were able to show that favorable conditions prevailed for Monet on the afternoons of both February 16, 1900, and February 20, 1900.

We consulted meteorological observations from four sources: the weather column in *The Times* of London, the reports of weather observers in both Camden Square and Brixton, and the detailed descriptions in Monet's letters. For February 16, 1900, *The Times* characterized the day as "Fine" with "Bright sunshine" for almost 6 h. The Camden Square observer noted that the day was fine with only a few clouds, while the Brixton records likewise indicated a blue sky with detached clouds. At 2 p.m. on February 16, 1900, Monet explained why he could write only a short note: "I am obliged to be briefer than usual in order to benefit from the good weather; I will work here [at the Savoy] until 4 o'clock, and then work at the hospital until 6 o'clock" (letter 1508 in Wildenstein 1974, p. 342). Monet's next letter detailed the successful result of this expedition, when he was able to capture "the Sun with an exquisite mist and a splendid sunset" at the hospital on the afternoon of February 16, 1900 (Letter 1509 in Wildenstein 1974, p. 342).

For February 20, 1900, *The Times* reported some showers early in the day but afternoon weather that became "fine" with "bright sunshine" for more than an hour. The Camden Square observer described the day as fine with some clouds, while the Brixton observer noted some passing showers and detached clouds near midday and then a change to blue sky by late afternoon (No letter by Monet survives from either February 20 or February 21, 1900).

The meteorological observations therefore are consistent with our astronomical calculations and provide support for the conclusions that Monet began W1602 on February 16, 1900, and W1604 on February 20, 1900.

Ruling Out 1901

A prolonged period of bad weather in February 1901 rules out that year as a possible candidate for the creation of W1602 and W1604.

At 2:30 p.m. on February 16, 1901, Monet wrote a letter lamenting that "it is raining and my dear Sun has totally disappeared." (Letter 1606 in Wildenstein 1974, p. 353) The weather column in *The Times* described the conditions over the following week as "cloudy" and "dull," with totally overcast skies, periods of snow, and a day so "densely gloomy" that "[a]rtificial light was absolutely indispensable all day."

On February 22, 1901, Monet complained that he had just experienced "a week without the Sun." By February 26, 1901, Monet declared that he "must mourn for all the motifs

with the Sun" as the important object, and he described the preceding period as "two weeks without the Sun." (Letters 1608c and 1610 in Wildenstein 1974, p. 354.) Monet therefore could not have begun either W1602 on February 16th or W1604 on February 20th in 1901.

Painting from Nature

As detailed in the preceding sections, the fact that the calendar dates determined from astronomical analysis also had unusually favorable weather conditions in 1900 provides supporting evidence that actual scenes observed from nature inspired Monet's paintings.

Monet's own words provide additional evidence that he would begin paintings like W1602 and W1604 only on days when the atmospheric conditions allowed him to see the position of the Sun among the Parliament towers.

During a prolonged period of bad weather in 1900 near the end of February and the beginning of March, Monet noted with dismay on March 7, 1900, that "Time marches on and the Sun also, so that on the day when it will decide to appear, it will no longer be in the same place. It is especially unfortunate for my paintings at the hospital. I feel that the Sun has already moved a great distance and that it no longer sets within my motif" (Letter 1525 in Wildenstein 1974, p. 344).

By March 9, 1900, the weather had improved, and Monet saw that his fears were confirmed: "The Sun, just as I predicted, now sets far away from the place where I dreamed of seeing it as an enormous ball of fire setting behind Parliament; it is therefore no longer necessary to think of that any longer" (Letter 1527 in Wildenstein 1974, p. 344).

Astronomers know the position of sunset on the horizon shifts most rapidly northward near the vernal equinox in March. Monet indeed complained on March 24, 1900, that the seasonal variations had shifted the position of sunset far to the north (to the right) of the Parliament towers: "For my motifs at the hospital there has been a complete disappointment. After a few days without seeing the Sun, here it is a kilometer from my motif. There is no more hope about this, and how distraught I am!" (Letter 1537 in Wildenstein 1974, p. 345)

The artist noted that he could travel to St. Thomas's Hospital and continue work on his canvases depicting gray and misty skies. Monet's explanation, that he could no longer begin any more pictures showing the Sun's "ball of fire" setting between the towers of Parliament, indicated that he was following his custom of working from natural scenes that he observed. This in turn helps to justify the use of astronomical calculations, combined with information from meteorological archives, London maps, architectural drawings, and Monet's correspondence, to determine dates and precise times for the origin of some of the paintings from the Parliament series.

London in Its Very Essence

Monet's observation of the setting Sun among the towers of Parliament at 4:28 p.m. on February 16, 1900, inspired him to begin the canvas W1602. The painting W1604 depicts the solar disk in a scene corresponding to 4:35 p.m. on February 20, 1900. If the weather cooperates, modern visitors to the steps near Westminster Bridge during the third week of

February (or the third week of October) can watch the Sun set behind the towers of Parliament, as Claude Monet did more than a century ago.

Art critic Octave Mirbeau offered his opinions regarding the London series paintings in an essay published at the time of their first exhibition in 1904:

> *Smoke and fog; shapes, architectural masses … the Sun imprisoned by the enveloping mist … infinitely changing and subtle … the drama of glittering reflections on the waters of the Thames … the special nature of this prodigious city created for painters, and which painters, up until Monet, have not been able to see … the Houses of Parliament … sometimes massive, elsewhere barely an outline, melting harmoniously into a fading blur of things only hinted at … It is almost a paradox that with paint and canvas one can create intangible matter, imprison the Sun, polarize and diffuse it, into the thick vapors, the foul soot and smoke of a city such as London … and draw from this empyreumatic atmosphere such magnificent and enchanting fantasies of light … Claude Monet. He has seen London, he has expressed London in its very essence, in its character, in its light ….* (Preface to Mirbeau 1904)

Texas, USA, and Birmingham, UK

Our Texas State University group became especially interested in the Parliament series at the time of a major exhibition, *Monet's London: Artists' Reflections on the Thames, 1859–1914*, which traveled in 2005 to museums in St. Petersburg (Florida), Brooklyn, and Baltimore (House et al. 2005). We learned that we were not the only group studying the scientific aspects of Monet's London paintings. At the University of Birmingham in England, environmental scientists John Thornes, Jacob Baker, and Soraya Khan used Monet's London paintings as proxy indicators for the Victorian smoke and fog and the atmospheric states that they depict. Our groups worked independently on the Parliament series and collaborated to analyze the views of the Thames bridges as observed from the Savoy Hotel. (Baker and Thornes 2006; Khan et al. 2010)

J. M. W. Turner: *Moonlight, A Study at Millbank*

The National Gallery in London regards the landscape painter Joseph Mallord William Turner (1775–1851) (Fig. 1.11) as perhaps the best-loved English artist from the Romantic period. A poll conducted by the BBC in 2005 voted Turner's *The Fighting Temeraire*, first exhibited at the Royal Academy in 1839, as the nation's favorite painting.

Turner included the new technology of the Industrial Revolution in his celebrated *Rain, Steam and Speed—The Great Western Railway*, first exhibited in 1844. Chapter 10 in this book uses memoirs, maps, meteorological records, and nineteenth-century train schedules to determine the precise time when the artist was inspired to create this railway scene by events during a memorable storm in June 1843.

Although Turner often painted sunrises, sunsets, and twilight skies, the night sky appears only rarely in his works. A chapter in my previous *Celestial Sleuth* book (Olson 2014, pp. 25–33) provided a topographical and astronomical analysis of a watercolor

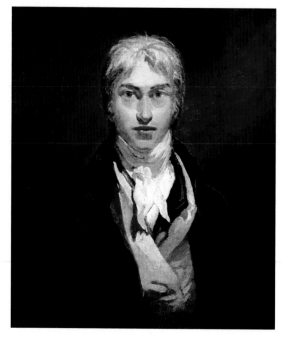

Fig. 1.11 J. M. W. Turner (1775–1851) in a self-portrait, circa 1799

depicting a stagecoach on a snowy mountain road at night and identified the Moon, Saturn, and the stars of Gemini in the winter sky above.

Moonlight on the Thames

Another work of astronomical interest dates from very early in Turner's artistic career. He exhibited *Moonlight, A Study at Millbank* (Fig. 1.12) at the Royal Academy in the summer of 1797, when he was only 22 years old. Art historians long considered this to be Turner's first exhibited oil painting. Because another of Turner's works was recently identified as an oil painting that appeared in the 1796 Royal Academy exhibition, the Millbank scene now appears as catalog number 2 in the modern compilation of more than 500 paintings by Turner. (Butlin and Joll 1984, p. 2) *Moonlight, A Study at Millbank*, now in the permanent collection at the Tate museum in Britain, shows the Thames with a full or nearly full Moon in the twilight sky and a bright star or planet nearby. The nineteenth-century critic John Ruskin judged that this Millbank work was "closely studied from the real moon, and very true in expression of its glow towards the horizon." (Ruskin 1857, p. 5)

The modern scholar David Hill likewise suggested "that the painting is the product of an actual act of observation by one who made a practice of studying such things as moonlight … Turner's moon is rising in the east and the first evening star shines above it. Light lingers in the sky …. We can almost hear the gentle plashing of the ripples and the dipping of the oars, or feel the warmth and closeness of the night" (Hill 1993, pp. 19–21).

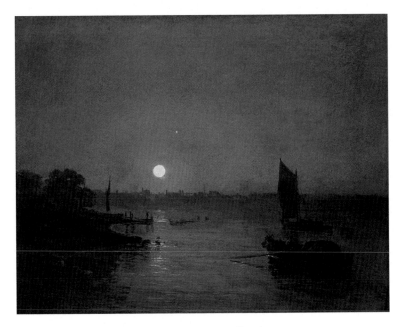

Fig. 1.12 J. M. W. Turner, *Moonlight, A Study at Millbank*

Art historian Paul Spencer-Longhurst agreed that "this cloudless scene was the result of careful observation, as indicated for example by the Evening Star above the moon to the right." (Spencer-Longhurst 2006, p. 86)

Our Texas State group wondered whether we could use topographical analysis and eighteenth-century maps to determine Turner's precise location at "Millbank" along the Thames in London. Did Turner's view look toward the eastern or western horizon? Did he observe the Moon rising or setting? Could we use astronomical calculations to identify the bright "star" near the Moon? Was the "star" actually a planet, and, if so, could we determine whether it was Mercury, Venus, Mars, Jupiter, or Saturn? Could we use computer astronomy programs to find a date and precise time when the sky matched the configuration in the painting? Could the analysis make a convincing case that Turner was inspired by observing an actual celestial event?

Our Texas State group became especially interested in answering these questions when this work was featured as the first painting in the *Turner Whistler Monet* exhibition, which traveled in 2004–2005 to museums in Toronto, Paris, and London.

The Case of the Missing "Star"

But there was a complication—the bright "star" (or planet) in *Moonlight, a Study at Millbank* is missing from many reproductions!

For example, no "star" appears in this painting as printed in the *Turner Whistler Monet* exhibition catalog, published by London's Tate Britain museum. (Lochnan 2004, p. 75)

This reproduction depicts the sky above the Moon as a relatively featureless twilight glow—with no "star" visible.

The Tate gift shop offers postcards and fine art prints with no "star" in the sky. Likewise, no bright "star" can be seen in the Millbank painting as reproduced in the digital download titled *Turner Whistler Monet Teachers' Pack*, offered online for use in classrooms (Tate Britain 2005).

This seems to raise a fatal problem for an astronomical analysis, especially troubling because the Tate Britain houses *Moonlight, A Study at Millbank* in its own permanent collection, and leading Turner experts compiled the exhibition catalogue. How could we date this painting, in part from the position of the "star" relative to the Moon's disk, if no bright "star" appears in these reproductions?

Our Texas State group suggested that the "star" may have been mistakenly identified as a defect and removed, using Photoshop™ or an equivalent program, from the digital files that the Tate Britain used to create the prints, teachers' guide, and catalog. To be certain that the original Turner painting showed a bright "star," we visited the museum in London and clearly saw the prominent white dot in the sky above and to the right of the Moon.

The Moon and Jupiter

Turner exhibited an oil painting entitled *Fishermen at Sea* at the Royal Academy in the summer of 1796 and *Moonlight, A Study at Millbank* there in the summer of 1797. Our calculations using computer planetarium programs quickly identified two possible dates in the second half of 1796 when a bright celestial object appeared near the Moon with a configuration similar to that of the painting.

On August 19, 1796, Jupiter and a nearly full Moon rose together into the evening twilight sky. On December 14, 1796, Saturn appeared close to the full Moon shortly after sunset.

Remarkably, weather observations exist from eighteenth-century London and can be used to rule out the December 1796 date. The monthly publication called *The Gentleman's Magazine* included in each issue a "Meteorological Table" contributed by William Cary (1759–1825), a maker of scientific instruments with a business on the Strand in London. For December 1796, Cary reported a stretch of bad weather for eleven straight days, with conditions described as "cloudy" or "rain" from December 11th through the 21st (Cary 1796b, p. 978). This eliminates the December 14th configuration of Moon and Saturn as a candidate for the inspiration of Turner's twilight scene with clear skies.

For August of 1796, Cary noted a long period of good weather, with conditions described as "fair" for every day from August 7th through the 26th (Cary 1796a, p. 626). Astronomical calculations, with the times given in Table 1.1 show that the grouping of the nearly full Moon and Jupiter at 8:30 p.m. on August 19, 1796, provided an excellent match to the appearance in Turner's painting.

In the magnitude system used by astronomers to describe brightness, negative values indicate very bright objects. On this evening, Jupiter had an apparent magnitude of −3, near its maximum possible brightness. The planet shone brilliantly, 5° above and to the right of the nearly full Moon in the twilight sky, making the Moon-Jupiter pair a memorable sight.

Table 1.1 Moon and Jupiter in the evening twilight sky on August 19, 1796

Greenwich Mean time	
7:13 p.m.	Sunset
7:35 p.m.	Jupiter rises
8:03 p.m.	Moon rises (Moon 98% illuminated)
8:30 p.m.	Moon and Jupiter rising together in the southeastern sky, with a configuration matching the painting

Consensus: The Moon and Jupiter

We soon learned that we were not the only astronomers to become interested in *Moonlight, A Study at Millbank*. The appearance of this painting in the Turner Whistler Monet exhibition inspired independent and nearly simultaneous analysis by Peter Nockolds, Mark Edwards, David Elmore, and our Texas State group. All of us did similar calculations, identified the same Moon-Jupiter grouping as the likely inspiration for Turner's painted scene, and noticed that the "star" had disappeared from the reproductions sold at the Tate Britain museum.

Peter Nockolds may have been the first to do an astronomical analysis. The Turner Whistler Monet exhibition opened in London on February 10, 2005. On the very next day Nockolds argued in a post to a history of astronomy online discussion group that the "astronomical data fits best to moonrise on 19th August 1796. Jupiter was then conjunct the Moon." He had observed the prominent bright "star" on the actual painting and expressed dismay that the Tate's catalog "thought that the star was simply a blemish and airbrushed it out" (Nockolds 2005, p. 1).

Mark Edwards calculated the same date of "19 August 1796" and noted: "What makes that painting particularly easy to date is Turner's fortuitous inclusion of the planet Jupiter near the full moon, curiously absent from the image on the Tate Britain gallery's website, but plainly visible on the original" (Edwards 2005, p. 17). Edwards visited the Tate gallery shop and found that "there was a postcard of the picture, showing the full Moon in all its glory, but wait a minute what happened to Jupiter? It was nowhere to be seen!" (Edwards 2006, p. 4).

David Elmore likewise traveled to London for the exhibition. His astronomical calculations determined that the best solution for the date was August 19, 1796, and that the planet was Jupiter. Elmore noticed that planet was touched out and did not appear on many of the Tate reproductions (Elmore 2005, p. 1).

Location: Near Tate Britain?

Our Texas State group wondered whether we could determine Turner's precise location along the Thames. We hoped to find a spot where the view matched the appearance of the river and its banks, the buildings in the distance, and the region of the sky where the Moon and Jupiter rose, all as depicted by the artist.

The materials posted online by the Tate Britain museum inadvertently caused considerable confusion about Turner's location for *Moonlight, A Study at Millbank*, which was described as "a view of what once was a desolate area surrounding what is now Tate Britain." (Tate Britain 2005, p. 10) The museum advised students: "Sketch the view of the Thames from the covered Tate to Tate pier across the road from Tate Britain. You will be working near to where Turner saw this view" (Tate Britain 2005, p. 10). The museum described the direction of the scene in the painting: "Turner here looks downriver towards the roofs and chimneys of Lambeth." Visitors were encouraged to walk along the banks of the Thames to see the places that inspired Turner. The museum published a map with a thumbnail of the moonlight painting adjacent to the modern museum site, and the accompanying text read: "As you set off from the pier in front of Tate Britain you will be near the site of Turner's *Moonlight, A Study at Millbank*" (Tate Britain 2005, p. 7). Readers of these materials stood on the bank of the Thames near the Tate Britain museum and attempted to replicate Turner's view—but without success.

A reviewer of the exhibition acknowledged that the museum had suggested that "Turner here looks downriver," but the frustrated reporter went on to say "This may mean upstream. 'What is the exact position of the artist on the riverbank?' must be the constant question asked by the visitor" (Hatts 2005, p. 1).

Peter Nockolds, Mark Edwards, and David Elmore also considered the location and direction of view specified in the exhibition material on the Tate website and likewise were unable to match the scene in the painting from that spot (Nockolds 2005, p. 1; Edwards 2006, p. 7; Elmore 2005, p. 1).

Our Texas State group realized that we could determine the correct location for the painting by consulting maps of London from Turner's time.

Location: Mill Bank Walk, Battersea, and the Red House

A key step in finding Turner's location was to realize what was meant by the word "Millbank" in the painting's title. We consulted maps from the 1790s and early 1800s and found that the "Millbank" name applied to three adjacent locations: Mill Bank Street (north of Horseferry Road, which now leads to Lambeth Bridge), Mill Bank Row (just south of Horseferry Road), and then a long path called Mill Bank Walk, which ran below a neighborhood called the Neat Houses Gardens and extended for more than 1½ miles to the west toward the channels of the Chelsea Water Works (Fig. 1.13).

Confirmation that we have determined the correct location for this painting comes from an eyewitness account by the artist's friend Edward Bell, who stated that Turner took his view from a point "near the Red House, Battersea." On the south bank, the five buildings near the lower left corner of this map detail include the notorious Red House tavern adjacent to Battersea Common Field.

A well-known London landmark, the Battersea Power Station, now stands on the south bank just below the position of the word "REACH" on this map.

The blue dot near the northeast end of Mill Bank Walk marks the location of the modern Tate Britain museum. This museum's materials posted online inadvertently caused considerable confusion about Turner's location for *Moonlight, A Study at Millbank*. As

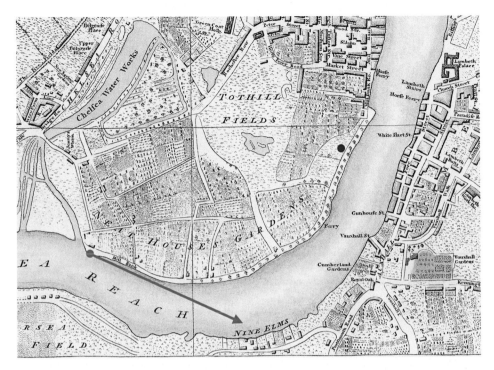

Fig. 1.13 This detail from John Fairburn's map of *London and Westminster 1802* shows the path called Mill Bank Walk running along the north bank of the Thames. The red dot marks Turner's location for *Moonlight, a Study at Millbank*, and the red arrow indicates the artist's direction of view toward the southeast, where the Moon and Jupiter were rising over the industrial district known as Nine Elms. The five buildings on the south bank near the lower left corner of this map detail include the notorious Red House tavern. The blue dot near the northeast end of Mill Bank Walk marks the location of the modern Tate Britain museum

explained in this chapter, frustrated readers of these materials stood on the bank of the Thames near the Tate Britain and attempted to replicate Turner's view—but without success.

The location of the modern Tate Britain museum is near the east end of what was then Mill Bank Walk. Our topographical and astronomical analysis, along with a site visit in August 2007, determined that Turner took his view from a spot near the west end of Mill Bank Walk. His precise position was near a building known as the White Lead Manufactory in Turner's time. Modern visitors can visit the location along Grosvenor Road on the north bank of the river, just east of the Grosvenor Bridge (Fig. 1.14). Trains to and from Victoria Station use this railway bridge, built in 1860, to cross the Thames. Modern visitors looking across the river will see the famed Battersea Power Station on the south bank of the Thames.

Fig. 1.14 The scene along the Thames is much changed from the appearance in Turner's time. This photograph from August 2007 shows the view looking downriver from Turner's location on the north bank of the Thames, just east of the modern Grosvenor Bridge. The water level here corresponds to an afternoon high tide. The tallest building in the distance is Keybridge House, and the imposing Battersea Power Station appears on the right edge of this image (Photograph by Russell Doescher. Used with permission)

Turner's oblique view downriver looked toward the buildings and chimneys in the neighborhood of Nine Elms, in the distance on the opposite shoreline below the Moon. Nine Elms received its name in the seventeenth century from a row of trees then bordering the road. The Nine Elms region and the nearby shoreline became an industrial district with the riverbanks lined by timber companies, vinegar factories, breweries and distilleries, lime kilns, and pottery factories.

Some corroboration of our topographical analysis comes from a contemporary account by Edward Bell, one of Turner's friends, in 1796. Bell's story appears in a nineteenth-century biography of the artist:

Mr. Bell, an engraver...was introduced to Turner, the celebrated water-colour painter, then living...in Maiden-lane....Mr. Bell stood by in the little room of Maiden-lane when Turner made his first attempt in oil, from a sketch in crayon, of a sunset on the Thames, near the Red House, Battersea. This sketch had been made the previous day, when both Bell and Turner, in a boat, had been nearly set fast in the mud by the tide leaving them stuck some distance from the shore. It was with great difficulty they eventually got afloat, so heedless had the enthusiasts been of either tide or time (Thornbury 1862, p. 75).

This passage appears to describe some of the events surrounding the creation of *Moonlight, A Study at Millbank*, considered in 1862 to be the artist's first oil painting.

The Red House mentioned by Bell was a well-known tavern notorious for illegal racing, gambling, and drunken brawls. Work crews demolished the structure in 1850 as part of the process that created the modern Battersea Park. Comparison of old and modern maps shows that the railway tracks at the south end of the modern Grosvenor Bridge pass almost directly over the former site of the Red House. Edward Bell's account therefore helps to confirm that we have identified the correct location and direction of view for Turner's twilight painting.

Tides on the Thames

Edward Bell's story provided one more detail of scientific interest when he described the low tide that caused such difficulty for the pair.

The Times of London published a tide table daily in a column titled "High Water This Day at London Bridge." The newspaper on August 19, 1796, predicted that the afternoon high water would occur at 3:05 p.m. at London Bridge. Adding the correction of a quarter hour appropriate to Turner's location upriver gives an approximate time of 3:20 p.m. for high water there. Adding a quarter of a tidal day gives an approximate time of 9:30 p.m. for the next low water near Chelsea, Battersea, and the Red House.

At 8:30 p.m., the time when Turner and Edward Bell could have observed the rising Moon and Jupiter at altitudes matching the painting, the water level in the Thames was falling and was only about one foot above the low tide level that would occur an hour later.

The tide calculation helps to explain Bell's recollection that their boat became "nearly set fast in the mud by the tide leaving them stuck some distance from the shore … with great difficulty they eventually got afloat, so heedless had the enthusiasts been of either tide or time." The agreement with Bell's story helps to confirm that the astronomical analysis arrived at the correct date.

Turner's Twilight

The correct location for Turner's *Moonlight, A Study at Millbank* is more than a mile west of the Tate Britain museum. These results from our topographical analysis and helps to explain the confusion of those who were unable to replicate the view from the Tate Britain pier. Modern visitors can find Turner's location along Grosvenor Road on the north bank of the Thames, just east of the Grosvenor Bridge. From this spot, the artist captured a memorable scene as the Moon and nearby Jupiter rose into the evening sky, about 1¼ h after sunset on August 19, 1796.

Ford Madox Brown: Moons and a Rainbow

The English artist Ford Madox Brown (1821–1893) was a leading figure in the Pre-Raphaelite movement during the middle of the nineteenth-century. In addition to masterpieces such as *The Last of England* and *Work*, he also created several paintings of astronomical interest. The canvas entitled *Walton-on-the-Naze* (Fig. 1.15) features both a rising full Moon and a

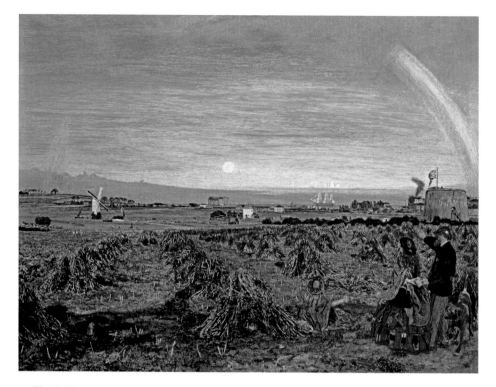

Fig. 1.15 Ford Madox Brown, *Walton-on-the-Naze*

rainbow that arcs high in the sky above a coastal town, while his *Carrying Corn* (Fig. 1.16) and *The Hayfield* (Fig. 1.17) depict full (or nearly full) Moons rising over rural landscapes. Could we use the Moon's phase and position, distinctive landscape features, the artist's letters and diary, the geometry of rainbows, and other clues to determine dates and precise times when Ford Madox Brown observed these spectacular scenes?

Walton-on-the-Naze

In the late summer of 1859 the artist took his family to the seaside town of Walton-on-the-Naze, a popular vacation spot in the county of Essex northeast of London. Brown's correspondence indicates that he was still at his home in the Kentish Town area of London on August 19th. A letter dated August 26th establishes that he had arrived at the coastal town to begin a sojourn at "Grosvenor Cottage, Walton on the Naze." Regarding the landscape painting inspired during this visit, an entry in the artist's account book confirms that this canvas was "[p]ainted on the spot … 1859." (Bennett 2010, p. 192; Trueherz 2011, p. 174)

Art historian Allen Staley noted that "*Walton-on-the-Naze* gives an extraordinary amount of information about the place. Brown's look was not a rapid glance, but a steady gaze taking in the myriad features of the landscape" (Staley 2001, p. 49).

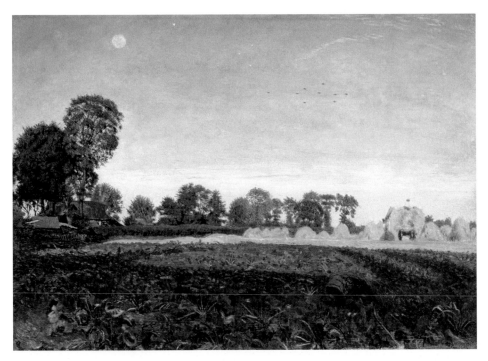

Fig. 1.16 *Carrying Corn* by Ford Madox Brown depicts the sky above a field with turnips in the foreground and wheat (British: "corn") in the distance, shortly before sunset. The nearly full Moon rises into the late afternoon sky and is accompanied by the bright planet Jupiter above and to the right of the Moon

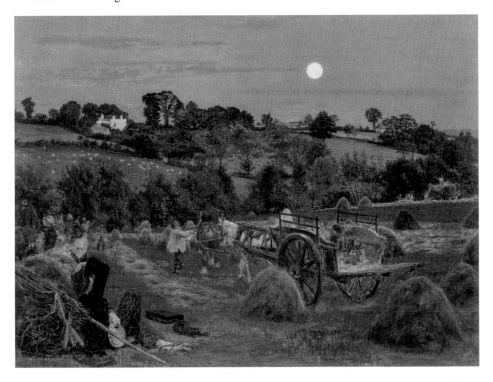

Fig. 1.17 *The Hayfield* by Ford Madox Brown shows the view to the southeast as a nearly full Moon rises into the evening twilight sky

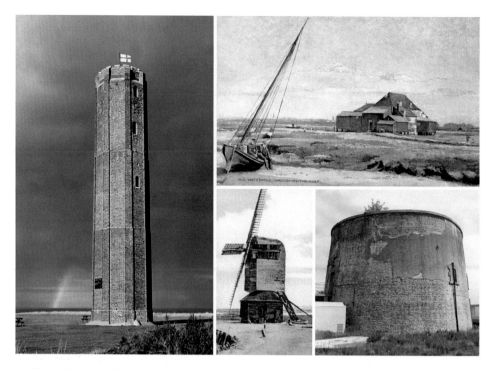

Fig. 1.18 These four structures are among those included by Ford Madox Brown in his panoramic view of *Walton-on-the-Naze*. Comparison with detailed maps allows us to determine the artist's position in a field west of the small bodies of water that are part of the region known as the Backwaters. (left) The Naze Tower, seen in this spectacular photograph from 2004, now includes a museum and gallery. By a remarkable coincidence, the photographer Nigel Pepper captured a rainbow just to the left of the tower, almost exactly as seen in Ford Madox Brown's painting. (Photograph courtesy of Naze Tower, www.nazetower.co.uk. Used with permission). (top right) The Walton Mill, a tidal mill worked by water dammed up in the adjacent Mill Pond, in a postcard view from circa 1910. (bottom center) The windmill in a postcard view from circa 1910. (bottom right) The Martello Tower, seen in a photograph from 2014 (Photograph by David Chandler. Used with permission)

Photographs, vintage postcards, and detailed maps allow us to identify the buildings and other structures in this painting (Fig. 1.18). On the distant horizon at the extreme left, the Walton Hall estate appears along with the vertical red column of the Naze Tower, erected in 1720–1721 as a navigational aid for ships in the English Channel. A windmill dominates the shore of a body of water known as the Saltings. Below the Moon is the Walton Mill, a tidal mill worked by water dammed up in the adjacent Mill Pond in the middle distance. At the far right of the canvas, a Union Jack flag flies prominently from the round structure of the town's Martello Tower, built in 1808–1812 as part of England's coastal defenses during the Napoleonic wars. Next to the Martello Tower, smoke rises into the sky from a steamship at the town's pier, while a 3-masted warship is visible out in the English Channel. The figures in the foreground at the lower right represent the artist, his wife Emma, and their daughter Catherine. In the catalog entry for this painting in an 1865

exhibition, Brown himself wrote about how "the gentleman descants learnedly on the beauty of the scene" (Bennett 2010, p. 192).

Combining the abundant topographical information with the nineteenth-century maps makes it relatively straightforward to determine the artist's position in a field west of the small bodies of water that are part of the region known as the Backwaters. The direction of view in the center of the painting is almost directly to the east, with the Naze Tower and the lefthand arc of the rainbow in the northeast, and the Martello Tower and the righthand arc of the rainbow in the southeast.

To determine the date and precise time of the depicted scene, our Texas State University group realized that we could use two celestial clues: the geometry of the rainbow and the position of the rising full Moon.

Rainbows Opposite the Sun

Rainbows always appear in the part of the sky that is opposite the Sun. To make this more precise, meteorologists and astronomers introduce the "anti-Sun," an imaginary point exactly opposite the actual Sun. For example, if the actual Sun is above the western horizon, then the anti-Sun is below the eastern horizon. The primary bow is always part of a circle with a radius of 42° and with the anti-Sun at the center of the circle.

In order to observe in the sky the largest possible rainbow arc, similar to that seen in Ford Madox Brown's painting, the anti-Sun must be only a short distance below the horizon. In that case the top of the rainbow arc can reach almost 42° up into the sky, and the total width of the bow from left to right can approach 84°. If the anti-Sun is just below the eastern horizon, then the actual Sun must be just above the western horizon, and the time must be only a few minutes before sunset. This appears to be the case for the panoramic view of *Walton-on-the-Naze*.

Full Moon Opposite the Sun

The lunar phase of a full Moon occurs when the Sun and Moon are on opposite sides of Earth. The behavior of a full Moon is also opposite to that of the Sun in the following senses: the full Moon rises in the east near the time when the Sun is setting in the west; the full Moon is highest in the night sky near local midnight when the Sun is absent from the sky; and the full Moon sets in the west near the time when the Sun rises in the east. Because of this position and behavior "opposite" to that of the Sun, astronomers in medieval times referred to the full Moon not only by the Latin phrase *Luna plena* ("full Moon") and but also by the term *oppositio Lunae* ("opposition of the Moon").

In the case of this Ford Madox Brown painting, the foreground observers have their backs to the setting Sun as they look in the opposite direction to watch the full Moon rise into the eastern sky.

Rare Scene: Full Moon Inside a Rainbow

The fact that both the rainbow display and the full Moon must appear opposite the Sun raises the possibility of an exceptionally rare event with the two sky phenomena occurring simultaneously: a rainbow with its center exactly opposite the setting Sun, and the rising full

Moon visible nearly at the center of the bow. Such a celestial scene can occur only when a rainbow shines forth during a rainstorm that happens to take place just before sunset on the day of a full Moon, with the lunar disk visible between the rain clouds. This is exactly the remarkable view captured in Ford Madox Brown's *Walton-on-the-Naze* painting!

Astronomical Calculations

After the artist's arrival in the coastal town in late August, the next full Moon fell on September 12, 1859. Detailed calculations demonstrate that the late afternoon sky on this date provided an excellent match to Ford Madox Brown's painting.

Moonrise occurred at 6:02 p.m., with sunset at 6:18 p.m. The canvas depicts the scene at an intermediate time, near 6:10 p.m., with both the Moon and the Sun above the horizon. These clock times are expressed in Greenwich Mean Time.

Two different astronomical reasons explain why Ford Madox Brown correctly did not place the painted Moon at the exact center of the rainbow. First, we calculate that the precise time of full Moon occurred on September 12, 1859, at 8:32 a.m. By the time of sunset, almost 10 h later, the Moon had moved several degrees beyond the point of exact opposition to the Sun.

The second reason, somewhat more complicated to explain, involves the 5° tilt of the Moon's orbit relative to the ecliptic plane, defined as the plane of Earth's orbit around the Sun and considered the fundamental plane of the Solar System. The intersection of the ecliptic plane with the celestial sphere is a line (technically, a great circle) called the ecliptic. Observers on Earth will always find the planets, the Moon, and the familiar zodiacal constellations on or near the ecliptic. The Sun itself and the anti-Sun are always exactly on the ecliptic. If a new Moon or a full Moon happens to occur with our satellite on the ecliptic, then a solar eclipse or a lunar eclipse will take place—which is the reason for the name "ecliptic." However, on any given random date the tilt of the lunar orbit has the consequence that the Moon can wander as much as 5° north or south of the ecliptic.

Near the time of sunset on September 12, 1859, we calculated that the Moon had progressed almost 10 h after the precise time of full Moon and had moved in its orbit more than 4° past the position of closest approach to the anti-Sun. The tilt of the lunar orbit placed the Moon about 2½° north of the ecliptic. The combination of these two effects caused the nearly full Moon, 99.8% illuminated, to be in a position about 5° north of the anti-Sun, that is, about 5° "above and to the left" of the center of the rainbow. The excellent agreement between this calculation and the position of the lunar disk in the Ford Madox Brown painting provided strong support for the conclusion that the canvas depicts the late afternoon sky of September 12, 1859.

We can eliminate the full Moon date of August 13, 1859, as a candidate, because the artist then was still in London. We can also rule out the dates near the full Moon of October 11, 1859, because of seasonal changes in the positions of sunset. Compared to September 12th, the position of the setting Sun on dates near October 11th shifted far to the south, with the effect of shifting the compass direction of the anti-Sun far to the north. Any late afternoon rainbows viewed during this period of October would have had the northern

("left") end of the rainbow completely off the left side of the canvas, the center of the bow shifted far to the left, and the southern ("right") end of the rainbow well to the left of the Martello Tower, in complete disagreement with the painted scene.

The only possible date and time to match the scene in *Walton-on-the-Naze* is September 12, 1859, near 6:10 p.m. Greenwich Mean Time.

We can use similar methods to analyze two more moonrise paintings from earlier in the artist's career. These two cases are much easier to understand because Ford Madox Brown kept a diary during the mid-1850s (Surtees 1981).

Carrying Corn

The painting *Carrying Corn* (Fig. 1.16) depicts a field in or near the rural Finchley district northwest of London. The time is late afternoon, with the full (or nearly full) Moon already risen into the sky and what appears to be a bright star or planet in the sky above and to the right of the Moon.

The artist's diary gives Monday, September 4, 1854, as the date when Brown went out to this "field to laying the outline of a small landscape, found it of surpassing loveliness." (Surtees 1981, p. 90) Art historian Mary Bennett points out that a label on the back of this canvas "in the artist's hand … reads: 'Carrying Corn, sketch from Nature.'" She also notes that the "diary for the next six weeks records over twenty visits to the field" (Bennett 2010, p. 180).

For September 4, 1854, the date of the original inspiration, we calculate that the nearly full Moon (94% illuminated) rose at 6:15 p.m., and that sunset occurred at 6:41 p.m., both expressed in Greenwich Mean Time. Our calculations for the times between moonrise and sunset suggest that the bright dot near the Moon in the painting represents the brilliant planet Jupiter, which occupied that position and was rising into the southeastern sky along with the lunar disk.

The Hayfield

The canvas known as *The Hayfield* (see Fig. 1.17 earlier) shows the view to the southeast across a field on the Tenterden estate in the rural Hendon district northwest of London. As he did for *Walton-on-the-Naze*, Brown included himself as an observer, this time at the lower left with his palette and other painting materials. The artist provided the date of inspiration with the diary entry for July 27, 1855: "Saw in twilight what appeared a very lovely bit of scenery with the full moon behind it just risen. Determined to paint it" (Surtees 1981, p. 146). Brown worked on this canvas for the next several months and confirmed the location with his diary entry for October 22, 1855: "work again at the Hendon moon piece on Lord Tenterden's property" (Surtees 1981, p. 155).

For July 27, 1855, the date of the original inspiration for the work, we calculate that the nearly full Moon (97% illuminated) rose at 7:26 p.m., that sunset occurred at 7:58 p.m., and that the painting corresponds to a time between sunset and the end of civil twilight at 8:40 p.m., all expressed in Greenwich Mean Time.

Rising Moons and a Rainbow

Ford Madox Brown was a master of depicting a full (or nearly full) Moon rising over a late afternoon or evening twilight landscape. The artist was inspired to create *Carrying Corn* shortly before sunset on September 4, 1854, and *The Hayfield* just after sunset on July 27, 1855. For his most spectacular such canvas, *Walton-on-the-Naze*, analysis based on the Moon's phase and position, distinctive topographic features, and the geometry of rainbows allows us to determine a date and a precise time: September 12, 1859, near 6:10 p.m. Greenwich Mean Time.

References

Anonymous (1865) Proposed St. Thomas's Hospital, Lambeth. *The Builder* **23** (No. 1174), 556.

Baker, Jacob, and John E. Thornes (2006) Solar position within Monet's Houses of Parliament. *Proceedings of the Royal Society A* **462** (No. 2076), 3775-3788.

Bell, Charles Francis (1901) *A List of the Works Contributed to Public Exhibitions by J.M.W. Turner, R.A.* London: George Bell and Sons.

Bennett, Mary (2010) *Ford Madox Brown: A Catalogue Raisonné*. New Haven, CT: Yale University Press.

Butlin, Martin, and Evelyn Joll (1984) *The Paintings of J. M. W. Turner*. New Haven, CT: Yale University Press.

Cary, William (1796a) Meteorological Table for August, 1796. *The Gentleman's Magazine* **66** (No. 2), 626.

Cary, William (1796b) Meteorological Table for December, 1796. *The Gentleman's Magazine* **66** (No. 6), 978.

Currey, Henry (1871) St. Thomas's Hospital, London. *Sessional Papers of the Royal Institute of British Architects, Session 1870-1871*, 61-78.

Edwards, Mark (2005) Time for Turner. *New Scientist* **187** (No. 2517), September 17, 2005, 17.

Edwards, Mark (2006) What Happened to Jupiter? *MIRA, Newsletter of the Coventry and Warwickshire Astronomical Society* **74**, Winter, 4-7.

Elmore, David (2005) personal communications.

Hatts, Leigh (2005) Turner Whistler Monet at Tate Britain. *London SE1* website, www.london-se1.co.uk, February 14, 2005.

Hill, David (1993) *Turner on the Thames*. New Haven, CT: Yale University Press.

House, John, Petra ten-Doesschate Chu, and Jennifer Hardin (2005) *Monet's London: Artists' Reflections on the Thames, 1859-1914*. Saint Petersburg, Florida: Museum of Fine Arts.

Khan, Soraya, and John E. Thornes, Jacob Baker, Donald W. Olson, and Russell L. Doescher (2010) Monet at the Savoy. *Area, Royal Geographical Society* **42** (No. 2), 208-216.

Lochnan, Katharine (2004) *Turner Whistler Monet*, with contributions by Luce Abélès, John House, Sylvie Patin, Jonathan Ribner, John Siewert, Sarah Taft, and Ian Warrell. Toronto: Art Gallery of Ontario, and London: Tate Publishing.

Mirbeau, Octave (1904) *Claude Monet: Vues de la Tamise à Londres*. Paris: Galeries Durand-Ruel.

Nockolds, Peter (2005) posts on HASTRO-L, February 11 and February 13, 2005, and personal communications.

Olson, Donald (2014) *Celestial Sleuth: Using Astronomy to Solve Mysteries in Art, History and Literature*. Springer Praxis: New York.

Ruskin, John (1857) *Notes on the Turner Gallery at Marlborough House 1856-7*. London: Smith, Elder & Co.

Spencer-Longhurst, Paul (2006) *Moonrise over Europe, J. C. Dahl and Romantic Landscape*. London: Philip Wilson Publishers.

Staley, Allen (2001) *The Pre-Raphaelite Landscape*. New Haven, CT: Yale University Press.

Surtees, Virginia (1981) *The Diary of Ford Madox Brown*. New Haven, CT: Yale University Press.

Tate Britain (2005) *Turner Whistler Monet Teachers' Pack*. London: Tate Publishing.

Thornbury, Walter (1862) *The Life of J. M. W. Turner, R.A., Volume I*. London: Hurst and Blackett.

Trueherz, Julian (2011) *Ford Madox Brown: Pre-Raphaelite Pioneer*. London: Philip Wilson.

Wildenstein, Daniel L. (1974) *Claude Monet. Biographie et Catalogue Raisonné, Vol. IV, 1899-1926, Peintures*. Lausanne and Paris: Bibliothèque des Arts.

Wildenstein, Daniel L. (1996) *Monet, Catalogue Raisonné*. Köln: Taschen.

2

Monet in Étretat, Édouard Manet, and Vincent van Gogh

Claude Monet created more than eighty paintings depicting the spectacular Normandy coastline near the town of Étretat. On November 27, 1885, he was working near Étretat on an isolated beach accessible only at low tide and surrounded by steep cliffs. The artist suffered a nearly fatal accident when he became so preoccupied with his canvas that he did not notice the incoming tide. Prominent signs on this beach warn of the dangers and caution visitors to monitor the tide tables carefully. Monet grew up on the Normandy coast, and his letters prove that he had often painted coastal scenes with careful attention to the tide levels. Can we explain how he could have made such a mistake in Étretat regarding the tides? Can computer calculations recreate the tide schedules of 1885 and allow us to determine the precise hour when Monet was nearly trapped and drowned by the waves that accompanied the rising tide?

Édouard Manet's *Moonlight Over the Port of Boulogne* includes stars and a full Moon in a deep blue sky above the port of Boulogne-sur-Mer in Northern France. Art historians have dated this painting to either 1868 or 1869. Could we identify the precise location from which Manet obtained this view? Could we use astronomical calculations of lunar phases, maps of Boulogne harbor, meteorological archives, the letters of the artist, and other clues to determine the date and precise time when Manet observed the moonlit harbor?

Vincent van Gogh included the planet Venus prominently in the skies of three twilight paintings created during the years 1889 to 1890. More than a decade earlier, the artist made an intriguing reference to the "Evening Star" in a letter to his brother Theo. Writing on April 8, 1877, Vincent described a trip on the last train of the previous evening to the town of Oudenbosch in the Noord Brabant region of the Netherlands. Then, as he walked from Oudenbosch to reach his hometown of Zundert, he observed the sky in which "the Evening Star shone through the clouds." Could we find nineteenth-century railroad schedules for help in determining the time when he viewed the heavens? What did van Gogh see in the sky during that walk? On that occasion, did Vincent observe Venus—or some other bright celestial object?

© Springer International Publishing AG 2018
D.W. Olson, *Further Adventures of the Celestial Sleuth*, Springer Praxis Books,
https://doi.org/10.1007/978-3-319-70320-6_2

Vincent van Gogh's first attempts to paint the night sky date from the year 1888, when he lived in the town of Arles. What constellation appears in his Arles canvas known as *Starry Night Over the Rhône*? How do the dates of the artist's letters and the orientation of the star patterns relative to the horizon of Arles allow us to determine the clock time when van Gogh observed the scene that inspired this painting? When did he set up his easel on the banks of the Rhône River? Was it shortly after sunset? Mid-evening? Near midnight? In the early morning hours? Shortly before sunrise? Some authors insist that this painting must be a composite, with the starry sky seen in one direction depicted above the river and the town viewed in another direction. Are those authors correct?

Claude Monet's Near-Drowning at Étretat

Claude Monet (1840–1926) (Fig. 2.1), a founding and leading member of the Impressionist movement, created almost 2000 paintings during his long career. More than 80 of these canvases depict the spectacular cliffs, arches, rocks, and beaches near the town of Étretat in Normandy.

The town lies near the center of a horseshoe-shaped bay that faces the English Channel. To the southwest of the town is the cliff known as the Falaise d'Aval, with the arch called the Porte d'Aval ("downstream portal"). Beyond this arch stands a tall pyramid-shaped rock called the Aiguille ("Needle"). Even farther to the southwest lies another bay and the Jambourg beach, accessible only at low tide. From the Jambourg beach, visitors can gaze back northeast to gain an entirely different perspective on the Porte d'Aval and Needle

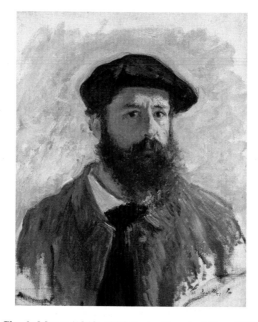

Fig. 2.1 Claude Monet (1840–1926) in a self-portrait from 1886 (W1078)

Fig. 2.2 The Needle and the Porte d'Aval on the beach near Étretat. (top) View from the top of the cliff looking along the Jambourg Beach toward the northeast with the Needle and the Porte d'Aval in the distance. (Photograph by the author.) (bottom left) Working down on the beach, Claude Monet painted what he called the "amazing things," including this canvas known as *The Needle and the Porte d'Aval* (W1034). (bottom right) During a research trip in August 2012, our Texas State University group was always careful to visit this beach only near low tide. (Photograph by Russell Doescher. Used with permission)

(Fig. 2.2). They can also look southwest to see an enormous arch called the Manneporte ("great portal") (Fig. 2.3).

The physical locations near Étretat are daunting. In Monet's day, reaching the Jambourg beach required a climb down a steep and dizzying zigzag trail on the towering chalk cliff. This trail is so dangerous that the city of Étretat has now posted at the top of the path a sign reading "Access Prohibited."

The Jambourg beach floods dangerously at high tide. Conjuring the image of Monet, carrying bulky painting equipment, scrambling up and down the cliffs, and wading in the seaweed, brings him and the moment of artistic creation very close in our imaginations.

Fig. 2.3 From locations down on this beach near Étretat, Monet painted the enormous arch known as the Manneporte. (top) View from the top of the cliff looking along the Jambourg Beach toward the southwest with the great arch in the distance. (Photograph by Moyan Brenn. Used with permission.) (bottom left) Claude Monet, *The Manneporte Near Étretat* (W1052). (bottom right) Claude Monet, *The Manneporte* (W832)

Monet followed the zigzag trail down to the Jambourg beach for the first time on February 3, 1883, and was immediately impressed by the cliffs and arches that he saw there:

As for the cliffs here they are like nowhere else. I went down today to a place I had never before dared to venture, and I saw the most amazing things, so I quickly returned to get my canvases. (Letter written from Étretat, Claude Monet to Alice Hoschede, February 3, 1883.)

During February 1883 Monet produced about twenty Étretat paintings, including three views from the Jambourg beach.

Nearly Fatal Accident in 1885

Two years later Monet returned to Étretat for another painting campaign. On November 27, 1885, he noticed that a strong wind in the channel was producing tall waves breaking on the rocks, and he planned to capture the dramatic scene at the Manneporte arch on the Jambourg beach. But the artist had a nearly fatal accident when he became so preoccupied with his work that he did not notice the incoming tide. In a letter written that evening, he first offered reassurances that he was all right and then explained what had happened:

After another rainy morning, I was happy to see the weather recover a little; although a strong wind was blowing and the sea was raging, but precisely because of this, I was counting on having a rich session at the Manneporte, but I happened to have an accident: do not be alarmed, I am safe and sound as I write, but little was lacking for you to have no news of me and for me never to see you again. I was in all the ardor of work under the cliff, well sheltered from the wind...convinced that the tide was falling, I was not alarmed by the waves that came to die out a few steps from me. In short, completely absorbed, I did not see an enormous wave which threw me against the cliff, and I tumbled head over heels into the foam, with all my materiel! I immediately thought myself lost, because the water was holding me, but finally I was able to get out on all fours, but in what condition, good God! With my boots, my heavy socks, and my old coat soaked: my palette remained in my hand but had struck me in the face, and my beard was covered with blue, yellow, etc. But finally, now that the excitement has passed, it is nothing at all. The worst thing is that I lost my canvas, which was instantly broken, as well as my easel, my bag, etc. Impossible to recover anything...it was all crushed by the sea...In sum, I had a lucky escape. But how I raged to see myself unable to work once I had changed and to see my canvas, on which I was counting, lost. I was furious. So I have telegraphed to Troisgros [an art supply dealer in Paris] to send to me what I am missing and to make a new easel for me for tomorrow. (Letter written from Étretat, Claude Monet to Alice Hoschede, evening of November 27, 1885.)

The artist provided another action-packed account of this accident in an interview with the art critic François Thiébault-Sisson. This version contains several additional details, the most notable being that Monet was saved in part because two locals on the nearby cliff observed his misadventure:

And Monet told me how one day in Étretat...he had been determined to reproduce every detail of a storm. After finding out exactly how far up the waves could reach, he planted his easel on a ledge of the cliff, high enough to avoid being submerged by the flood tide. As a further precaution he anchored his easel with strong ropes and attached his canvas securely to the easel. After this, he commenced to paint. The sketch was already promising to be something marvelous when a deluge of water

Fig. 2.4 The children's book *Monet Paints a Day* depicts the events of November 27, 1885. This illustration shows Monet underwater after being swept into the sea by the great wave. (*Monet Paints a Day,* text copyright © 2012 by Julie Danneberg; illustration copyright © 2012 by Caitlin Heimerl. Used with permission of Charlesbridge Publishing, Inc., 85 Main Street, Watertown, MA 02472, www.charlesbridge.com)

poured down upon him from the sky. At the same time, the storm redoubled in violence. Stronger and stronger waves rose in furious swirls, drawing imperceptibly closer, unnoticed by the artist. Indifferent to all this, Monet was working furiously. All of a sudden, an enormous wall of water tore him from his stool. Submerged and without air, he was about to be swept out to sea when, by a sudden inspiration, he dropped his palette and paint brushes and seized the rope that held his easel. This did not keep him from being tossed about like an empty barrel and, had chance not brought two fishermen on the cliff to his rescue, he would have dined with Pluto (Thiébault-Sisson 1927, p. 3).

The last sentence's reference to Pluto, the ruler of the underworld, emphasizes how close Monet came to drowning (Fig. 2.4).

How could this accident have happened? Monet grew up in Le Havre, on the Normandy coast, and he had often painted coastal scenes with careful attention to the tide levels. How could the artist have made such a mistake regarding the tides? Monet gave the explanation in his letter:

> *The cause of all this, because I am very careful and I never go out without checking the exact time of high tide, is that when I looked at the schedule at the hotel indicating the tides, I did not notice that yesterday's sheet had not been torn off, so that the tide was rising instead of falling, as I was convinced it was* (Letter from Claude Monet to Alice Hoschede, written from Étretat, evening of November 27, 1885).

Moon Phase, Moon's Distance, Tides, and a Storm

Normandy is famous for its remarkable tides, with a mean range near Étretat of about 18 ft (5.5 m), a range of about 24 ft (7.3 m) near new or full Moons, and extreme tide ranges that at certain times of the year can reach 28 ft (8.5 m).

In a letter written a few days before the accident, Monet mentioned bright moonlight that evening: "Against my habit, I went to bed later, at 11:30 p.m. The moonlight was superb." (Letter written from Étretat, Claude Monet to Alice Hoschede, November 21, 1885.)

Computer calculations show that the Moon's disk was 99.5% illuminated on the evening of November 21, 1885, with the precise moment of full Moon falling on the morning of November 22nd. A lunar perigee occurred on November 24th, with the Moon reaching the point in its orbit closest to Earth and therefore producing the greatest lunar gravitational tide-raising forces on Earth's oceans. These combined effects caused enhanced tide ranges for almost a week following the full Moon.

In addition to these astronomical factors, meteorological events can significantly affect the tides. Low barometric pressure and storms producing strong onshore winds can increase water levels, augment the height of the waves, and allow the tide to reach farther up onto the beach.

Monet in his November 21st letter mentioned a falling barometer, presaging a storm: "I'm afraid of the weather…This morning I was desperate, the barometer had fallen considerably during the night, the weather was so bad…the rain started and then Sun and then rain again…the infernal barometer drops more and more." (Letter written from Étretat, Claude Monet to Alice Hoschede, November 21, 1885.)

The artist's letters between November 22nd and November 27th are filled with references to bad weather, rain, and the falling barometer. The weather column in *The Times* of London described a massive storm on November 26th over much of Britain, with heavy seas on the coasts.

The *Bulletin International du Bureau Central Météorologique de France* for November 27, 1885, noted that "the storm in Britain has moved to the east" and was now affecting the Normandy coast. The *Bulletin* characterized the state of the sea as "*t. houl.*" ("*tres houleuse*," or "very rough") and pointed out that the "wind blows with violence in the Channel." Local newspapers also mentioned the storm, with the *Journal de Rouen* for November 27, 1885, warning that the "situation remains bad on the west of Europe, and the barometer

Fig. 2.5 (left) During our visit to Étretat in August 2012 members of our Texas State University group (Marilynn and Don Olson) enjoyed excellent weather as we climbed up and down the cliffs on the steep trails leading to the beaches. (Photograph by Russell Doescher. Used with permission.) (right) Storms and strong winds can play a role in causing high tides to cover the beaches and great waves to crash against the cliffs near Étretat. This woodcut by famed artist Édouard Riou appeared on the front page of the journal *L'Illustration* for March 4, 1882

has descended again." These meteorological effects, especially the strong winds, played an important role in creating the great wave that swept Claude Monet into the sea (Fig. 2.5).

Étretat Tide Calculations

Could we use modern computing methods to determine the precise time when Monet met with his accident?

A technique called harmonic analysis allows us to calculate the tide schedule that was posted at the Hotel Blanquet on November 26th and mistakenly remained posted at the hotel during the next day. Monet studied these incorrect tide times just before venturing to the Jambourg beach on November 27th. Our results (Table 2.1) from harmonic analysis list both tide schedules, including the November 27th tide times that actually prevailed during this painting expedition.

These nineteenth-century times are expressed in Étretat local mean time, less than 1 min ahead of Greenwich Mean Time. Modern France in the late Fall now employs a time zone exactly 1 h ahead of Greenwich Mean Time.

Table 2.1 Tide table for Étretat

November 26, 1885		November 27, 1885	
High tide	12:45 a.m.	High tide	1:32 a.m.
Low tide	7:05 a.m.	Low tide	7:51 a.m.
High tide	1:00 pm	High tide	1:47 p.m.
Low tide	7:32 p.m.	Low tide	8:20 p.m.

Fig. 2.6 Prominent signs at Étretat employ several languages (French, English, and German) to list tide times and to warn visitors that the beaches flood dangerously and can become completely submerged at high tide. These photographs date from our Texas State University research trip in August 2012. On November 27, 1885, Monet was careful to read the tide table — but the posted times were for the wrong day! (Photographs by the author)

Read the (Correct) Tide Table!

The tide calculations show that Monet must have had his accident at a time near 1:00 p.m. on November 27, 1885. The artist, mistakenly using the tide schedule for the previous day, would have been confident that the tide would rise no higher after 1:00 p.m. The astronomical factors, combined with the storm raging in the Channel and the strong winds, produced the great wave that nearly had fatal consequences for the artist.

During the research trip in 2012 by our Texas State University group, we were careful to visit the Jambourg beach only near low tide. The town posts signs in several languages and in bold letters that warn visitors: "During high tide the beach is completely submerged, for your safety please don't forget to read the tide table" and "ATTENTION! BE CAREFUL. Please don't forget to read the tide table" (Fig. 2.6).

Monet was careful to read the tide table, which turned out to be for the wrong day. The artist's experience suggests that an additional warning may be needed: be sure to read the tide table for today's date!

Manet's *Moonlight Over the Port of Boulogne*

Moonlight Over the Port of Boulogne, a spectacular painting by Édouard Manet (1832–1883), depicts stars and a full Moon in a deep blue sky above the port of Boulogne-sur-Mer in northern France. From an elevated location the artist looks down on the harbor as bright moonlight silhouettes fishing boats. Larger ships appear in the distance, a group of the fishermen's wives wearing distinctive white caps have gathered on the pier, and some barrels on the right occupy the dimly lit foreground (Figs. 2.7, 2.8, and 2.9).

Antonin Proust (1832–1905), a longtime personal friend of the artist, wrote an essay about this period in Manet's artistic career and assured his readers that the painting was created on the spot to capture the impression of one specific night in Boulogne. Proust, using an alternate title for the canvas, tells us that the artist's motto was: "'Be true'—that was his formula. At Boulogne, where he painted his admirable *Femmes de Pêcheurs au Clair de Lune* [Wives of the Fishermen in the Moonlight], he was so scrupulous in this respect that he absolutely refused to touch his canvas with the brush when he could not find the scene exactly as it was the night before." (Proust 1901, p. 234)

Fig. 2.7 Édouard Manet, *Clair de Lune Sur le Port de Boulogne* (*Moonlight Over the Port of Boulogne*)

Fig. 2.8 This bust of Édouard Manet (1832–1883) marks the artist's grave in Paris's Passy Cemetery. (Photograph by the author)

Fig. 2.9 The sketch shown here appeared in July 1869 in a catalog for the Brussels Salon des Beaux-Arts de Belgique. This event marked the first public exhibition of Manet's moonlight canvas, listed as number 756 among more than 1700 works displayed at the Jardin Botanique

Could we identify the location from which Manet obtained this view? Art historians have dated this painting to either 1868 or 1869. Can we use astronomical calculations of lunar phases, maps of Boulogne, meteorological archives, the letters of the artist, and other clues to determine the date and precise time when Manet observed the moonlit harbor? Could we find a night when the conditions matched the scene depicted in this canvas?

Table 2.2 Summer full
Moon dates in 1868 and 1869

1868 July 4	1869 June 24
1868 August 3	1869 July 23
1868 September 2	1869 August 22
	1869 September 20

1868 or 1869?

Antonin Proust recalled that Manet created the Boulogne moonlight painting in the summer of 1868 (Proust 1897, p. 175).

Théodore Duret (1838–1927), another friend of the artist during this period, provided a second account. Manet painted Duret's portrait in 1868. Duret recalled that Manet "spent part of the summers of 1868 and 1869 at Boulogne, where he painted seascapes and views of the port." Duret vividly described the nocturnal picture as an "admirable rendering of the mystery of night and the fantastic appearance of clouds riding across a moonlit sky" but was less certain about the precise year and offered only that the canvas dated to either 1868 or 1869. (Duret 1902, p. 101; Duret 1910, p. 76)

The 1869 date was insisted upon by biographer Adolphe Tabarant, along with many later commentators (Tabarant 1931, p. 579; Tabarant 1947, p. 163-165; Hanson 1966, p. 111; Cachin 1983, pp. 310–312; Herbert 1988, p. 274). However, our calculation of full Moon dates (Table 2.2) helps to show that Tabarant's reasoning for the 1869 date is flawed.

Tabarant argued that in July 1869 Manet became frustrated with some bad newspaper reviews and also with a portrait that was giving him great difficulty in his Paris studio: "At this point of time in July…furious, he stopped and abandoned everything, and made a hurried departure to the sea, to Boulogne." (Tabarant 1947, p. 163) According to Tabarant, the artist then created the moonlit harbor painting and almost immediately sent it via his friend, Alfred Stevens, to the Salon des Beaux-Arts de Belgique, which would open to the public in late July at the Jardin Botanique de Bruxelles. (Tabarant 1947, p. 165) But Tabrant's chronology cannot be correct. The announcements for the Belgian Salon stated that paintings would not be accepted after June 30th, with an exceptional deadline of July 10th only for works that had just been exhibited in the Paris Salon. The preceding table shows that the full Moon fell on July 23, 1869, too late for Manet to create the moonlight painting and convey it to Belgium before these deadlines.

Tabarant made another error regarding the calendar when he insisted that a related letter, written by Manet from Boulogne (and quoted later in this chapter), must be from 1869. Tabarant asserted that all contrary opinion must be mistaken. However, the letter itself bears the date July 29 (without a year) and includes a reference to "Saturday 1 August." Calendar calculations show that August 1st was indeed a Saturday in 1868, not in 1869.

We therefore follow Antonin Proust in dating the Boulogne moonlight painting to the summer of 1868. Our analysis agrees with the conclusion of several recent authors who also favor the date of 1868 for this canvas (Tinterow and Loyrette 1994, p. 415; Wilson-Bareau and Degener 2003, pp. 66–72, 96)

From what location near the Boulogne pier did Manet obtain this view? And toward which direction was Manet looking to observe the Moon? Is the Moon in the painting rising up from the eastern horizon, passing over the horizon to the south, or sinking toward the western horizon?

A Window in Hotel Folkestone

According to Théodore Duret, whose information may have come directly from the artist, the view was taken "from a window of the Hotel Folkestone on the pier in Boulogne." (Duret 1902, p. 101) Later commentators agree on the same vantage point (Figs. 2.10 and 2.11).

Another important topographic clue comes from the fiery chimney visible near the painting's left edge, below the Moon. Maps of Boulogne from the 1860s show an industrial area known as Capécure with sawmills, spinning mills, cement plants, and foundries (Fig. 2.12). The orange flames rising from the painted chimney suggest that Manet depicted one of the foundries.

Fig. 2.10 This nineteenth-century albumen photograph shows the steamship pier at Boulogne-sur-Mer, with vessels of the fishing fleet visible at the right. Manet created his night scene from a window of the Hotel Folkestone, the building marked by a red arrow

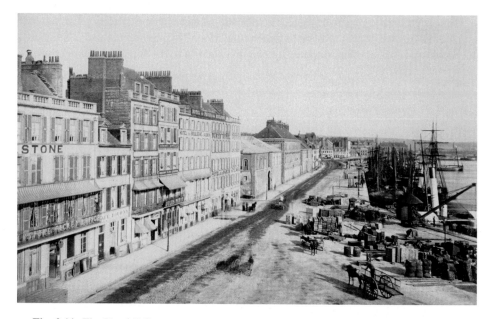

Fig. 2.11 The Hotel Folkestone appears at the extreme left of this nineteenth-century albumen photograph. At the pier are a steamship and vessels of the fishing fleet. The angle of Manet's view down onto the scene suggests that his hotel window was on the level called in France the "première étage," equivalent to the second story in American terminology. Similar groups of barrels and bales on the pier appear in this photograph and in Manet's canvas

The line of sight from Hotel Folkestone to the Capécure foundries points slightly east of south. The Moon in Manet's painting therefore appears in the sky almost directly south of Manet's hotel window.

As readers can determine by observation on several days during each lunar month, the full or nearly full Moon always passes through the southern sky near local midnight, which must be the approximate time of Manet's painting. We can be certain that Manet was familiar with the harbor at this time of night, because one of his letters proposed a trip with departure from Boulogne on the midnight boat!

Letters of the Artist

On July 29, 1868, Manet wrote from Boulogne-sur-Mer to fellow artist Edgar Degas in Paris:

> *I am planning to make a little trip to London, tempted by the low cost of the journey; do you want to come along? You can go from Paris to London 1ˢᵗ class return…buy your ticket from M. Spiers, 13 rue de la Paix. I think that we should explore the terrain over there because it could provide an outlet for our products…I am enclosing a list of departure times.*

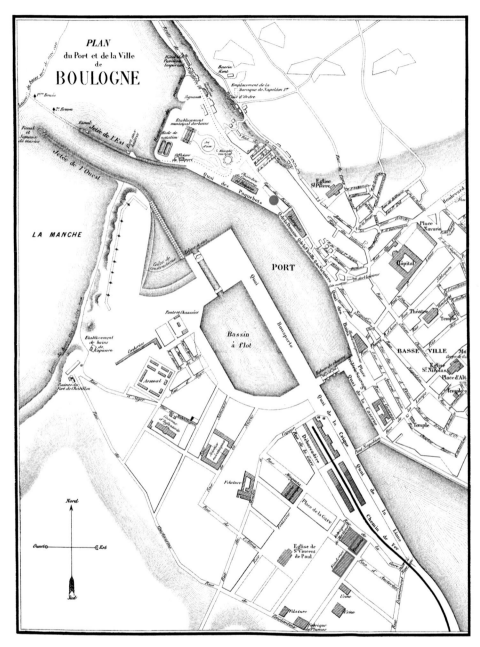

Fig. 2.12 This map of Boulogne-sur-Mer appeared in an 1864 guidebook titled *Brunet's New Guide to Boulogne and its Environs*. The jetties at the harbor entrance extend into the English Channel (*La Manche*) at the upper left. The red dot marks Manet's location in the Hotel Folkestone. The red outlines mark foundry buildings that stood among spinning mills, saw-mills, cement plants, and other factories in the Capécure industrial district at the south end of the town

By leaving on Saturday 1 August at 4 in the afternoon, we can embark the same evening on the midnight boat...Let me know by return and keep the luggage to a minimum.

Édouard Manet

(Letter from Édouard Manet to Edgar Degas, Boulogne-sur-Mer, July 29 [1868]; published in Wilson-Bareau 2004, p. 51.)

Travel guides from the 1860s and 1870s list Spiers as an agent for the General Steam Navigation Company, with rail connections from Paris to Boulogne and then steamships requiring about 8 h to cross the Channel and travel up the Thames directly to London. Based on another letter from a few days later, evidently Degas chose to remain in Paris:

I wanted to write to you from London but I was so busy during my two days there that I did not have a moment...Degas was very silly not to have come with me. I was enchanted by London...

ever yours, Édouard Manet

(Letter from Édouard Manet to Henri Fantin-Latour, Boulogne-sur-Mer, Sunday [probably August 2 or August 9, 1868]; published in Wilson-Bareau 2004, p. 51.)

The date of the reply from Degas, declining the invitation to come along on August 1st, is not known. This in turn makes it difficult to determine when Manet himself spent the two days in London and exactly when he returned to France. The tides during this period of the lunar month were such that the General Steam Navigation Company vessels were departing from London Bridge wharf at 1:00 a.m., according to advertisements in *The Times* of London. Manet may have been back in Boulogne by the mornings of August 2nd, 3rd, or 4th, making the times near midnight on the nights of August 2nd to 3rd, 3rd to 4th, or 4th to 5th good candidates for the harbor painting with the Moon in the southern sky.

Astronomical Calculations

Astronomers say that the Moon is making a "transit of the local meridian" when it passes through the part of the sky that is exactly south of the observer. Computer planetarium programs allow us to calculate times for lunar transits (Table 2.3) as seen from Boulogne.

Weather Observations

An 1868 publication titled *Bulletin International de l'Observatoire Imperial de Paris* recorded daily meteorological data from observers in Paris, Boulogne-sur-Mer, Le Havre, and other nearby locations. A daily column called "The Weather" in *The Times* of London included information from both sides of the channel.

Manet's painting shows stars and the Moon in a sky with dramatic clouds. The Boulogne observer for the *Bulletin International* noted clear skies on August 1st, 2nd, and 3rd, with cirrus clouds moving in during the night of the 3rd to 4th. Overcast skies alternated with

Table 2.3 Moons in the southern sky of Boulogne-sur-Mer

Night	Moon's illuminated fraction	Time of lunar transit (Moon exactly due south)
1868 August 2nd–3rd	99.7%	11:45 p.m.
1868 August 3rd–4th	99.8%	12:31 a.m.
1868 August 4th–5th	97.9%	1:16 a.m.

The results are expressed in Paris local mean time, which was 10 min ahead of Greenwich Mean Time and was employed in 1868 by the railroads and steamships serving this port. The precise moment of the full Moon (100% lit) was August 3rd at 12:02 p.m. Paris local mean time

broken clouds during the evening of the 4th, with overcast prevailing by the morning of the 5th. The evidence of the clouds suggests that the night of August 3rd to 4th best corresponds to the painting, with the night of August 4th to 5th also a possibility.

We noticed one more intriguing meteorological clue—the direction of the wind. The painting shows a plume of smoke rising from a foundry chimney and drifting from left to right. Because the view is toward the south, the wind must therefore have been coming from the southeast, east, or northeast. The reports from the contemporary weather observers show that the direction of the wind matched the appearance of the painting on August 1st, 2nd, and 3rd, and on the morning of August 4th. The wind direction shifted to the southwest by about 6 p.m. on August 4th and remained in that direction until the afternoon of the next day. This rules out the night of August 4th to 5th as a match for the painting.

The Mystery of Night

Our analysis includes five components: the position of the Moon in the southern sky; the full or nearly full lunar phase; the appearance of the sky with stars and the Moon visible through dramatic clouds; the direction of the wind blowing the plume of smoke rising from the foundry; and the artist's return from his two days spent in London. Based on this evidence, the best match to Manet's Boulogne moonlight painting corresponds to a time near midnight on the night of August 3rd to 4th, 1868.

Knowing the details of time and place can bring us closer to the moment when Édouard Manet created this "admirable rendering of the mystery of night" (Duret 1902, p. 101; Duret 1910, p. 76).

Van Gogh and an Evening Star

Vincent van Gogh (1853–1890) (Fig. 2.13) included the planet Venus prominently in the skies of three spectacular twilight paintings created during the years 1889–1890. More than a decade earlier, the artist wrote a letter with an intriguing reference to a sighting of the "Evening Star." On this occasion in 1877, did Vincent observe Venus – or some other bright celestial object?

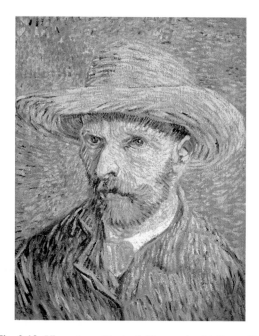

Fig. 2.13 Vincent van Gogh, *Self-portrait with Straw Hat*

Venus in Three Paintings: 1889–1890

In mid-June of 1889 van Gogh painted his famous *Starry Night*, with a waning crescent Moon and stars surrounded by halos in a swirling sky. The view from his window in the St. Paul monastery looked toward the east, and a letter from June 1889 described how the artist "looked at the countryside from my window a long time before sunrise" and observed "the Morning Star, which looked very large" (Van Gogh Letters Project 2017, letter 777). Several authors have used planetarium programs to identify the brightest of *Starry Night's* painted "stars" as the planet Venus, then near maximum brilliancy in the morning twilight sky (Boime 1984, p. 87; Whitney 1986, p. 356; Olson 2014, pp. 46–47).

On April 20, 1890, a dramatic grouping of Venus and Mercury near a thin waxing crescent Moon in the evening twilight inspired the artist to create *Road with Cypress and Star.* (Olson 2014, p. 47) On June 16, 1890, the planet Venus dominated the evening twilight sky depicted in *White House at Night* (Olson 2014, pp. 35–47).

These three striking canvases show Venus once in its role as Morning Star and twice as Evening Star (Fig. 2.14).

In addition to these examples from 1889–1890, van Gogh more than a decade earlier mentioned the "Evening Star" in a letter to his brother Theo. Writing on April 8, 1877, Vincent described what he saw on the previous night during a long walk through the countryside in the Noord Brabant region of the Netherlands.

Fig. 2.14 Details from three paintings by Vincent van Gogh show depictions of Venus. (left) Venus near its maximum brilliancy as Morning Star in the sky next to the cypress tree of *Starry Night* from mid-June 1889. (center) Venus as Evening Star in the twilight scene of *Road with Cypress and Star* on April 20, 1890. (right) Venus as Evening Star on June 16, 1890, in the sky of *White House at Night*

Dordrecht in 1877

In 1877 Vincent van Gogh worked as a clerk in the bookshop operated by the firm of Blussé and van Braam in the city of Dordrecht, Holland. On Saturday, April 7th, Vincent received a letter from his hometown of Zundert with the news that longtime family friend Johannes Aertsen was on his deathbed. Van Gogh immediately borrowed the railway fare from his roommate Paulus Coenraad Görlitz. Because there was no direct rail service to the small village of Zundert, Vincent caught the last train from Dordrecht to the town of Oudenbosch and arrived there in the evening. He then walked from the Oudenbosch station and reached Zundert in the early morning hours of Sunday.

Vincent's Account

Van Gogh described the events, including a sighting of an "Evening Star" during his walk, in a letter written on Sunday, April 8, 1877, to his brother Theo:

> *Yesterday morning I received a letter from home in which Father wrote that Aertsen was dying and that he had been there again to see him, as he had expressed the wish that Father should visit him. At this news my heart was drawn so strongly toward Zundert that I felt the need to go there again....*

> *On Saturday evening I left on the last train from Dordrecht to Oudenbosch and walked from there to Zundert. It was so beautiful there on the heath, even though it was dark, one could make out the heath and the pine-woods and the marshes stretching far and wide The sky was gray but the Evening Star shone through the clouds, and now and then other stars were visible too. It was still very early when I arrived at the cemetery in the churchyard at Zundert, where it was so quiet. I went to have a look at all the old places and paths and waited for the Sun to rise. You know the*

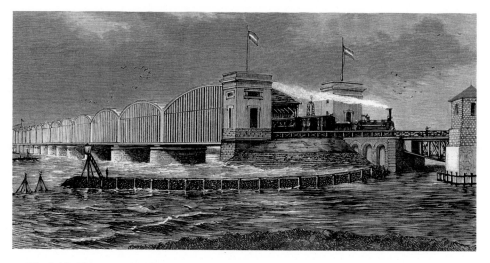

Fig. 2.15 This engraving from the 1870s shows a steam train on the Moerdijk railway bridge (Dutch: *Moerdijkbrug*). Vincent van Gogh's train from Dordrecht used this bridge to cross the waterway known as the Hollandsch Diep before proceeding on the line to Oudenbosch. The bridge had opened in 1872 and was then considered the longest railway bridge in Europe

story of the Resurrection, everything there reminded me of it in that quiet cemetery this morning. I heard from Aertsen and Mientje, as soon as they were up, that their Father had died that night, oh, they were so sad and their hearts were so full

Your most loving brother,

Vincent

(Van Gogh Letters Project 2016: letter 110, Vincent van Gogh to Theo van Gogh, April 8, 1877.)

Railway Schedule: Dordrecht to Oudenbosch

As a first step toward identifying van Gogh's Evening Star, we wanted to determine the time when the last train from Dordrecht arrived at the Oudenbosch station, where Vincent began his walk across the countryside. Our Texas State University group corresponded with Cor Kerstens, a local historian in Noord Brabant, and he in turn found the answer by consulting Marius Broos, an expert on railway history in the Netherlands.

In 1877, five trains departed daily from Dordrecht, crossed the waterway known as the Hollandsch Diep on the newly constructed Moerdijk railway bridge (Fig. 2.15), and then made stops at the towns of Zevenbergen and Oudenbosch (Fig. 2.16) before terminating at Roosendaal. A local newspaper, *De Grondwet*, published the timetable (Table 2.4).

Fig. 2.16 (top) Vincent van Gogh traveled by train from Dordrecht to Oudenbosch on the evening of April 7, 1877. A steam train passes the Oudenbosch railway station in this postcard view, circa 1910. (bottom) The original Oudenbosch station was built in 1854 and still stands today with only relatively minor modifications. (Both pictures courtesy of Marius Broos. Used with permission)

Table 2.4 Railway (Dutch: *Spoorwegen*) timetable valid between October 15, 1876, and May 15, 1877

Dordrecht	6:25 a.m.	10:43 a.m.	1:58 p.m.	5:52 p.m.	**7:32 p.m.**
Zevenbergen	7:03 a.m.	11:15 a.m.	2:43 p.m.	6:21 p.m.	8:15 p.m.
Oudenbosch	7:14 a.m.	11:26 a.m.	2:54 p.m.	6:32 p.m.	**8:26 p.m.**
Roosendaal	7:24 a.m.	11:36 a.m.	3:04 p.m.	6:41 p.m.	8:36 p.m.

The entries marked in **bold** indicate van Gogh's departure and arrival on April 7, 1877, when he traveled on the last train of the day

Table 2.5 Lunar phases	1877 March 29	Full Moon
	1877 April 5	Last quarter Moon
	1877 April 13	New Moon

The times in this table and throughout this chapter are expressed in Greenwich Mean Time, employed by Dutch railways and other transportation companies in the nineteenth century. Sunset at Oudenbosch had occurred at 6:25 p.m. on April 7th, so it was already dark when Vincent began walking from the station at Oudenbosch after the arrival of his train at 8:26 p.m.

Walking from Oudenbosch to Zundert

If van Gogh proceeded on the 12-mile trek across the countryside from Oudenbosch to Zundert at a normal walking speed of 3 miles/h, the trip would have occupied approximately 4 h, and he would have arrived at the Zundert churchyard by about 12:30 a.m. As detailed in his letter, Vincent then waited in the church graveyard for sunrise, which occurred at 5:01 a.m.

Moonlit Night?

A recent van Gogh biography by Steven Naifeh and Gregory White Smith described the walk from Oudenbosch as "Vincent's strange moonlight pilgrimage to Zundert." (Naifeh and Smith 2011a, p. 154) The notes to this biography asserted that "Vincent's account of this nocturnal journey" and his views of "the heath and the pine-woods and the marshes stretching far and wide" can be understood only "if there was at least partial moonlight." (Naifeh and Smith 2011b, p. 319)

However, calculations of the lunar phases (Table 2.5) and the time of moonrise show that van Gogh was not walking through a moonlit landscape when he left Oudenbosch.

On the night of April 7th to 8th the Moon appeared as a waning crescent, 27% illuminated, and did not rise until 3:29 a.m., several hours after Vincent had sufficient time to reach the Zundert churchyard. During his pilgrimage from Oudenbosch to Zundert he would have been guided only by the light from stars, and possibly planets, with no moonlight to illuminate the heath.

Venus or Mercury as Evening Star?

What was the Evening Star that van Gogh observed as he began his walk from Oudenbosch?

Wikipedia offers two possible candidates with its definition of Evening Star as: "The planet Venus when it appears in the west (evening sky), after sunset … Less commonly, the planet Mercury when it appears in the west (evening sky) after sunset."

However, on April 7th to 8th both Venus and Mercury had reached positions in their orbits that placed them very close to the Sun in the sky and therefore in configurations impossible for viewing. When the Sun set on April 7th at 6:25 p.m., Venus was already below the horizon, and Mercury set only 4 min after sunset. Venus did not rise until the next morning, April 8th at 4:59 a.m., only 2 min before the sunrise at 5:01 a.m. Mercury rose at 5:10 a.m., 9 min after sunrise. Both planets were completely lost in the glare of the Sun's light.

On April 7th to 8th Mercury and Venus were not visible at all in either the evening or morning twilight sky, and neither of these inner planets was van Gogh's Evening Star.

Mars, Jupiter, or Saturn as Evening Star?

Our Texas State group employed historical almanacs in several previous projects. (Olson 2014, p. 173, 181–233, 336, 346) We knew that these quaint pamphlets could employ the term "Evening Star" for any bright planet visible in the evening sky just after sunset. The almanacs sometimes used "Evening Star" to refer to any planet that rose before midnight. We therefore checked the positions of the outer planets Mars, Jupiter, and Saturn on the night of April 7th to 8th, 1877. However, this exercise produced no successful planetary candidate for van Gogh's Evening Star, because Jupiter rose at 12:56 a.m., Mars rose at 2:20 a.m., and Saturn did not rise until 4:18 a.m.

No planets at all, either from the inner or outer Solar System, were visible before midnight on the night of April 7th to 8th. Then what did Vincent identify in his letter as the Evening Star?

Van Gogh's Evening Star

When either Mercury or Venus does appear as Evening Star, observers will find that planet relatively close to the horizon in the western half of the sky. No naked-eye planets occupied that position on the evening of April 7th. Was any other bright celestial object shining in that part of the heavens as van Gogh began walking from the train station in Oudenbosch?

Computer planetarium programs set for the nearby paths (4°32′ east longitude, 51°35′ north latitude) quickly provided the answer: at 8:26 p.m. the bright star Sirius stood 10° above the horizon to the southwest.

In the magnitude system used by astronomers to describe the apparent luminosity of celestial objects, negative numbers represent the brightest objects. Sirius, with apparent magnitude −1.5, ranks as the brightest star in the night sky (Figs. 2.17 and 2.18). Sirius is bright enough to remain visible near the horizon and even to shine through thin clouds or thin overcast. The brilliance of Sirius is exceeded only by the Sun, Moon, and several planets, none of which were in the evening sky as van Gogh began his walk across the countryside. Sirius set at 9:52 p.m. on April 7th, after Vincent had been walking for almost 1½ h.

The position and brightness of Sirius, low in the southwestern sky as Vincent van Gogh set out from Oudenbosch, makes it an excellent candidate for van Gogh's Evening Star.

Fig. 2.17 Sirius, the brightest star in the night sky, appears at the upper left above a landscape in the Canary Islands. (Photograph by Babak Tafreshi. Used with permission)

Commemorations

Readers who wish to repeat this stellar observation have the opportunity to do so every year on the anniversary of Vincent's walk. A Facebook group known as Van Goghs Nachtwandeling (English: Van Gogh's Night Walk) was organized in 2013 with support from the staff of the Vincent van Gogh House museum in the artist's birthplace of Zundert. The group meets each year on the evening of April 7th at Oudenbosch station and makes the trek to Zundert. If the weather cooperates, the walkers as they set out from Oudenbosch will see Sirius low in the sky and sinking towards the horizon to the southwest, just as Vincent van Gogh observed the star on the evening of April 7, 1877.

Van Gogh's *Starry Night Over the Rhône*

A chapter in this author's previous *Celestial Sleuth* book detailed how our Texas State University group employed astronomical analysis to derive dates and times and to identify celestial objects in three night sky paintings by Vincent van Gogh (1853–1890). At 9:08 p.m. on July 14, 1889, the artist witnessed a dramatic moonrise over the Alpilles mountain range to the southeast of the village of Saint-Rémy-de-Provence, and then he depicted the scene in his *Moonrise (Wheat Stacks)*. In the sky of Saint-Rémy-de-Provence on April 20, 1890, a spectacular grouping of Venus and Mercury near a thin waxing crescent Moon

Fig. 2.18 Sirius is known as the "Dog Star" because of its position in the constellation of Canis Major, the Greater Dog. Elijah Burritt in 1835 published this star chart showing Canis Major and the nearby constellations of Lepus the Hare and Columba the Dove

inspired him to create *Road with Cypress and Star*. On June 16, 1890, the planet Venus dominated the evening twilight sky painted in *White House at Night* at the town of Auvers. (Olson 2014, pp. 35–64)

In addition to these examples from 1889 and 1890, van Gogh's first attempts to paint the night sky date from the year 1888, when he lived in the town of Arles.

Writing in April 1888 from Arles to his friend and fellow artist Emile Bernard, Vincent described his intentions: "A starry sky, for example, well—it's a thing that I'd like to try to do." (Letter 596 at the Van Gogh Letters website.) By autumn of that same year the project produced two masterpieces, the canvases known today as *Café Terrace at Night* and *Starry Night Over the Rhône* (Fig. 2.19). Art historians have used van Gogh's correspondence to show that he created *Café Terrace at Night* in mid-September 1888. (Letters 678 and 681 at the Van Gogh Letters website.)

Vincent included a small sketch and a description of *Starry Night Over the Rhône* in a letter written from Arles to his brother Theo near the end of September 1888:

Included herewith a little sketch of a square no. 30 canvas – the starry sky at last, actually painted at night, under a gas lamp. The sky is greenish - blue, the water royal blue, the ground mauve. The town is blue and violet. The gaslight is yellow, and its reflections are reddish-gold and taper off down to green - bronze. On the

Fig. 2.19 Vincent van Gogh, *Starry Night Over the Rhône* (F474)

greenish-blue field of the sky the Great Bear sparkles green and pink, with a discreet
paleness that contrasts with the harsh gold of the gaslight. Two colorful little figures
of lovers in the foreground. (Letter 691 at the Van Gogh Letters website.)

Vincent described the weather conditions and provided additional details about both of
the night sky paintings from Arles in a letter written during the first week of October 1888
to his friend and fellow artist Eugène Boch:

I worked at full tilt, because the autumn is windless and superb ... a view of the café
on the Place du Forum, where we used to go, painted at night. And lastly, a study of
the Rhône, of the town lit by gaslight and reflected in the blue river. With the starry
sky above – with the Great Bear – pink and green sparkling on the cobalt blue field
of the night sky, while the lights of the town and their harsh reflections are of a
reddish gold and a green tinged with bronze. Painted at night. (Letter 693 at the Van
Gogh Letters website.)

Vincent used the name Great Bear (French: *Grande Ourse*) for the constellation includ-
ing the stars that are better known in America as the Big Dipper and are easy to recognize
in the sky of *Starry Night Over the Rhône*.

Fig. 2.20 To illuminate his canvas during the creation of *Starry Night Over the Rhône*, van Gogh may have used a combination of gaslight, moonlight from a bright nearly full Moon, and his famous candle hat (Illustration by Ivan Stalio. Used with permission)

Time of Night

Vincent's letters make it clear that he created *Starry Night Over the Rhône* outside at night, with his easel set up near the Rhône River (Fig. 2.20). The letters also establish that the date must fall in the second half of September 1888. But at what time of night did van Gogh observe the scene that inspired this painting? Was it shortly after sunset? Mid-evening? Near midnight? In the early morning hours? Shortly before sunrise?

In the author's honors course at Texas State University, the students first read van Gogh's correspondence and several catalog entries regarding this painting to establish the location in Arles and the approximate calendar date. The students then used the orientation of Ursa Major relative to the horizon to determine the time of night.

The students employed planetarium computer programs to find that the time depicted must be about 10:30 p.m. if *Starry Night Over the Rhône* was created near September 15th. The corresponding results for September 22nd and 30th are about 10:00 p.m. and 9:30 p.m., respectively. These results are expressed in the nineteenth-century system known as local mean time, which for Arles was about 18 min ahead of Greenwich Mean

Time. For any date in the second half of September 1888 we conclude that Vincent must have been working at his easel near the Rhône at about 10 p.m. local mean time (Figs. 2.21 and 2.22).

Our results are in good agreement with the clock times determined by two pioneering researchers, after allowing for the different time systems employed.

The astronomer Michael Shurman in 1981 was perhaps the first to calculate the time of night for *Starry Night Over the Rhône*. Writing before personal computers and planetarium programs became widely available, Shurman employed more traditional methods: "Using star maps or a planetarium to simulate the orientation of the Dipper relative to the horizon and assuming the date of painting to be three weeks into September, one can deduce the local time to be about 11:00 p.m." (Shurman 1981, p. 35) Shurman apparently expressed his calculated time in the modern system of Central European Time, 1 h ahead of Greenwich Mean Time.

The astronomer Charles Whitney in the mid-1980s likewise used star charts and a planetarium to arrive at the same result for the clock time: "this rendition of the region of the Big Dipper is so realistic in appearance that it can, indeed, be used as a time-keeper …. The orientation of the Dipper is a clue to the time of night if we know the approximate date …. The fact that the Dipper, as painted by van Gogh, is almost parallel to the horizon implies, if the date is late September as indicated by his letters, the time is around 11 p.m." (Whitney 1986, p. 354) As Shurman did, Whitney apparently employed the Central European Time zone, 1 h ahead of Greenwich Mean Time.

Moreover, we point out that Daylight Savings Time, 2 h ahead of Greenwich Mean Time, now prevails in France during the second half of September, and modern observers will therefore see the Big Dipper in the correct orientation relative to the horizon when their watches display times closer to midnight.

After allowance for the different time systems, the independent astronomical analyses all agree: Vincent must have observed the sky at about 10 p.m. in the local mean time system used in the nineteenth century.

Composite

Charles Whitney's analysis went on to establish another significant result: *Starry Night Over the Rhône* must be a composite, with the starry sky seen from one direction depicted above the river and town viewed in another direction.

Our analysis of a map of Arles from van Gogh's time (Fig. 2.23) confirms that Whitney was correct. During the autumn of 1888, van Gogh moved into the Yellow House, itself the subject of a painting and a watercolor, on the Place Lamartine near the north end of Arles.

Starry Night Over the Rhône contains a number of topographic clues: the St. Antoine church near the left edge of the canvas, the gaslights along the riverbank, the bend of the river above the Trinquetaille Bridge, and the figures walking on the lower port (French: *Bas-Port*) in the foreground. A comparison with the nineteenth-century map of Arles shows that the artist could have obtained this view only from a spot on the west side of Place Lamartine and not far from the Yellow House. To obtain the view of the town and the river, Vincent looked to the southwest.

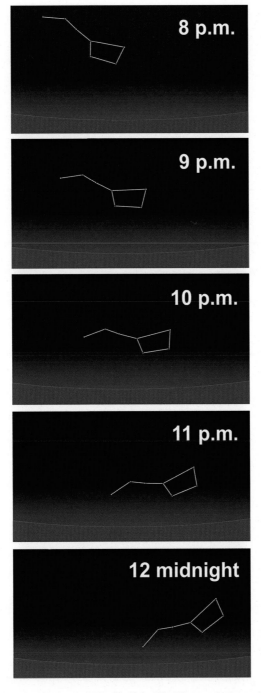

Fig. 2.21 This illustration shows how the tilt of the Big Dipper relative to the horizon changes over the course of an evening in the second half of September. Vincent van Gogh must have observed the stars of Ursa Major at about 10 p.m. local mean time, when the orientation of the stars of the Big Dipper matches the appearance of his painting. (Illustration by the author)

Fig. 2.22 This photograph shows Ursa Major, including the seven stars well-known as the Big Dipper, with an orientation relative to the horizon that nearly matches the appearance of van Gogh's *Starry Night Over the Rhône*. (Photograph by Vincent Carnevale. Used with permission)

However, Ursa Major is a *northern* constellation. For example, a well-known method uses two stars of the Big Dipper to point to the North Star. We conclude that van Gogh's painting shows the stars of the *northern* sky above the terrestrial scene of the town and river to the *southwest* of his position.

Our topographical and astronomical analysis agrees with the result originally obtained by Charles Whitney:

This shoreline appears on the left side of the painting, so in painting this Starry Night on the Rhone, van Gogh was facing southwest. And yet, the Big Dipper can only lie in the north. This led me to the conclusion that van Gogh has produced a composite scene ... He has placed the river and the lights he would have seen while looking southwest under the sky he would have seen while looking north (Whitney 1986, p. 355).

Whitney even provided the explanation for Vincent's choice to employ a composite:

And why had he put the northern sky over the southwestern view of Arles? Our planetarium experiment suggested two possible reasons. In the first place, the sky toward the southwest at that time of night was rather lackluster ... the rather inconspicuous constellation of Capricornus would have hung over the river. Nothing to inspire a painting (Whitney 1986, pp. 355–356).

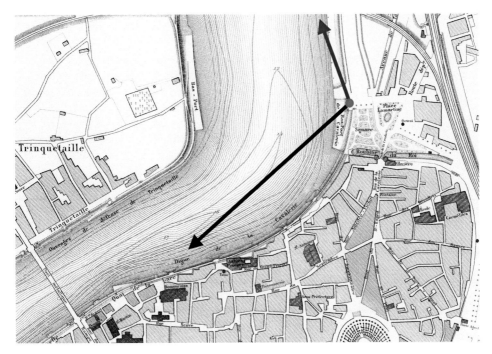

Fig. 2.23 Vincent van Gogh created *Starry Night over the Rhône* at the position marked by the red dot on this 1892 map of Arles from the *Atlas des Ports de France*. This location was not far from his Yellow House (highlighted in yellow). The black arrow indicates his direction of view toward the southwest with the town on the left bank of the river. The blue arrow indicates the direction toward the constellation of the Great Bear (Ursa Major), which includes the seven stars of the Big Dipper

Whitney also noted that a full Moon fell in the third week of September 1888:

The moon would have given him light to see his way around the river front, but it would have obliterated all but the brighter stars in the sky for several nights, and it would have brightened the southern sky for an even longer period, perhaps a week or so. It is possible that van Gogh chose the northern sky because it was more interesting and because it was farther from the hindrance of the moonlight (Whitney 1986, p. 356).

Ursa Major in the Southern Sky?

During a research trip to Arles our Texas State group was able to identify many van Gogh sites, including the viewpoints for the night scenes. The Arles tourism office on its website provides maps to guide interested visitors on a "Circuit Arles et Vincent Van Gogh" and has posted signs at various locations, including the correct viewpoint for *Starry Night Over the Rhône*.

Other van Gogh websites, however, give a misleading impression of what a visitor will see from this viewpoint at night:

The location of the specific subject of this Van Gogh painting is very similar today compared to how it appeared in 1888. Of course modern conveniences are much in evidence, but remarkably little has changed with the distinctive shore line, the Trinquetaille bridge in the background and at night the Ursa Major constellation can still be seen reflected in the waters of the Rhone just as it was in Van Gogh's day. (Van Gogh Gallery website, Starry Night over the Rhone, http://www.vggallery. com/painting/p_0474.htm.)

As explained in the previous section, visitors will be disappointed if they look for Ursa Major over the river to the southwest. They can see the Big Dipper, but only by turning around and looking toward the north.

Candle Hat

A full Moon fell on September 20, 1888, near the time when van Gogh created *Starry Night Over the Rhône*. In addition to bright moonlight during this period, van Gogh would have had some illumination provided by the town's gas lamps. For a better view of his palette and the canvas while he worked outdoors at night, Vincent fixed candles to his hat (Fig. 2.20), according to a famous story.

Some skeptical modern art historians deny that the candle hat ever existed. For example, in his authoritative van Gogh catalog Jan Hulsker judged that the artist's mention of the town's gas lamps "is really sufficient to refute the romantic legend that Van Gogh used to paint at night with a wreath of small burning candles affixed to his straw hat. This account is found in many books but is not supported by a single document." (Hulsker 1980, p. 360)

However, our Texas State University group agrees with the opinion expressed by the historian Peter Green regarding the skeptical attitude in fashion among modern scholars: "[W]e have to use our reason and historical judgment to sort the true from the false … The problem is complicated by a familiar scholarly phenomenon: the common need to prove one's critical ability through skepticism, which in some cases seems to exploit a deep and passionate affinity, well beyond reason, with the demolition of 'myth' per se." (Green 1996, p. xxii)

In the case of the candle hat, we point out that there is good evidence for its existence. The art historian Marc Edo Tralbaut developed much of the information during a visit to Arles in the 1920s, when he could interview both people who personally knew Vincent and also their descendants who knew the family stories dating from the artist's time in Arles. Tralbaut heard about the artist's use of the candle hat for both *Café Terrace at Night* and *Starry Night Over the Rhône*:

But how was he to see the subtle shades of colour on his palette and his canvas in the dark? His picture had to be painted from life if it were to succeed. Late one evening a strange figure could be seen making his way along the narrow, winding, ill-lit streets. He had a bundle of gear under his arm and a wooden box slung on his back.

On his head he wore a capacious hat on to whose broad brim were fixed a number of candles. When he reached the place du Forum, he set up his easel in front of the café and put a blank canvas on it. The canvas was also decorated with candles above and beside it. He then lit the candles and started to paint. The next day the whole of Arles had heard of this crazy sight and had concluded that the painter was mad. They did not guess that this 'madman' had just painted a masterpiece.

Vincent was so enthusiastic about the results of this experiment that he thought of another subject that he could tackle with the aid of his birthday-cake hat. One evening as he was walking along the bank of the Rhône he had been even more struck than usual by the splendor of the blue starry sky ... the night sky as a vast bowl of stars over a wide mirror of water (Tralbaut 1969, pp. 245–248)

Tralbaut heard more stories about van Gogh from the Ginoux family, who ran the Café de la Gare where Vincent often took his meals. Van Gogh created six versions of a portrait known as *L'Arlésienne*, which depicted Madame Ginoux. From this family Tralbaut learned the fate of the candle hat:

Vincent left many belongings including the hat with Madame Ginoux, and long after he died her niece and other Arles children used to play with it, without realizing the purpose that it had once served. (Tralbaut 1969, p. 250)

Tralbaut personally investigated the dim illumination on the banks of the Rhône at a time when the gas lamps were still in place, and he concluded that "Vincent's illuminated hat would have been an efficient, if bizarre, necessity." (Tralbaut 1969, p. 249)

Our Texas State University group, while searching online for references to the use of a candle hat, discovered that van Gogh may have been following a long tradition for artists working at night. A review of a 1983 exhibition devoted to the works of Francisco Goya (1746-1828) identified in one of Goya's self-portraits "an unusual and very special hat with metal candlesticks around the crown" with which he could work long into the night. (Harris 1983, p. 512) The catalog entry for this same painting in a 1989 Goya exhibition likewise described how the Spanish artist would give the finishing touches to a painting at night and explained that "Goya used for this purpose the hat shown in this portrait, trimmed with metallic pincers in which he inserted candles." (Sánchez et al. 1989, pp. 41–42) An article about the working practices of the French artist Anne-Louis Girodet (1767–1824) described how he could paint at night because he would "place an enormous hat on his head, and cover it with candles." (Reade 1849, p. 60) A biographer of Goya compared the method of the Spanish artist to that of Girodet, who "at night, painted with a crown of candles on his head." (Matheron 1858, p. 61)

Vincent van Gogh, knowledgeable about the history of art, may have been aware of this remarkable method for working indoors at night and then extended its use to his outdoor night scenes.

What's in a Name?

For Vincent van Gogh's paintings the titles used in modern books and exhibitions show considerable variation and are very often different from the titles employed by the artist himself. To avoid ambiguity, modern art historians therefore have agreed to identify van

Gogh's works by the "F" numbers assigned by Jacob-Baart de le Faille in his pioneering and monumental compilation (de la Faille 1928).

The painting numbered F474 shows the stars of Ursa Major and the river at Arles in September 1888 and has acquired the modern title of *Starry Night Over the Rhône*. But Vincent himself never used this title and always referred to this painting as *Starry Night* (French: "*la nuit étoilée*"). Vincent wrote a letter from Arles to his brother Theo in October 1888 and listed fifteen paintings in progress, including this canvas that he called "the starry night." On June 6, 1889, Vincent wrote again to his brother Theo and suggested that he select the Arles "starry night" for an upcoming exhibition. Regarding this *Exposition des Independants* held during the late summer and autumn of 1889, Theo reported on the reception of Vincent's paintings, including the Arles "Starry Night." ("*la nuit étoilée*") (Letters 703, 777, and 799 at the Van Gogh Letters website.) In his pioneering catalog, de la Faille himself referred to the Arles painting of stars over the Rhône as "Starry Night," that is, "*474. Nuit étoilée. Septembre 1888*" (de la Faille 1928, p. 135).

The painting numbered F612 from mid-June of 1889 shows a cypress tree, a waning crescent moon, and stars surrounded by halos in a swirling sky above the town of Saint-Rémy-de-Provence and is now universally known as the famous *Starry Night*. But Vincent himself and his brother Theo never used that title for this work. Vincent in his letters called it "study of a starry sky" ("*étude de ciel étoilée*") and "study of night" ("*étude de nuit*"), while Theo in his reply referred to this Saint-Rémy-de-Provence canvas as "the village in the moonlight" ("*le village au clair de lune*"). The artist and his brother never used the title *Starry Night* for this famous painting F612 (Letters 782, 805, and 813 at the Van Gogh Letters website)

This anomaly never fails to surprise students. When Vincent and Theo wrote about the *Starry Night*, they were consistently referring to the F474 canvas with Ursa Major above the Rhône in Arles.

Van Gogh's Town and Starry Sky

Starry Night Over the Rhône is a composite, with the northern stars of Ursa Major depicted above the town and river to the southwest of the artist's position. Vincent van Gogh created this spectacular canvas in the second half of September 1888 by setting up his easel on the banks of the Rhône during the late evening, at about 10 p.m. local mean time. The artist's location was only a short distance from his Yellow House on Place Lamartine. Writing from Arles in April 1888 Vincent had described his plans to depict a "starry sky … it's a thing that I'd like to try to do." Modern visitors to Paris's Orsay Museum can admire one of the remarkable results: the painting now known as *Starry Night Over the Rhône*.

References

Boime, Albert (1984) Van Gogh's *Starry Night*: A History of Matter and a Matter of History. *Arts Magazine* **59** (No. 4), December, 86-103.

Cachin, Françoise (1983) *Manet 1832-1883*. New York: Metropolitan Museum of Art.

de la Faille, Jacob-Baart (1928) *L'Oeuvre de Vincent van Gogh, Catalogue Raisonné*, 4 volumes. Paris and Brussels: Les Éditions G. Van Oest.

Duret, Théodore (1902) *Histoire d'Édouard Manet et de son œuvre*. Paris: H. Floury.

Duret, Théodore (1910) *Manet and the French Impressionists*. Philadelphia: J. B. Lippincott Co.

Green, Peter (1996) *The Greco-Persian Wars*. Berkeley, CA: University of California Press.

Hanson, Anne Coffin (1966) *Manet 1832-1883*. Philadelphia: Philadelphia Museum of Art and Art Institute of Chicago.

Harris, Enriqueta (1983) Goya in Madrid. *Burlington Magazine* **125** (No. 965), August, 511-512, 515.

Herbert, Robert L. (1988) *Impressionism: Art, Leisure, & Parisian Society*. New Haven: Yale University Press.

Hulsker, Jan (1980) *The Complete Van Gogh: Paintings, Drawings, Sketches*. New York: Harry N. Abrams, Inc.

Matheron, Laurent (1858) *Goya*. Paris: Schulz and Thuillié.

Naifeh, Steven, and Gregory White Smith (2011a) *Van Gogh: The Life*. New York: Random House.

Naifeh, Steven, and Gregory White Smith (2011b) *Van Gogh: The Life*, companion website, http://vangoghbiography.com.

Pérez Sánchez, Alfonso E., and Eleanor A. Sayre (1989) *Goya and the Spirit of Enlightenment*. Boston: Museum of Fine Arts.

Proust, Antonin (1897) Edouard Manet: Souvenirs (1). *La revue blanche* **12** (No. 89), 15 février 1897, 168-180.

Proust, Antonin (1901) The Art of Edouard Manet. *The Studio* **21** (No. 94), January 15, 1901, 71-77, 227-236.

Reade, John Edmund (1849) *Prose from the South*. London: Charles Ollier.

Shurman, Michael M. (1981) Vincent van Gogh's *Starry Night at Arles*. *The Astronomical Quarterly* **4** (No. 13), 35-36.

Tabarant, Adolphe (1931) *Manet: Histoire catalographique*. Paris: Éditions Montaigne.

Tabarant, Adolphe (1947) *Manet et ses oeuvres*. Paris: Gallimard.

Thiébault-Sisson, François (1927) Autour de Claude Monet, Anecdotes et souvenirs. *Le Temps*, January 8, 1927, English translation in *Monet, A Retrospective* (1985), Charles Stuckey, ed. New York: Hugh L. Levin Associates, Inc., 345-349.

Tinterow, Gary, and Henri Loyrette (1994) *Origins of Impressionism*. New York: Metropolitan Museum of Art.

Tralbaut, Marc Edo (1969) *Vincent van Gogh*. New York: Viking Press.

Van Gogh Letters Project (2017), http://vangoghletters.org.

Whitney, Charles A. (1986) The Skies of Vincent van Gogh. *Art History* **9** (No. 3), 351-362.

Wilson-Bareau, Juliet, and David Degener (2003) *Manet and the Sea*. Philadelphia: Philadelphia Museum of Art.

Wilson-Bareau, Juliet (2004) *Manet by himself: Correspondence & conversation, Paintings, pastels, prints & drawings*. New York: Barnes & Noble Books.

3

Caspar David Friedrich, Canaletto, and Edvard Munch

Caspar David Friedrich, one of Germany's greatest painters from the nineteenth-century Romantic era, is famed for his spectacular twilight scenes. An important series of three similar works began with *Two Men Contemplating the Moon* (Galerie Neue Meister, Dresden). He altered the foreground figures for the canvas *Man and Woman Contemplating the Moon* (Alte Nationalgalerie, Berlin), and then he reintroduced the two male figures for a third version titled *Two Men Contemplating the Moon* (Metropolitan Museum of Art, New York). In all three paintings a bright "star" appears close to a thin crescent Moon in a twilight sky.

What is the celestial body next to the Moon? Is it a bright star? Or is the "star" actually a planet and, if so, can we determine which planet Friedrich observed? How can astronomical calculations and the letters of the artist help to determine a date and time when Friedrich could have observed this celestial scene? Does our identification of the object near the Moon agree or disagree with the results of previous scholars? Regarding the location depicted, some art historians asserted that the picture shows a bluff on the shoreline of the island of Rügen in the Baltic Sea. Other writers identified the scene as a steep slope in the Harz Mountains. How can we use memoirs, letters, maps, a visit to the site, and other clues to suggest a different location in Germany? Was Friedrich's view toward the eastern or the western horizon? Is the Moon rising or setting? And what is the connection between these Caspar David Friedrich twilight paintings and Samuel Beckett's celebrated play, *Waiting for Godot*?

The eighteenth-century Italian artist Giovanni Antonio Canal, better known as Canaletto, created more than a thousand paintings and drawings, but only a very small number of them have been dated. Canaletto's detailed and topographically accurate depictions of scenes in Venice include two works, *Night Festival at San Pietro di Castello* and *Night Festival at Santa Marta*, of special interest to astronomers. Each canvas includes the Moon in the sky. How can we combine astronomical calculations of the lunar phases, the positions of the Moon in the sky, the positions of the saints' days in the church calendar, eighteenth-century maps, and other clues to determine dates and times for these two paintings?

© Springer International Publishing AG 2018

D.W. Olson, *Further Adventures of the Celestial Sleuth*, Springer Praxis Books, https://doi.org/10.1007/978-3-319-70320-6_3

The Norwegian artist Edvard Munch included in dozens of his works the full Moon seen over the Oslofjord, often with a column of light reflected in the water below. His *Moonlight* canvas from 1895 provides a notable example with the Moon near the horizon. Did Munch look toward the eastern horizon and depict the lunar disk shortly after moonrise? Or was the artist facing a different direction? Can we use topographic details in the painting to determine the artist's location and his direction of view? What does it mean for the Moon to be "running high" or "running low"? What is the connection between Munch's *Moonlight* painting and an 18.6-year cycle of the Moon?

Caspar David Friedrich: Moon and "Star"

Caspar David Friedrich (1774–1840) (Fig. 3.1) is "universally acclaimed as Germany's greatest Romantic painter, but his pictures are rarely seen outside his native country." (Tinterow and Rewald 2000, p. 36) Visitors to Germany can see rich collections of Friedrich's works in the museums of Hamburg, Berlin, Munich, and other locations.

The group of Friedrich paintings at Dresden's Galerie Neue Meister includes a spectacular twilight scene titled *Two Men Contemplating the Moon* (*Zwei Männer in Betrachtung des Mondes*) (Fig. 3.2). Friedrich created multiple copies of this popular work. He altered the foreground figures for the canvas *Man and Woman Contemplating the Moon* (*Mann und Frau den Mond betrachtend*) (Fig. 3.3), now in Berlin's Alte

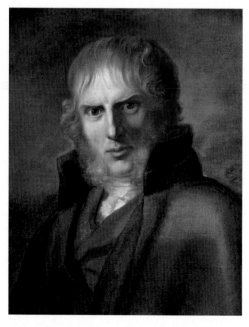

Fig. 3.1 The German Romantic artist Caspar David Friedrich (1774–1840) in a portrait by Gerhard von Kügelgen (1772–1820)

Fig. 3.2 Caspar David Friedrich, *Two Men Contemplating the Moon* (*Zwei Männer in Betrachtung des Mondes*), first version

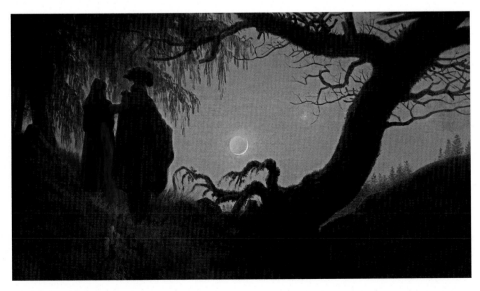

Fig. 3.3 Caspar David Friedrich, *Man and Woman Contemplating the Moon* (*Mann und Frau den Mond betrachtend*)

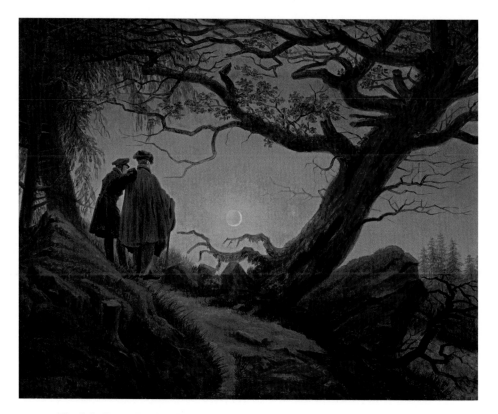

Fig. 3.4 Caspar David Friedrich, *Two Men Contemplating the Moon*, later version

Nationalgalerie. The artist reintroduced the two male figures for a third version, *Two Men Contemplating the Moon*, recently acquired by the Metropolitan Museum of Art in New York (Fig. 3.4). In all three paintings a bright "star" appears close to a crescent Moon in a twilight sky.

What is the celestial body next to the Moon? Did Friedrich observe Sirius, Aldebaran, Antares, Regulus, Spica, or some other bright star near the Moon? Is the "star" actually a planet, and, if so, can we identify whether it is Mercury, Venus, Mars, Jupiter, or Saturn? Some art historians asserted that the location depicted is a bluff on the shoreline of Rügen, an island in the Baltic Sea. Other writers identified the scene as a steep slope in the Harz Mountains. Can we suggest a different location in Germany? How can we use memoirs, letters, and other clues to determine a precise date when Friedrich could have witnessed this memorable twilight scene? And finally, how can we use biographies of the playwright Samuel Beckett to show that these Caspar David Friedrich paintings helped to inspire the celebrated play, *Waiting for Godot*?

Created Before 1820

Art historians consider the version now in Dresden to be the earliest. Its first owner, the Norwegian painter Johan Christian Dahl (1788–1857), wrote that this canvas was "painted by Friedrich in 1819. He gave it to me in exchange for one of my own works," and Dahl added that, because of its popularity, "Friedrich had to copy it several times." (Rewald 2001, p. 16) Confirmation of this completion date comes from the artist Peter von Cornelius and his student Karl Förster, who visited Friedrich's studio in Dresden in April of 1820 and saw the painting depicting "two young men, wrapped in cloaks and holding their arms around each other, enthralled to look out into the moonlit landscape." (Förster 1846, p. 157)

Waxing Crescent Moon and Earthshine

In all three versions Friedrich depicts the Moon with the "horns" (the sharp points of the lunar crescent) directed up and to the left. Astronomers recognize that this orientation corresponds to an observation in the evening twilight, shortly after sunset. The lunar phase is a waxing crescent (growing in light), and the date must be a few days after a new Moon. The Sun would be below the horizon to the right of the Moon's location in the sky.

The authors of the complete catalog of Friedrich's works therefore correctly identified the lunar phase as the "waxing moon in the background." (Börsch-Supan and Jähnig 1973, p. 356) Art historian Sabine Rewald likewise referred to "the waxing moon." (Rewald 2001, p. 30)

Rewald also gave the correct explanation for the dim glow that completes the circle of the lunar disk: "Its faintly illuminated orb exhibits what astronomers describe as 'earth-shine.'" (Rewald 2001, p. 30)

The cause of earthshine is sunlight that strikes Earth and reflects up to provide a faint illumination on the otherwise dark part of the Moon. Leonardo da Vinci in the early sixteenth century provided the first correct explanation of earthshine, and one of Leonardo's drawings of the lunar disk appears remarkably similar to the depictions by Caspar David Friedrich (Fig. 3.5).

Lunar Misconception: Rising Moon?

A common error committed by writers describing a crescent Moon in an evening twilight scene is to say that the Moon is "rising." Actually such a Moon must be setting.

Johan Christian Dahl himself made this mistake in about 1830 when he created a list of his collection of paintings and mentioned the "moonlit landscape, two male figures contemplate the rising crescent." (Börsch-Supan and Jähnig 1973, p. 356)

Wieland Schmied named the lunar phase correctly but committed this error regarding the motion of the Moon when he wrote: "The Moon has risen, the two men stop and contemplate the delicate, silver sickle of the waxing Moon." (Schmied 1999, p. 8)

A Metropolitan Museum of Art publication, written shortly after that museum acquired their version, made the same mistake by describing how Friedrich included "the fir, the gnarled oak, and the rising moon." (Tinterow and Rewald 2000, p. 36) By the time of an exhibition during the following year, the art historians had consulted astronomers and

Fig. 3.5 As explained in this chapter, Friedrich's twilight scenes depict the thin waxing crescent Moon, with the faint glow known as earthshine completing the circle of the lunar disk. Leonardo da Vinci gave the first scientifically correct explanation of earthshine and included a diagram with the lunar phase almost identical to that in Friedrich's paintings. (top left): *Two Men Contemplating the Moon*, detail. (bottom left): *Man and Woman Contemplating the Moon*, detail. (top right): Leonardo da Vinci (1452–1519). (bottom right): Earthshine drawing by Leonardo da Vinci from the Codex Leicester

correctly referred to the "sickle of the waxing moon" as "the sinking moon." (Rewald 2001, p. 30)

Readers in the northern hemisphere can verify the tilt of the lunar crescent and the motion of the Moon relative to the horizon for themselves during every lunar month by observing on a date several days after new Moon. In the western sky shortly after sunset, the Moon will appear with the "horns" of the thin lunar crescent directed up and to the left. Continuing to watch for some minutes or hours will confirm that the waxing crescent Moon is sinking down toward the western horizon, with sunset followed by moonset.

Lunar Misconception: Eclipse?

An essay by Kasper Monrad made a different error by suggesting that Friedrich's painting "shows a lunar eclipse. The Moon is obviously covered by a shadow, so that only a thin edge is illuminated." (Monrad and Bailey 1991, p. 146) A decade later Monrad acknowledged that the "prevailing opinion is that the couple is witnessing a waxing moon just after the new moon, with the dark side of the moon illuminated by earthshine." He then went on to repeat his idea: "But another, more compelling interpretation is that they are watching a lunar eclipse. The moon is quite obviously shadowed, so that only a thin crescent is lit up." (Rewald 2001, pp. 27–28)

Astronomers know that the diameter of Earth's shadow at the Moon's distance is much larger than the Moon's diameter. During a lunar eclipse, therefore, the arc that divides light and dark on the lunar surface has a curvature obviously different from Friedrich's depictions. Astronomer Peter Brosche has explained this in some detail, and art historian Sabine Rewald followed Brosche in rejecting Monrad's lunar eclipse theory for the same reasons (Brosche 1995, p. 194; Brosche 1996, p. 235; Rewald 2001, p. 22).

Readers can look online for lunar eclipse and lunar phase photographs and will readily see that the curvature of the edge of Earth's shadow during a lunar eclipse is completely different from the appearance of the terminator (the division between the lit and dark parts of the Moon) in a thin waxing crescent lunar phase. The appearance of the lunar disk in Friedrich's painted Moons cannot represent a lunar eclipse.

Venus as Evening Star?

An apparently universal consensus in the existing literature identifies the celestial body next to the Moon as Venus, appearing as the evening star. Peter Brosche judged that the age of the Moon in the painting is approximately three days after new Moon and that "the 'star' to its right can by its brightness only be Venus." (Brosche 1995, p. 194) Sabine Rewald agreed regarding both the "three-day old sickle of the waxing moon" and the "position of the planet Venus, or the evening star, to the right of the moon." (Rewald 2001, p. 14) Reinhard Wegner argued regarding "the bright star in the immediate vicinity of the Moon. It can only be Venus." (Wegner 2004, p. 31) Paul Spencer-Longhurst described the figures in the paintings as "deeply absorbed in contemplation of a young sickle moon … To its right shines Venus, or the Evening Star" (Spencer-Longhurst 2006, p. 92). Werner Busch likewise asserted that the canvas included "the sickle of the waxing Moon, just after the New Moon, with a conspicuous halo and with the accompanying star, Venus. The specific grouping makes it clear that it can only be the Evening Star." (Busch 2008, p. 172)

Our Texas State group agrees that Moon-Venus conjunctions can be especially spectacular and memorable, but we suggested that groupings of the Moon with other celestial bodies might also be considered as possibilities for Friedrich's inspiration.

Rügen?

Regarding the location of Friedrich's evening walk, Sabine Rewald summarized: "The landscape depicted has been variously described as a cliff on the island of Rügen and as a spot in the Harz Mountains." (Rewald 2001, p. 14)

Max Semrau, an early proponent of the Rügen site, wrote in 1917 that "the singular situation in *Two Men Contemplating the Moon* (Dresden Gallery) can be understood only if one imagines the two figures standing on the Rügen bluffs, perhaps the Stubnitz, and considering the Moon's disk emerging from the sea." (Semrau 1917, pp. 18–19) Georg Bock in 1927 agreed regarding the Rügen location, and the catalog for a 1957 Berlin exhibition likewise asserted that Friedrich "probably looked out from the steep cliffs on the shoreline at Stubnitz on Rügen." (Bock 1927, p. 27; Börsch-Supan and Jähnig 1973, p. 356)

Although Friedrich did often create drawings and paintings depicting scenes on Rügen, an island in the Baltic Sea off the northeastern corner of Germany, there are several fatal problems with the Rügen interpretation. The steep bluffs on the Rügen shoreline are white chalk cliffs that do not at all resemble the slope in these twilight landscape paintings.

Moreover, the cliffs in the Stubnitz region face the wrong direction. Observers on these Rügen bluffs look to the east and northeast and can observe thin crescent Moons only in morning twilight skies, with the waning Moon rising into the sky and with the horns of the crescent directed up and to the right. Thus, the topographical evidence and the tilt of the lunar crescent rule out Rügen as the site for Friedrich's evening scenes.

Harz Mountains?

Rewald also mentioned that a possible location for Friedrich was "a spot in the Harz Mountains." (Rewald 2001, p. 14)

Max Sauerlandt, an early proponent of this identification, wrote in 1905 that the Dresden canvas depicted "possibly a Harz motif." (Börsch-Supan and Jähnig 1973, p. 356)

Hans Joachim Neidhardt in 1976 correctly described some of the problems with the Rügen interpretation and then offered: "As regards the place represented … the rocky structures and forest of firs in the background evoke rather a mountainous country, the Harz, for example." (Neidhardt 1976, p. 59)

Friedrich scholar Herrmann Zschoche published a detailed monograph about the walking tour when Friedrich, accompanied by the sculptor Christian Gottlieb Kühn, visited the Harz Mountains. The trip extended from June 16th to July 9th of 1811 (Zschoche 2008, pp. 24–55).

Astronomical calculations by our Texas State group established that Venus was in the morning sky throughout all of June and July of 1811. No other planet or bright star appeared near the thin waxing crescent Moon in the evening twilight skies during this period.

If both the Rügen cliffs and the Harz Mountains are ruled out, where else in Germany could Caspar David Friedrich have witnessed the scene that inspired his paintings?

Krippen

The scholars at the Metropolitan Museum of Art offered a brief allusion to the possibility of another location when they suggested that the two figures in their painting may be Friedrich himself "with his favorite student, August Heinrich … who had recently died …

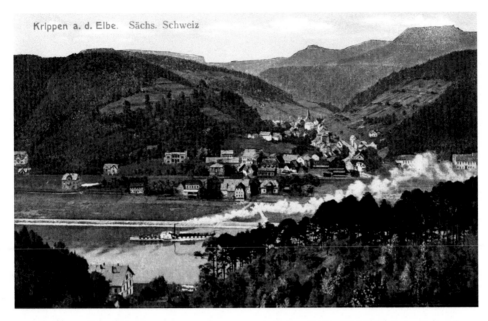

Krippen a. d. Elbe. Sächs. Schweiz

Fig. 3.6 This vintage postcard view looks to the south across the Elbe River, toward the village of Krippen, Germany. Caspar David Friedrich may have been inspired to create *Two Men Contemplating the Moon* while walking on the hill seen above and to the left of the town. From this slope, the artist's direction of view looked across the valley toward the west, the direction of the evening twilight sky

It is thought that Friedrich painted this picture in remembrance of their evening walks together in the mountains outside Dresden." (Tinterow and Rewald 2000, p. 36)

Frank Richter wrote a detailed monograph regarding Friedrich's travels in this mountainous region known as Saxon Switzerland, to the southeast of Dresden. For the scene of *Two Men Contemplating the Moon*, Richter suggested a specific location in the hills near Krippen, a small village directly across the Elbe River from the well-known resort town of Bad Schandau (Fig. 3.6). Richter argued that the twilight paintings should be seen:

> ...*in connection with Friedrich's stay in 1813 in Krippen ... On the regular walks around the place Friedrich with great probability used several times the path that initially leads steeply up from Krippen to Reinhardtsdorf ... every now and then large boulders lie next to the path.* (Richter 2009, p. 131)

Richter acted as our guide when our Texas State University group visited Krippen in August 2014. We verified that Friedrich could have taken his views from a path called the Puschelweg, from another path called the Krippenweg, or from the slopes near an overlook called Carolahöhe. From these and other nearby locations, Friedrich could have looked across the valley toward the west, the direction of the evening twilight sky. We noted the presence on the slopes of large boulders, like those in Friedrich's paintings

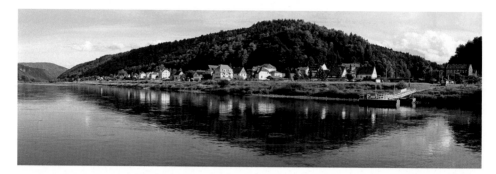

Fig. 3.7 This panoramic photograph from August 2014 looks toward the east and southeast and shows the Elbe River, the village of Krippen, Germany, and the steep slopes of the imposing hill above Krippen where Caspar David Friedrich could have taken his views of the twilight scene (Photograph by the author)

Fig. 3.8 This August 2014 view on the Puschelweg path shows that large boulders, similar to those in Friedrich's paintings, can be found on the steep slopes near Krippen, Germany (Photograph by Marilynn Olson. Used with permission)

(Figs. 3.7, 3.8, 3.9, and 3.10). We also observed that the hills near Krippen were covered by forests of evergreen spruces (German: *Fichten*) and firs (*Tannen*), matching the trees seen on the right and left sides of the canvases. Friedrich scholars have established that the artist based the dramatic oak in the paintings on a drawing made in 1809 near Neubrandenburg in the north of Germany (Rewald 2001, p. 36).

Fig. 3.9 Frank Richter (far left) acted as guide for our Texas State University group during our August 2014 visit to the Saxon Switzerland region of Germany (Photograph by Russell Doescher. Used with permission)

Fig. 3.10 Our Texas State University group is not alone in linking Caspar David Friedrich's paintings to the town of Krippen, Germany. The designer of this remarkable sundial, one of more than two dozen on Krippen's *SonnenUhrenWeg* (Sundial Way), used *Two Men Contemplating the Moon* as the overall theme. A paintbrush casts the shadow, spots of color on an artist's palette mark the hours, and a yellow disk represents the Moon. The dial is located directly below the hill slope from which Friedrich could have observed the celestial scene on June 30, 1813 (Photograph by Roger Sinnott. Used with permission)

Friedrich in Krippen

Friedrich resided in the village of Krippen for an interesting reason related to the return of Napoleon's Grande Armée back to central Europe following the disastrous campaign of 1812 in Russia. Napoleon and his troops entered Dresden in 1813, and Friedrich moved to Krippen to wait out the occupation.

The artist's letters provide a range of possible dates for his stay in Krippen. Writing from the village on May 30, 1813, Friedrich explained:

> *I have been living in the country for 14 days, across the Elbe from Bad Schandau. Why I left Dresden, you can easily imagine. The lack of food was so great that people were supposed to be starved.* (Zschoche 2006, p. 79)

On July 14, 1813, Friedrich wrote: "I have been gone from Dresden for nearly two months, and I am living in Krippen, a village on the Elbe." (Zschoche 2006, p. 84)

Independent confirmation of Friedrich's presence in Krippen comes from the artist's habit of writing dates on his drawings. Karl Ludwig Hoch compiled a list of 22 drawings that depict the area around Krippen and that Friedrich created between June 1st and July 22nd of 1813 (Hoch 1995, pp. 64–65). According to local tradition, Napoleon himself and several of his officers passed through Krippen on June 20, 1813, a date when Friedrich was making sketches of trees in the hills nearby.

The letters and the dated drawings establish that Friedrich's stay in Krippen extended from about the middle of May until at least the third week of July in 1813. During this time, new Moons fell on May 29th and June 28th, and following each of those dates the waxing crescent Moon would have returned to the evening twilight sky.

The Moon and a Planet

Using computer planetarium programs for a location south of Krippen (14° 10′ East Longitude, 50° 54′ North Latitude), we immediately found a remarkable event with a bright planet very close to the Moon, in a configuration that is a close match to Caspar David Friedrich's paintings.

On June 30, 1813, in the western sky shortly after sunset, the Moon appeared as a thin waxing crescent, 2½ days after the preceding new Moon. We calculated that the illuminated fraction of the lunar disk was 8%, in good agreement with the illumination of the crescents as depicted by Friedrich. In the magnitude system used by astronomers to describe brightness, negative values indicate very bright objects. On this evening, Jupiter had an apparent magnitude of −2, and the bright planet therefore would have been visible even near the western horizon. Jupiter stood only two degrees to the north of the Moon, that is, to the right and slightly above the thin lunar crescent, just as seen in Friedrich's canvases.

Waiting for Godot

As a final note, we point out a surprising connection between this series of three Caspar David Friedrich moonlight landscapes and a famous play by Samuel Beckett (Fig. 3.11).

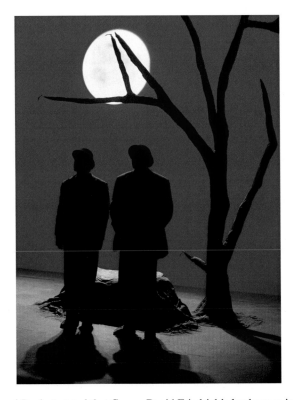

Fig. 3.11 Samuel Beckett stated that Caspar David Friedrich's landscapes inspired his most famous play, *Waiting for Godot*. In his biography of Beckett, James Knowlson observed that "This inspiration is at its most obvious in the two moonlight scenes that end each act, where the two figures of Estragon and Vladimir by the tree watching the moon rise are silhouetted against a night sky." (Knowlson 1996, p. 342) This photograph shows the set design for a production of *Waiting for Godot* in 2015 at the Rogue Theatre, Tucson, AZ (Photograph by Tim Fuller. Used with permission)

According to a poll of 800 playwrights, actors, directors, and journalists, Beckett's *Waiting for Godot* was "voted the most significant English language play of the twentieth century." (Berlin 1999, p. 1)

Beckett in 1937 made a pilgrimage to the great art museums of Europe, including the Dresden galleries:

> ... *his main purpose in visiting Dresden was to see the art collection ... where the Caspar David Friedrichs caught his eye; he confessed to having a "pleasant predilection for 2 tiny languid men in his landscapes, as in the little moon landscape."* (Knowlson 1996, pp. 235–236)

Beckett himself explicitly stated, decades later, that Friedrich's compositions had helped to inspire his famous play:

The visual conception of his new play was inspired, according to Beckett himself, by a painting by Caspar David Friedrich. This inspiration is at its most obvious in the two moonlight scenes that end each act, where the two figures of Estragon and Vladimir by the tree watching the moon rise are silhouetted against a night sky. But it may be even more fundamental. The American theater scholar Ruby Cohn, a friend of Beckett, said that in 1975, while she was in Berlin for rehearsals of Waiting for Godot, *she, together with Beckett, saw the Berlin Caspar David Friedrich paintings in the famous collection of German Romantics. As they were looking at Friedrich's painting Mann und Frau den Mond Betrachtend (Man and Woman Observing the Moon) of 1824, Becket announced unequivocally: "This was the source of Waiting for Godot, you know."* (Knowlson 1996, p. 342)

Beckett "even wrote the artist's name 'K. D. Friedrich' on a page of his directorial notebook, which faced his analysis of the moonlight scene." (Haynes and Knowlson 2003, p. 53)

Caspar David Friedrich himself could have been inspired by a close grouping of the thin waxing crescent Moon and the bright planet Jupiter on the evening of June 30, 1813. Modern readers can travel to Dresden and Berlin in Germany—as Samuel Beckett did—or to the Metropolitan Museum of Art in New York City, to draw their own inspiration from the three resulting canvases of the memorable twilight scene.

Canaletto: Night Festivals in Venice

The Italian artist Giovanni Antonio Canal (1697–1768), better known as Canaletto, created more than a thousand paintings and drawings, but only a very small number of them have been dated. The art historian J. G. Links, a leading authority on Canaletto, described this situation by imagining an exhibition consisting only of canvases for which the years were known: "When the dated works were hung, the walls would for the most part still be bare … a handful of dated paintings and drawings … A couple of dozen dated works provided the firm ground; the rest is quicksand, over which we must travel as best we may." (Links 1982, p. 20) The catalog for a major Canaletto exhibition at New York's Metropolitan Museum of Art included an impressive number of the artist's paintings, but the authors admitted that "very little of it can be given specific dates with any confidence." (Baetjer and Links 1989, pp. 12–14)

Canaletto created detailed and topographically accurate depictions of scenes in Venice. Our Texas State University group, including art historian Francine Carraro, wondered whether we could successfully apply astronomical analysis to a pair of these works. They depict two of Venice's night festivals, and each canvas includes the Moon in the sky (Fig. 3.12). How could we use astronomical calculations, eighteenth-century maps, the positions of saints' days in the church calendar, and other clues to determine dates and times for these two paintings?

Fig. 3.12 Canaletto (1697–1768), framed by the gibbous Moon of *Night Festival at San Pietro di Castello* (detail) and the full (or nearly full) Moon of *Night Festival at Santa Marta* (detail)

The Painting Night Festival at San Pietro di Castello

Canaletto made the unusual choice of a gibbous lunar phase (more than 50% lit but less than 100% lit) for the Moon in the upper right corner of *Night Festival at San Pietro di Castello* (Figs. 3.13 and 3.14). The scene includes the domed church of San Pietro (English: St. Peter), the campanile or bell tower in the plaza, and, at the far right, the wooden footbridge leading to the island of Castello at the eastern end of Venice. A study of eighteenth-century maps shows that the view at the center of the painting looks almost directly to the east, with the Moon therefore in the sky to the southeast.

The feast day for St. Peter and Paul falls on June 29th each year, with the vigil and the festival beginning on the previous evening. In the plaza, just to the left of the campanile, Canaletto depicted a puppet show in progress. This clue suggests a time during the evening vigil.

On the face of the Moon, Canaletto attempted to indicate the dark surface features known as lunar maria. We were not able to identify the specific maria and use them to determine convincingly whether the Moon is waxing or waning. However, northern hemisphere skywatchers know that waxing gibbous Moons, a few days before full Moon, appear in the southeast during the late afternoon, at sunset, and for the next several hours after sunset. The position of the Moon is therefore consistent with the activities in the picture, if we assume that Canaletto observed a waxing gibbous Moon in the evening hours of the vigil on June 28th.

The Painting Night Festival at Santa Marta

A full (or nearly full) Moon appears in the sky at the upper left of Canaletto's *Night Festival at Santa Marta* (Fig. 3.15), with a glitter path of reflected light in the water below. The view looks along the shore toward the tower of the church of Santa Marta (English: S. Martha) in the distance. Just visible at the extreme left edge of the canvas is the last house at the extreme west end of the region known as the Giudecca. A close examination also reveals the island and church of San Giorgio in Alga, just to the right of the glitter path in the Venetian lagoon. Consulting eighteenth-century maps demonstrates that the center of the view looks almost directly west and that the lunar disk must be in the southwest.

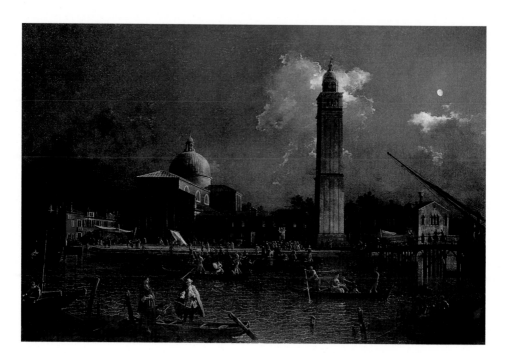

Fig. 3.13 Canaletto, *Night Festival at San Pietro di Castello*

Fig. 3.14 The scene of Canaletto's *Night Festival at San Pietro di Castello* is easy to recognize today. (Photograph by Roger Sinnott. Used with permission)

Fig. 3.15 Canaletto, *Night Festival at Santa Marta*. A full (or nearly full) Moon appears in the sky at the upper left, with a glitter path of reflected light in the water below. Consulting 18th century maps demonstrates that the center of the view looks almost directly west and that the lunar disk must be in the southwest. A modern comparison photograph is not possible for Canaletto's Santa Marta painting, because the setting has been completely altered by the demolition of the Santa Marta church tower and the construction of modern buildings now used by the Venice Port Authority. The main building of the Santa Marta church still exists and can be found near the S. Marta stop on Venice's water bus lines, but the view of the church from Canaletto's position is blocked by the modern buildings

The feast day of Sts. Mary and Martha is July 29th, with the vigil beginning on the previous evening. Astronomers know that full (or nearly full) Moons pass over the horizon directly south near midnight and then descend into the southwestern sky. Therefore, the time depicted here must be in the hours between midnight and morning twilight on July 29th.

Chronology

Canaletto created the two night festival paintings, along with two daytime views, as a set of four works commissioned by the German merchant Sigismund Streit. Architectural clues regarding the houses depicted in the daytime scenes of the Streit commission, along with the chronology of Canaletto's travels between England and Italy, prove that the artist worked on this series no earlier than 1753. Streit sent the four canvases, accompanied by detailed descriptions, to Germany in 1763 (Links 1982, p. 205; Baetjer and Links 1989, pp. 269–272). The night festival paintings therefore must date from the period between 1753 and 1763.

At first, astronomical dating might seem almost impossible, because gibbous Moons and full Moons occur during every month. However, the known dates of the saints' days greatly simplify the analysis. We needed to calculate the Moon's phase and position only on June 28th and July 29th in each of the years from 1753 through 1763.

Astronomical Calculations: Vigil of San Pietro

We used computer planetarium programs to search this period for a waxing gibbous Moon in the southeastern sky during the evening hours on June 28th, with a unique result: the year 1757.

During the vigil of San Pietro in that year, Canaletto would have observed a waxing gibbous Moon (88% lit) with its position matching the appearance of *Night Festival at San Pietro di Castello* on June 28, 1757, at about 8:30 p.m. local mean time.

Astronomical Calculations: Festival of Santa Marta

For the Santa Marta painting, we noticed that the Moon's glitter path formed a long column in the water. As explained by authorities on atmospheric optics, such a pillar of light forms only when the Moon is relatively low in the sky (Minnaert 1954, pp. 15–27; Greenler 1980, pp. 67–68; Shaw 1999, pp. 43–44).

We checked July 29th in each of the years 1753–1763 and looked for a full (or nearly full) Moon sinking low (altitude less than 15°) in the southwestern sky during the hours between midnight and morning twilight. We again obtained a unique result: the year 1757.

On the morning of July 29th in that year, the nearly full Moon was 94% lit, with the precise moment of full Moon (100% illuminated) falling on the next day, July 30th.

Canaletto would have observed a scene matching *Night Festival at Santa Marta* on July 29, 1757, at about 2 a.m. local mean time.

Festival of the Redentore: Not Painted

The residents of Venice also celebrate the *Festa del Redentore* (English: The Feast of the Redeemer) each year on the third Sunday in July, with the vigil beginning on the preceding Saturday evening. Our Texas State University group used calendrical and astronomical analysis to solve a mystery: Why did Canaletto *not* create a painting of this festival during the summer of 1757?

Calendar calculations place the date of the *Redentore* in 1757 on Sunday, July 17th, with the vigil beginning on the evening of Saturday, July 16th. Astronomical calculations establish that a new Moon fell exactly on that same date: July 16, 1757. The coincidence with a dark new Moon period may explain why the artist did not include the *Redentore* event in his series of night festival paintings.

Traveling Over Quicksand

As mentioned earlier in this chapter, art historians have lamented that only a handful of Canaletto's paintings and drawings have been dated: "[T]he rest is quicksand, over which we must travel as best we may." (Links 1982, p. 20) This chapter shows how we

can attempt to traverse this treacherous territory by employing a combination of astronomical calculations, eighteenth-century maps, and calendar analysis. That both of the calculated dates for the night festival paintings fall in the same year helps to make the result more convincing. *Night Festival at San Pietro di Castello* matches the scene at Venice with a waxing gibbous Moon in the southeastern sky on the evening of June 28, 1757. Canaletto was inspired to create *Night Festival at Santa Marta* as a nearly full Moon was sinking toward the southwestern horizon in the early morning hours of July 29, 1757.

Other Paintings with Gibbous Moons

The astronomer William Livingston wrote an article entitled "What's Wrong with a Gibbous Moon?" and pointed out the rarity of this lunar phase in artwork, compared to the numerous examples of paintings with crescent or full Moons (Livingston 1992, pp. 159–160). Livingston discussed the gibbous Moon in Jean-François Millet's *Sheepfold, Moonlight* (The Walters Art Gallery, Baltimore, MD). In addition to Canaletto's *Night Festival at San Pietro di Castello* discussed in this chapter, gibbous Moons also appear in a small number of other works, including: Dierick Bouts's *Capture of Christ* (Alte Pinakothek, Munich); Marc Chagall's *Horsewoman on Red Horse* (private collection) and *Holy Family* (private collection); August Egg's *Past and Present, No. 1* and *No. 2* (Tate Britain, UK); Samuel Palmer's *Harvest Moon, Shoreham* (Tullie House Museum, Carlisle, UK); Jan van Eyck's *Crucifixion* (Metropolitan Museum of Art, New York); Hiroshige's Japanese woodblock print *Moon over Ships Moored at Tsukuda Island from Eitai Bridge*; and eight examples of Yoshitoshi's Japanese woodblock prints from *One Hundred Aspects of the Moon*.

Edvard Munch: The Moon "Runs Low"

Norwegian artist Edvard Munch (1863–1944) is best known for his iconic painting *The Scream*, which has uniquely become the symbol of anxiety in our modern age. A chapter in the author's previous *Celestial Sleuth* book detailed how the atmospheric effects of the dust, gas, and aerosols that spread worldwide after the eruption of the volcano Krakatoa could explain the spectacular blood-red sky of *The Scream* (Olson 2014, pp. 67–82).

Our Texas State University group also provided in that same chapter an astronomical analysis of four more works by Munch. The positions of the planet Jupiter and the Pleiades star cluster allowed us to determine that the artist was inspired to create his *Starry Night* in mid-August of 1893. Meteorological archives and the bright star Arcturus in the sky dated the origin of *The Storm* to 9:15 p.m. on August 19, 1893. The location of the rising Sun along the eastern horizon helped to show that Munch's *Sunrise in Åsgårdstrand* depicted the morning sky as seen from this town on September 3, 1893, at 5:30 a.m. We also solved a long-standing mystery by demonstrating that the yellow disk in the sky of *Girls on the Pier* must be the full Moon, not the Sun as some art historians had claimed (Olson 2014, pp. 83–110).

Fig. 3.16 Edvard Munch, *Moonlight*, 1895

During Munch's career, dozens of his works included the full Moon seen over the Oslofjord, often with a column of light reflected in the water below. His *Moonlight* provides a notable example (Fig. 3.16). The artist indicated 1895 as the year of creation by signing the canvas with "E Munch 95" at the lower left (Woll 2009, p. 371).

Glitter Paths

Astronomers and atmospheric scientists use the term *glitter path* for the reflected light that can take the form of an especially long and impressive column when the Sun or a bright Moon is low in the sky above a body of water (Minnaert 1954, pp. 16–27; Shaw 1999, pp. 43–45).

Munch himself provided a memorable description of a glitter path that he observed in the Oslofjord:

The Moon became gold ... a golden column appeared in the water – and rocked back and forth – it melted in its own glowing light – and the gold flowed out over the surface of the water. (Edvard Munch, translation of document T2782-ah in the Munch Museum archives.)

These words by the artist serve as a good description of the scene in his *Moonlight* painting. Because this canvas shows the lunar disk close to the horizon, it might seem logical to identify the lunar phase and position as a full Moon low in the eastern sky, not long after moonrise. But does the view in *Moonlight* look toward the east? Can we use topographic details in the painting to determine the artist's location and his direction of view?

Åsgårdstrand and Borre

A book published by Oslo's Nasjonalmuseet surveyed that museum's important collection of works by Munch and concluded regarding Moonlight that the "motif is probably taken from the area around Åsgårdstrand, where Munch stayed in the summer of 1895." (Yvenes 2008, p. 32)

Our Texas State group wondered whether we could make this more specific. In August 2008 we went on a research trip to find Munch's exact location in or near Åsgårdstrand, a town on the west side of the Oslofjord (Figs. 3.17 and 3.18). Undergraduate physics student Ava Pope studied the distant horizon in the painting and noticed an important clue. On the right side of the canvas, hills and other shoreline features appear below the Moon, but on the left side open water forms the horizon. This proves that the direction of view definitely does not look east because observers looking across the water in that direction would see, on the far side of the fjord, the land and hills extending completely along the horizon both to the right and left.

Fig. 3.17 This photograph from June 6, 2009, shows the view from Borre National Park as a nearly full Moon passes low in the sky above the Slagentangen industrial complex. Clouds covered the lunar disk a few minutes later, as the Moon moved to the right and approached a potential closer match between the photograph and Munch's *Moonlight* painting. The open water, visible to the left of the lights of the oil refinery, provided the clue to identifying the Borre woods as Munch's location (Photograph by Trond Erik Hillestad. Used with permission)

Fig. 3.18 Members of our Texas State University group (Marilynn Olson, Ava Pope, and Don Olson) framed a glitter path below the lunar disk as seen from the town of Åsgårdstrand in August 2008. We could rule out Åsgårdstrand as the site for Munch's *Moonlight* painting, because the hills on the opposite shoreline of the Oslofjord extend along the horizon to the left of the bright lights that identify the Slagentangen industrial complex (Photograph by Russell Doescher. Used with permission)

We explored the region around Åsgårdstrand and found a match to the painted scene from a unique spot: the woods near the shore in Borre National Park. This site, famed for its exceptional Viking grave mounds, lies about 2 miles north of Åsgårdstrand. We were able to match Munch's view by looking to the south, toward what is now the Slagentangen industrial complex on the shore about 4½ miles south of Borre. Astronomers express compass directions with a coordinate called azimuth, with 0° marking due north, 90° due east, 180° due south, and 270° due west. As seen from Borre, the lunar disk in Munch's *Moonlight* painting stands near azimuth 164°, that is, slightly to the east ("to the left") of due south.

This raises an apparent contradiction for those accustomed to viewing the sky in typical years from the United States and other northern mid-latitude locations. Those observers know that the Moon, when it passes over the southern horizon, reaches its highest point in the sky for that night. Why did Munch depict the Moon so low in the southern sky?

The answer is that in certain circumstances the Moon never rises much above the southern horizon for observers at high latitudes such as in Norway, and especially in certain years.

Moon "Runs Low"

The path of the Moon through the sky and the number of hours that the Moon spends above the horizon vary greatly over the course of a month and also over the course of an 18.6-year lunar cycle. Every 18.6 years, the 23.5° tilt of Earth's axis and the 5° tilt of the lunar orbit combine in such a way that extreme paths are possible, with the Moon running exceptionally high or exceptionally low through the sky (Lovi 1987; Meeus 2007). When the Moon "runs high," it rises in the northeast, passes high overhead, and remains thereafter above the horizon for many hours before finally setting in the northwest. The Moon "runs low" when it rises in the southeast, skims at a relatively low altitude through the sky not far above the southern horizon, and remains thereafter above the horizon for only a relatively short time before setting in the southwest. We computed the times when extreme high and low Moons were possible, with the results including the years 1801, 1820, 1838, 1857, 1876, 1894, 1913, 1932, 1950, 1969, 1987, 2006, 2025, and 2043.

A chapter in the author's previous *Celestial Sleuth* book detailed how our Texas State group discovered the importance of 1857 as a special year in the 18.6-year cycle. Astronomical calculations regarding the Moon's unusual path "running low" through the sky on August 29, 1857, helped to explain a long-standing mystery regarding Abraham Lincoln and the event known as the Almanac Trial from his days as a lawyer (Olson 2014, pp. 204–212).

The result that the year 1894 was a special year in this lunar cycle has significance for Munch's *Moonlight* and also for many of his other depictions of the Moon in works inspired during the 1890s. The gradual changes of this cycle imply that the Moon could run very low in the years 1893, 1894, and 1895. This behavior of "running low" and passing only a short distance above the southern horizon would take place near the summer solstice for full Moons and, later in the summer, for the nearly full lunar phases within a few days before full Moon (Fig. 3.19).

Munch and the Moon in 1895

According to the standard chronology of Munch's life, the artist resided during part of July 1895 at Nordstrand on the east side of the Oslofjord, and he subsequently spent time in Åsgårdstrand. By September he had traveled to Paris (Langaard and Revold 1961, p. 25).

Full Moons occurred in 1895 on July 6th, August 5th, and September 4th. The biographical information suggests the period near August 5, 1895, as the time of the inspiration for the *Moonlight* canvas. The nearly full Moon at its highest point passed only 2°, 4°, 8°, and 12° over the southern horizon on the nights of August 2nd to 3rd, 3rd to 4th, 4th to 5th, and 5th to 6th, respectively, in 1895. The sky on any of those dates could have provided the inspiration for Munch.

Viking Graves and Lunar Reflections

Although the lunar disk in Munch's *Moonlight* is very close to the horizon, the topographical and astronomical analysis shows that the Moon is *not* rising in the east. According to the effects of an 18.6-year lunar cycle, the full (or nearly full) Moons in the summer of

AUGUST hath 31 days. [1895.

○ Full Moon, 5th day, 8h. 51m., morning, W.
☾ Last Quarter, 13th day, 0h. 18m., evening, W.
● New Moon, 20th day, 7h. 56m., morning, E.
☽ First Quarter, 27th day, 0h. 43m., morning, W.

D. M.	D. W.	Aspects, Holidays, Events, Weather, &c.	Farmer's Calendar.
1	Th.	Lammas Day. ☿ in ♌, ☌ ☿ ♃.	THE merchants, the mechanics,
2	Fr.	1st. ☾ runs low. *Weather*	and most of the professional men
3	Sa.	{ 1st. Joseph Holt, ex.-Sec. of War, died, 1894, aged 87.	are having a vacation, while the
4	**F**	8th Sunday after Trinity.	farmer is busy at work in the hot midsummer sun, and his wife
5	Mo.	☿ in Perih. *unsettled.*	may be sweating over a hot fire
6	Tu.	Transfiguration. Med. tides.	cooking for her fortunate cousins, who sit on the veranda breathing
7	W.	☾ in Apogee. *Close with*	the pure country air.

Fig. 3.19 This excerpt from the *Old Farmer's Almanac* informed readers that both a full Moon and a period during which the "☾ runs low" would occur during the first week of August in 1895

1895 passed very low over the southern horizon. From a viewpoint in the Borre woods, most likely during the first week of August 1895, the artist could have observed the Moon low in the sky just above the shoreline where the Slagentangen oil refinery complex is now located. The most extreme Moons "running low" over the southern horizon will next occur in the years 2024–2026. However, modern observers can approximately recreate Munch's experience near midnight on any summer full Moon night by traveling to Borre and walking past the Viking grave mounds to the shore, to behold the lunar disk and the sparkling glitter path on the fjord.

References

Baetjer, Katharine, and J. G. Links (1989) *Canaletto*. New York: Metropolitan Museum of Art.

Berlin, Normand (1999) Traffic of our stage: Why *Waiting for Godot*? *The Massachusetts Review* **40** (No. 3), Autumn, 420.

Bock, Georg (1927) *Die Bedeutung der Insel Rügen für die deutsche Landschaftsmalerie.* Greifswald: Buchdruckerei Hans Adler.

Börsch-Supan, Helmut, and Karl Wilhelm Jähnig (1973) *Caspar David Friedrich: Gemälde, Druckgraphik und bildmässige Zeichnungen.* Munich: Prestel-Verlag.

Brosche, Peter (1995) Sie betrachten auch die Venus, Astronomisches zu Caspar David Friedrichs berühmtem Gemälde. *Sterne und Weltraum* **34** (No. 3), 194-196.

Brosche, Peter (1996) Nachtrag zu Caspar David Friedrich ("Sie betrachten auch die Venus"). *Sterne und Weltraum* **35** (No. 3), 235.

Busch, Werner (2008) *Caspar David Friedrich: Ästhetik und Religion.* Munich: Verlag C. H. Beck.

Förster, Christian Friedrich Ludwig (1846) *Biographische und literarische Skizzen aus dem Leben und der Zeit Karl Förster's.* Dresden: H. M. Gottschalck.

Greenler, Robert (1980) *Rainbows, halos, and glories.* New York: Cambridge University Press.

Haynes, John, and James Knowlson (2003) *Images of Beckett.* New York: Cambridge University Press.

Hoch, Karl-Ludwig (1995) *Caspar David Friedrich in der Sächsischen Schweiz: Skizzen, Motive, Bilder.* Dresden: Verlag der Kunst.

Knowlson, James (1996) *Damned to Fame: The Life of Samuel Beckett.* New York: Simon & Schuster.

Langaard, Johan, and Reidar Revold (1961) *A Year by Year Record of Edvard Munch's Life.* Oslo: Aschehoug.

Links, J. G. (1982) *Canaletto.* Ithaca, NY: Cornell University Press.

Livingston, William (1992) What's Wrong with a Gibbous Moon? *Sky & Telescope* **83** (No. 2), February, 159-160.

Lovi, George (1987) The High-Low Moon of 1987. *Sky & Telescope* **73** (No. 1), January, 57-58.

Meeus, Jean (2007) Northernmost and southernmost Full Moons, in *Mathematical Astronomy Morsels IV.* Richmond, VA: Willmann-Bell, Inc.

Minnaert, Marcel (1954) *The Nature of Light & Colour in the Open Air.* New York: Dover Publications, Inc.

Monrad, Kasper, and Colin J. Bailey (1991) *Caspar David Friedrich und Dänemark.* Copenhagen: Statens Museum for Kunst.

Neidhardt, Hans Joachim (1976) in *La peinture allemande à l'époque du Romantisme: catalogue d'une exposition realisee par la Reunion des musees nationaux et tenue a l'Orangerie des Tuileries, 25 octobre 1976-28 fevrier 1977.* Paris: Éditions des Musées Nationaux.

Olson, Donald W. (2014) *Celestial Sleuth: Using Astronomy to Solve Mysteries in Art, History and Literature.* Springer Praxis: New York.

Rewald, Sabine (2001) *Caspar David Friedrich: Moonwatchers.* New York: Metropolitan Museum of Art.

Richter, Frank (2009) *Caspar David Friedrich: Spurensuche im Dresdner Umland und in der Sächsischen Schweiz.* Husum: Verlag der Kunst.

Schmied, Wieland (1999) *Caspar David Friedrich: Zyklus, Zeit und Ewigkeit.* Munich: Prestel Verlag.

Semrau, Maximilian (1917) *Bilder aus Greifswalds Vergangenheit*. Greifswald: Verlag Bruncken & Co.

Shaw, Joseph A. (1999) Glittering Light on Water. *Optics & Photonics News* **10** (No. 3), March, 43-45.

Spencer-Longhurst, Paul (2006) *Moonrise over Europe, J. C. Dahl and Romantic Landscape*. London: Philip Wilson Publishers.

Tinterow, Gary, and Sabine Rewald (2000) Recent Acquisitions, A Selection: 1999-2000. *Metropolitan Museum of Art Bulletin* **58** (No. 2), Fall, 36.

Wegner, Reinhard (2004) *Kunst, die andere Natur*. Göttingen: Vandenhoeck & Ruprecht.

Woll, Gerd, ed. (2009) *Edvard Munch, Complete Paintings: Catalogue Raisonné, Volume I, 1880-1897*. London: Thames & Hudson.

Yvenes, Marianne (2008) *Måneskinn* [*Moonlight*], in *Edvard Munch i Nasjonalmuseet*. Oslo: Oslo Nasjonalmuseet.

Zschoche, Herrmann (2006) *Die Briefe*. Hamburg: ConferencePoint Verlag.

Zschoche, Herrmann (2008) *Caspar David Friedrich im Harz*. Dresden: Verlag der Kunst.

4

Monet in Le Havre: Origins of Impressionism

The iconic painting *Impression, Sunrise* by Claude Monet has a special interest in part because the title inspired the name of the Impressionist movement after this work appeared in an 1874 Paris exhibition. The date of *Impression, Sunrise* has long been a subject of controversy. Not only the time of year but even the calendar year of the painting is in dispute, with both 1872 and 1873 cited by various authors.

The scene shows the Sun rising into a misty sky above the harbor of Le Havre. From what location did Monet observe the harbor? Some authors claimed that the painting represents the view from a boat. Or was it painted from the elevated location of a window overlooking the harbor? Some eminent art historians claimed that the depicted scene is actually a sunset. Could we use nineteenth-century maps and photographs to demonstrate that the painting actually shows a rising Sun? What clues in the painting allow us to infer that the time is near a high tide? Could we use astronomical calculations, the position of the Sun, tide calculations, and meteorological archives to determine a list of possible dates when Monet could have been inspired to create this canvas? The left side of the painting includes several plumes of smoke rising into the sky. How could we use the direction of the wind to narrow down the list of possible dates?

According to the standard catalogs of Monet's works, the famous *Impression, Sunrise* was part of a series of three similar works created during a visit to Le Havre. Monet in his entire career painted only a small number of night scenes, but this series includes a nocturnal harbor view titled *Port of Le Havre, Night Effect*. At first glance, the obscure scene in the night painting appears to offer little information useful for dating, but a closer look revealed several clues. For example, astronomical calculations of the Moon's position and hydrodynamic calculations of the tide levels could be used to answer some of the questions. We also consulted navigational guides that described the system of colored signal lights used at night on moving ships and on buildings and signal masts along the quais and jetties of Le Havre harbor.

Could this analysis determine whether Monet created *Impression, Sunrise* and *Port of Le Havre, Night Effect* in 1872 or 1873? Could we even calculate dates and precise times for the scenes that inspired Monet?

© Springer International Publishing AG 2018
D.W. Olson, *Further Adventures of the Celestial Sleuth*, Springer Praxis Books,
https://doi.org/10.1007/978-3-319-70320-6_4

An earlier Monet canvas, titled *Marine, Night Effect* and dated to the mid-1860s, has a number of similarities to the Le Havre night painting from the 1870s. *Marine, Night Effect* includes a sailboat, a steamship, and a great sailing ship near a harbor entrance under a night sky with dramatic clouds outlined by bright moonlight. According to the existing literature, this painting depicts the entrance to the harbor of Honfleur. How could we use the detailed descriptions in mariner's guides and nineteenth-century lists of lighthouses to demonstrate that *Marine, Night Effect* does not depict the harbor of Honfleur but instead belongs to one of Monet's Le Havre campaigns?

Dating Monet's *Impression, Sunrise*

The art historian Daniel Wildenstein prepared a complete catalog of Monet's works and letters, with a revised edition appearing two decades later. (Wildenstein 1974; Wildenstein 1996) Art historians identify each Monet painting by its number in these Wildenstein catalogs. The canvas of *Impression, Sunrise* (known as W263) bears the year "72" next to Monet's signature, and an early publication by Wildenstein accordingly assigned it to 1872. (Wildenstein 1967, p. 40) However, the catalogs published by Wildenstein instead dated three consecutively numbered paintings with similar views of the Le Havre harbor — *Sunrise, Marine* (W262), *Impression, Sunrise* (W263), and *Port of Le Havre, Night Effect* (W264) — to a campaign that Wildenstein placed in the spring of 1873 (Figs. 4.1, 4.2, and 4.3) (Wildenstein 1974, pp. 65–69; 1996, pp. 113–114).

Could an astronomical analysis determine whether Monet created these works in 1872 or 1873? Could we calculate dates and precise times for the scenes that inspired Monet?

Monet and Astronomy

In the previous *Celestial Sleuth* book, the opening chapter detailed a study of Monet's 1883 *Étretat, Sunset* (W817). A site visit to the distinctive cliffs, arches, and rock formations of the Normandy coastline allowed our Texas State University group to find Monet's location on the Étretat beach. Several sets of meteorological records exist from 1883, and Monet's almost daily letters from January and February 1883 contain weather information and other clues. Combining this evidence with computations of the tide levels at sunset and with astronomical calculations of the Sun's position in the sky, we were able to determine a date and precise time for the sunset scene that Monet captured: February 5, 1883, at 4:53 p.m. local mean time (Olson 2014a, pp. 3–25).

The Sun in the Mist

Impression, Sunrise poses a much more difficult problem in dating for at least two reasons. First, the hazy nature of the scene has produced considerable disagreement regarding Monet's location, his direction of view, and which part of the Le Havre harbor is depicted. Also, relevant biographical material is almost nonexistent, with only a very small number of Monet's letters surviving from 1872 and 1873. However, the historical importance of

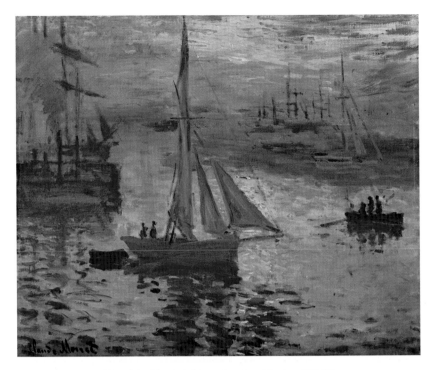

Fig. 4.1 Claude Monet, *Sunrise, Marine* (W262)

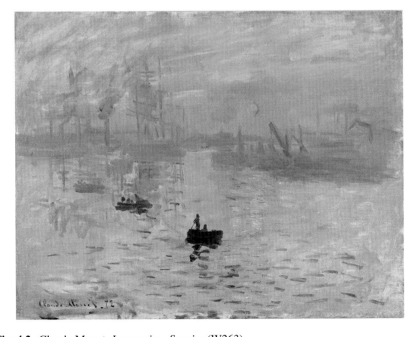

Fig. 4.2 Claude Monet, *Impression, Sunrise* (W263)

Fig. 4.3 Claude Monet, *Port of Le Havre, Night Effect* (W264)

this painting is a strong motivation for attempting to determine Monet's location and to calculate a precise date.

Monet's Window: The Words of the Artist

As part of an interview published in 1898, Monet himself made it clear that the famous painting showed the view from a window overlooking the harbor at Le Havre. Discussing the exhibition of 1874, the artist recalled:

> *I had submitted something done in Le Havre, from my window, the Sun in the mist ... They asked me the title for the catalogue, and it could not really pass for a view of Le Havre: I replied: « Put Impression. ». From that came "impressionism," and the jokes proliferated* (Guillemot 1898, n. p.)

Date and Location: Wildenstein's Opinions

In a 1967 essay, Wildenstein described *Impression, Sunrise* as "painted in 1872 in Le Havre." (Wildenstein 1967, p. 40) Wildenstein's 1974 catalog gave more detailed information about the location and stated that: "Monet occupied a room in Hôtel de l'Amirauté overlooking the Grand Quai ... this is where he painted *Impression (cat. 263)*" (Wildenstein 1974, p. 47).

However, contrary to his earlier essay, Wildenstein in his 1974 catalog judged that: "... the date 72 following the signature on *Impression (263)* does not correspond to reality" (Wildenstein 1974, p. 65).

The caption to the painting's illustration in this catalog read: "Cat. 263 — *Impression, Sunrise*, 1873" (Wildenstein 1974, p. 67).

Wildenstein advanced the theory that Monet had created *Impression, Sunrise* and related paintings during a visit to Le Havre in the spring of 1873 and asserted that: "From a trip to Normandy, Monet brought back … a group of canvases painted in the port of Le Havre (*259-264*), one of which was to cause quite an uproar (*263*)" (Wildenstein 1974, p. 65).

Wildenstein explained his reasoning about the date in a footnote and quoted from an April 22, 1873, letter in which Monet mentioned in passing, "I went to Rouen" (Wildenstein 1974, p. 65). Although Monet did not explicitly state in this letter that he also worked in Le Havre during this spring 1873 trip, Wildenstein evidently assumed that the artist did make a side trip to Le Havre shortly before writing this letter.

Wildenstein concluded in another footnote that Monet created all three paintings with similar views — W262, W263, and W264 — in the spring of 1873 when he was in a hotel on the Grand Quai (the "Great Pier") and looked to the southeast over the *avant-port* (the outer harbor) of Le Havre. Wildenstein compared the famous *Impression, Sunrise* (W263) to:

> Sunrise (Marine) (262) … *which represents essentially the same motif in a very similar lighting. In both cases, installed on the Grand Quai at Le Havre… probably at a window of the Hôtel de l'Amirauté … Monet painted the old avant-port … in the direction toward the southeast. All the cartographic studies and all the evidence collected from local historians agree on this point. See also* Port of Le Havre, Night Effect (264). (Wildenstein 1974, p. 69)

Wildenstein reiterated these conclusions about the year and the direction of view for the three paintings in a catalog entry: "263, IMPRESSION, SUNRISE … Painted at Le Havre in 1873. Represents the old avant-port viewed in the direction toward the southeast. Cf. numbers 262 and 264" (Wildenstein 1974, p. 226).

Following the publication of Wildenstein's catalog, some authors persisted in dating *Impression, Sunrise* to 1872, while others adopted the revised year of 1873. John House surveyed the literature regarding Monet's production during the decade of the 1870s and recognized that "problems arise, during the same period, over the dating of Monet's spells of work at Rouen and Le Havre" (House 1978, p. 679). An especially striking example of this dating uncertainty appears in a lavishly illustrated volume by Robert Gordon and Andrew Forge. On the page facing illustrations of W262 and W263 the authors state that: "The two paintings opposite, and one of the harbor at night [W264], were painted from Monet's hotel window in Le Havre in 1872." But the captions contradict the text by listing a different year: "*Impression, Soleil Levant (Impression, Sunrise). 1873*" and "*Soleil Levant, Marine (Sunrise, Seascape). 1873*" (Gordon and Forge 1983, pp. 58–59).

Le Havre in Photographs and Maps

To resolve questions about paintings depicting the harbor of Le Havre as it appeared in the nineteenth century, modern scholars can turn to an extensive cartographic and photographic record. The immense number of travelers and tourists who have passed through Le Havre makes it easy to find hundreds of postcard views of the port, with these images

Fig. 4.4 This map shows Le Havre harbor in the 1870s. The red dot indicates Monet's position in the Hôtel de l'Amirauté, and the red arrow points in the direction of the low Sun seen in *Impression, Sunrise*. The white rectangle at the bottom center of this map is the *Bassin de la Floride*, and immediately to the right is the quadrilateral shape of the *Bassin de Mi-Marée*, with the red arrow passing over it. Near the lower left corner of this map, two concentric circles represent the tiered Semaphore building

dating primarily from the years circa 1900–1910. For the decades of the 1870s and the 1880s, researchers can turn to albumen prints by such pioneering photographers as Emile-André Letellier and Étienne Neurdein.

After studying maps (Fig. 4.4) and photographs of old Le Havre, we agreed with Wildenstein's conclusion regarding the direction of view, that *Impression, Sunrise* shows the avant-port observed toward the southeast.

As seen from Monet's location on the Grand Quai, the Sun in *Impression, Sunrise* stands above the eastern end (the left end, as seen in the painting) of the Quai Courbe, which projects its semi-circular shape into the avant-port from the south. Near the Sun and to the right of the Sun, the painting shows cranes and derricks of a vast construction project on the Quai Courbe, and rising into the sky behind the quai we recognize masts of sailing ships in the Bassin de Mi-Marée.

The painting also includes, to the left of the Sun and Quai Courbe, a channel of water that curves gently to the right as it goes into the distance. In this channel, Monet included a tall sailing ship with its masts and spars reaching up into the sky. This great ship is not under sail and may be in tow through the avant-port near either the tide gate called Écluse de la Floride leading into the Bassin de Mi-Marée or the tide gate called Écluse des Transatlantiques leading into the Bassin de l'Eure.

On the far left of the painting, we see more vertical elements, some of which may be the stacks of tugboats and others that may be chimneys of the works adjacent to the dry docks in the Bassin de la Citadelle. Also visible near the left side of the painting are the

masts of at least one more sailing ship, which may be in the avant-port or in the Bassin de la Citadelle or, perhaps more likely, in the lock that leads into the Bassin de la Citadelle.

Returning our attention to the objects in the middle distance on the right side of *Impression, Sunrise*, we note that our conclusions agree with those previously reached by Paul Tucker, who described the "numerous vertical elements … those to the right are cranes and heavy machinery that were part of a huge construction project that had been initiated just before the Franco-Prussian War and had been taken up again after the armistice." (Tucker 1984, p. 74)

Before 1870 the Bassin de la Floride extended along the entire length on the south side of Quai Courbe. As part of the construction project in the 1870s, engineers built an earthern traverse structure, a kind of cofferdam, dividing the Bassin de la Floride into two parts. The project came under the direction of the engineer Émile ThÉodore Quinette de Rochemont, who provided a timeline for the progress of the work: "The Bassin de la Floride will be divided into two parts by a traverse. The smaller part, to the east, will be transformed into the Bassin de Mi-Marée … The traverse, made entirely of earth and designed to separate the Bassin de la Floride into two parts, was constructed during 1870–1871" (Quinette de Rochemont 1875, pp. 117–118).

On the right side of Monet's *Impression, Sunrise* we recognize the cranes and derricks of this vast construction project on Quai Courbe and the masts of sailing ships in the more distant Bassin de Mi-Marée.

Identifying Monet's Hotel Window

In a letter written on January 27, 1874, Monet gave his current address as "Hôtel de l'Amirauté au Havre" (Wildenstein 1974, p. 429). Monet's painting *The Grand Quai at Le Havre* (W295), usually dated to 1874, provides an especially clear look at the quai and harbor in the light of a bright afternoon Sun (Fig. 4.5) and makes it possible to identify the precise location of Monet's hotel room.

Several nineteenth-century photographs (Fig. 4.6) depict the main building of Hôtel de l'Amirauté, with the hotel name prominently displayed on the façade. The architectural details visible in these close-up views in turn allow us to recognize this hotel in wider-view photographs taken from across the harbor. An early albumen photograph (Fig. 4.7), taken circa 1875, shows the three buildings of the Hôtel de l'Amirauté: an annex at Grand Quai 41, the main building at Grand Quai 43, and an annex at Grand Quai 45. Contemporary guidebooks published by Adolphe Joanne and Karl Baedeker made it clear that the main building stood at Grand Quai 43 but that the hotel included rooms at all three addresses: 41, 43, and 45 (Joanne 1872, p. 596; Baedeker 1881, p. 350).

In a chapter published in a recent exhibition catalog (Olson 2014b), our Texas State University group compared the small buildings and ornate lampposts as seen in Monet's *The Grand Quai at Le Havre* (W295) with the same features in albumen photographs from the 1870s and 1880s. A three-dimensional topographical analysis revealed that Monet's view was possible only from the room marked with an "X" in Fig. 4.7. Monet's room for *The Grand Quai at Le Havre* (W295) therefore was in the hotel annex at Grand Quai 45, not in the main hotel building.

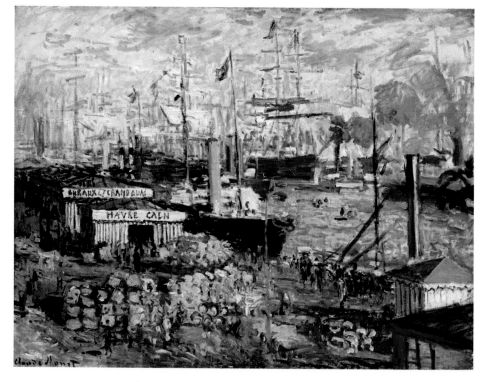

Fig. 4.5 Claude Monet, *The Grand Quai at Le Havre* (W295)

Perhaps worth noting is that Monet may have selected this room in the hotel annex because this chamber had not just a window but also a balcony.

Rooms With a View

Monet had a pattern of working in hotels, from rooms with windows or balconies commanding views over a harbor or a river. Monet also had the habit of returning to the same hotel more than once, with multiple painting campaigns based at Hôtel Blanquet in Étretat and likewise multiple working visits to the Savoy Hotel in London. No direct information exists regarding the hotel employed for *Impression, Sunrise*, but Monet's letters prove that he resided at Hôtel de l'Amirauté in late January 1874, and the established pattern makes this same Le Havre hotel also the probable candidate for 1872 or 1873.

During another visit to Le Havre in late January 1883, Monet stayed in the Hôtel Continental near the breakwaters on the north jetty. Each room on the seaward side of this first-class hotel featured a balcony overlooking the entrance to the avant-port. However, this location is not a candidate for the viewpoint of *Impression, Sunrise*, because Hôtel Continental did not open its doors until June 1882 (Bradshaw 1887, p. 370).

Fig. 4.6 These nineteenth-century photographs show the Hôtel de l'Amirauté with the hotel name prominent on the façade. The distinctive architectural features allow us to recognize the hotel in wide-angle photographs taken from across the harbor

Direction to the Rising Sun

At Le Havre, as in all cities in mid-northern latitudes, after the instant of sunrise the Sun then rises "up and to the right" into the sky. According to our topographical analysis, the low Sun in *Impression, Sunrise* stands over the eastern end of Quai Courbe, but the actual point of sunrise must have been in the direction of the water in the channel to the east (in the painting, to the left) of this quai. To express the direction of this sunrise point in a precise way, astronomers use a coordinate called azimuth to identify the compass directions, with 0° at the north, 45° at the northeast, 90° at the east, 135° at the southeast, 180° at the south, etc. On the nineteenth-century map of the harbor (Fig. 4.4) the line of sight from the Hôtel de l'Amirauté to the east end of Quai Courbe points in the direction of azimuth 122°, measured from true north. As observed by Monet on the morning that inspired *Impression, Sunrise*, the point of sunrise on the horizon would have been slightly to the left of the east end of Quai Courbe, most probably near azimuth 117–121°. The low Sun over the quai in the painting would correspond to an azimuth of approximately 123–127°. The Sun rises in this position twice during each year, in mid-November and late January.

Fig. 4.7 This albumen print shows the Grand Quai as it appeared in the 1870s. Near the center of the view we recognize the three buildings of the Hôtel de l'Amirauté: an annex at Grand Quai 41, the main building at Grand Quai 43, and an annex at Grand Quai 45. A three-dimensional topographical analysis reveals that Monet's view for W295 is possible only from the room marked with a yellow "X" in the hotel annex at Grand Quai 45, not in the main hotel building at Grand Quai 43

The Sun's altitude in *Impression, Sunrise* can be estimated first by using the known diameter of ½° for the solar disk to deduce that the Sun is standing somewhat less than 2° above the distant horizon. An independent estimate compares the altitude of the Sun to the masts of the sailing ships in the Bassin de Mi-Marée, located to the right of the Sun in the painting. This method uses typical sailing ship mast heights of about 50 m, the known distance of 550 m from the hotel to the center of Bassin de Mi-Marée, and the elevation of Monet's balcony at 9 m above the Grand Quai and 11 m above the water level. For such a configuration, the tops of the distant masts extend approximately 4° above the horizon, and the Sun's calculated altitude is perhaps closer to 3°. We therefore estimate that the disk of the Sun in *Impression, Sunrise* has an altitude of about 2° or 3° above the horizon, a low Sun position corresponding to a time approximately 20–30 min after sunrise.

The Stand of High Tide

The great sailing ships and steamers could pass through the Le Havre avant-port only for a period lasting three or four hours and centered on the time of high tide. Before and after this interval, the water level in the avant-port channel was not sufficiently deep, and the large ships would run aground. A noteworthy hydrographic feature of Le Havre is that the

Table 4.1 Possible ranges of dates for *Impression, Sunrise*

1872 January 21–25	At 8:00 a.m. to 8:10 a.m.
1872 November 11–15	At 7:25 a.m. to 7:35 a.m.
1873 January 25–26	At 8:05 a.m.
1873 November 14–20	At 7:30 a.m. to 7:40 a.m.

On each of these dates and times, a low Sun would be rising over the east end of Quai Courbe, and a high water stand would allow maneuvers by the great sailing ships in the Le Havre avant-port

tide curve can exhibit a nearly flat maximum near the time of high tide. For a long interval of time called the "high water stand" the water level remains nearly constant. Émile ThÉodore Quinette de Rochemont described this phenomenon in his 1875 monograph on the port of Le Havre: "This feature of the tidal curve is very advantageous for navigation; it permits us to leave the bassins open for about three hours" (Quinette de Rochemont 1875, p. 37).

During the time of high water stand, the tide gates [French: *écluses*] leading to the Bassin de Mi-Marée and the Bassin de l'Eure, and the lock [*sas*] leading to the Bassin de la Citadelle, could remain open. Tugboats towed the sailing ships through the avant-port and the tide gates. In *Impression, Sunrise* the masts of the largest sailing ship extend well up into the sky and indicate that this vessel is much closer to Monet's hotel than are the distant masts on the right side of the painting. This largest sailing ship may be under tow through the avant-port. The requirement that the low rising Sun in *Impression, Sunrise* correspond within one or two hours to the time of high water gives us a strong tidal constraint on the possible dates.

Our computer algorithms allow us to calculate the positions of the Sun and the Moon and the resulting tide curves for dates in the nineteenth century. The times of high tide and the water level at the tide gates were also printed in a nineteenth-century publication called the *Almanach du Commerce du Havre*. Table 4.1 lists the most likely ranges of dates for *Impression, Sunrise*, based on the topographical analysis, astronomical calculations of the Sun's position, and tide calculations of high water stand.

Glitter Path

Below the disk of the Sun, the sparkling light on the water of the avant-port is known, as indicated earlier, by atmospheric scientists as a glitter path. The depiction in *Impression, Sunrise* makes this certainly the most famous glitter path in history! As explained in standard references on this phenomenon, the vertical elongation of the glitter path in the painting is entirely consistent with the low altitude of the Sun (Lynch and Livingston 2001, pp. 83–87).

A Spring Sunrise?

William Seitz in 1960 published a Monet chronology with the entry: "1872 SPRING: In Le Havre. Paints the *Impression*" (Seitz 1960, p. 46). William Gaunt in 1970 likewise asserted that "Monet painted this picture of the sun seen through mist at the harbor of Le Havre when he was staying there in the spring of 1872" (Gaunt 1970, p. 90).

As cited earlier, Daniel Wildenstein's catalog also placed this painting in the spring season, but in the year 1873. Specifically, Wildenstein dated all three Le Havre paintings with similar views (W262, 263, and 264) to the time period just before April 22, 1873 (Wildenstein 1974, pp. 65–69). Wildenstein's judgment about the season and the year has proved especially influential.

Joel Isaacson's 1978 Monet biography followed Wildenstein's theory in assigning *Impression, Sunrise* to "Monet's sojourn in Le Havre in March or April 1873" (Isaacson 1978, p. 204). The Getty Museum, following the acquisition of *Sunrise (Marine)* (W262) in 1998, issued a press release promoting the scene as a sunrise from the spring of 1873:

Getty Museum Acquires Early Impressionist Painting by Claude Monet

Created during the spring of 1873, the painting depicts the bustling port of Le Havre on the northern French coast, as light dawns on the water Monet traveled to Le Havre from his home in Argenteuil in the spring of 1873. While there he painted several paintings of its harbor. Sunrise is most closely related to the famous Impression, Sunrise *(Paris, Musée Marmottan), painted during this trip.* (Getty Museum 1998, p. 1)

The Getty Museum website likewise described *Sunrise (Marine)* as dated to "March or April 1873" and "painted during the spring of 1873." But if our topographical analysis is correct, the paintings W262-263 cannot date from the spring season of any year. To see the rising Sun in March and April, an observer in a window on the Grand Quai would look to the east in March, or even somewhat to the northeast in April, over the ticket bureaus and sheds on the Grand Quai. There is then no plausible candidate for the quai that we see on the right side of *Impression, Sunrise* and no plausible position for the group of sailing ships, tugboats, and small boats that the painting includes to the left of the rising Sun.

Moreover, placing *Impression, Sunrise* in the spring season contradicts Wildenstein's own statement, elsewhere in the same catalog, about the topography of the port and the direction of view: "Monet painted the old avant-port ... in the direction toward the southeast. All the cartographic studies and all the evidence collected from local historians agree on this point" (Wildenstein 1974, p. 69).

We agree that Monet's *Impression, Sunrise* does show a view to the southeast, with the solar disk in a position attained only in late fall (mid-November) or winter (late January).

View From a Boat?

In an essay published in 1956, William Seitz speculated that Monet's *Impression, Sunrise* was "painted at dawn, perhaps from a boat" (Seitz 1956, p. 36). Seitz repeated this idea in a 1960 book, in which he offered his theory regarding the origin of *Impression, Sunrise*: "[I]t is easy to imagine oneself in Monet's position here in the harbor of Le Havre, bobbing on the waves in a small boat – a lone observer, engrossed in a unique and transitory moment that will never be repeated" (Seitz 1960, p. 92).

Perhaps influenced by Seitz's vivid account, Trewin Copplestone likewise described Monet's sunrise as "a transient moment he observed from a small boat in the harbor" (Copplestone 1998, p. 37).

Monet famously did employ a studio boat on the Seine near Argenteuil. This floating studio was the subject of several Monet works (e.g., W323, W390-393), and two Manet paintings from 1874 show Monet held on his studio boat.

But *Impression, Sunrise* cannot have been viewed from a small boat in the harbor for at least two reasons. First, Monet explicitly stated he observed the scene "from my window" (Guillemot 1898, n. p.). Moreover, a quick glance at the three small boats that form a diagonal line in the bottom half of *Impression, Sunrise* proves that Monet was well above the water level. If Monet had sketched the view from his own small boat in the harbor, the heads of the oarsmen in the three small boats would all have been even with each other and with the horizon line. Instead, study of the canvas proves that Monet was looking down on the three small boats, because the horizon line in the painting is located far above the oarsmen, consistent with Monet's window being well above the water level. As a concrete example, Monet's window for *The Grand Quai at Le Havre* (W295) was 9 m above the pier and approximately 11 m above the water level at high tide. In *The Grand Quai at Le Havre* (W295) the artist looks down on two small boats in the avant-port from approximately the same perspective as he looks down on the three small boats in *Impression, Sunrise*.

Impression, Sunset?

According to a footnote in Wildenstein's catalog, *Impression, Sunrise* appeared in the catalog for the sale on June 5–6, 1878, with the erroneous title *Impression, Sunset* (French: *Impression, soleil couchant*) (Wildenstein 1974, p. 69). The art dealer Paul Durand-Ruel made the same error when he recalled regarding the 1874 exhibition that: "*Marine at Sunset* appeared in the catalogue under the title of *Impression*" (Venturi 1939, p. 200). Thus began many years of misunderstanding.

Paul Konody continued the pattern in his entry on "Impressionism" for the *Encyclopedia Britannica* and stated that "the word Impressionism was coined by a journalist as a term for opprobrium in a derisive criticism of a painting by Claude Monet, called 'Impressions,' the actual subject of which was a sunset" (Konody 1959, p. 125).

Probably the most detailed assertions that *Impression, Sunrise* depicts a sunset appeared in a Monet biography authored in 1966 by Charles Merrill Mount, who made a trip to the harbor and argued that he had verified the claim:

> *Soon again, that same January, 1872, Monet set off for Le Havre, where his quest appears to have been disappointed. Only two hasty sketches were brought away, showing a setting sun hanging over the harbor's west end.*

> *...since both rapid views of Le Havre painted on Monet's 1872 visit were present, Edmond Renoir dutifully labeled one* Le Havre: Fishing Boats Leaving Port, *and the second* Impression: Rising Sun, *though Monet might have told him that the sun, hovering over the west end of the harbor, surely was setting....*

> *Whether the sun in this canvas is rising, as Edmond Renoir thought, or setting has also caused considerable discussion. Since all arguments must ultimately be settled by geography at Le Havre, I took the problem there, discovering that Monet habitually worked either from the principal jetty, nearest to his youthful haunts at*

Ste.-Adresse, or from the quay adjacent to this jetty. From either position an east-west axis will extend over the sea. Thus, this sun over the sea is in the west, or setting position. (Mount 1966, p. 213, 245, 416)

Probably the most influential assertions that *Impression, Sunrise* (W263) depicts a sunset appeared in a 1973 volume by John Rewald, who concluded: "Among the works painted from his window in Le Havre were two views of the harbor, one with a rising, one with a setting sun shining through the fog ... which, in the artist's own words, were impressions of mist" (Rewald 1973, pp. 285–289).

In the captions to the illustrations of these two works, Rewald identifies W262 as "MONET: *Impression, Sunrise* (Le Havre), 1872" and identifies W263 as "MONET: *Impression, Setting Sun (Fog)*, (Le Havre), d. 1872" (Rewald 1973, pp. 316–317). In a note, Rewald reiterates that in W263 "the sun seems to be setting rather than rising" (Rewald 1973, p. 339).

Rewald's interpretation has been influential and often-repeated in the years since 1973. For example, a survey of Impressionism by John Russell Taylor employed the title "Impression: setting sun (fog), 1872" (Taylor 1981, p. 29) for W263. Many subsequent authors have likewise followed Rewald by describing W263 as a sunset painting (Denvir 1993, p. 88; Southgate 2004, p. 2523).

As astronomers, our Texas State group was at a loss to understand Rewald's remarks, and Rewald offered no information regarding how he could distinguish sunrises from sunsets. Such a distinction could easily be done for any photograph of the Moon near the horizon. The dark lunar surface features called *maria* make it easy for an astronomer to distinguish moonrises from moonsets with just a glance. The side of the Moon containing the distinctive feature called Mare Crisium always rises first and also sets first, and the side with Mare Imbrium always rises last and sets last.

However, the Sun's surface has no such features visible to the naked eye. Astronomers looking at still photographs or paintings of the Sun near the horizon require some additional information, perhaps an accurate memoir or statement from the artist, or topographical information to clarify whether the western horizon or eastern horizon is depicted, or some other convincing evidence.

When we view a scene in a motion picture or a sequence in a television program showing the motion of the Sun near the horizon, the difference between a sunrise and sunset becomes obvious. In mid-latitudes of the northern hemisphere, the Sun rising up from the eastern horizon always moves up and to the right, while the setting Sun always follows a path down and to the right as it approaches the western horizon. A potentially confusing point is that movie and television directors have been known to film sunsets and to reverse the motion in attempts to fool the viewers into thinking that they are watching sunrises. Astronomers can easily detect such faked "sunrises" in motion pictures, because the "rising" Sun then moves in the incorrect direction, up and to the left relative to the horizon. However for a single image of a low Sun in a photograph or painting, there is no simple and straightforward way for astronomers to distinguish a rising Sun from a setting Sun.

The accompanying map (Fig. 4.4) shows that sunsets can indeed be observed by looking generally west from the quais of the avant-port. But, unlike the appearance of W263, the right side of such a sunset view would show the long line of hotels and other

large buildings on the Grand Quai, curving gently to the left with the disk of the Sun over the north jetty in the distance. Moreover, there are no bassins for large vessels to be found on the north side of the Le Havre entrance channel that passes between the north jetty and the south jetty. The waters just north of the north jetty instead formed the bathing beach for the Hôtel Frascati. The appearance of Monet's *Impression, Sunrise* (W263), with the masts of large sailing ships visible in the distance to the right of the low Sun, cannot be a sunset view.

Meteorological Observations in 1872

Returning our attention to the dating of Monet's sunrise paintings, we note that additional evidence can be found in the reports of nineteenth-century meteorological observers.

If the year 1872 is accepted at face value for *Impression, Sunrise* on the basis of the "72" next to the artist's signature, then, as explained earlier, the best matches occurred during the ranges of dates 1872 January 21–25 and 1872 November 11–15. Meteorological reports allow us to reject some of these ten proposed dates, because of the bad weather common on the Normandy coast during the late fall and winter months. Weather archives also can identify some dates when the sky conditions match the appearance in *Impression, Sunrise*.

The Times of London in 1872 included a daily weather column, with observations of temperature, barometric pressure, wind speed and direction, state of the heavens, and other information, recorded at 8 a.m. from various locations including London, Portsmouth, and Dover on the English side of the Channel, Cape Grisnez on the French side of the Channel, along with Paris, Brussels, and other continental cities (*Times* 1872). The *Bulletin International de l'Observatoire de Paris* collected daily observations at 8 a.m. from stations throughout France, including Le Havre (*Bulletin International* 1872). By a fortunate coincidence, this 8 a.m. time matches almost perfectly the clock time corresponding to the low Sun in *Impression, Sunrise*.

On January 21, 1872, at 8 a.m., the Le Havre observer reported light winds and a choppy sea accompanied by a sky that was cloudy and overcast, making this morning at least a possible time when Monet could have been painting.

On January 22, 1872, at 8 a.m., the Le Havre weather observer reported moderate winds and a choppy sea accompanied by mist or fog, making this date a better candidate.

The dates January 23, 24, and 25, 1872, can be ruled out as good candidates for Monet's paintings because of a massive winter storm that developed when a low pressure system passed over England and then France. By the morning of January 23, strong winds prevailed and rain fell on both sides of the Channel. For the observations from January 24, *The Times* entitled the column "The Weather and the Gale," and the text described how the "wind rose to a very severe south-west gale on the south-east coast of England in the night" which also "extended over France, Belgium, and the Netherlands." George L. Symons, an experienced weather observer, sent a letter to *The Times* on January 24 and emphasized the almost unprecedented nature of this great storm. He described the "barometric depression" as "unparalleled during my own period of observation (16 years)." *The Times* concluded that this was "the heaviest gale that has occurred in the south of England for many years." The French observers reported heavy seas, rain, and remarkably

strong winds. The journal *L'Univers Illustré* used especially colorful language to describe the period including January 23–25, 1872:

> *Storms, raging hurricanes, torrential rains: this is the weather report of the week that just ended. The material losses which these atmospheric upheavals caused in France and England are enormous...lamentable catastrophes that have claimed numerous victims. At Havre and at Nantes, the storm broke out in a terrible manner.* (L'Univers Illustré 1872, p. 67)

Another spell of bad weather allows us to eliminate three of the dates in the range November 11–15, 1872, as candidates for *Impression, Sunrise*. On November 11, 12, and 14, 1872, Le Havre experienced heavy rain with periods of very strong winds and heavy seas. The weather columnist for *The Times* likewise described the "very heavy sea" on the French coast accompanied "at intervals by violent showers of hail and rain, at which times the wind rose almost to a hurricane." However, the strong winds and boisterous weather moderated on at least two mornings during this range of dates.

On November 13, 1872, at 8 a.m., the Le Havre observer reported light winds and a choppy sea accompanied by fog or mist, making this date a possible candidate for Monet's painting. On November 15, 1872, at 8 a.m., the Le Havre observer noted light winds and fine conditions on the sea accompanied by misty or foggy conditions, making this date a possible candidate.

Meteorological Observations in 1873

If the year 1873 is accepted for *Impression, Sunrise*, following Wildenstein's suggestion that the "72" next to Monet's signature might be a mistake, then a similar meteorological analysis identifies two promising dates in early 1873.

On January 25, 1873, at 8 a.m., the Le Havre observer reported light winds and a calm sea accompanied by sky conditions that were misty or foggy, making this morning a possible candidate for Monet's painting. On January 26, 1873, at 8 a.m., the Le Havre weather observer reported moderate winds and a calm sea accompanied by misty or foggy conditions, making this date also a possible candidate.

Six Possible Dates for Impression, Sunrise

Our method so far considered four components: topographical analysis applied to photographs and maps of the Le Havre harbor, astronomical calculations of the direction to the rising Sun, hydrographic calculations of the tide levels, and meteorological observations. Table 4.2 shows the six dates are consistent with all of these factors, if Monet created *Impression, Sunrise* as an accurate depiction of what he saw from his hotel window.

The nineteenth-century clock times are expressed in local mean time, less than 1 min different from Greenwich Mean Time. Modern France during the late fall and winter seasons now employs a time system one hour ahead of Greenwich Mean Time, so a low Sun would now appear over the harbor on these dates when modern clocks show times closer to 9 a.m.

Table 4.2 Possible dates and times for *Impression, Sunrise*, based on the position of the rising Sun, calculation of the tide level, and meteorological observations of the sea and sky

Date	Local mean time	Winds
1872 January 21	8:10 a.m.	SE, light
1872 January 22	8:10 a.m.	SW, moderate
1872 November 13	7:35 a.m.	E, light
1872 November 15	7:35 a.m.	SE, light
1873 January 25	8:05 a.m.	E, light
1873 January 26	8:05 a.m.	SE, moderate

Table 4.3 Possible dates and times for *Impression, Sunrise*, based on the position of the rising Sun, calculation of the tide level, meteorological observations of the sea and sky, and the direction of the wind

Date	Local mean time
1872 November 13	7:35 a.m.
1873 January 25	8:05 a.m.

Wind and Smoke: Narrowing the Search

Another clue to dating is provided by the plumes of smoke visible on the left side of *Impression, Sunrise*. The smoke appears to be drifting from left to right as it rises up into the sky. This clue suggests a preference for the two dates and times (Table 4.3) with the wind coming from the east.

For several other Monet paintings from Le Havre, we can be certain that the artist depicted the topography of the port accurately (Figs. 4.8 and 4.9). *Impression, Sunrise* likewise appears to be an accurate representation of a sparkling glitter path extending across the waters of the harbor, beneath a solar disk seen through the mist accompanying a late fall or winter sunrise.

Dating Monet's Port of Le Havre, Night Effect

Claude Monet painted only a small number of night scenes. The example known as *Port of Le Havre, Night Effect* has an interesting connection to Monet's most famous painting, *Impression, Sunrise*.

As mentioned earlier in this chapter, Daniel Wildenstein's catalog listed three related paintings (Figs. 4.1, 4.2, and 4.3) — *Sunrise, Marine* (W262), *Impression, Sunrise* (W263), and *Port of Le Havre, Night Effect* (W264) — as among the works created during a visit to Le Havre: "From a trip to Normandy, Monet brought back … a group of canvases painted in the port of Le Havre (*259-264*), one of which was to cause quite an uproar (*263*)" (Wildenstein 1974, p. 65).

Our analysis in the first part of this chapter determined the two most probable dates and times for *Impression, Sunrise*: November 13, 1872, and January 25, 1873.

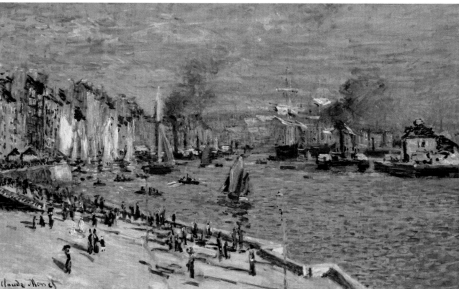

Fig. 4.8 Comparison of nineteenth-century photographs to Monet's canvases demonstrates that the artist accurately depicted the entrance to the port of Le Havre. (top): The photographer for this albumen print, circa 1880, set up his camera on the top level of the building known as the Semaphore. (bottom): Claude Monet, *View of the Avant-port at Le Havre* (W297). The slightly different perspective for the lights along the jetty shows that Monet took this view from the middle level of the Semaphore

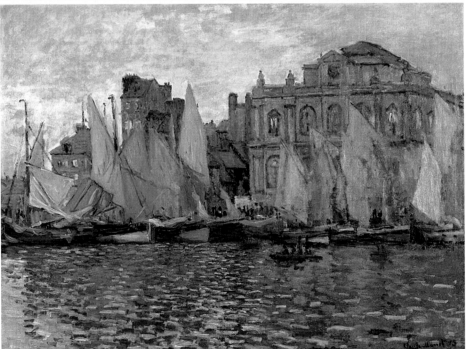

Fig. 4.9 Monet accurately depicted the buildings of the avant-port at Le Havre. The nearly identical alignment of the corner of the Le Havre Museum and the chimneys behind the museum demonstrates that the postcard photographer and Monet employed almost identical viewpoints on Quai Courbé. (top): Postcard view of the Le Havre Museum, circa 1900. (bottom): Claude Monet, *The Museum at Le Havre* (W261)

An essay by Géraldine Lefebvre gave reasons based on art history for preferring the year 1872 and argued that it seems difficult to question the date "72" entered by Monet next to his signature on the canvas (Lefebvre 2014, pp. 72–73).

If we follow Wildenstein and assume that Monet created all three views—W262, W263, and W264—during the same campaign, then astronomical analysis of the *Port of Le Havre, Night Effect* (W264) could provide additional evidence to determine whether the year of creation was 1872 or 1873. At first glance, the obscure scene in the night painting appears to offer little information useful for dating, but a closer look reveals several clues (Olson and Piner 2016).

High Tide in the Night Scene

On the left side of *Port of Le Havre, Night Effect*, the masts of a great sailing ship rise well up into the sky. This ship may be under tow and following a tugboat through the avant-port. White lights on a distant pier reflect in the water beyond the ship.

As mentioned earlier in this chapter, the great ships could pass through the Le Havre avant-port only for a period lasting about three or four hours and centered on the time of high tide. Before and after this interval, the water level in the avant-port was not sufficiently deep.

The requirement that *Port of Le Havre, Night Effect* had been painted within one or two hours of the time of high water gives us a strong tidal constraint on the possible dates and times.

Navigation Lights at Night

Red and green navigation lights of several vessels reflect in the waters of the avant-port in *Port of Le Havre, Night Effect*. White lights shine high up on several masts. Géraldine Lefebvre observed that Monet must have been "inspired by the luminous spectacle of the outer harbor at night … red lights can be made out quite clearly … on moving boats … white lights hanging from the masts stand out against the deep blue of the night" (Lefebvre 2014, pp. 73–74).

Regulations adopted jointly by Great Britain and France provided detailed instructions regarding the use of white lights on the masts. Regarding the colored lights, the regulations required that vessels: "… when under way shall carry … *On the starboard side*, a green light … *On the port side*, a red light …" (Holt 1867, pp. 8–9; *Almanach du Commerce du Havre* 1872, p. 59).

The red and green lights in Monet's night scene indicate that the ships are under way and therefore provide additional evidence that this painting depicts a scene of activity in the harbor during the stand of high water.

Moonlit Clouds

Port of Le Havre, Night Effect provides another clue useful for astronomical dating. Moonlight illuminates clouds in the night sky, an effect that is especially prominent in the upper left corner of the canvas. Computer algorithms allow us to calculate lunar phases for dates in the nineteenth century. The phases of the Moon were also printed in the *Almanach du Commerce du Havre*.

Table 4.4 High water at night

Date in 1872	Lunar phase	Time of high water stand
November 12	Moon 93% lit	6:15 p.m. to 9:45 p.m.
November 13	Moon 98% lit	7:00 p.m. to 10:30 p.m.
November 14	Moon 100% lit	7:30 p.m. to 11:00 p.m.
November 15	Moon 99% lit	8:00 p.m. to 11:30 p.m.
November 16	Moon 97% lit	8:45 p.m. to midnight
November 17	Moon 92% lit	9:15 p.m. to 12:45 a.m. (Nov. 18)

For the year 1872 our previous analysis found that the most probable date and time for *Impression, Sunrise* is November 13th at 7:35 a.m. As part of the analysis for *Port of Le Havre, Night Effect* we realized that a full Moon fell on the night of November 14th to 15th. Table 4.4 lists dates and times with a bright full or nearly full Moon in the eastern or southeastern sky during the time of the evening high water stand.

During each of these time periods, high water would allow the movement of ships in the avant-port of Le Havre, and, depending on the weather conditions, a bright Moon in the eastern or southeastern sky could illuminate clouds above the harbor.

New Moon in Late January 1873

For the year 1873 our previous analysis found that the most probable date and time for *Impression, Sunrise* is January 25th at 8:05 a.m. This date fell only a few days before the new Moon of January 28th. During this period, the Moon was first a thin waning crescent visible only near the eastern horizon before sunrise, then a new Moon, and thereafter a thin waxing crescent visible only near the western horizon after sunset. Such lunar phases would not be bright enough to light up the clouds as seen in Monet's night effect painting. Moreover, thin crescent Moons can never stand high in the sky at night. Astronomical considerations of moonlight therefore rule out late January 1873 as a possibility for *Port of Le Havre, Night Effect*.

View to the West at Night?

As detailed earlier in this chapter, some scholars insisted that *Impression, Sunrise* (W263) was an erroneous title because the canvas, according to these authorities, actually depicted a setting Sun over the west end of Le Havre harbor. The analysis of our Texas State group agreed instead with Wildenstein's conclusion that W263 does show a rising Sun to the southeast of the Grand Quai.

A similar question could be raised regarding whether the night scene (W264) looks towards the southwest or toward the southeast. Vintage maps (Fig. 4.4) and photographs of old Le Havre allow us to answer this question and establish that Monet's view for the night scene did not look toward the southwest from his hotel window or balcony.

If Monet had been looking toward the southwest, then a tiered structure known as the Semaphore would have been visible on the north jetty (Fig. 4.10). From a viewpoint on the Grand Quai, the Semaphore building would have blocked the vertical outline of the light-house near the end of the north jetty.

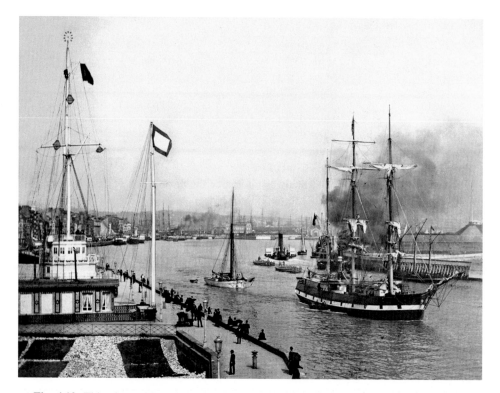

Fig. 4.10 This nineteenth-century photograph shows a great ship departing the port of Le Havre, as tide signals and other navigational information are displayed by a system of flags and balls on the mast above the tiered Semaphore building and also on a nearby mast. At night, the signals were given by white, green, and red lights. The photographer's location for this daytime image was near the top of the lighthouse (*Feu de port*) at the end Le Havre's north jetty. Buildings along the Grand Quai are visible on the left side of the photograph

During the daytime, a system of flags and balls on a mast above the Semaphore building indicated the state of the tide, and a similar system on another nearby mast gave information regarding movements into and out of the port. At night, the signals were given by white, green, and red lights. The 1872 *Almanach du Commerce du Havre* explained the daytime patterns of flags and balls and then added:

TIDE SIGNALS
During the night, the same signals will be made with lights, and the mast will be indicated by a white light placed at the intersection of the mast with the yard. A green light will replace the ball. (Almanach du Commerce du Havre 1872, p. 33)

The *Almanach* described the daytime signals for port movements and went on to note:

TABLE OF SIGNALS
During the night, the white flag with a blue border is replaced by a white light; the green flag by a green light, and the balls by red lights. (Almanach du Commerce du Havre 1872, p. 48)

The fact that neither the Semaphore building nor any of these colored signal lights can be seen in Monet's night painting helps to confirm that the direction of view is not toward the southwest. The night scene (W264) appears to look generally toward the southeast, similar to the sunrise paintings (W262 and W263).

Meteorological Observations in 1872

Returning our attention to the dating of Monet's *Port of Le Havre, Night Effect* (W264), we found additional evidence in nineteenth-century meteorological reports.

As we did for the sunrise painting, we consulted the daily weather column in *The Times* of London for 1872, with observations recorded at 8 a.m. from locations on both sides of the Channel. The *Bulletin International de l'Observatoire de Paris* also collected daily observations at 8 a.m. from stations throughout France, including Le Havre. The *Bulletin* recorded the direction and strength of the wind each day at 6 p.m. Night weather conditions could be deduced from reports in *The Times* regarding the London, Chatham, and Dover Railway Company packet boats carrying the night mails across the Channel.

The analysis thus far, based on moonlight and tides, found that the best matches to Monet's night scene occurred during the range of dates November 12–17, 1872. Meteorological observations allow us to reject many of these proposed dates because of the bad weather that prevailed generally on the Normandy coast. Throughout much of the interval Le Havre experienced heavy rain with periods of very strong winds and heavy seas. The weather columnist for *The Times* mentioned the "very heavy sea" on the French coast accompanied "at intervals by violent showers of hail and rain, at which times the wind rose almost to a hurricane." However, the strong winds and boisterous weather moderated on two mornings (November 13th and 15th) and one night (November 14th to 15th) during this range of dates.

The rough weather caused significant delays to the Channel mail steamers for three straight nights (November 11th to 12th, 12th to 13th, and 13th to 14th). The vessels from the continent arrived so late at Dover that the railway company had to add special trains to carry the mail up to London.

On the morning of November 14th, a low pressure system prevailed at the north end of the Channel, and Le Havre was experiencing bad weather with rain, heavy seas, and very strong winds from the northwest. We can be certain that this low pressure system then moved from north to south and passed over Le Havre before 6 p.m. on November 14th, because the Le Havre weather observer at 6 p.m. noted a shift in wind direction with a rather strong wind then coming from the east. The low pressure system continued to the south toward the Bay of Biscay.

The improved weather conditions allowed the mail steamers to run on schedule during the night of November 14th to 15th, with the Dover report stating that:

The boisterous weather that has prevailed on the French coast during the past week has now so moderated that the Belgian and French mail steamers arrived at Dover in time for the despatch of the mails for London, per South-Eastern Railway, by their usual trains leaving here at 1 40 a.m. and 4 15 a.m. (The Times [London], "The Weather," November 16, 1872)

Table 4.5 Dates and times for Monet's paintings of the Le Havre harbor

	Date	Local mean time
Impression, Sunrise (W263)	Morning of November 13, 1872	7:35 a.m.
Port of Le Havre, Night Effect (W264)	Evening of November 14, 1872	7:30 p.m. to 11:00 p.m.

The analysis is based on astronomical calculations of the positions of Sun and Moon, hydrographic calculations of the tide levels, meteorological observations of the sea and sky, the direction of the wind, and the assumption that these paintings were inspired in the same year

By the evening of November 15th strong winds and rain resumed with storm warnings issued for the Channel. The evening of November 14, 1872, is therefore the best candidate for the night effect painting, with the bright moonlight, the tide level, and the weather matching the scene depicted by Monet.

Conclusions: Le Havre at Sunrise and at Night

The components of our method—topographical analysis of the Le Havre harbor, astronomical calculations of the positions of Sun and Moon, hydrographic calculations of the tide levels, and meteorological observations regarding the state of the sky and sea and the direction of the wind—allow us to draw an interesting conclusion. If Monet created *Impression, Sunrise* (W263) and *Port of Le Havre, Night Effect* (W264) as accurate depictions of what he saw from his hotel window, and if these two works date from the same painting campaign in Le Havre, then the pattern of lunar phases definitely rules out the year 1873. Table 4.5 lists the most probable dates in 1872 consistent with all the factors.

Another Night Harbor Painting by Monet

The Monet painting entitled *Marine, Night Effect* (W71) (Fig. 4.11), dated to the mid-1860s and now in the collection of the National Galleries of Scotland at Edinburgh, has a number of similarities to the Le Havre night scene. The Edinburgh canvas includes a sailboat, a steamship, and a great sailing ship near a harbor entrance under a night sky with dramatic clouds outlined by bright moonlight. On the right side of W71 is a jetty with a white light shining at the top of a lighthouse and reflecting in the waves. According to Wildenstein's catalog, the canvas depicts the entrance to the harbor of Honfleur. (Wildenstein 1974, p. 152) The Edinburgh museum, in the text of the sign posted on the wall next to the painting, likewise describes the painting as a "moonlit view of the harbor at Honfleur."

However, an 1855 list of lights on the coast of France described this Honfleur lighthouse as having a "fixed red light" (Ministère des travaux publics 1855, p. 26). The same description of a fixed red light on this Honfleur jetty appeared in similar volumes for 1866, 1870, and 1872 (Coulier 1866, pp. 114–115; *Description des phares* 1870, p. 119; Joanne 1872, p. 312). These same sources all listed the lighthouse on Le Havre's north jetty as having a fixed white light.

If the white light painted by Monet accurately represents the color of the light that he saw on the jetty, then we can conclude that the Edinburgh canvas (W71) does not depict the harbor of Honfleur but instead belongs to one of Monet's Le Havre campaigns.

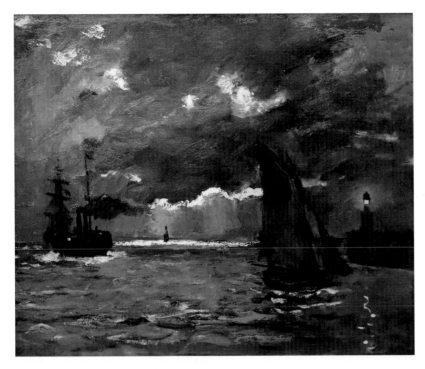

Fig. 4.11 Claude Monet, *Marine, Night Effect* (W71). According to both the Edinburgh museum and Daniel Wildenstein's catalog, this canvas dates from the decade of the 1860s and depicts the entrance to the harbor of Honfleur. However, navigation guides in the 1850s, 1860s, and 1870s consistently described the Honfleur lighthouse as displaying a fixed red light. The white light visible here shining at the top of the lighthouse and reflecting in the waves suggests that this painting instead belongs to one of Monet's Le Havre campaigns

References

Almanach du Commerce du Havre, 1872. Le Havre: Alph. Lemale.

Bulletin International de l'Observatoire de Paris, 1872 and 1873.

Baedeker, Karl (1881) *Paris and Environs.* London: Dulau and Co.

Bradshaw, George, and Company (1887) *Bradshaw's Continental Railway, Steam Transit, and General Guide, No. 482, July 1887.* London: W. J. Adams and Sons.

Copplestone, Trewin (1998) *Claude Monet.* New York: Gramercy.

Coulier, Philippe Jean (1866) *Description des phares existent sur le littoral maritime du globe.* Paris: Robiquet.

Denvir, Bernard (1993) *The Chronicle of Impressionism: A Timeline History of Impressionist Art.* Boston: Bulfinch Press.

Description des phares existant sur le littoral maritime du globe. A l'usage des navigateurs. Mai 1870. (1870) Paris: Robiquet.

Gaunt, William (1970) *The Impressionists.* London: Thames and Hudson Ltd.

Getty Museum, press release, Getty Museum Acquires Early Impressionist Painting by Claude Monet, November 12, 1998. http://www.getty.edu/art/gettyguide/artObjectDetail s?artobj=133580

Gordon, Robert and Andrew Forge (1983) *Monet*. New York: Abrams.

Guillemot, Maurice (1898) Claude Monet. *Revue Illustrée*, 13th year (No. 7), March 15, 1898, n. p.

Holt, William (1867) *Admiralty court cases on the rule of the road, as laid down by the articles and regulations now in force under order in council for preventing collisions at sea*. London: W. Maxwell & Son.

House, John (1978) The new Monet Catalogue (Daniel Wildenstein). *Burlington Magazine*, **120** (No. 907), October, 678-681.

Isaacson, Joel (1978) *Observation and Reflection: Claude Monet*. E. P. Dutton: New York.

Joanne, Adolphe (1872) *Itinéraire Général de la France: Normandie*. Paris: Librairie Hachette.

Konody, Paul G. (1959) Impressionism entry in *Encyclopaedia Britannica*. William Benton: Chicago and London, Volume 12 (H-J).

Lefebvre, Géraldine (2014) *Impression, Sunrise* in the Port of Le Havre, in the exhibition catalogue *Monet's Impression Sunrise, The Biography of a Painting*, Marianne Mathieu and Dominique Lobstein, eds. Paris: Musée Marmottan Monet.

L'Univers Illustré (1872) Bulletin. 15e année (No. 880), 3 Février 1872, 67.

Lynch, David K. and William C. Livingston (2001) *Color and Light in Nature, 2nd edition*. New York: Cambridge University Press, and references therein.

Ministère des travaux publics (1855) *Description sommaire des phares et fanaux allumÉs sur les côtes de France au 15 août 1855*. Paris: Imprimerie Impériale.

Mount, Charles Merrill (1966) *Monet, a Biography*. New York: Simon and Schuster.

Olson, Donald W. (2014a) *Celestial Sleuth: Using Astronomy to Solve Mysteries in Art, History and Literature*. Springer Praxis: New York.

Olson, Donald W. (2014b) Dating Monet's *Impression, Sunrise*, in the exhibition catalogue *Impression, Sunrise: The Biography of a Painting*. Marianne Mathieu and Dominique Lobstein, eds. Paris: Musée Marmottan Monet.

Olson, Donald W., and Edwin L. Piner (2016) Datation du Port du Havre, Effet de Nuit, in *Monet au Havre*, Géraldine Lefebvre, ed. Paris: Hachette.

Quinette de Rochemont, Émile ThÉodore (1875) *Notice sur le port du Havre*. Paris: Imprimerie Nationale.

Rewald, John (1973) *The History of Impressionism*, 4th edition. New York: Museum of Modern Art.

Seitz, William Chapin (1960) *Claude Monet*. New York: Harry N. Abrams.

Seitz, William Chapin (1956) Monet and Abstract Painting. *Art Journal* **16** (No. 1), 34-46.

Southgate, M. Therese (2004) The Cover. *Journal of the American Medical Association* **291** (No. 21), June 2, 2004, 2523.

Taylor, John Russell (1981) *Impressionism*. London: Octopus Books Ltd.

The Times of London (1872) columns titled "The Weather" and "The Weather and the Gale," January 22-26, 1872, and November 12-17, 1872.

Tucker, Paul (1984) The First Impressionist Exhibition and Monet's *Impression, Sunrise*: A Tale of Timing, Commerce and Patriotism. *Art History* **7** (No. 4), December, 465-476.

Venturi, Lionello (1939) Mémoires de Paul Durand-Ruel in *Les Archives de l'Impressionnisme*, Paris and New York: Durand-Ruel, Tome II.

Wildenstein, Daniel (1967) *Monet, Impressions*. Lausanne: International Art Book.

Wildenstein, Daniel (1974) *Claude Monet. Biographie et catalogue raisonné, Tome I, 1840-1881, Peintures*. Lausanne and Paris: Bibliothèque des Arts.

Wildenstein, Daniel (1979) *Claude Monet. Biographie et catalogue raisonné, Tome II, 1882-1886, Peintures*. Lausanne and Paris: Bibliothèque des Arts.

Wildenstein, Daniel (1996) *Monet, Catalogue RaisonnÉ*. Köln: Taschen.

5

VJ Day Times Square Kiss and Ansel Adams in Alaska

Alfred Eisenstaedt created one of the iconic images of the twentieth century when he captured a sequence of four photographs showing a sailor kissing a woman in white on VJ Day, August 14, 1945, in Times Square, New York City. The second photograph from this series appeared in *Life* magazine two weeks later and has been reprinted countless times over the last seven decades.

How can astronomical and topographical analysis determine new information about these famous images? The questions of identifying the sailor and the woman in white have long been controversial, in part because their faces are largely hidden. Dozens of men have claimed to be the sailor, and at least half a dozen candidates exist for the woman in the white dress. Astronomy can be used to solve a related mystery—at what time were the VJ Day Kiss photographs taken? Analysis of the directions of sunlight and shadows can determine the precise hour and minute for the Kiss photographs and can help to evaluate which of the various claimants' accounts are more credible or less credible, and even which candidates might be ruled out.

A contact sheet made from Eisenstaedt's roll of film includes 23 photographs taken just before the famous Kiss sequence. Can astronomy of sunlight and shadows determine precise clock times for some of these? Are these results consistent with the time calculated for the Kiss photographs? Can we use the clock times and the landmarks in his images to track Eisenstaedt's movements in Times Square? And how can Pennsylvania Railroad timetables from the summer of 1945 play an important role in the analysis?

Ansel Adams kept meticulous records of camera and darkroom data, including the type of film, lens, filter, aperture, shutter speed, developer, paper, etc. But Adams never recorded the dates for any photographs, even his most famous works. As explained in the author's previous *Celestial Sleuth* book, astronomical analysis of three Ansel Adams moonrise photographs determined for each of them the precise time, accurate to the minute, when Adams tripped the shutter. Could we apply similar astronomical and topographical analysis to his famous *Denali and Wonder Lake* (formerly known as *Mount McKinley and Wonder Lake*)? Could we determine the precise location, in the enormous expanse of Alaska's Denali National Park, where Adams set up his tripod for this view? The image includes no celestial objects in the sky, which is just a featureless expanse. Astronomical calculations might

© Springer International Publishing AG 2018
D.W. Olson, *Further Adventures of the Celestial Sleuth*, Springer Praxis Books,
https://doi.org/10.1007/978-3-319-70320-6_5

therefore seem irrelevant. How could we use shadows and other clues to deduce the precise position of the Sun in the sky and thereby determine a date and precise time for *Denali and Wonder Lake*? What important clues could be found in other photographs taken by Adams on this trip to Wonder Lake? How could we use the archive of modern webcam images from Denali National Park to confirm our calculations of date and time?

The VJ Day Times Square Kiss

VJ Day, on August 14, 1945, marked the end of World War II. In the midst of the celebration in Times Square in New York City, Alfred Eisenstaedt created one of the iconic images of the twentieth century when he captured a sequence of four photographs showing a sailor kissing a woman in white (Fig. 5.1) (*Life* 1945, p. 27; Eisenstaedt 1969, p. 56; Eisenstaedt 1985, p. 74). The U. S. Navy photographer Victor Jorgensen, standing only a few feet away, took a similar photograph (Fig. 5.2) of the same kissing pair simultaneous with

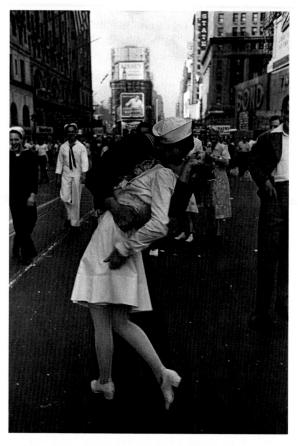

Fig. 5.1 This iconic image first appeared on page 27 of the August 27, 1945, issue of *Life* magazine. The shadow on the façade of the Loew's Building, at the upper right above the Bond Clothes clock, allowed us to determine the precise time when Alfred Eisenstaedt took this photograph (Photograph by Alfred Eisenstaedt/LIFE © Time Inc. Used with permission)

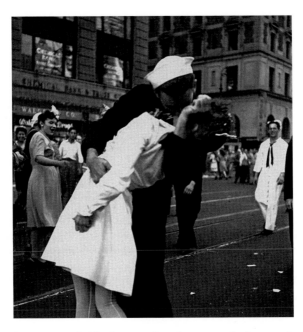

Fig. 5.2 Victor Jorgensen took this photograph at almost exactly the same instant as the second of Eisenstaedt's four images and from a position only a few feet to Eisenstaedt's right. Some recent theories suggest that the Kiss photographs were taken near 2 p.m., but this cannot be correct because Jorgensen reached Manhattan on a train that did not arrive at Penn Station until 3:00 p.m. Gloria Bullard has identified herself as the nurse in the background, under the "W" of "Walgreen Drugs" at the extreme left of Jorgensen's photograph (Photograph courtesy of the U. S. Navy, National Archives. Used with permission)

Eisenstaedt's second image. Our Texas State University group used astronomy to determine new information about these famous photographs.

The questions of identity—who is the sailor and who is the woman in white—have been a source of much controversy, in part because their faces are largely hidden. Glenn McDuffie, George Mendonsa, and Carl Muscarello are among the dozens of men who have claimed to be the sailor. Candidates for the woman in white include Edith Shain, Barbara Sokol, Greta Friedman (known as Greta Zimmer in 1945), and several others.

Astronomy is especially useful to solve a related mystery: at what time were the Kiss photographs taken? Analysis of sunlight and shadows can determine the precise hour and minute for the Kiss photographs and can help to evaluate which of the various claimants' accounts are more credible or less credible, and even which candidates might be ruled out.

Kiss After 7:03 p.m.?

After a series of rumors and false alarms throughout the day, radio networks nationwide carried a brief statement from the White House at 7:00 p.m., and by 7:03 p.m. the moving electric sign on the Times Building displayed the long-awaited words: "OFFICIAL *** TRUMAN ANNOUNCES JAPANESE SURRENDER ***." The authors of the *Wikipedia* page assumed that the Kiss followed shortly thereafter:

Eisenstaedt was photographing a spontaneous event that occurred in Times Square as the announcement of the end of the war on Japan was made by U. S. President Harry S. Truman at seven o'clock. (*Wikipedia* page for "V-J Day in Times Square," wikipedia.org/wiki/V-J_Day_in_Times_Square, accessed February 20, 2015.)

A front-page *New York Times* story published on the VJ Day anniversary in 2010 expressed the same opinion: "For decades, the world has believed that the photographs were taken after—perhaps just seconds after—President Truman's announcement at 7:03 p.m." (*The New York Times*, August 14, 2010, p. A1).

Kiss Near 6 p.m.?

However, that same *New York Times* story went on to propose a scenario with an earlier time of day. The reporter interviewed Gloria Bullard, who identified herself as a figure in the background of the Jorgensen photograph (see Fig. 5.2). She gave an account of witnessing the famous Kiss and contradicted the conventional wisdom by implying that the event occurred *not* after 7:03 p.m. but instead "earlier—before the war was officially over" (*The New York Times* 2010, p. A1).

After leaving Times Square on VJ Day, Gloria spent a few minutes walking over to 8th Avenue. She estimated that it then took two more hours of travel time to reach her home town of New Canaan, Connecticut, via a series of bus and train connections. Gloria noticed that dusk was settling on the town and the streetlights were just coming on as she walked down the final blocks near her home (*The New York Times* 2010, p. A17).

For New Canaan, we calculate that sunset fell at 7:54 p.m. and the end of civil twilight followed at 8:24 p.m., expressed in Eastern War Time, equivalent to modern daylight saving time. We can be certain that this is the correct time system, because the front page of *The New York Times* on August 14, 1945, listed the Manhattan sunset time as 7:56 p.m.

We consulted summer 1945 timetables for the New York, New Haven, and Hartford Railroad and found that only a relatively small number of trains ran on the New Canaan branch. The train best matching Gloria's description reached her home town station at 8:12 p.m. Bright twilight prevailed then, with the Sun only 4° below the horizon, and the twilight would have been deepening as she walked home. Subtracting somewhat more than two hours from Gloria's arrival time in New Canaan suggests that the Kiss in Times Square would have occurred at about 6 p.m.

Kiss Near 2 p.m.?

Lawrence Verria and George Galdorisi proposed in their recent book, *The Kissing Sailor*, that the Kiss photographs were taken much earlier in the day, around 2 p.m. The authors also offer detailed arguments supporting George Mendonsa and Greta Zimmer as the kissing pair (Verria and Galdorisi 2012).

According to the book, George Mendonsa attended the 1:05 p.m. showing of a movie at Radio City Music Hall. But after only a few scenes had played, theater employees

interrupted the show with the dramatic announcement of the war's impending end. Mendonsa left the theater and made a brief stop for some drinks. The authors deduced that he reached Times Square and kissed a woman in white about 2 p.m.

Greta Zimmer in 1945 worked as a dental assistant in a white uniform strongly resembling a nurse's uniform. According to her account of VJ Day, the dentists returned from their lunch hour at about 1 p.m. She then took a late lunch hour and began walking from the dental office on Lexington Avenue over to Times Square, to see if she could confirm the rumors that she had heard from the morning's patients. She was reading the messages on the animated electric signs when she was suddenly kissed by a sailor. Greta returned to the dental office and reported the news from Times Square. The doctors then instructed her to cancel the rest of the afternoon's appointments and to close the office (Verria and Galdorisi 2012, p. xi, 55, 73; Fletcher 2009, p. 48; Friedman 2005, p. 1). The details are entirely inconsistent with both the 6 p.m. and 7:03 p.m. times theorized for the Kiss.

The accounts of George Mendonsa and Greta Zimmer appear to mesh consistently only with a time for the Kiss near 2 p.m.

The Kissing Sailor book received much favorable media attention, which regarded the book's scenario as a definitive answer. David Hartman, longtime host of ABC's *Good Morning America*, wrote the foreword and judged that the book's authors had "finally revealed, with certainty, what millions have wanted to know for decades." Photographer David Hume Kennerly wrote a jacket endorsement and called the book a "whodunit that provides once and for all the identification of the world's best-known smoochers." NBC journalist Tom Brokaw also wrote jacket copy for what he described as a "wonderful detective story." *Publishers Weekly* judged that the "authors deliver a convincing conclusion."

So, which is it? Did Eisenstaedt take his Kiss photographs near 2 p.m., near 6 p.m., shortly after 7:03 p.m., or at some other time?

The Bond Clock

The New York Times online version of the story about Gloria Bullard prompted 144 comments, with much debate about the time of day depicted in the Kiss photographs. The astronomer Steven D. Kawaler was apparently the first to notice that the Eisenstaedt photographs included a large display clock on the Broadway façade of the Bond Clothes store! Kawaler's online comment suggested that the time displayed might be either 5:50 p.m. or 6:50 p.m., with the uncertainty related to the oblique angle of view from Eisenstaedt's location.

A later commentator was more certain that the clock showed 5:50 p.m., while an even later contributor opted for 4:50 p.m. on the clock face. The Bond clock had a prominent minute hand but an unusually short hour hand, adding to the difficulty of reading the time (Fig. 5.3).

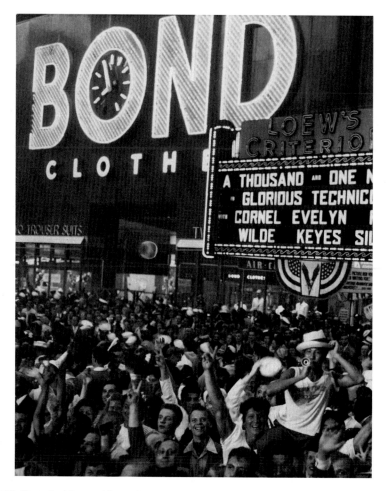

Fig. 5.3 By coincidence, this amateur VJ Day photograph of the Bond Clothes clock shows the exact time of Manhattan sunset: 7:56 p.m. Unlike the prominent minute hand, the short hour hand of the Bond clock is hard to make out in the oblique views of Eisenstaedt's Kiss series (Collection of the author)

Half a dozen online comments to this same article made the intriguing point that a prominent shadow appears on the façade of a building in the background, just above the Bond clock in the Eisenstaedt photographs. Analysis of the Sun's position could determine the time.

Our purpose in this chapter is to show how analysis of sunlight and shadows does allow us to obtain a precise result for the time when Eisenstaedt tripped the shutter for the famous VJ Day Kiss photograph.

Buildings as Sundials

The basic astronomical idea is that every tall building in Manhattan acts like a gnomon, which is the part of a sundial that casts a shadow. As the Sun moves across the sky during the course of the day, the shadow of a tall building will likewise move relative to the nearby buildings.

Our Texas State group has past experience using astronomy of sunlight and shadows to determine dates and times. For Ansel Adams's *Moon and Half Dome*, the shadow of a ledge projected across the base of Half Dome served as the last piece of evidence to determine the precise date and time of this iconic Yosemite photograph. Mountain shadows played a similar role in our dating of Ansel Adams's *Autumn Moon* (Olson 2014, p. 113–136).

We began the VJ Day Kiss analysis by studying hundreds of photographs dating from the 1940s to become familiar with the buildings in and near Times Square. We also collected vintage maps from the Sanborn Map Company, maps from the G. W. Bromley & Co. Manhattan Land Book series, and photographs taken by the Hamilton Aerial Map Service.

From this topographic evidence we could see that the prominent shadow, just above the Bond clock in Eisenstaedt's photographs, fell on the 45th Street façade of the Loew's Building, home to the theater known as Loew's State. From the known dimensions of the 16-story Loew's Building, we determined that the top of the shadow reached up to the windows on the 8th floor, at 94 ft above street level.

To do the astronomical analysis, we needed to identify the building that was casting the shadow onto the Loew's Building.

Hotel Astor Water Tank?

We first looked at the Hotel Astor, a plausible candidate because this hotel is located immediately to the west of the Loew's Building. Because the shadow on the Loew's Building has a flat top only about 16 ft wide, our thought was to search old photographs and blueprints to find a flat-topped water tower on the Astor roof. This theory immediately foundered because we learned that the summit of the Astor Hotel held no standard water tanks at all! Instead, the top was known as the Astor Roof Garden, an elegant site for music, dining, and dancing.

Paramount Building Clock Tower?

Our next guess for the object casting the shadow was the clock tower above the top floor of the 33-story Paramount Building. This clock tower had a round globe at the summit, not a flat top, but the extreme height of the Paramount Building made it a logical candidate to cast shadows across Times Square.

Astronomers specify compass directions numerically with a coordinate called azimuth, with north defined as 0°, east as 90°, south as 180°, and west as 270°. From the vintage maps and plans we calculated that an imaginary observer in the 8th floor window of the Loew's Building would have seen the top of the Paramount clock tower at an azimuth of 230° (that is, 40° south of west) and an altitude of 39° above the horizon. On August 14th

the altitude of the Sun, when in the azimuth of the Paramount Building, exceeded 54°. The clock tower could therefore be conclusively ruled out as a candidate to cast the shadow in the Kiss photographs.

Hotel Lincoln? Times Building? Schlitz Sign?

Similar calculations eliminated three other candidates. The Hotel Lincoln on 8th Avenue and the Times Building were too far away to cast the observed shadow. A Schlitz beer sign on the roof of the Bond Clothes building was closer to the Loew's Building but too short to cast the shadow observed in the Kiss photographs. But something must have cast its dark shadow onto the Loew's Building!

Astor Roof Sign: 5:51 p.m.

A breakthrough came while looking again at vintage photographs of the Hotel Astor. We realized that the hotel had a sign in the shape of an inverted "L" projecting above the roof (Fig. 5.4). Blueprints preserved at Columbia University show that the vertical arm of the sign was 40 ft high, while the horizontal top was 18 ft wide and stood 150 ft above street level.

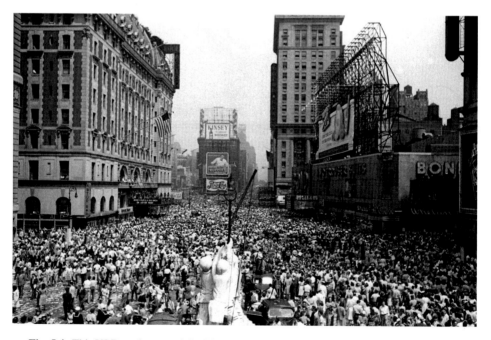

Fig. 5.4 This VJ Day photograph by Eisenstaedt shows the Hotel Astor on the left, with the Astor Roof sign in the shape of an inverted "L." The right side includes the 16-story Loew's Building in the background. The shadow cutting diagonally across Times Square from right to left corresponds to the Sun's position at 12:30 p.m. (Photograph by Alfred Eisenstaedt/ LIFE © Time Inc. Used with permission)

Measurements on our collection of vintage photographs and maps established that the top of the sign and the top of the shadow on the Loew's Building had a horizontal separation of 134 ft and a difference of 56 ft in height above street level. A line from the 8th floor window in the Loew's Building to the top of the Astor roof sign would point toward an azimuth of 270° (exactly due west) and an altitude of +22.7° above the horizon. As seen from the Loew's Building 8th floor, the upper edge of the solar disk would have been disappearing behind the Astor roof sign at 5:51 p.m. Eastern War Time.

Because the solar disk has a finite size, with a diameter of about ½°, the 18-foot-wide top of the Astor roof sign would project to a dark shadow with a width of about 16 ft on the façade of the Loew's Building, in perfect agreement with the shadow observed in Eisenstaedt's photographs.

Our topographical analysis ruled out every other tall structure in or near Times Square. Only the Astor roof sign could cast the observed shadow, and it did so at exactly 5:51 p.m.

Confirmation: Model of Times Square

Because the topographical calculations and projective geometry are complicated, we checked our mathematical results by building a scale model of the buildings in Times Square, with a small L-shaped sign near the appropriate corner of the "Hotel Astor" model. A rotating 3-foot-by-4-foot flat mirror allowed us to project the Sun's rays onto the model from any desired angle. The location, size, and shape of the shadow on our model "Loew's Building" exactly matched the properties of the shadow in Eisenstaedt's Kiss photographs.

Confirmation: Pennsylvania Railroad

Victor Jorgensen took his Kiss photograph at the same time as Eisenstaedt's second image. Two days later, Jorgensen's wife wrote a letter describing how on VJ Day they had traveled up to Manhattan on a train departing from Washington, D.C., at 11:00 a.m. We located railroad timetables from the summer of 1945 and identified this as the Pennsylvania Railroad train called "The Judiciary," which arrived at Penn Station at exactly 3:00 p.m. Allowing some time for checking into a hotel, where they dropped off some photographic gear, and then proceeding to Times Square, Jorgensen cannot have reached Times Square until at least 3:30 p.m. and perhaps even after 4:00 p.m. Victor Jorgensen, along with his friend and fellow photographer Horace Bristol, remained in Times Square and took photographs until it got dark (Conner and Heimerdinger 1996, p. 70–75).

Jorgensen's train trip and the timing of his arrival in Times Square provide strong additional evidence to rule out the proposed 2 p.m. time for the Kiss photographs but are consistent with our calculated time of 5:51 p.m.

Confirmation: Peace at Last

Another Eisenstaedt VJ Day photograph, known as *Peace at Last*, shows a couple looking up at the Times electric sign (Fig. 5.5). In the background the Times Building's shadow projects onto the last word in the sign "PUBLIC TELEPHONE CENTER for the ARMED FORCES." Vintage photographs and maps show that this shadow corresponds to a solar azimuth of 261° (that is, the Sun was 9° south of due west) and a time of 5:00 p.m.

Fig. 5.5 This Eisenstaedt VJ Day photograph, known as *Peace at Last*, shows a couple look-ing up at the moving electric sign on the Times Building. The shadow of the Times Building projects onto the 43rd Street façade of the Public Telephone Center for the Armed Forces in the background and allowed us to determine that this image was captured at 5:00 p.m. A roll of Kodak Plus-X film includes *Peace at Last*, followed by a dozen other scenes, and then the famous Kiss series. The sequence of negative numbers proves that the Kiss photographs must have been taken after 5:00 p.m. (Photograph by Alfred Eisenstaedt/LIFE © Time Inc. Used with permission)

A contact sheet for a roll of Kodak Plus-X film in the *Life* archives includes two versions of *Peace at Last* (negatives #10 and #11 at 5:00 p.m.), followed by a dozen photographs (#12–23) showing revelers on the west side of the Times Building and near the New York movie theater, and then the famous Kiss series (#24–27). This time sequence is consistent with our result that Eisenstaedt took the Kiss photographs at 5:51 p.m.

On another roll of film Eisenstaedt's last VJ Day photographs look down from elevated positions onto the massive crowd in Times Square after the 7:03 p.m. official announce-ment of war's end. Several of these images include the large Toffenetti Restaurant clock showing times between 7:40 p.m. and 7:47 p.m. Eisenstaedt later recalled that he turned in his film to the *Life* office at about 8 p.m. (Loengard 1998, p. 24).

Anniversaries of VJ Day

Modern readers can find the precise location of the original Kiss in Times Square by going to the west side of the pedestrian island, opposite the Bubba Gump Shrimp Co. sign now on the ground floor of the Paramount Building. The Times Building still remains, though now covered by large electronic signs. The Hotel Astor, Loew's Building, and most of the other 1945 buildings were demolished long ago, and taller modern skyscrapers now block the August 14th late afternoon shadows.

The organization known as the Times Square Alliance has sponsored "Times Square Kiss-In" events every five years on the anniversary of the end of World War II (Fig. 5.6), and a special commemoration is likely on August 14, 2020, the 75th anniversary of the Kiss.

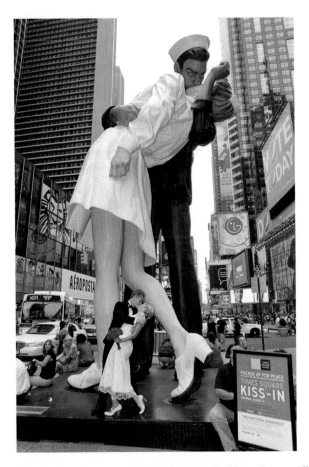

Fig. 5.6 To mark the 65th anniversary of VJ day in 2010, the Times Square Alliance brought this enormous statue of the Kiss to Times Square and invited couples to replicate the pose. A special event is expected on August 14, 2020, at the 75th anniversary (Photograph by Asterio Tecson. Used with permission)

Who is the Sailor? Who is the Woman in White?

The astronomical analysis of the shadows in Times Square proves that Eisenstaedt and Jorgensen captured their Kiss photographs at 5:51 p.m.

The widely accepted scenario placing the Kiss photographs near 2 p.m. and identifying Greta Zimmer Friedman as the woman in white and George Mendonsa as the sailor therefore should be reconsidered. Greta's accounts referred to her kiss occurring during a late lunch hour beginning at about 1:00 p.m. and mentioned that she returned to the office and canceled afternoon dentist appointments. These details are entirely inconsistent with the 5:51 p.m. time.

According to the time scheme proposed in *The Kissing Sailor*, George Mendonsa watched the opening scenes of the 1:05 p.m. movie at Radio City Music Hall before proceeding to Times Square to participate in a kiss near 2 p.m. Newspaper ads for Radio City listed afternoon showings of that feature film, "A Bell for Adano," at 1:05 p.m. and 4:07 p.m. If George Mendonsa is indeed the sailor in the famous photographs, he could have attended the later showing.

However, we should remember that the identities of the sailor and the woman in white became a public controversy only after August 1980, when *Life* magazine published an article about the identity of the nurse and asked: "Now, if the sailor can recognize himself, would he please step forward?" (Life 1980a, p. 4). This 1980 query from *Life* eventually brought forth dozens of candidates for the sailor and several more for the woman in white (*Life* 1980b, 1980c, 1980d). It is possible that most of these claimants were present in Times Square on VJ Day and that each of them kissed someone. Which are in Eisenstaedt's photographs? Maybe none of them. The actual subjects may not have seen the August 1980 issue of *Life* or, indeed, even been alive in 1980.

Some mysteries of identity are beyond the reach of astronomical calculations, but the August 14th late-afternoon shadows provide the key to unlocking at least some of the secrets of the iconic VJ Day images.

Ansel Adams in Alaska

The American landscape photographer Ansel Adams (1902–1984), best known for his images of Yosemite, created one of his most memorable compositions during a trip to Alaska. Adams originally used *Mount McKinley and Wonder Lake* as the title, but with the renaming of the national park and the mountain, the photograph is now known as *Denali and Wonder Lake* (Fig. 5.7).

Historian and conservationist Douglas Brinkley judged this dramatic view to be "a true modern masterpiece … one of the greatest modern landscape photographs" (Brinkley 2011, p. 332–333).

Adams himself attached considerable importance to the image. Between 1948 and 1976 he produced seven portfolios, each a limited edition including from ten to sixteen signed photographic prints. Adams selected *Denali and Wonder Lake* as print number one in Portfolio One (Adams 1948, p. 3). Decades later, when the original sets had become

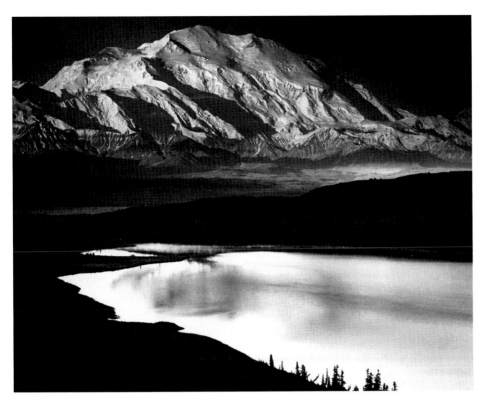

Fig. 5.7 *Denali and Wonder Lake, Denali National Park, Alaska*, 1948, photograph by Ansel Adams (Collection Center for Creative Photography, The University of Arizona, © 2018. The Ansel Adams Publishing Rights Trust. Used with permission)

expensive and difficult to obtain, the complete run of portfolios appeared in a book of laser-scanned reproductions, with the Wonder Lake image chosen for the front cover (Adams 1981).

Uncertain Chronology

A recent biography by Mary Street Alinder, an assistant to Adams for many years, observed that "Ansel was notoriously bad at dating his own negatives … although he kept immaculate records of each negative's f/stop, lens, and exposure" (Alinder 2014, p. 123). The text of an exhibition catalog agreed that "Dating Adams' work is notoriously difficult … The artist often claimed to remember nearly every detail that went into taking a specific photograph but rarely to be able to recall a date" (Adams, Haas, and Senf 2005, p. 147). The years given by Adams in his captions were often just approximate guesses.

Even for the date of his most famous composition, *Moonrise, Hernandez, New Mexico*, Adams (Fig. 5.8) was uncertain and gave the year as 1940, 1941, 1942, 1943, and 1944 in different publications. The presence of the Moon in the Hernandez image provided a key

Fig. 5.8 Ansel Adams (1902–1984) during a return visit in June 1980 to the scene of his most famous photograph. The graveyard on the left side of this image appears dramatically illuminated by a setting Sun in the iconic *Moonrise, Hernandez, New Mexico* (Photograph by David Roybal, courtesy Palace of the Governors Photo Archives, New Mexico History Museum, Department of Cultural Affairs, negative number HP.2014.14.1774. Used with permission)

to establishing the correct date. Dennis di Cicco of *Sky & Telescope* magazine used astronomical computing methods to prove that the Hernandez photograph must have been taken at 4:49 p.m. Mountain Standard Time on November 1, 1941 (di Cicco 1991a, p. 480; di Cicco 1991b, p. 533).

Inspired by di Cicco's analysis, our Texas State group dated Ansel Adams's *Autumn Moon* to 7:03 p.m. Pacific Daylight Time on September 15, 1948, and his *Moon and Half Dome* to 4:14 p.m. Pacific Standard Time on December 28, 1960 (Olson et al. 1994, p. 82–86; Olson et al. 2005, p. 40–45; Olson 2014, p. 113–136). We wondered if we could use similar astronomical methods to find a date and precise time for *Denali and Wonder Lake*. The existing literature regarding this image was typically contradictory, with about half of the sources asserting that the photograph was created in 1947 and the other half preferring the year of 1948.

Was It 1947?

In the early 1970s Ansel Adams sat for a series of oral history interviews archived at the library of the University of California. He recalled traveling to Alaska on two trips, which he dated to 1947 and 1948. The weather in Alaska often proved frustrating, but he marveled at his unusually good fortune during half a dozen fine days at Denali in 1947 (Adams et al. 1978, p. 280–281).

Adams in 1983 published *Examples: The Making of 40 Photographs*. The chapter devoted to *Denali and Wonder Lake* gave the month of creation as July 1947 (Adam 1983a, p. 75).

His *Autobiography* appeared in 1985 and described the making of *Denali and Wonder Lake* during a joint trip to Alaska with Ansel accompanied by his son Michael in 1947 (Adams 1985, p. 284). A 1985 collection titled *Ansel Adams: Classic Images* likewise dated the Wonder Lake scene to 1947 (Adams, Alinder, and Szarkowski 1985, catalog number 54).

A lavish large-format volume, *The American Wilderness*, appeared in 1990 with the caption for *Denali and Wonder Lake* listing the date as 1947 (Adams and Stillman 1990, catalog number 99).

An Adams biography written in 1998 by Jonathan Spaulding agreed that the photograph captured the "snow-covered peak" and the moment when "Wonder Lake shimmered with the iridescent reflection of the dawn" on a morning in 1947 (Spaulding 1998, p. 233–236, 428).

The PBS television series called *American Experience* in 2002 created an extensive website to accompany the program *Ansel Adams: A Documentary Film* by Ric Burns. The online image gallery assigned *Mount McKinley and Wonder Lake, Denali National Park* to 1947. A detailed timeline included the entry "1947 Adams goes to Alaska … While there, he makes photographs of Denali National Park" (PBS 2002). A compilation in 2007 contained 400 Ansel Adams photographs arranged chronologically, with the Wonder Lake scene and other Alaska images dated to 1947 (Adams and Stillman 2007, p. 233–235).

Andrea Gray Stillman in 2012 published a detailed study of twenty of Ansel Adams's most significant images. Stillman, an authority with much experience using the photographer's correspondence and other archival material to deduce dates for his images, surveyed all of the previous literature and judged that *Denali and Wonder Lake* could be dated to 1947 (Stillman 2012, p. 179–180).

Or Was It 1948?

Other sources support 1948 as the year of creation.

Near the end of 1948 Ansel Adams published his first portfolio collection of prints, with the accompanying text dating the *Denali and Wonder Lake* photograph to 1948. The proximity in time provides strong evidence that 1948 is the correct year (Adams 1948, p. 3). The 1983 edition of Ansel Adams's instructional book about print making used *Denali and Wonder Lake* as an example and listed the date as 1948 (Adams 1983b, p. 166).

In a 1988 collection of Ansel Adams's letters, the editorial notes assert that the photographer made only two trips to Alaska, in 1948 and 1949. Because *Denali and Wonder Lake* was included in Portfolio One before the end of 1948, the only possible year for this image would therefore be 1948, if this note is correct (Adams, Alinder, and Stillman 1988, p. 208).

A 1992 book compiled Adams's photographs of national parks throughout the United States, with the Wonder Lake scene dated to 1948 (Adams, Stillman, and Turnage 1992, p. 6). A catalog for an Ansel Adams exhibition on the 100th anniversary of his birth dated the creation of *Denali and Wonder Lake* to 1948 (Adams and Szarkowski 2001, catalog

numbers 109 and 110). Anne Hammond's 2002 biography likewise favored the year 1948 for this photograph (Hammond 2002, p. 121).

In connection with a major Ansel Adams exhibition held at the Boston Museum of Fine Arts in 2005, the catalog entry assigned *Denali and Wonder Lake* to the year 1948. However, the catalog also took note of the uncertainty by mentioning that the exhibited print bore the date "1947" written on the back (Adams, Haas, and Senf 2005, p. 157).

Mary Alinder's biography of Ansel Adams gave a detailed account of his travels month-by-month throughout all of 1947 and 1948. Alinder described photographic expeditions during each month of 1947, with trips to California, Arizona, New Mexico, Texas, Utah, and other locations as far east as Virginia—but not to Alaska in 1947. This biography placed the joint trip with Michael to Denali in 1948, including the stay for several days at Wonder Lake, with a second Alaska visit by Ansel alone in the summer of 1949. Alinder's account of the 1948 events at Denali described the making of "what would become another of his masterpieces. Fully exposed in the light of sunrise" the mountain has "every nuance of form revealed in chiaroscuro … Wonder Lake has an amorphous, pearly glow, its edges defined by dark shoreline…." Alinder concluded that Adams captured the "sublime" image on the 1948 trip (Alinder 2014, p. 185).

The sources about the making of *Denali and Wonder Lake*, along with subsequent entries in exhibition catalogs, appear to be about equally divided between 1947 and 1948 as the year of creation. Could an astronomical analysis independently determine the correct date?

Celestial Sleuthing: Paintings and Photographs

Our Texas State group has successfully employed astronomy to establish dates and precise times for paintings and photographs. The author's previous *Celestial Sleuth* book detailed how we have dated three night sky paintings by Vincent van Gogh, three works by Edvard Munch, a sunset canvas by Claude Monet, a night scene by J. M. W. Turner, and two moonrise photographs by Ansel Adams (Olson 2014). Chapters 1–4 of this present book extend our methods to more paintings by Claude Monet, J. M. W. Turner, Ford Madox Brown, Édouard Manet, Vincent van Gogh, Caspar David Friedrich, Canaletto, and Edvard Munch. But the skies in all of those examples featured celestial objects: the rising or setting Sun, the Moon, or bright stars and planets.

Denali and Wonder Lake includes no celestial objects in the sky, which is just a featureless expanse. How could astronomical analysis play a significant role in determining the date and precise time for this famous photograph?

As a starting point, we turned to the existing literature, which provides much background information regarding the trip to Denali.

Adams at Wonder Lake

Interested readers will find the most detailed accounts published by Ansel Adams himself in his book *Examples: The Making of 40 Photographs* and in his *Autobiography* (Adams 1983a, p. 74–77; Adams 1985, p. 280–290). Adams described the trip made with his son Michael first by ship to Juneau, Alaska, then by plane to Anchorage, and finally via an

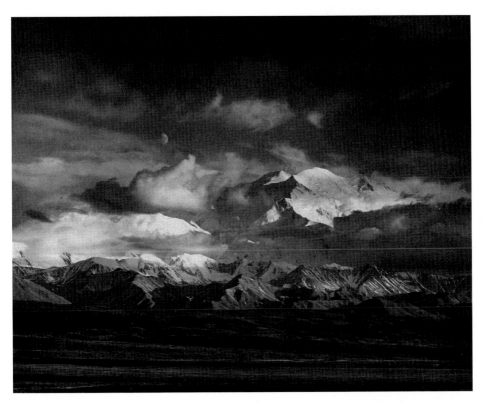

Fig. 5.9 *Moon and Denali,* Denali National Park, Alaska, 1948, photograph by Ansel Adams (Collection Center for Creative Photography, The University of Arizona, © 2018. The Ansel Adams Publishing Rights Trust. Used with permission)

Alaska railroad railcar to McKinley Park station. The National Park Service provided automobile transportation along the nearly 90 miles of the park road leading out to the Wonder Lake ranger station, where Ansel and Michael were to spend about half a dozen days. As their automobile approached Wonder Lake, Ansel called for the car to stop so that he could make a photograph of Denali surrounded by clouds, with shadows cast by a Sun low in the northwestern quadrant of the sky, and the Moon visible through a break in the clouds. The dramatic image is now known as *Moon and Denali* (Fig. 5.9).

The pair arrived at the ranger station in the evening and, after an early supper and a brief rest, Ansel and Michael arose at about midnight. In the next few hours they watched as the glow of impending dawn brought pink hues to the summit of Denali. The mountain grew brighter as the Sun approached the horizon. When direct sunlight first began to strike the highest elevations of Denali and to cast shadows across the north face of the mountain, Wonder Lake and its shoreline still remained in shadowed darkness. Adams found an ideal spot overlooking the lake and used his 8 × 10 view camera to capture the memorable

Denali and Wonder Lake, with the foreground waters glowing by reflected light from the snowy peak and the sky. He tried a few more alternate exposures, but clouds obscured first the summit and soon the entire mountain, and further photography became impossible. Regarding the sequence of events, Michael Adams later recalled how he:

> *...never forgot the moment when his father shot that iconic photograph. With their tripod set and doused in citronella against the bugs, they waited for the right moment, sheltered by a few stunted spruces and embraced by that nearly perfect silence peculiar to Alaska. Quiet and untouched, McKinley asserts a rock-hard permanence. Clouds shift rapidly around its summit; looking up at it for too long can induce motion sickness. Michael remembered the moon glow and the palette of colors that swirled at dawn and dusk. From their ridge, they waited patiently for the flashing moment when, as Jack Kerouac would declare, everything becomes understood. All around them rolled the tundra; and over Wonder Lake the ripples reflected and distorted light. It was hard to tell whether the light was falling or rising. "We both knew the moment," said Michael. "It was really something special. We had been to a lot of national parks, seen a lot of sights, but this was beyond amazing."*
> (Brinkley 2011, p. 332–333)

Moon and Denali

Our Texas State group noticed that both Ansel and Michael had mentioned the Moon. We realized that we could use the lunar phase and position in the sky of *Moon and Denali* to calculate the date of that evening scene. *Denali and Wonder Lake* must have been created on the following morning!

We first needed to determine the precise spot where Adams observed the Moon and set up his tripod, somewhere along the park road in the last miles before the automobile reached Wonder Lake.

The foreground of *Moon and Denali* includes geological features known as "cirques," semi-circular steep-sided hollows shaped like amphitheaters and caused by the eroding activity of glaciers. Excellent topographic maps of Denali National Park are available, and my student Ava Pope and I spent many hours comparing the topographic contours with the cirques in the photograph. We were able to identify three of the photographed cirques and also a foreground peak known as Gunsight Mountain. From the maps we obtained precise longitudes, latitudes, and elevations for these features and for five distinctive landmarks near the summit of distant Denali. Relative to the park road, the foreground cirques were about 12 miles away, Gunsight Mountain was about 16 miles distant, while North Peak and South Peak of Denali were fully 26 miles and 28 miles away, respectively. The differences in distance allowed us to use the parallax method, which measures how nearby objects shift relative to the distant background as the observer changes position.

We wrote a computer program that could calculate the view from any possible spot for Ansel Adams's tripod. The program correctly allowed for refraction (the gradual bending of light as it travels through Earth's atmosphere) and for the curvature of Earth, with both factors especially important because of the great distances involved. Denali is such a large mountain that it can be photographed from many miles away!

Our computer program eventually produced a camera position where the calculated view appeared to match the photograph, with the foreground features correctly aligned with the peaks and landmarks on distant Denali. We then sent an email to Jon Paynter, a geographic information systems specialist at Denali National Park. At our request he traveled to the site and took comparison photographs that verified and slightly refined the computer calculations. Ansel Adams set up his tripod for *Moon and Denali* near the point with GPS coordinates 150° 40′ 49″ west longitude, 63° 26′ 34″ north latitude, a location on the park road about 8 miles before they reached the ranger station at Wonder Lake. We now measured a print and used the directions to the known geographic features on Denali to determine the precise coordinates of the Moon hovering in the sky nearby.

Astronomers use altitude to indicate the height of a celestial object above the horizon and employ azimuth to express compass directions numerically, with azimuth progressing around the horizon from 0° at due north, 90° due east, 180° due south, and 270° due west.

As observed from Adams's tripod position along the park road, the center of the lunar disk stood at altitude 8° 01′ above the horizon and was in the direction toward azimuth 196° 26′, that is, about 16° west of due south. The photograph shows the Moon in the waxing gibbous lunar phase, that is, more than 50% and less than 100% illuminated.

We then used computer planetarium programs to determine when in the summers of 1947, 1948, or 1949 a waxing gibbous Moon appeared in that position in the sky, with only one possible result: *Moon and Denali* was captured on July 14, 1948, at 8:28 p.m.

This clock time, like the others in this chapter, is expressed in Central Alaska Standard Time, ten hours behind Greenwich Mean Time. We consulted almanacs from 1948 and also checked the sunrise and sunset times in the Anchorage newspapers from July of that year and verified that Alaska did *not* adopt daylight saving time in 1948.

We calculated that the lunar disk had an illuminated fraction of 69%, an excellent match for the waxing gibbous phase seen in the photograph. The preceding first quarter Moon, with 50% illumination, had occurred on July 13th, one day earlier.

Denali and Wonder Lake

To determine the tripod position from which Ansel Adams photographed *Denali and Wonder Lake*, we again employed topographic maps and computer techniques and aligned nearby shoreline features along Wonder Lake against the distant features on Denali, with North Peak and South Peak, respectively, 27 miles and 29 miles from the shore of the lake. When Jon Paynter checked our results with a site visit, he learned of an interesting local tradition. Although they are not official park service names, a path known as Ansel Adams Trail leads to a hill known locally as Ansel Adams Knob, with a commanding view across Wonder Lake to Denali. Based on our calculations and the comparison photographs, Ansel Adams set up his tripod for *Denali and Wonder Lake* near 150° 51′ 42″ west longitude, 63° 28′ 34″ north latitude.

The Shadows Know

Because we had dated *Moon and Denali* to the evening of July 14, 1948, we knew from Adams's accounts that he photographed *Denali and Wonder Lake* on the next morning:

July 15th. Although no celestial object appears in the sky of the Wonder Lake image, we realized that astronomical methods could determine the corresponding clock time.

We studied the north face of Denali and used the dramatic shadows in the photograph to deduce the Sun's position in the sky. This shadow analysis employed a method almost identical to that which our Texas State group used to find the precise clock time for the famous Times Square VJ Day Kiss photograph, as explained earlier in this chapter.

Calculating the path of the Sun in the morning sky of July 15, 1948, was a straightforward task for computer planetarium programs. Using topographic maps to determine the direction and length of the shadows cast was much more difficult and required complicated trigonometric calculations to study how the long shadows projected across the curved slope of Denali's north face. We were at first able to obtain only an approximate result: the calculated shadows cast by the Sun matched those seen in the photograph for times between about 3:40 a.m. and 3:50 a.m. on July 15th.

Wonder Lake Webcam

For the third time in this project, Jon Paynter at Denali National Park provided invaluable assistance.

From our computers in Texas, we noticed that the park service had set up a webcam pointed toward Denali from a location near Wonder Lake. We searched the webcam online archive and looked for a year when the weather was favorable on July 15th. Our search was rewarded when we saw that blue skies prevailed on the morning of July 15, 2008. The online images are low resolution, but Jon Paynter was able to locate the original high resolution images captured by the Olympus camera that served as the webcam (Fig. 5.10).

We compared the shadows in the original Ansel Adams photograph with webcam images from 3:30 a.m. and 3:45 a.m. Our calculations allowed for the small differences in solar position between 1948 and 2008. We also allowed for the difference between the views from the webcam position and from Ansel Adams Knob, also a small correction because the distant features of Denali were nearly 30 miles away. Interpolation allowed us to determine that Ansel Adams tripped the shutter for *Denali and Wonder Lake* on July 15, 1948, at 3:42 a.m.

Confirmation

The Center for Creative Photography at the University of Arizona in Tucson acts as the repository for the Ansel Adams collection. Archivist Leslie Squyres kindly made copies of exposure records from 1948. One sheet lists twelve photographs, including one called

Fig. 5.10 (continued) These photographs show the scene at 2:00 a.m., 2:30 a.m., 3:00 a.m., 3:45 a.m., and 5:00 a.m., Central Alaska Standard Time, ten hours behind Greenwich Mean Time. The closest match to the Adams photograph is the fourth frame, taken at 3:45 a.m. Detailed analysis of the shadows in the entire sequence of webcam images, captured every fifteen minutes, allowed us to determine that Ansel Adams photographed *Denali and Wonder Lake* at 3:42 a.m. on July 15, 1948 (Photographs courtesy National Park Service. Used with permission)

Fig. 5.10 This selection of images from the Wonder Lake webcam show the changing pattern of twilight, sunlight, and shadows over the course of three hours on the morning of July 15, 2008.

"McKinley—Dawn" and five entries labeled "McKinley from Point above Wonder Lake." The heading on this exposure record specifies Isopan 8 × 10 sheet film, loaded into the plate holders on July 12, 1948. These entries may refer to the famous photograph and, in any event, definitely place Ansel Adams at Wonder Lake at the same time period in 1948 determined by our astronomical calculations.

The Lens

Our Texas State group obtained another result regarding the lens that Ansel Adams employed to create *Denali and Wonder Lake*. In his most detailed account Ansel Adams mistakenly stated that he used a 23-in. focal length component of his Cooke Series XV lens to create *Denali and Wonder Lake* (Adams 1983a, p. 76). This error also appears in several later publications by Adams and almost every later author has repeated this mistake.

Photographic journals from the 1930s and 1940s show the Cooke Series XV triple convertible lens advertised with three possible focal lengths: 12.25″, 19″, or 26.5″. We also confirmed by email correspondence with the manufacturer in the UK that the Cooke Series XV did not offer a component of 23″ focal length.

Our calculations of the field of view indicate that Adams used the 26.5″ focal length lens component for *Denali and Wonder Lake*. This is confirmed by Adams's July 1948 Exposure Record, which included a column with the heading "LENS F. L." for focal length and listed "26" for large format photographs captured near Wonder Lake.

Precise Times in 1948

The combination of Ansel Adams's memoirs, topographical and astronomical analysis, along with the gracious help of Jon Paynter at Denali National Park, allowed us to determine that *Moon and Denali* shows the mountain and the sky on July 14, 1948, at 8:28 p.m. and that, only a few hours later, Adams used a 26.5″ lens to capture his spectacular *Denali and Wonder Lake* on July 15, 1948, at 3:42 a.m. Central Alaska Standard Time.

Scholars of the history of photography have a use for dates that augment a chronology of Ansel Adams's images and his photographic trips. For the general public, the scientific results can offer an emotional satisfaction. Knowing the details of the place, the date, and the time when Adams captured a photograph provides the opportunity for an imaginative experience. The science brings the modern reader closer to the moment of creation or to the person that they admire. The idea of solving mysteries in art, history, and literature by means of astronomy offers the potential to open doors to a richer experience of nature and human culture.

References

Adams, Ansel, James L. Enyeart, Richard M. Leonard, Ruth Teiser, and Catherine Harroun (1978) *Conversations with Ansel Adams*. Berkeley, CA: University of California, Regional Oral History Office.

Adams, Ansel (1948) *Portfolio One, Twelve Photographic Prints by Ansel Adams*. San Francisco: Grabhorn Press.

Adams, Ansel, and John Szarkowski (1981) *The Portfolios of Ansel Adams*. Boston: Little, Brown and Company.

Adams, Ansel (1983a) *Examples: The Making of 40 Photographs*. Boston: Little, Brown and Company.

Adams, Ansel (1983b) *The Print, The New Ansel Adams Photography Series, Volume 3*. Boston: Little, Brown and Company.

Adams, Ansel, and Mary Street Alinder (1985) *Ansel Adams, an Autobiography*. Boston: Little, Brown and Company.

Adams, Ansel, James Alinder, and John Szarkowski (1985) *Ansel Adams: Classic Images*. Boston: Little, Brown and Company.

Adams, Ansel, Mary Street Alinder, and Andrea Gray Stillman (1988) *Ansel Adams: Letters and Images, 1916-1984*. Boston: Little, Brown and Company.

Adams, Ansel, and Andrea Gray Stillman (1990) *The American Wilderness*. Boston: Little, Brown and Company.

Adams, Ansel, Andrea Gray Stillman, and William A. Turnage (1992) *Our National Parks*. Boston: Little, Brown and Company.

Adams, Ansel, and John Szarkowski (2001) *Ansel Adams at 100*. Boston: Little, Brown and Company.

Adams, Ansel, Karen E. Haas, and Rebecca A. Senf (2005) *Ansel Adams in the Lane Collection, Museum of Fine Arts, Boston*. Boston: MFA Publications.

Adams, Ansel, and Andrea Gray Stillman (2007) *Ansel Adams: 400 Photographs*. Boston: Little, Brown and Company.

Alinder, Mary Street (2014) *Ansel Adams: A Biography*. New York: Bloomsbury.

Brinkley, Douglas (2011) *The Quiet World: Saving Alaska's Wilderness Kingdom, 1879-1960*. New York: Harper.

Conner, Ken, and Debra Heimerdinger (1996) *Horace Bristol: An American View*. San Francisco: Chronicle Books.

di Cicco, Dennis (1991a) Ansel Adams' *Moonrise* Turns 50. *Sky & Telescope* **82** (No. 5), November, 480.

di Cicco, Dennis (1991b) Dating Ansel Adams' *Moonrise*. *Sky & Telescope* **82** (No. 5), November, 529-533.

Eisenstaedt, Alfred (1969) *The Eye of Eisenstaedt*. New York: Viking Press.

Eisenstaedt, Alfred (1985) *Eisenstaedt on Eisenstaedt*. New York: Abbeville Press.

Fletcher, Guy (2009) A Kiss for the Ages. *Frederick*, September, 46-55.

Friedman, Greta Zimmer (2005) Interview with Greta Friedman, August 23, 2005. Veterans History Project, Library of Congress.

Hammond, Anne (2002) *Ansel Adams: Divine Performance*. New Haven, CT: Yale University Press.

Life (1945) Victory Celebrations. August 27, 1945, 21-27.

Life (1980a) Editor's Note. August 1980, 4.

Life (1980b) The Smack Seen Round the World. August 1980, 7-10.

Life (1980c) Who is the Kissing Sailor? October 1980, 68-72.

Life (1980d) Kissers All. December 1980, 33.

Loengard, John (1998) *Life Photographers: What They Saw.* Boston: Bulfinch Press.

New York Times (2010) Nurse's Tale of Storied Kiss. No, Not That Nurse. August 14, 2010, A1 and A17.

Olson, Donald (2014) *Celestial Sleuth: Using Astronomy to Solve Mysteries in Art, History and Literature.* Springer Praxis: New York.

Olson, Donald W., Russell L. Doescher, Amanda K. Burke, Mario E. Delgado, Marillyn A. Douglas, Kevin L. Fields, Robert B. Fischer, Patricia D. Gardiner, Thomas W. Huntley, Kellie E. McCarthy, and Amber G. Messenger (1994) Dating Ansel Adams' *Moon and Half Dome. Sky & Telescope* **88** (No. 6), December, 82-86.

Olson, Donald W., Russell L. Doescher, Kara D. Holsinger, Ashley B. Ralph, and Louie Dean Valencia (2005) Ansel Adams and an "Autumn Moon." *Sky & Telescope* **110** (No. 4), October, 40-45.

PBS (2002) *Ansel Adams: A Documentary Film by Ric Burns*, and accompanying website www.pbs.org/wgbh/amex/ansel.

Spaulding, Jonathan (1998) *Ansel Adams and the American Landscape: A Biography.* Berkeley, CA: University of California Press.

Stillman, Andrea Gray (2012) *Looking at Ansel Adams: The Photographs and the Man.* Boston: Little, Brown and Company.

Verria, Lawrence, and George Galdorisi (2012) *The Kissing Sailor: The Mystery Behind the Photo that Ended World War II.* Annapolis, MD: Naval Institute Press.

Part II
Astronomy in History

6

Braveheart and the Battle of Stirling Bridge, the Discovery of the Ring Nebula, and the 1913 Great Meteor Procession

Astronomical analysis can help to solve mysteries about historical events. Our Texas State University group used hydrographic calculations of tide levels, astronomical calculations of lunar phases, analysis of calendars, and study of archival primary sources to derive new results for the three examples described in this chapter.

William Wallace, better known as Braveheart, was a national hero of Scotland and a military leader in the wars against the English. He first became famous as a warrior and commander after a stunning victory over the English army at the Battle of Stirling Bridge in 1297. Why did the battle take place at Stirling? What was the strategic importance of this location?

It might seem that the position and phase of the Moon would play no role in the events, because the battle took place during daylight hours. However, the River Forth that passes under Stirling Bridge is a tidal river, with tide times and water levels affected by the motions of the Sun and Moon.

Did the battle begin near the time of low water, when the nearest river fords were passable? Or did the fighting commence near the time of high water, when the fords were impassable and the marshy ground near the bridge was unsuitable for the horses carrying the heavily armored knights of the English cavalry? Do our tide calculations agree or disagree with the tide information in the existing literature about this battle? And how do we calculate dates from the calendars used in the thirteenth century?

The Ring Nebula, one of the most spectacular objects in the night sky, is a favorite choice for covers of astronomy books and for observation by both professional and amateur astronomers. Who was the first to view this cloud? Books and articles by dozens of authors over the last two centuries have reached a unanimous consensus that the discoverer was Antoine Darquier, an astronomer working in 1779 in the south of France. Can we find primary sources to prove that another astronomer observed the Ring Nebula before Darquier? How can eighteenth-century newspapers, star charts, and other clues help to answer this question of priority? What is the connection to the Comet of 1779?

© Springer International Publishing AG 2018
D.W. Olson, *Further Adventures of the Celestial Sleuth*, Springer Praxis Books,
https://doi.org/10.1007/978-3-319-70320-6_6

The most remarkable procession of meteors in recorded history passed nearly horizontally over Canada in 1913. According to the University of Toronto astronomer Clarence A. Chant: "To most observers the outstanding feature of the phenomenon was the slow, majestic motion of the bodies; and almost equally remarkable was the perfect formation which they retained." The artist Gustav Hahn created a painting showing groups of the fireballs passing over Toronto. At what locations in western Canada were the meteors first seen? Could we use ships' logs to extend the track of meteor observations to vessels in the Atlantic Ocean? Was this procession of fireballs really seen along a track that extended more than a quarter of the way around Earth?

Braveheart and the Battle of Stirling Bridge

Scots, who have with Wallace bled,
Scots, whom Bruce has often led,
Welcome to your gory bed
Or to victory.
Now is the day, and now is the hour.
(*Scots Wha Hae*, Robert Burns, 1793).

The name of William Wallace (c. 1272–1305) (Fig. 6.1), a Scottish leader in the wars against the English, appears in the opening line of the Robert Burns 1793 poem that served for centuries as an unofficial national anthem of Scotland. Wallace became well-known to modern audiences after the 1995 release of the award-winning film *Braveheart*. He first gained his reputation as a warrior and commander by defeating the English at the Battle of Stirling Bridge in 1297.

Because the battle took place during daylight hours, it might seem that astronomical factors would play no role in the events. However, the positions of the Sun and Moon govern the tides, and the river that passes under Stirling Bridge is subject to the great tides of the North Sea.

Tidal River at Stirling

James Fergusson's biography of Wallace explained why the battle took place at the town of Stirling on the River Forth, which widens below the town into an estuary known as the Firth of Forth before reaching the North Sea: "Stirling, with its solitary bridge over the deep tidal waters of the Forth, was then, as it remained for centuries afterwards, the gateway into the northern parts of Scotland; and of that gateway the bridge was the key" (Fergusson 1948, p. 25).

James Mackay, another biographer of Wallace, likewise pointed out that:

Stirling, at the very heart of the kingdom, was of immense strategic importance
Through this plain meandered the mighty River Forth, tidal as far inland as Stirling and
rapidly widening below the town to form that Scots Sea Stirling was ... the gateway
to the Highlands, and the key to that gateway was the narrow wooden bridge which
spanned the swirling Forth a little above the town. This solitary bridge was vital in any
confrontation between the Scots and the might of England. (Mackay 1995, p. 139)

Fig. 6.1 William Wallace (c. 1272–1305), depicted in stained glass windows at the Wallace Monument in Stirling (left) and at St. Margaret's Chapel in Edinburgh (right) (Photographs by the author)

Mackay described how the battle was fought near the tidal river but lamented that "We do not know what the state of the tide was on that fateful day" (Mackay 1995, p. 152).

Our Texas State group decided to calculate the tide times on the day of the battle. We wondered: did the tidal conditions work in favor of the English army or the Scottish warriors?

Battle of Stirling Bridge

The English forces under John de Warenne, the 6th Earl of Surrey, established their camp on the south side of the river. The Scots, commanded jointly by Andrew de Moray and William Wallace, were vastly outnumbered but did have the advantage of a commanding position overlooking the bridge from the high ground near a location called Abbey Craig, in the Ochil Hills on the north side of the river (Figs. 6.2 and 6.3).

Fig. 6.2 This aerial view looks down onto the serpentine loops of the River Forth at Stirling with the Wallace Monument in the foreground. The tower was completed in 1869 on Abbey Craig, the location from which William Wallace observed the movements of the English army before the Battle of Stirling Bridge (Photograph by Buster Brown. Used with permission)

The English could make their attack only by crossing the River Forth on a wooden bridge, so narrow that only two horsemen could ride abreast. The north end of the bridge led to a causeway that ran for almost a mile across a "low-lying area of marsh, subject to inundation at high spring tides … to the left and right of the causeway the ground would have been much too soft and swampy for cavalry to operate." Ignoring these disadvantages and confident of an easy victory, the English commanders on the evening before the battle "gave orders that the army should prepare to cross the bridge early the following morning" (Mackay 1995, pp. 143–145).

Two fords "above and below the town and usable only at low tide" offered alternatives to using only the wooden bridge (Mackay 1995, p. 143). Sir Richard Lundin made an impassioned plea to the English commanders and explained that he could outflank the Scots by crossing at one of the nearby fords. A medieval chronicle recorded Lundin's argument:

> *My lords, if we cross the bridge we are dead men. For we cannot go over except two by two, and with the enemy already formed up on our flank; their whole army can charge down upon us whenever they will, all in one front. But there is a ford not far from here, where we can cross sixty at a time. Let me now therefore have five hundred knights and a small body of infantry, and we will get round the enemy on their rear and crush them; and meanwhile you, my lord Earl, and the others who are with you, will cross the bridge in perfect safety.* (Hamilton 1849, p. 136)

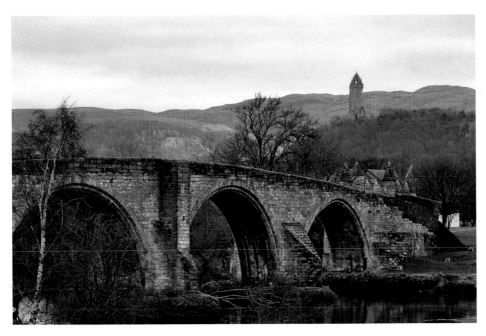

Fig. 6.3 This view looks to the northeast, with the Stirling stone bridge in the foreground, the Wallace Monument on the heights of the Abbey Craig in the distance, and the Ochil Hills in the background. The original wooden bridge that played an important role in the battle was located several hundred feet upstream (to the left) of the stone bridge (Photograph by Jim Wilson. Used with permission)

John de Warenne rejected this excellent advice, and the English advance across the bridge and causeway proceeded throughout the morning until 11 a.m., as described in the chronicle:

Thus, amazing though it is to relate and terrible as was to be its outcome, all these experienced men, though they knew the enemy was at hand, began to cross a bridge so narrow that even two horsemen could scarcely and with much difficulty ride side by side. And so they did from early in the morning until the eleventh hour, without interruption or hindrance, until the vanguard was on one side of the river and the remainder of the army on the other. There was, indeed, no better place in all the land to deliver the English into the hands of the Scots, and so many into the power of the few. (Hamilton 1849, pp. 137–138)

In addition to holding the high ground, the Scots now had the advantage of deciding when the battle would begin:

The main factor in Wallace's favour was that he could choose exactly against what odds he would fight. It must have been a nerve-wracking business, trying to gauge the right moment. If he launched the counter-attack too soon, his troops would stand a better chance of defeating the smaller English force which had managed to cross

the river, but this would leave the main army intact, to strike again and ravage the southern districts in revenge. If he waited until Surrey's entire army had crossed, his lightly armed troops would be outnumbered and overwhelmed ... the Scots waited until 'as many of the enemy had come over as they believed they could over-come,' a point which seems to have been reached around eleven o'clock. (Mackay 1995, p. 149)

James Mackay's book described what happened at 11 a.m.:

From his vantage-point Wallace gave the signal to attack by a single blast from a horn ... As soon as the sound rang out and reverberated round the crags, the Scots, like some gigantic coiled spring, surged forward en masse, brandishing spears and swords and giving vent to blood-curdling yells as they charged ... the main Scottish forces had descended the slopes, gathering momentum as they ran, spears levelled, straight into the English mass. The heavy cavalry, floundering in the marshy ground, proved ineffectual while the shock and impact of the Scottish charge sent the disorganized and unprepared English infantry reeling. (Mackay 1995, p. 149)

The Scots cut down almost the entire English force on the north side of the river (Fig. 6.4). A small number were able to swim back across the stream, and a few English knights led by Sir Marmaduke Tweng fought their way back south across the bridge (Fig. 6.5).

Julian Calendar

We needed to know the date of this battle in order to calculate the positions of the Sun and the Moon and the schedule of the tides. The medieval chronicle by Walter of Guisborough used the Julian calendar and Roman notation to express the date as "Anno Domini MCCXCVII ... III idus Septembris ... feria quarta" (Hamilton 1849, p. 122, 140).

The Roman numerals equate to 1297 as the year, and "feria quarta" indicates the fourth day of the week, that is, Wednesday. The chronicle gives the battle date relative to the Ides of September. (This method of dating is similar to that of the Ides of March, famed as the date when Julius Caesar was assassinated in 44 B.C.) The Ides of September always falls on September 13th, and Table 6.1 gives the count of nearby dates in this calendar system.

The Battle of Stirling Bridge therefore took place on Wednesday, September 11, 1297 (Julian calendar).

Moon's Age

Table 6.2 lists the lunar phases, calculated as an intermediate step toward finding the tide times.

Tide Calculations

Tide calculations are straightforward for Scottish ports such as Rosyth and Leith in the relatively open waters of the Firth of Forth. Predictions for Stirling are rendered more

Fig. 6.4 The English army contends with Scottish soldiers under William Wallace in this chromolith from an 1868 collection called *Pictures of English History*

difficult by the circuitous path followed as the tide works its way upstream and passes through serpentine loops of the river before reaching the town and the battle site.

The UK Hydrographic Office in the modern era uses a simplified method for tide predictions at Stirling. The computer programs first calculate an accurate time for high water at Rosyth and then add a correction of sixty minutes to estimate the time of high water upriver at Stirling (UK Hydrographic Office 2016). However, there is good evidence indicating that this time correction was significantly greater for Stirling in the past.

The Scottish civil engineer Robert Stevenson in 1828 authored a report describing conditions in the River Forth and suggesting improvements. He noted that below Stirling "there are seven principal fords, or shallow parts of the river, which form so many obstructions to navigation." Stevenson pointed out that the "joint effect of the crooked channel of the river, and the obstructions caused by the fords, produces a great retardation in the velocity" of the flood tide as it moves upstream. He recommended that "the fords might be cleared" by "works of excavation" that would eliminate the problems with shallow water

Fig. 6.5 Near the end of the battle the wooden bridge over the River Forth was destroyed. This woodcut, showing the view toward the south with Stirling Castle in the distance, appeared in 1873 in James Grant's *British Battles on Land and Sea*

Table 6.1 Roman calendar dates preceding the Ides of September

III Idus	September 11th
II Idus	September 12th
Idibus	September 13th

Table 6.2 Lunar phases in August and September of the year 1297

August 19	New Moon
August 27	First quarter Moon
September 2	Full Moon
September 9	Third quarter Moon
September 11	Battle of Stirling Bridge
September 18	New Moon

The dates are expressed in the Julian calendar system. Astronomers measure the "age" of the Moon by counting the number of days since the preceding new Moon. At the time of the battle, the Moon's age was 23 days

(Stevenson 1828, pp. 229–230). Clearing the fords and deepening the channel would have the effect of allowing the tidal effects to propagate more rapidly.

Hydrographers in the nineteenth century characterized a port by the quantity known as "high water, full and change" (HWF&C), which describes the average time of high tides on the days of the full Moon or the new ("changing") Moon. Stevenson in 1828 observed that HWF&C was 5 h and 10 min at Sterling. In the latter half of the nineteenth century, when excavation and dredging had cleared the channel, the tide tables listed HWF&C as 3 h and 52 min at Stirling. This difference suggests that the flood tide before 1828 required more than an additional hour to work its way upstream to Stirling (Stevenson 1828, p. 229; Hydrographic Department, Admiralty 1881, p. 156).

Our Texas State University group employed modern computing methods for tide prediction. We converted September 11, 1297, in the Julian calendar to the equivalent date, September 18, 1297, in the Gregorian calendar system required by the modern UK Hydrographic Office computer software. We then made the appropriate correction taking into account the channel excavations in the nineteenth century to arrive at the final result. On September 11, 1297 (Julian calendar), high water at Stirling occurred at about 11:18 a.m.

Cook's Calculation?

We searched the existing literature about the Battle of Stirling Bridge and found one previous effort to calculate a precise tide time. In 1908 William B. Cook, a local historian in Stirling, published his attempt at a "computation of the actual state of the water on the day of the battle." He claimed that "high water that morning was at seven minutes past two o'clock." However, to obtain the 2:07 a.m. result, his flawed calculation made a series of calendrical and astronomical errors. To mention just one, Cook estimated that the "moon was twelve days old" on the battle date. As explained here in Table 6.2, the actual age of the Moon then was 23 days. This enormous error in the lunar phase, along with several other errors, completely invalidates Cook's tide calculation (Cook 1908, p. 125).

The Tides of War

James Fergusson pointed out that the flat land near the river was always "swampy and soft, unfitted for an effective charge of the English cavalry" (Fergusson 1948, p. 28). James Mackay generally agreed regarding the problems faced by "heavy cavalry, floundering in the marshy ground" but regretted that he did "not know what the state of the tide was on that fateful day" (Mackay 1995, p. 149, 152).

Our tidal calculations helped to complete this argument by showing that high water occurred near 11 a.m., almost exactly the time when the Scots charged down onto the English army at the north end of the wooden bridge. The high water would have hindered the English cavalry by partially flooding the marshes on either side of the causeway.

The tide level also restricted the availability to the English of the nearby river fords. The flanking movement advocated so strongly by Sir Richard Lundin would have been possible when the water level was low at the fords during morning twilight, before the Sun rose at about 6 a.m. By late morning the high tide rendered the fords impassable for purposes

of either a flanking movement, a reinforcement of the English forces on the north side of the river, or a path of retreat back to the south.

Wallace's Victory

William Wallace made brilliant use of the terrain and timed his attack for maximum effect. He also received indirect help from the Moon and the tides that covered the river fords and also rendered the English cavalry ineffective in the marshy ground near the wooden bridge and causeway. The result of the Battle of Stirling Bridge was a disaster for the English army and a victory for the Scots that established the reputation of William Wallace, as he became known as Braveheart, the Guardian of Scotland.

Who Discovered the Ring Nebula?

Astronomers have long regarded the cloud known as the Ring Nebula as one of the show-pieces of the night sky. It is a favorite target of amateur astronomers, is intensely studied by professional astrophysicists, and is relied upon for show-stopping images on countless book covers and calendar pages.

In the eighteenth-century list of nebulae and star clusters compiled by French astronomer Charles Messier (Fig. 6.6, right), the Ring Nebula appears as the 57th entry. Modern skywatchers employ the name M57 for this object.

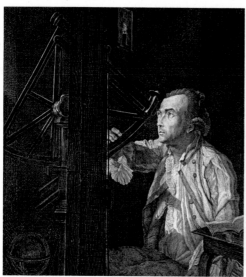

Fig. 6.6 (left): Antoine Darquier (1718–1802) observing with a quadrant in his private observatory at Toulouse, France. This illustration, based on a painting by Léonard Defrance and engraved by Géraud Vidal, appeared in the first volume of Darquier's *Observations Astronomiques, Faites a Toulouse* (1777). (right): Charles Messier (1730–1817) in a portrait attributed to the eighteenth-century artist Nicolas Ansiaume

Fig. 6.7 A team led by C. Robert O'Dell (Vanderbilt University), Gary J. Ferland (University of Kentucky), and William J. Henney and Manuel Peimbert (Universidad Nacional Autónoma de México) directed the Hubble Space Telescope's Wide Field Camera 3 toward M57 on September 19, 2011, and used seven different filters to take a series of exposures. The combined results produced this spectacular image, issued in 2013 as part of the Hubble Heritage Project

On September 19, 2011, an international team directed the Hubble Space Telescope's Wide Field Camera 3 toward M57 and used seven different filters to take a series of exposures. The combined data produced a spectacular image, issued in 2013 as part of the Hubble Heritage Project (Fig. 6.7).

The accompanying photo release, entitled "Most detailed observations ever of the Ring Nebula," described the final result as the "best view yet of the iconic nebula." The text also looked back at the history of the object and assigned credit for the discovery of this nebula not to Messier himself but to another eighteenth-century French astronomer, Antoine Darquier (Fig. 6.6, left).

Darquier as Discoverer?

According to the Hubble Space Telescope photo release: "The Ring Nebula...was discovered in 1779 by astronomer Antoine Darquier de Pellepoix, and also observed later that

same month by Charles Messier...." (NASA/ESA Hubble Space Telescope Photo Release heic1310, May 23, 2013) (https://www.spacetelescope.org/news/heic1310/)

Darquier likewise receives the credit at the public outreach web pages of the European Southern Observatory:

> *Antoine Darquier de Pellepoix of Toulouse, France, discovered the Ring Nebula. He first saw the Ring in January 1779 by using a telescope of about 3-inch aperture...A short time later, Charles Messier also saw it and added it to his catalogue... as M57...Darquier discovered the Ring nebula...just a few days before Messier.* (https://www.eso.org/public/outreach/eduoff/cas/cas2002/cas-projects/germany_m57_1/)

In fact, there is a long history of authors identifying Darquier as the discoverer of M57. The encyclopedic compilation *Cosmos* by the famed nineteenth-century scholar Alexander von Humboldt included a discussion of the nebulae in Messier's catalog and asserted: "No. 57, Messier...it was first observed by Darquier at Toulouse in 1779, when the comet discovered by Bode came into its vicinity" (Humboldt 1850, p. 330; 1852, pp. 234–235).

A volume by the influential nineteenth-century astronomy popularizer Camille Flammarion used similar language regarding this nebula: "Viewed for the first time by Darquier in 1779 and included as No. 57 in Messier's catalogue" (Flammarion 1882, p. 217).

Modern Consensus: Darquier

Readers now have access to a variety of books surveying the Messier catalog, and each work that we have consulted lists Darquier as the discoverer of M57.

John Mallas and Evered Kreimer in 1978 provided a black-and-white photograph and a modern discussion for each Messier object. The text for M57 stated that the "famous Ring nebula was discovered not by Messier but by Antoine Darquier of Toulouse in 1779" (Mallas and Kreimer 1978, p. 123).

An elaborate atlas by Ronald Stoyan in 2008 offered full-color photographs for the Messier objects and mentioned for M57 that Darquier was "its discoverer" and that "[s]oon, Charles Messier learned of Darquier's observation and looked for this nebula himself" (Stoyan 2008, p. 217).

Similar statements crediting Darquier appear in books by Kenneth Glyn Jones, Wolfgang Steinicke, and Stephen James O'Meara (Jones 1991, p. 196; Steinicke 2010, p. 35; O'Meara 2014, p. 220).

However, one scholar, J. A. Bennett, had some suspicions regarding the discovery of M57: "It seems strange, for example, that no sources are cited for Darquier's discovery of M57" (Bennett 1976, p. 67).

Since Bennett wrote those perceptive words in 1976, scans of the primary sources with the observations by Darquier and other eighteenth-century astronomers have become readily available online. This makes it possible to answer conclusively the question, who discovered M57?

Despite the impressive consensus of the authors listed above, the first person to observe the Ring Nebula was *not* Darquier.

Messier's 1779 Observations: Comet and Nebulae

Many astronomers are aware that Charles Messier's main interest was the search for comets and that his catalog listed faint clouds that could be mistaken for comets. Messier noticed and eventually added to his catalog several nebulae that happened to be located near the path of a comet that he observed in 1779.

In the journal *Histoire de l'Academie Royale des Sciences, Année MDCCLXXIX* [1779], available online at both the Bibliothèque Nationale de France and Google Books, Messier published an article with a title than can be translated as "Memoir Containing the Observations of the 17th comet observed at Paris, at the Observatory of the Marine, from January 18 until May 17, 1779." Messier's observatory was at the top of a tower in the Hôtel de Cluny, now home to the French National Museum of the Middle Ages (Figs. 6.8 and 6.9).

Messier recalled that the "sky was perfectly clear on the night of January 18–19, 1779," as he was preparing to make a routine observation to determine the precise time when Jupiter's "first satellite" (Io) would disappear into the shadow of the planet. While waiting for this eclipse to take place, Messier took advantage of the clear skies to sweep with a wide-field comet seeker telescope. At about 5 a.m. on January 19, 1779, Messier was rewarded by finding a comet in the constellation of Cygnus the Swan:

> It had been announced in the volume of the Connoissance des Temps, *for the 19th in the morning, an immersion of the first satellite of Jupiter. Before making the observation of this satellite, I scanned the sky with an ordinary telescope of 2 feet focal length, very sharp and clear & with a large eye-piece, which allowed seeing a span in the sky of 5 or 6 degrees, and I discovered to the east a nebulosity which was a few minutes in extent, and which could not be seen with the naked eye. I thought that this nebulosity could only be a comet, appearing near the head of the Swan, and near a star of the fifth magnitude, the second in the constellation Cygnus.* (Histoire de l'Academie Royale des Sciences 1779, p. 318)

Messier then employed a different instrument, an "achromatic telescope of 3½ ft [focal length] with a triple objective, made in London by Dollond," to determine the precise time, 5:53 a.m., when he saw the eclipse of Io begin.

The telescopes of optician John Dollond were among the best available at the time, and Messier used this same instrument as he quickly turned his attention back to the new comet. At 6:08 a.m. Messier determined the celestial coordinates of the comet by measuring its offset from the nearby comparison star, 2 Cygni, with its coordinates known from the catalog compiled by the British Astronomer Royal, John Flamsteed. Messier noted that the "nucleus of the comet seemed quite brilliant…the nucleus was surrounded by nebulosity…the tail appeared…directed toward the northeast."

Besides the comet, Messier made another discovery on the morning of January 19th. He saw, "not far from the comet," a "very faint nebula … twilight prevented me then from determining its place." Messier reported that overcast skies prevented observations on January 20th, 21st, and 22nd, but that on "the 23rd in the morning, the sky was clear…I saw that the comet since the 19th had approached the star γ of Lyra." Messier also looked back at the "very faint" stationary cloud that he had discovered on the 19th and carefully

Fig. 6.8 The Hôtel de Cluny included the tower supporting Messier's observatory, the location where he discovered comets and nebulae. This view, drawn by Frederick Nash and engraved by John Pye, appeared in *Picturesque Views of the City of Paris and its Environs* (London, 1823)

measured the precise position of this "nebula near the head of the Swan." Messier eventually included this object as the 56th entry in his famous catalog with the description:

Nebula without stars, having little light; M. Messier discovered it on the same day as he discovered the comet of 1779, the 19th of January. On the 23rd, he determined its position by comparing it with the star 2 Cygni, according to Flamsteed: it is near the Milky Way; and close to it is a star of 10th magnitude. M. Messier reported it on the chart of the comet of 1779.

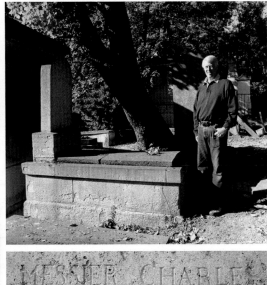

Fig. 6.9 (left): The building behind author Don Olson in this 2014 photograph was known in the eighteenth century as Hôtel de Cluny and included the Observatoire de la Marine. Charles Messier made many of his discoveries from the observatory at the top of the tower. The building now houses the Cluny Museum, the French National Museum of the Middle Ages. The wooden observatory structure used by Charles Messier was demolished in the nineteenth century, but the historic stone tower still exists. (Photograph by the author.) (right): A pilgrimage by author Don Olson to place flowers on the grave of Charles Messier required a visit to Section 11 of Père Lachaise Cemetery in Paris (Photograph by Marilynn Olson. Used with permission)

On Messier's chart of the comet's path this cloud is labeled "Neb 1779" (Figs. 6.10 and 6.11). Modern astronomers have been able to resolve individual stars in this object, now known as M56 and classified as a globular cluster because of its round shape.

Messier continued observing the comet's position on January 24th and 25th and used comparison stars in Lyra, but overcast skies prevailed on January 26th–30th. Messier made his next major discovery on the next night and wrote in his memoir:

> *On January 31ˢᵗ in the morning, the sky was perfectly clear…In comparing the comet to β Lyrae on this morning, I observed in the telescope a small patch of light, which seemed to consist of only very small stars, which we cannot distinguish with this instrument: this patch of light was round and was located between γ & β Lyrae. (Histoire de l'Academie Royale des Sciences 1779, p. 321)*

Messier immediately measured the coordinates of this cloud in Lyra. The description and position prove that Messier definitely observed the Ring Nebula on January 31, 1779.

Fig. 6.10 Messier published this chart showing the track of the Comet of 1799 through the constellations of Vulpecula, Cygnus, Lyra, Hercules, Corona Borealis, Boötes, Coma Berenices, and Virgo. In 1799 Messier noticed six nebulae near the path of the comet, and he later added them to his catalog as M56 and M57 in Lyra, and M58, M59, M60, and M61 in Virgo. Because this chart was not published until 1782, Messier also marked the positions in Virgo and Coma Berenices of eleven nebulae observed during 1781 and later added to his catalog as M84 to M91 and M98 to M100

Fig. 6.11 This detail from Messier's chart shows the path (*ROUTE APPARENTE*) of the comet of 1799 as it moved from Cygnus, through Lyra, and into Hercules. Messier first spotted the comet near the star 2 Cygni on January 18th (by astronomical reckoning from noon to noon), equivalent to 5 a.m. on the morning of January 19th (by civil reckoning from midnight to midnight). On that same night Messier discovered, between the Swan and the Lyre, the cloud marked "Neb 1779" and now recognized as the star cluster M56. On January 31st Messier first noticed, between β and γ Lyrae, the cloud also marked "Neb 1779" and now recognized as the planetary nebula M57, the Ring Nebula

Later in 1779 Messier attempted unsuccessfully to resolve individual stars in this cloud:

On the 3ʳᵈ of September, I again examined this light with the achromatic telescope, when I used a magnification of about one hundred twenty times; I could not recognize, just as on the first time, whether it was composed of small stars…I also recorded it on the chart of the apparent path of the comet. (Histoire de l'Academie Royale des Sciences 1779, p. 321)

On Messier's chart of the comet's path this object is labeled "Neb 1779" (Fig. 6.11, earlier). Messier eventually included this object as the 57th entry in his catalog and provided this description:

Patch of light located between γ & β Lyrae, discovered while observing the Comet of 1779, which passed very close: it seemed that this patch of light, which is round, was composed of very small stars: with the best telescopes it is not possible to see them, it remains only a suspicion that they are there. M. Messier reported this patch of light on the chart of the Comet of 1779. M. Darquier in Toulouse discovered this nebula, while observing the same Comet, & he reports: "Nebula between γ & β Lyrae; it is very dim, but with a sharp boundary; it is as large as Jupiter & resembles a planet which is fading away."

The quote from Darquier compares the angular size of M57 to Jupiter and may be in part responsible for the name "planetary nebula" eventually used for this class of objects.

The last sentence in the M57 catalog entry, well-known to Humboldt, Flammarion, and the later commentators, explains why the consensus of all these authors gives the credit for the discovery to Darquier. A recent book interprets Messier's language in exactly this way: "It is believed Darquier's observation preceded Messier's independent recovery made on January 31, 1779, since Messier acknowledges that Darquier observed it before him" (Chen and Chen 2015, p. 92).

On what date did Darquier first begin observing the comet? On what date did Darquier spot the Ring Nebula in Lyra? Did these dates fall before or after Messier's observation on January 31, 1779? Coulc we find a primary source written by Darquier?

Darquier's Observations in 1779

In fact, two such primary sources are available online. The first consists of a lengthy letter sent from Darquier to Messier in September 1779 and published in *Histoire de l'Academie Royale des Sciences* immediately after Messier's contribution.

Darquier explained why he did not even begin to follow the path of the comet and to scan the sky near the comet's path until more than a week into February of 1779:

I was informed about the apparition of the Comet of 1779 only by the Gazette de France, *which arrived here on February 9ᵗʰ, in which Monsieur Messier announced the discovery that he had just made…*

On the night of February 9ᵗʰ-10ᵗʰ, I searched around midnight; I found the comet by the bend of the left leg of Hercules. (Histoire de l'Academie Royale des Sciences 1779, p. 363)

The Bibliothèque Nationale de France has scanned the eighteenth-century issues of the *Gazette de France* and made them available online. A story about the new comet appeared in the *Gazette* for Tuesday, January 26, 1779, and included the lines:

> *Monsieur Messier...discovered at l'Observatoire de la Marine, on the 19th of this month, at about five o'clock in the morning, a new comet; it appeared near the head of Cygnus, between this constellation and that of the Lyre: one could observe it quite well with a telescope of two feet* [focal length]; *but with the naked eye, it was not possible to see it....*

This newspaper reached Darquier in the south of France two weeks later, on Tuesday, February 9, 1779. Such a delay is typical for the eighteenth century, according to Gilles Feyel, an expert on the distribution of early French newspapers, including the Paris editions and provincial editions of the *Gazette de France* (Feyel 1991; Feyel 2013).

In his September 1779 letter to Messier, Darquier included his remarks and observed positions for the comet. He also detailed an ambitious observing project, carried out between February 10th and the end of April. For the sky near the path of the comet, Darquier created his own catalog with measurements of the celestial coordinates for one nebula and 270 stars, including many not included in Flamsteed's catalog. Darquier described his own discovery of the nebula in Lyra:

> *In the course of my work, I encountered some nebulae, most of which are unknown; but one which caught my attention is a nebula located between the two beautiful stars β & γ Lyrae; it is very dim, but with a sharp boundary; it is as large as Jupiter & resembles a planet which is fading away: one finds its position determined in my catalogue. (Histoire de l'Academie Royale des Sciences 1779, p. 366)*

Darquier did not give a precise date for this observation, but it cannot be earlier than February 10th. He was incredulous that such an object could be previously unknown to astronomers, and he offered the (incorrect) theory that perhaps this nebula had only recently appeared:

> *If one considers that this nebula, which is located between two beautiful stars, which are very close to each other and can pass at the same time in the same telescope field, and to which astronomers had often turned their instruments, there is reason to be astonished that we have not spoken about it; it must also be admitted that it takes a rather powerful telescope to perceive it: Might this be a new production of nature? Or would it have the same age as the stars that surround it? (Histoire de l'Academie Royale des Sciences 1779, p. 366)*

Darquier's Publication in 1782

Darquier in 1782 published a compilation titled *Observations Astronomiques, Faites a Toulouse, par M. Darquier...Deuxieme partie*. This volume, available online at the website of the Bibliothèque of the Université de Toulouse, reprints the 1779 letter to Messier. At the end, Darquier made one additional remark regarding the nebula in Lyra:

> *This nebula has not been noticed, at least as far as I know, by any astronomer; one cannot perceive it except with a powerful telescope. It does not resemble any other*

known: it is as large as Jupiter, perfectly round and with a sharp boundary; with a
dim light like the dark part of the Moon in the syzygies; it seems that its center has
a little less of the dim glow than the rest of its surface. (Darquier 1782, p. 218)

Darquier compared the brightness of the Ring Nebula to earthshine (see Fig. 3.5, earlier), the faint light visible on the dark part of a thin waning or waxing lunar crescent Moon shortly before or after the time of syzygy (new Moon).

Then Darquier added the phrase describing the center of the nebula as *"un peu moins terne,"* compared to the rest of the surface. These words could mean "a little less dull," or brighter, or "a little less of the dim glow," meaning fainter! If the latter interpretation is correct, then we have the important result that Darquier was the first astronomer to notice that the nebula has the form of a faint ring, with less light at the center.

Regardless of how this last sentence is translated, it is clear from the primary sources that the consensus in the previous literature—that Darquier was the first to observe the Ring Nebula, just a few days before Messier—has the order of priority backwards. Messier observed the nebula in Lyra and measured its coordinates on January 31, 1779. Darquier did not even know about the comet and did not scan the sky near its path until after February 9, 1779.

Independent Discoveries

Messier misled many later commentators when he wrote in his catalog that "M. Darquier in Toulouse, discovered this nebula." Messier, knowing that he had seen the nebula before Darquier, apparently employed the word "discovered" here to describe an independent discovery.

This use of language is almost identical to the sense in which Messier's catalog entry for M56 asserts that Messier "discovered" the comet of 1779 on January 19th. Messier likewise wrote in his memoir that he "discovered" the comet in Paris at 5 a.m. on the morning of January 19, 1779. However, by the time that he wrote his memoir and his catalog, Messier was well aware that the comet had been seen in Germany before the Paris "discovery." In that same 1779 memoir he reprints two German articles describing how Johann Elert Bode in Berlin had spotted this same comet at about 8 p.m. on the evening of January 6, 1779. This comet is now known by the name C/1779 A1 Bode. Messier's chart of the comet's path begins in Vulpecula with Bode's observations plotted as a dotted line with the initial point labeled "at Berlin on January 6." The path marks the positions observed by Messier along a solid line continuing from a point in Cygnus with the label "Discovered at Paris."

The word "discovered" in the Messier catalog entry for M57 should likewise be read as indicating that Darquier made an independent discovery of the nebula. The primary sources prove that Messier's sighting of M57 occurred earlier.

Messier as Discoverer

Messier's memoir and accompanying chart show that he continued to follow the Comet of 1799 for 3½ more months as the celestial visitor passed through the constellations of Hercules, Corona Borealis, Boötes, Coma Berenices, and Virgo. Near the path of this comet Messier observed not only M56 and M57 in January but also in April and May four

nebulae (M58, M59, M60, and M61) now recognized as galaxies in Virgo. The tale of the multiple independent discoveries of these and other Virgo cluster galaxies is another story for another time.

For now, we can conclude that the literature regarding the Messier catalog should be updated: the discoverer of M57 was none other than Charles Messier himself.

The Great Meteor Procession of 1913

On the evening of February 9, 1913, the most remarkable procession of fireballs ever recorded passed over Canada (Fig. 6.12). University of Toronto astronomer Clarence A. Chant collected eyewitness accounts, primarily from Ontario, and summarized the local observations:

> *At about 9.05* [Eastern Standard Time] *on the evening in question there suddenly appeared in the northwestern sky a fiery red body…which was then seen to be followed by a long tail … it moved forward on a perfectly horizontal path…without the least apparent sinking towards the earth…it simply disappeared in the distance… Before the astonishment aroused by this first meteor had subsided, other bodies were seen coming from the north-west…Onward they moved, at the same deliberate pace…with tails streaming behind…To most observers the outstanding feature of the phenomenon was the slow, majestic motion of the bodies; and almost equally remarkable was the perfect formation which they retained.* (Chant 1913a, pp. 146–148)

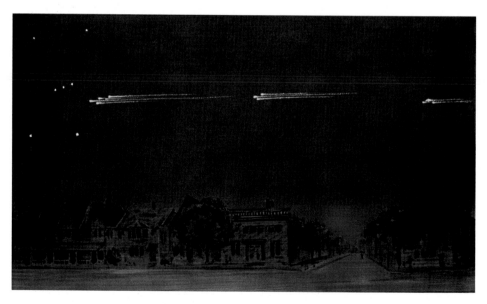

Fig. 6.12 This painting by artist and amateur astronomer Gustav Hahn depicts the meteor procession of February 9, 1913, as observed near High Park in Toronto. Hahn estimated that the fireballs passed just below the three stars that mark the Belt of Orion, the constellation visible near the left edge of the painting (University of Toronto Archives, A2008-0023, © Natalie McMinn. Used with permission)

Chant also obtained a few reports from western Canada. At the towns of Mortlach and Pense in Saskatchewan, observers described a procession with hundreds of meteors passing from west to east at about 7 p.m. Mountain Time.

Perhaps the most surprising account sent to Chant came from Bermuda. At about 10 p.m. Atlantic Time, Col. W. R. Winter saw "two leading bodies" trailed by about one hundred smaller meteors in a "procession" traveling nearly horizontally in the sky east of Bermuda. Because all the observing sites fell close to a great circle, and all the local times corresponded nearly to 2:00 a.m. Greenwich Mean Time, Chant deduced that the same phenomenon had been witnessed along the ground track from Saskatchewan to Bermuda, an unprecedented "distance of 2437 miles [3922 km]" (Chant 1913b, pp. 438–441).

Extending the Ground Track

William F. Denning became interested in the event and obtained observations of the meteor procession from two ships: *S. S. Bellucia* and *S.S. Newlands*. The *S. S. Newlands* was below the equator off the coast of Brazil, and Denning remarked that the ground track of the 1913 procession extended for about 5500 miles [8850 km] (Denning 1915, p. 287; Denning 1916, p. 294).

William H. Pickering uncovered observations from three more ships (*S. S. Tennyson*, *S. S. Custodian*, and *S. S. Manuel Calvo*) near Bermuda (Pickering 1923, p. 443).

Alexander Mebane filled in the ground track with several dozen accounts, mostly newspaper stories from Minnesota, Michigan, New York, Pennsylvania, and New Jersey (Mebane 1956, pp. 408–410).

John O'Keefe found a newspaper story with meteor observations from Didsbury, Alberta, extending the known ground track farther west to a total length of about 6040 miles [9720 km] (O'Keefe 1968, p. 98).

Newly Discovered Accounts

As the 2013 centenary of the meteor procession approached, Australian researcher Steve Hutcheon and this author wondered whether we could find even more reports of the 1913 meteors. At the Library of Congress historical newspaper site we located two such stories based on interviews with the captain of the *S. S. Zafra*:

FLOCK OF METEORS CHASED SHIP UPON ITS HOODOO VOYAGE
...Hardly had the skipper turned in when a white-faced seaman appeared at the door of his stateroom and pleaded with him to come on deck. "The world is coming to an end, sir, sure," he groaned...An unearthly flare hung over the ship, and, sailing across the sky was what looked like a flock of monstrous birds of fire. They were coming towards the Zafra, and they passed over her, shedding their unearthly radiance...the meteors...sailed on...The crew stayed on deck, shivering and praying, until the last faint glow of their taillights had flickered away in the distance. (New York *Evening World*, February 14, 1913)

40 METEORS PASSED HIM BY

…The meteors were fired slowly. It took six minutes for forty of them…to write their glowing bluish white autographs across the sky. In this six minutes of incandescent glory the skipper read over the love letters of his youth and made his will, as he thought that the last day might be pretty close. He says the stream of meteors passed from northwest to southeast…. (New York *Sun*, February 15, 1913)

These accounts, though colorful, did not extend the ground track, because the *S. S. Zafra* was just northeast of Bermuda.

William F. Denning in 1916 had remarked that as the meteor procession passed the *S. S. Newlands*, 3 degrees below the equator, the fireballs were "still going strongly … and may have pursued their luminous career far southwards over the South Atlantic Ocean, but navigators alone, during morning watches, can give us further information on the subject" (Denning 1916, pp. 294–295).

Denning's call for further observations has now finally been answered! With assistance from British and German archivists we located seven meteorological logbook entries from ships at latitudes south of the *S. S. Newlands*. These remarks were recorded as occurring on February 10, because the local times were just after midnight.

A logbook at the UK National Meteorological Archive included this account:

S. S. Julia Park (32°44′ W, 4°41′ S):
Witnessed a brilliant Meteoric shower immediately overhead. More than a hundred being seen within a minute, and all travelling from NNW, the whole breadth of the sky, and very low down.

Six logbooks at the German Meteorological Service archives described the meteor procession. We translated the following accounts from the original German:

Steamship *Bahrenfeld* (31°55′ W, 4°18′ S):
From $0^h 5^m$ to $0^h 10^m$ a.m. true solar time an exceptionally strong shooting star event took place. The shooting stars of intense yellow color were all moving in the west from approximately WNW magnetic to ESE. Noteworthy was their moderate speed.

Sailing ship *Ponape* (28°41′ W, 8°23′ S):
At $12\,\tfrac{1}{2}^h$ three great meteors (emitting sparks) in succession. Impact was heard on board.

Sailing ship *Barthold Vinnen* (29°51′ W, 9°36′ S):
At $12^h 10^m$ there was exhibited a strange spectacle of nature. In the direction NbyW suddenly appeared north of the constellation of the Lion, coming seemingly from infinity, an uncounted number of shooting stars. The track appeared like a chain of star molecules and was resplendent in a grayish light. They moved southeast at a slow speed and disappeared in the region near Alpha Crucis and Alpha and Beta Centauri…The duration of the display was about ten minutes.

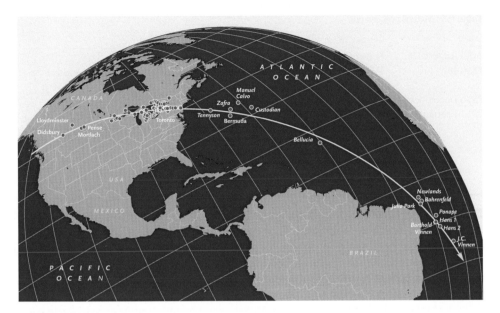

Fig. 6.13 The red dots mark locations where the meteor procession of February 9, 1913, was observed. The accounts from the seven ships farthest south, in the shipping lanes off the coast of Brazil, were discovered during our literature search near the time of the 2013 centenary. The ground track, projected onto the rotating Earth, deviates somewhat from a great circle, with the southern part of the track shifted several degrees to the west because of the rotation of Earth during the time of flight from Canada to the shipping lanes below the equator (*Sky & Telescope* diagram. Used with permission)

Sailing ship *Hans* (Captain Bade, 29°39′ W, 9°37′ S):
At 12h 40m suddenly about 70 shooting stars were flying across space with tremendous speed. They came up from the NNW horizon and disappeared in the SSE horizon. Many of the shooting stars had no sparkling tails behind them, but looked like stars that suddenly were flying across space.

Sailing ship *Hans* (Captain Külsen, 28°36′ W, 10°48′ S):
At 12h 30m an uncounted number of shooting stars passed over from NW to SE.

Sailing ship *J. C. Vinnen* (24°29′ W, 14°41′ S):
At 12h 40m local mean time we observed a strikingly bright star in the direction NWbyN, at an altitude of about 10° above the horizon. This star grew in size and brightness as we watched and eventually burst apart in a bright shower, and after this from the same direction came over 100 meteors, some of them very bright with long tails. Their path was from Orion to the Southern Cross, which they traversed in 20 seconds. The last and less bright came at 12h 50m.

These last seven ship accounts, all previously unknown, extend the ground track to more than 7000 miles [11,000 km]—more than ¼ of the way around Earth (Fig. 6.13).

Table 6.3 Meteor processions

Date	Ground track
1783 August 18	Scotland, England, English Channel, France
1860 July 20	Wisconsin, Michigan, Ontario, western New York, Pennsylvania, eastern New York, Atlantic Ocean
1876 December 21	Kansas, Missouri, Illinois, Indiana, Ohio, Pennsylvania
1913 February 9	Alberta, Saskatchewan, Manitoba, Minnesota, Michigan, Ontario, New York, Pennsylvania, New Jersey, North Atlantic Ocean, South Atlantic Ocean

This shows how archives can provide new information even 100 years after a spectacular celestial event. To travel so far around the curvature of Earth, the individual members of the 1913 meteor procession apparently followed tracks similar to the gradual reentry of satellites in low Earth orbit. The lack of precise altitude and speed information from 1913 means that we cannot accurately determine the Solar System orbit of the parent meteoroid before it was captured to become a temporary "mini-Moon" of Earth. To explain how the individual meteors became so spread out, taking several minutes for the procession to pass by each observing location, John O'Keefe suggested that the parent body fragmented in the lower atmosphere on the revolution immediately prior to the one that was observed (O'Keefe 1961, p. 564). The individual smaller bodies would then proceed around Earth on orbits with slightly different heights and periods and would reenter the lower atmosphere one revolution later to form the procession that amazed observers from Canada to the South Atlantic.

Walt Whitman and a Meteor Procession

Table 6.3 lists the meteor processions recorded during the last three centuries, with the 1913 event by far the most spectacular. As detailed in the author's first *Celestial Sleuth* book (Olson 2014, pp. 332–344), the meteor procession on July 20, 1860, has a special interest because the group of fireballs inspired Walt Whitman to write "Year of Meteors," a poem with lines about "the strange huge meteor-procession, dazzling and clear shooting over our heads … it sail'd its balls of unearthly light over our heads, Then departed, dropt in the night, and was gone."

References

Bennett, J. A. (1976) Discoverers of Nebulae. *Journal for the History of Astronomy* **7** (No. 1), 67.

Chant, Clarence A. (1913a) An Extraordinary Meteoric Display. *Journal of the Royal Astronomical Society of Canada* **7**, 145-215.

Chant, Clarence A. (1913b) Further Information Regarding the Meteoric Display of February 9, 1913. *Journal of the Royal Astronomical Society of Canada* **7**, 438-447.

Chen, James L., and Adam Chen (2015) *A Guide to Hubble Space Telescope Objects.* New York: Springer.

Cook, William B. (1908) Notes for a New History of Stirling, Part VI, The Battle of Stirling Bridge, the Kildean Myth. *The Stirling Antiquary* **4**, 116-140.

Darquier, Antoine (1782) *Observations Astronomiques Faites à Toulouse par M. Darquier, Deuxième Partie.* Paris: Laporte.

Denning, William F. (1915) The Great Meteoric Stream of February 9, 1913. *Journal of the Royal Astronomical Society of Canada* **9**, 287-289.

Denning, William F. (1916) Great Meteoric Stream of February 9th, 1913. *Journal of the Royal Astronomical Society of Canada* **10**, 294-296.

European Southern Observatory (2016) "Ring nebula M57 (NGC 6720)." https://www.eso.org/public/outreach/eduoff/cas/cas2002/cas-projects/germany_m57_1/

Fergusson, James (1948) *William Wallace, Guardian of Scotland.* Stirling: Eneas Mackay.

Feyel, Gilles (1991) Gazette de France (1631-1792) in *Dictionnaire des Journaux, 1600-1789.* Paris: Universitas.

Feyel, Gilles (2013) private communication.

Flammarion, Camille (1882) *Les Étoiles et les Curiosités du Ciel.* Paris: Marpon and Flammarion.

Hamilton, Hans Claude, ed. (1849) *Chronicon Domini Walteri De Hemingburgh, Volume II.* London: Sumptibus Society.

Histoire de L'Académie Royale des Sciences (1779) Mémoire contenant les observations de la XVII.ᵉ Comète, Observée à Paris, de l'Observatoire de la Marine, depuis le 18 Janvier jusqu'au 17 Mai 1779. *Histoire de L'Académie Royale des Sciences, Année 1779*, 318-372.

Humboldt, Alexander von (1850) *Kosmos, Band III.* [German] Stuttgart and Tübingen: F. G. Cotta Verlag.

Humboldt, Alexander von (1852) *Cosmos, Volume III, Part II.* [English translation] London: Longman, Brown, Green, and Longmans, and John Murray.

Hydrographic Department, Admiralty (1881) *Tide Tables for the British and Irish ports for 1882.* London: Hydrographic Department, Admiralty.

Jones, Kenneth Glyn (1991) *Messier's Nebulae and Star Clusters.* New York: Cambridge University Press.

Mackay, James (1995) *William Wallace, Brave Heart.* Edinburgh: Mainstream Publishing Co.

Mallas, John H., and Evered Kreimer (1978) *The Messier Album.* New York: Cambridge University Press.

Mebane, Alexander D. (1956) Observations of the Great Fireball Procession of 1913 February 9, Made in the United States. *Meteoritics* **1** (No. 4), 405-421.

NASA/ESA Hubble Space Telescope (2013) heic1310 – Photo Release, Most detailed observations ever of the Ring Nebula, May 23, 2013. https://www.spacetelescope.org/news/heic1310/

O'Keefe, John A. (1961) Tektites as Natural Earth Satellites. *Science* **133** (No. 3452), 562-566.

O'Keefe, John A. (1968) New Data on Cyrillids. *Journal of the Royal Astronomical Society of Canada* **62**, 97-98.

Olson, Donald (2014) *Celestial Sleuth: Using Astronomy to Solve Mysteries in Art, History and Literature*. Springer Praxis: New York.

O'Meara, Stephen James (2014) *The Messier Objects, Second Edition*. New York: Cambridge University Press.

Pickering, William H. (1923) The Meteoric Procession of February 9, 1913. *Popular Astronomy* **31**, 443-449.

Steinicke, Wolfgang (2010) *Observing and Cataloguing Nebulae and Star Clusters*. New York: Cambridge University Press.

Stevenson, Robert (1828) On the best means for improving the river Forth from Alloa to Stirling. Reprinted in 1841 in *The Civil Engineer and Architect's Journal* **4**, 229-230.

Stoyan, Ronald (2008) *Atlas of the Messier Objects, Highlights of the Deep Sky*. New York: Cambridge University Press.

United Kingdom Hydrographic Office (2016) Admiralty EasyTide online tidal prediction service, www.ukho.gov.uk/easytide.

7

World War II and the Korean War

Astronomy played significant roles in many of the important battles in military history. The author's previous book (Olson 2014) discussed examples from World War II, and this chapter presents new results for events from that war and also from the Korean conflict.

In the early days of World War II, the British battleship HMS *Royal Oak* exploded in the sheltered harbor of Scapa Flow in the Orkney Islands at the northern end of Scotland. This disaster on the night of October 13–14, 1939, took the lives of 833 sailors. Did a German U-boat somehow gain entrance to Scapa Flow? Or, as many British sailors contended in the following decades, was this the result of sabotage? Are the German accounts of a submarine attack accurate, or were they just wartime propaganda?

Would a German submarine commander want his U-boat to be concealed in the darkness of a new Moon, or would he want to see the targets in the brightness of a full Moon? What was the lunar phase that night? Was the Moon unusually close to Earth or far from Earth? How did the lunar distance affect the tide levels and the possibility of a submarine making a successful entry into Scapa Flow? Can we explain why many previous authors described the Scapa Flow tide levels and tidal streams incorrectly? What is the connection between a bright aurora borealis and the sinking of the *Royal Oak*? Does the scientific evidence regarding three specific points—the Moon's phase and distance, the aurora borealis, and the direction of the tidal stream—support the German accounts, or does this analysis prove that the U-boat commander's story is just an elaborate fabrication?

Why was June 6, 1944, chosen as the D-Day date for the invasion of Normandy? What was the importance of the lunar phase and the tidal conditions? The first unit to go into action on D-Day consisted of British soldiers carried on gliders that descended silently onto French soil just after midnight, more than 6 h before the amphibious landings began at Utah Beach and Omaha Beach. The British glider-borne forces carried out a daring and spectacular night assault that successfully captured crucial bridges inland from the landing beaches. Did these airborne troops want the darkness of a new Moon or the illumination of a bright full Moon in the sky? Can eyewitness accounts from the participants in the airborne assault clarify the importance of moonlight conditions for the glider pilots tasked with landing next to the bridges? What was the lunar phase on D-Day? Many later authors

© Springer International Publishing AG 2018
D.W. Olson, *Further Adventures of the Celestial Sleuth*, Springer Praxis Books,
https://doi.org/10.1007/978-3-319-70320-6_7

have insisted on the importance of a "late-rising Moon" for the D-Day invasion. Are these authors correct? When did the Moon rise?

During the Korean War, the U. S. Marines fought a legendary campaign in bitterly cold conditions near the Chosin Reservoir, known thereafter as "Frozen Chosin." On a cold night in December 1950, they spied a single star in the sky above the mountains near the town of Koto-ri. After the war, why did the veterans group known as The Chosin Few choose this star as their logo? In May 2017 a ceremony dedicated the Chosin Few Memorial, adjacent to the National Museum of the Marine Corps in Virginia. At the top of the monument is a sculpture depicting the iconic symbol: the "Star of Koto-ri." In what part of the sky did it appear? Was it a star or a bright planet? Can astronomical analysis identify the "Star of Koto-ri"? Why was this celestial body so important?

World War II: U-47 and HMS *Royal Oak*

In the sheltered harbor of Scapa Flow (Fig. 7.1) in the Orkney Islands at the northern end of Scotland, a series of explosions on the night of October 13–14, 1939, sank the British battleship HMS *Royal Oak* (Fig. 7.2). Was this the result of German U-boat action or, as many British sailors contended, of sabotage? German publications described how the submarine U-47 carried out this daring attack. Are these German accounts accurate, or were they just wartime propaganda?

British sailors from the *Royal Oak* insisted that the night was very dark. Then how could the lookouts on a submarine see a target at the claimed range of 3000 m? Did the Germans concoct a story about spotting the battleship at that extreme distance? What was the phase of the Moon that night? What is the connection between the direction of magnetic north, a bright aurora borealis, and the sinking of the *Royal Oak?*

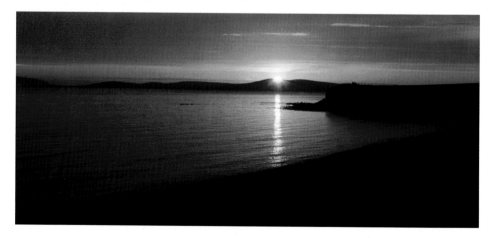

Fig. 7.1 Sunset at Scapa Flow in the Orkney Islands, at the northern end of Scotland (Photograph by Alan Guthrie. Used with permission)

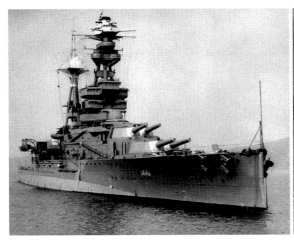

Fig. 7.2 HMS *Royal Oak* in pre-war photographs

The German commander Günther Prien described how the U-47 could barely escape from Scapa Flow because the submarine was opposed by a very strong tidal current running into the harbor. But many authors writing from the Allied side have asserted that Prien could not be telling the truth about this. According to the tide tables, the water level inside Scapa Flow was falling, and these writers deduce that the tidal stream must have been running *out* of the harbor. Does a hydrographic calculation support Prien's description, or can we demonstrate that he invented this part of the German story to make his account more dramatic?

Does the scientific evidence regarding three specific points—the Moon's phase and distance, the aurora borealis, and the direction of the tidal stream—support the German accounts, or does this analysis prove that the U-boat commander's story is just an elaborate fabrication?

Was the U-47 even in Scapa Flow that night?

Scapa Flow Harbor

During the early days of World War II, the British Royal Navy considered that their fleet could find a safe haven in Scapa Flow, a large harbor surrounded by several of the Orkney Islands. The British planned to improve anti-aircraft defenses to counter possible air attacks by the Luftwaffe but did not consider U-boats a significant threat, because booms and anti-submarine nets guarded the major entrances. The small gaps between some of the islands were protected by "block ships," old merchant ships sunk to obstruct these narrow and shallow channels leading into the main harbor. The British planners also judged that the extremely strong tidal currents in the minor channels would make navigation there by submarines impossible.

German Planning: Moon and Tides

Rear Admiral Karl Dönitz, commander of Germany's U-boat fleet in 1939, dreamed of sending a U-boat on a mission into Scapa Flow and agreed with the British that the "difficulties lay most of all in the extraordinary current conditions in the Scapa area." (Dönitz 1958, p. 69) However, he thought that an opportunity presented itself in one of the narrow channels leading into Scapa Flow. This location at first glance appeared to be "blocked by two merchant ships, apparently sunk, which lie diagonally across the channel of Kirk Sound, and another vessel lying on the north side of the other two," but the German admiral noticed: "To the south of them … is a narrow gap … To the north of the sunken merchant ships is another small gap. The shores on both sides are practically uninhabited. Here, I think, a penetration would be possible at night on the surface at slack water. The main difficulty lies in navigation." (Dönitz 1958, pp. 69–70) The term "slack water" refers to the time period when the tidal streams slow and briefly come to a stop before reversing direction. Dönitz judged that the "most favorable date for the operation appeared to me to be the night of October 13–14," in part because "there would be a new Moon." (Dönitz 1958, pp. 69–70).

Dönitz selected Günther Prien, commander of the U-47, for this mission (Fig. 7.3). Prien himself, along with his chief navigator and his first officer, worked with nautical charts, handbooks for mariners, hydrographic atlases, and nautical almanacs. For the best time to make the attempt, each of them independently found the same date preferred by Dönitz: the moonless night of October 13–14, 1939. (Snyder 1978, p. 72).

Scapa Flow and a "Supermoon"

The darkness of a new Moon period would help to conceal the U-47 from the British. The astronomical conditions on the chosen date also provided another remarkable benefit: one of the highest tides of the entire year. An exceptionally high tide would help the submarine to avoid becoming grounded while trying to pass through the shallow waters of Kirk Sound.

Fig. 7.3 LEFT: The U-47 leaving port. RIGHT: Günther Prien on the conning tower of the U-47

Table 7.1 Perigean spring tides produced by a "supermoon"

October 11, 1939	Lunar perigee
October 12, 1939	New Moon
October 13–14, 1939	Exceptionally high tides help U-47 to enter Scapa Flow

Spring tides are those of increased range occurring twice monthly near the times of new Moon and full Moon, when the alignment of Sun, Moon, and Earth, known as a syzygy, allows the tide-raising forces of the Moon and Sun to combine for a greater net effect. Perigean tides of increased range also occur monthly when the Moon is near perigee, the point in its orbit where the Moon is nearest Earth and the lunar tide-raising force is greatest. If the time of lunar perigee falls near either a new Moon or full Moon, then perigean spring tides with exceptionally large range can occur. Instead of technical terms like perigee and syzygy, the popular press now uses the term "supermoon" when a new Moon or full Moon nearly coincides with a lunar perigee.

Astronomer Bradley E. Schaefer has studied the influence of the Moon on events during World War II (Schaefer 1994, p. 87) and pointed out for the Scapa Flow attack that "Prien chose a New Moon night where the Moon was closest to Earth in its orbit (at perigee) and the spring tide would be at its extreme high." (Schaefer 2005, p. 1151).

Table 7.1 lists the astronomical events that produced the tidal conditions favorable for the German attempt.

Two British eyewitnesses observed this unusual tide. At about 11 p.m. on October 13th, more than an hour before the U-47 attempted its passage into Scapa Flow, Warden Alfred Flett of the Civil Defense was walking along the shore of Kirk Sound and noticed that "there was a very high tide." (Weaver 1980, p. 38) At about 12:20 a.m. on October 14th, taxi driver Robbie Tullock was driving along the shore in the town of St. Mary's at the west end of Kirk Sound. Tullock did not see the U-47, then passing by on the surface, but the German crew later said that they saw his car and worried that the driver had spotted the submarine when a beam from his single headlight shone out across the sound. Tullock did notice the water level at the shore and was surprised because "I had never seen such a high tide there before." (Weaver 1980, p. 46).

The exceptionally high tide level helped to make possible what many in the Royal Navy had considered unthinkable—the passage of a U-boat through the narrow and shallow Kirk Sound channel into Scapa Flow.

Prien's Accounts

The German version of the Scapa Flow mission comes from several sources. Prien gave newspaper and radio interviews shortly after the return to Germany. More details appeared in the U-47's log (Prien 1939), formally known as the *Kriegstagebuch* (Daily War Diary). Prien also wrote a memoir (Prien 1940) with assistance and some embellishment from the ghost writer Paul Weymar.

According to Prien's accounts, the U-47 surfaced east of the Orkney Islands at 11:31 p.m. on October 13th and set a course toward Scapa Flow. Aided by an incoming tidal stream that began to run shortly after midnight, the submarine's passage through Kirk Sound at first proceeded at incredible speed. Passing to the north side of the block ships, the U-47 grounded briefly on some cables but managed to get free. At 12:27 a.m. Prien recorded in his log the famous words: "*Wir sind in Scapa Flow!!!*" ("We are in Scapa Flow!!!") (Prien 1939).

The U-47 first headed west into the harbor, but, after finding no targets in that direction, Prien headed back east and then north. The submarine's lookouts then spotted what the log described as two battleships. This was actually the single battleship HMS *Royal Oak*, with the second ship most likely the seaplane carrier HMS *Pegasus*.

Prien estimated the range as 3000 m, set his torpedoes to run at a depth of 7.5 m, and fired a spread of three torpedoes. After an agonizing interval of 3½ min, one torpedo detonated near the bow of *Royal Oak* and sent a column of water into the air, while nothing was seen of the other two.

To the amazement of the German crew, there was no reaction! The British officers, not even considering the possibility of a U-boat inside their sheltered harbor, judged that an internal explosion had occurred in the storeroom for inflammable materials, located near the bow, and that the matter was not serious.

While the crew was reloading the forward torpedo tubes, the U-47 turned around and fired once from a stern tube, with no result. Prien turned around yet again and fired another spread of three from the forward tubes (Fig. 7.4). As recorded in the U-47 log: "Three shots from the bow. Three minutes after the firing came detonations on the nearer ship. There were tremendous roars, bangs, crashes, and rumbling. First water columns, then pillars of fire, and fragments flew through the air." (Prien 1939).

Prien's memoir described the events more vividly:

Then something occurred that no one had anticipated, and no one who had seen it would ever forget for the rest of their life. A wall of water shot up into the sky. It was as if the sea suddenly rose up. Loud explosions came one after the other like a heavy bombardment in a battle and coalesced into one mighty ear-splitting crash. Flames sprang up skyward—blue—yellow—red. The heavens disappeared behind this hellish fireworks display. Black shadows flew like huge birds through the flames and splashed into the water. Fountains that were yards high sprang up where the huge fragments had fallen … I could not take my eyes from the glass. It was as if the gates of hell had suddenly been torn open and I was looking into the flaming inferno. I looked down into my boat … I called down, "He's finished." (Prien 1940, pp. 182–183)

The U-47 immediately headed back east toward the open waters of the North Sea. According to Prien, a strong tidal stream was running into the harbor, so he coupled up the electric motors and the diesels, with both running at extreme emergency power ahead (German: "*Beide Maschinen äußerste Kraft voraus!*") during the escape. (Prien 1940, p. 184) Prien's preliminary report to Dönitz briefly summarized the mission:

The passage both entering and returning was possible, under great difficulties. There was only a very small gap by the block ships; there were very strong currents;

Fig. 7.4 The final salvo of three torpedoes from the U-47 produced multiple explosions on HMS *Royal Oak* (Illustration by Michel Guyot. Used with permission)

and during the exit from the harbor we encountered a 10-knot current running against us … Three hits on the Royal Oak. The ship exploded within a few seconds. (Dönitz 1958, p. 70)

Or Was It Sabotage?

Doubts about Prien's version of the events began almost immediately and persisted for decades after the war. Alexandre Korganoff described the controversy:

… some survivors of the Royal Oak *remain convinced that Prien never entered Scapa Flow … The theory of sabotage or accidental explosion has numerous supporters especially among those who escaped from the* Royal Oak *… certain former sailors from* Royal Oak *remain convinced that no submarine had ever penetrated Scapa Flow. Expressing the opinion of numerous comrades, Mr. Arthur W. Scarff declared to journalists his conviction that the ship had not been torpedoed. Mr. Ellis Clarke stated that he would maintain, for his part, to the end of his days that the battleship had been blown up by sabotage.* (Korganoff 1974, pp. 198–200, 217)

In October 1939, only a few days after the *Royal Oak* sinking, newspaper reporters from the London *Daily Express* listened to a German radio broadcast and branded Prien's account as "a fake." After hearing Prien's radio interview in an English language version on the BBC, several *Royal Oak* survivors called him a "bloody liar" and insisted that "most of the broadcast was at such variance with their experience that they concluded, like the *Daily Express*, that it had been made by someone without any personal knowledge of the raid." (Weaver 1980, p. 130).

Gerald Snyder described a post-war reunion at which the British sailors were "still doubting the sinking was the work of U-47" and reiterating "their belief the *Oak* was not sunk by a submarine at all." (Snyder 1978, p. 227) Snyder also pointed out "talk of sabotage would grow and fester. 'Who Really Sank the *Royal Oak?*' newspapers and magazines would headline long after the war ... '*Was* it a submarine?' For years every survivor would be asked this last question." (Snyder 1978, p. 193).

H. J. Weaver interviewed many *Royal Oak* survivors for his book about the events in Scapa Flow:

> *Instantly, stories about sabotage were voiced: anything was preferable to accepting that a U-boat had penetrated the supposedly impregnable Home Fleet base. Even today, there are Royal Oak survivors who believe that this is the true explanation of the loss of their ship ... Even after all these years some of them still maintain that Lt. Prien's account is at such variance with the truth that there can be only one explanation: he never saw the inside of Scapa Flow* (Weaver 1980: jacket copy, 16)

Weaver noted one aspect of his research trips to the Orkney Islands: "...if you come across a group of men engaged in deep discussion it is an even chance that they are arguing about whether or not Lt. Prien ever saw the inside of Scapa Flow." (Weaver 1980, p. 165).

A recent study by Geirr Haarr also mentions the controversy, which included

> *... doubts on his achievement to the extent that British sources at times questioned that he had actually been inside Scapa Flow The sinking of the battleship Royal Oak by U47 at Scapa Flow has become one of the most controversial events of the early WWII at sea. This is partly because of the audacious way in which it was accomplished, partly because of the significance it had on the war at sea, but not least because of the many mysteries and legends surrounding the event.... some episodes remain unclear to this day.* (Haarr 2013, p. 160, 167, 176)

This chapter will use astronomical analysis to address two of the disputed aspects of Prien's story: the visibility that night in Scapa Flow and the direction of the tidal stream at the time when the U-47 supposedly escaped from the harbor.

Did Prien Lie About Spotting the Royal Oak?

Commander Prien, as noted in a preceding section, fired his first spread of torpedoes from a range that he estimated as 3000 m. He measured a running time of 3½ min for this first spread and about 3 min for his second salvo, apparently fired from a slightly closer range.

We can calculate the expected running time at a range of 3000 m because Dönitz directed the use of G7e electric torpedoes (Dönitz 1958, p. 70), with a known speed

through the water of 30 knots. (Weaver 1980, p. 53; Komstam 2015, p. 45) Standard conversion factors establish 30 knots as equivalent to 15.4 m per second. The calculated torpedo run time is therefore:

$$(3000 \text{ m}) / (15.4 \text{ m / s}) = 195 \text{ seconds} = 3 \text{ minutes 15 seconds},$$

a result in good agreement with Prien's observed times as recorded in the log book. This consistency check supports the range estimate of approximately 3000 m. Was the night bright enough for the German lookouts to spot a battleship at this distance?

Alexander McKee judged that the sighting as described was impossible because "the battleship herself was invisible from the Flow at anything over 250 yards." (McKee 1959, p. 6) McKee interviewed a *Royal Oak* crew member, Acting Petty Officer T. W. Blundell, who expressed his strong opinion that Prien was a "ruddy liar ... It was pitch black and cloudy; he couldn't have seen us from the distance he said he fired ... The U-boat story was cooked; it wasn't there." (McKee 1959, p. 149).

Alexandre Korganoff conducted interviews and collected an "avalanche of statements in favour of complete darkness." According to these witnesses, the scene that night was "pitch-black" and the "night was so dark that on the deck of *Pegasus* the men were knocking against one another ... survivors state that they heard men speaking without making them out, in the darkness." (Korganoff 1974, p. 225).

On a dark night during a new Moon period, how could the lookouts on the U-47 have spotted the *Royal Oak* at a range of 3000 m, a distance of almost 1.9 miles?

The Explanation: Magnetic North and a Brilliant Aurora

We can resolve this apparent contradiction regarding the visibility by considering three factors: an exceptionally bright display of the aurora borealis (the Northern Lights), the direction of magnetic north, and the compass heading on which the U-47 approached the *Royal Oak*.

In his first press conference after returning to Germany, Prien mentioned that he had experienced in Scapa Flow "the clearest night and the most extraordinary display of Northern Lights I have seen in fifteen years at sea." (*The New York Times*, October 19, 1939, p. 4) The U-47 log entry for October 13th made a brief reference to "light clouds, a very bright night, Northern Lights on the entire northern horizon." (Prien 1939).

The most detailed description of the sky appeared in Prien's memoir, *Mein Weg nach Scapa Flow*. Upon surfacing to the east of Scapa Flow, Prien first noticed the glow in the heavens:

> There was a strange brightness, not from the Moon, also not from a searchlight; we could not see the light source. It seemed as if below the horizon in the north an immense arch had been set on fire, illuminating the cloud bank above. The Northern Lights! It struck me like a blow. No one had thought of that. We had selected the night of the new Moon for the undertaking. And now it was already dimly lit and becoming ever brighter. For the north wind was blowing and was pushing the cloud bank away toward the south. (Prien 1940, p. 177)

As Prien was pondering whether the British might spot the U-47 in the bright conditions, First Watch Officer Engelbert Endrass studied the glow of the aurora and then calmly noted: "Good light for shooting, Herr Kapitänleutnant." (Prien 1940, p. 178).

Before the U-47 passed through Kirk Sound, Prien observed that the aurora had become even brighter:

> *The north wind had pushed the compact cumulus clouds away toward the south, and only a very thin veil of mist was trailing behind them across the sky. In this veil the Northern Lights showed ever brighter, with reddish-yellow and blue rays shooting up to the zenith of the heavens. It was a magic light, a light as on Judgment Day.* (Prien 1940, p. 179)

Prien focused on navigation as the submarine passed through the narrows of Kirk Sound, surrounded by dark hills. But after entering the main harbor of Scapa Flow, he again noticed the spectacular sky and its reflection in the waters below:

> *And then suddenly it became bright again. A bay opened up in front of us, wide and extending as far as to the horizon. Calm and still water, in which the burning heavens were mirrored. It was as though the sea was illuminated from below. "We are inside!" I said to those below.* (Prien 1940, pp. 179–180)

Prien was able to make out his target as a dark shape silhouetted against the bright aurora (Fig. 7.5):

> *It was a wide bay ... Slowly, looking around on all sides, we moved forward in the still water ... At last ... over there ... very close to the shore ... the mighty silhouette of a battleship! Solid, distinct, as if drawn with black ink against the glowing heavens: the bridge, the mighty funnel, and aft, like fine filigree, the tall, high mast ... closer we approached ... closer... The ship lay there like a sleeping giant. 'I believe that the ship is from the Royal Oak class,' I whispered.* (Prien 1940, p. 180)

Fig. 7.5 A brilliant display of the Northern Lights helped the crew on the conning tower of the U-47 to spot the silhouette of HMS *Royal Oak* in Scapa Flow on the night of October 13–14, 1939. Günther Prien's memoir described the scene (Illustration by Don Hollway. Used with permission)

In addition to these descriptions of the Northern Lights from the German side, a number of British reports confirm the presence of an aurora. The Royal Navy Board of Enquiry Report summarized the meteorological conditions: "The weather on the night of October 13th/14th was fine and clear and the sea calm. The night was fairly light and for periods the sky was lit up by the Aurora and Northern Lights." (Admiralty 1939, p. 2).

H. J. Weaver located additional British auroral observations and concluded:

...there is no doubt that the Northern Lights were active that night. The log of Southampton, patrolling east of the Shetlands, some 175 miles away, contains the entry: '2030 Observed the Aurora Borealis.' This is confirmed by the log of Jackal, one of her escorting destroyers: 'An excellent display of Northern Lights throughout the watch.' John Laughton, an Orkney resident, recalls seeing the 'Merry Dancers,' as they are known locally over Scapa Flow early that night.... (Weaver 1980, p. 35)

Weaver also interviewed taxi driver Robbie Tullock, who vividly recalled that "the night was so bright ... All the hills and fields were lit up ... he was surprised when I told him there had been no moon." (Weaver 1980, p. 39).

Our Texas State group realized that not only the brightness but also the compass direction of the auroral display could help to explain how the U-47 crew members were able to see the *Royal Oak*. The Northern Lights receive that name, of course, because they are generally brightest in the north. But the charged particles of the solar wind produce the glow in the atmosphere when they are directed toward "auroral ovals" around the Earth's magnetic poles, not the geographic poles. We consulted nautical charts of Scapa Flow from the 1930s and noted that the magnetic variation in 1939 was 14° W, that is, the direction toward magnetic north was 14° west of true north.

Wilhelm Spahr, the Chief Navigator of the U-47, prepared a *Wegekarte* (Route Map) with compass headings marked along the path of the submarine in Scapa Flow. At the time when Prien first spotted the *Royal Oak* almost directly ahead of the U-47, the submarine was running along the coast on a course directed 20° west of true north. Prien fired the final spread of torpedoes toward a direction 14° west of true north.

Therefore, when Prien and the others on the conning tower of the U-47 first saw the battleship and when they fired the fatal salvo, they were looking in almost exactly the same direction as the Northern Lights above the horizon and the bright reflections in the water "in which the burning heavens were mirrored."

The enhanced visibility in this direction explains how the lookouts on the U-47 could observe the *Royal Oak* at a range of 3000 m and agrees perfectly with Prien's statement that he saw "the mighty silhouette of a battleship! Solid, distinct, as if drawn with black ink against the glowing heavens"—the result of an exceptionally brilliant display of the Northern Lights on the night of October 13–14, 1939.

Did Prien Lie About the Tidal Stream?

The final spread of torpedoes struck home at 1:16 a.m. When the *Royal Oak* disappeared beneath the waves at 1:29 a.m., the U-47 had already turned around to make its escape from Scapa Flow. According to Prien's accounts, the submarine was then opposed by a strong incoming tidal current as the U-47 struggled to pass eastward through Kirk Sound and back into the open sea.

Prien's first brief report to his superiors mentioned that "during the exit from the harbor we encountered a 10-knot current running against us." (Dönitz 1958, p. 70) The log contained more details:

I decide to withdraw ... With engines at ¾ speed ahead we proceed on the course for departure. At first everything is easy up to Skaildaquoy Point. Then trouble begins again. The water level has fallen, and the current is incoming. With engines at slow and dead slow I attempt to get out. I must go on the south side in the narrows because of the water depth. The swirling eddies begin again ... with engines at slow (10 knots) I am standing still. With engines at half speed I pass by the southern block ship agonizingly slowly. The helmsman performs magnificently. With engines at ¾ speed, at full speed, and finally at emergency power forward we are free of the block ships barrier, then before me a pier! By hard rudder maneuvers we are also around it, and at 0215 hours we are again outside. (Prien 1939)

Prien's memoir contains the most dramatic account of the extreme measures required to make the escape against the incoming current:

"Couple up the electric motors, both engines extreme power ahead!" [German: "Beide Maschinen äußerste Kraft voraus!"] There was nothing more to do, only one thing: to get out of the witch's cauldron, and to bring the boat and the crew safely home. The hills closed in again at the narrows. The current, which here had the force of a raging torrent rushing into the bay, grabbed us and shook us from side to side. The engines were running at the maximum revolutions.

And then it was as though we could advance forward only at a snail's pace. At times we even seemed to be motionless, like a fish in a mountain stream, always staying in the same place ... we could not move forward. The boat was tossed from side to side "Extreme power ahead!" [German: "Äußerste Kraft voraus!"], I called out. "The engines are running at extreme power," came the reply from below. It was a nightmare, and there we lay, held fast by an invisible force ... Our boat shuddered in all the seams—it strained with all its strength against the current. We must do it ... we must get out ... agonizingly slowly the boat passed through the narrows. It was dark around us ... Then before us lay the sea. The great, broad, free sea—vast under the endless sky—and we are through! (Prien 1940, pp. 184–185)

Skeptical modern authors checked the tide tables and found that high water occurred before midnight. Prien's dramatic account of the incoming tidal stream therefore seemed impossible. How could the tide level inside Scapa Flow be falling, if the tidal stream was rushing into Scapa Flow at near-maximum speed? Common sense seemed to suggest that the tidal current should then be running out of the harbor, aiding Prien to make his escape. Did Prien lie about the direction of the tidal stream?

Alexander McKee thought that Prien's account of the escape, and in fact his entire story, could not be believed:

The tide was not coming in at ten knots; it was actually going out. The Tide Tables make that clear ... High tide in Kirk Sound ... was at about ten P.M. ... when Prien

was making his escape, the tide would have been going out fairly strongly. He would have had the tide with him, but what he describes is a desperate struggle against a tide race pouring into Scapa Flow … Prien was unscrupulous with regard to what he entered in the log … some of the most glaring errors in Prien's story cannot be accounted for in any way other than by the supposition that he was not there. (McKee 1959, pp. 181–182)

Gerald Snyder had the same opinion regarding Prien's statements about the current direction: "Prien was wrong: he had the current, he didn't have to fight it—the Tide Tables for the night of 13 October show he had a strong outgoing tide.".… (Snyder 1978, p. 155).

Lawson Wood was also skeptical of Prien's report and asserted that: "… the *U-47* had escaped from Scapa Flow on an outgoing tide." (Wood 2000, p. 99).

A recent analysis by Angus Konstam likewise argued that the U-47 log was not accurate: "The confusion in the diary continued. It claimed it was now low tide and the current was against the boat as it entered Kirk Sound. The tide was ebbing, but it was far from low tide, and the U-boat was actually helped along by the current." (Komstam 2015, p. 63).

Does a hydrographic calculation support Prien's description, or can we demonstrate that he invented this part of the German story to make his account more dramatic?

Tidal Stream Calculations

As this section will explain, a careful calculation demonstrates that Prien did correctly describe the direction of the current and that the skeptics regarding Prien's account of the tidal stream were all mistaken.

Between 1:30 a.m. and 2:15 a.m., as the U-47 made its escape to the east, the incoming tidal stream ran toward the west through Kirk Sound at near-maximum speed, just as Prien wrote in his log and his memoir. How could this be? How could the tide level inside Scapa Flow be falling, when the waters of the tidal stream were rushing rapidly through Kirk Sound *into* Scapa Flow?

The answer is related to the complicated nature of Scapa Flow, which had seven channels for entrance or exit: Kirk Sound, Skerry Sound, East Weddel Sound, and Water Sound on the east side, Hoxa Sound and Switha Sound on the south, and Hoy Sound to the northwest. Water could be rushing in through some of these channels and simultaneously rushing out through other channels, with the net effect on the water level inside Scapa Flow determined only by a detailed calculation.

We consulted a manual called the *British Islands Pilot, Hydrographic Office Publication Number 149*. This volume pointed out that the "great rapidity of the tidal current among the Orkneys makes a correct knowledge of their periods and velocities of the utmost importance to the mariner" and also emphasized the subtle point, missed by many later commentators, that "the slack-water does not coincide with high and low water, but depends more on local circumstances." (Hydrographic Office 1925, pp. 63–64).

This hydrographic manual used the standard port of Dover as a reference to calculate the behavior of the tidal streams in Kirk Sound, with the rule that the "east-going tidal current runs from 6¼ h before to ¼ h before high water at Dover, and the west-going tidal

currents from ¼ h before to 5¾ h after high water at Dover." The text emphasized "the great rapidity of the tidal currents through the narrows" of Kirk Sound. (Hydrographic Office 1925, p. 308).

The same rule and time differences appeared in another volume, entitled *North Sea Pilot, Part I, Comprising the Faeröes, Shetlands, and Orkneys*. The section for Kirk Sound advised mariners that the "west-going tidal stream begins a quarter of an hour before high water at Dover" and specified that the stream would run "at a rate of 8 knots, at springs," that is, near the times of new or full Moon. (Hydrographic Department 1934, p. 248) On the night of the *Royal Oak* disaster this current may have been even stronger than normal, perhaps reaching the speed of 10 knots described by Prien, because of the lunar perigee that fell near the time of new Moon.

Carrying out the tidal stream calculation correctly requires an understanding of the time systems employed in 1939. Because of the war, British Summer Time (1 h ahead of Greenwich Mean Time) remained in force in Britain until November 1939. Germany in 1939 did not employ Summer Time. However, the convention for U-boats operating any-where in the North Sea or the Atlantic Ocean was to remain on Berlin time, which in 1939 was 1 h ahead of Greenwich Mean Time. Tide tables in 1939 expressed the times of high and low waters in Greenwich Mean Time.

According to *The Admiralty Tide Tables, Tidal Predictions for the Year 1939, Home Waters*, high water at Dover occurred on October 13th at 11:23 p.m. Greenwich Mean Time, equivalent to October 14th at 12:23 a.m. British Summer Time. The west-going tidal stream began to run about ¼ h earlier and shortly after midnight (British Summer Time) acquired near-maximum speed.

Tide tables show that the high waters at several locations inside Scapa Flow did occur well before midnight. The *Admiralty Tide Tables* for 1939 predicted a time of 9:08 p.m. Greenwich Mean Time (10:08 p.m. British Summer Time) for high water at Stromness, and *Peace's Orkney Almanac 1939* predicted 10:01 p.m. Greenwich Mean Time (11:01 p.m. British Summer Time) for high water at St. Mary's, near the west end of Kirk Sound.

The counter-intuitive situation therefore prevailed as the U-47 passed eastward on its escape between about 1:30 a.m. and 2:15 a.m. British Summer Time. The water level was rapidly dropping at the same time when a strong west-going tidal stream was running through Kirk Sound into the harbor. We noted that a few authors did correctly describe the direction of the tidal stream and therefore did not question Prien's account of the tidal cur-rents during his escape.

Alexandre Korganoff consulted the French Navy Hydrographic Department and attempted to use their high and low water times to make a detailed calculation for the tidal streams. Korganoff then made some mathematical errors (for example, confusing 0.25 h with 25 min of time) and also failed to correct from Greenwich Mean Time to British Summer Time. Korganoff did correctly conclude that the current "was bearing to the west, that is, towards Scapa Flow" during Prien's escape. (Korganoff 1974, p. 70, pp. 171–174).

H. J. Weaver correctly faulted those previous authors who had merely looked up the times of high waters and then tried "to deduce from tide tables the flow of currents in complicated channels like the Orkneys." Weaver did not himself attempt a detailed numerical calculation of the tidal streams, but he did correctly note that "the sea flowed *into* Scapa Flow through the eastern entrances and *out* through the western entrances for most of the time that the tide was falling in the anchorage." (Weaver 1980, p. 22, pp. 35–36).

In addition to the calculations of our Texas State group and the qualitative opinions expressed by Korganoff and Weaver, an even more authoritative source exists to confirm the west-going direction of the tidal stream during Prien's escape. After consulting the hydrographic manuals, the authors of the Royal Navy Board of Enquiry Report concluded regarding the submarine that "if it entered by Kirk Sound ... and left as soon as the torpe-does were fired, the tide would then have been running against it, perhaps as much as 8 knots." (Admiralty 1939, p. 2).

Our tidal stream calculation, along with these sources, supports the accuracy of Prien's account when he described how the submarine struggled against the tidal current during the escape from Scapa Flow.

Confirmation and Churchill

Physical evidence also exists to prove that a German submarine penetrated Scapa Flow and sank the *Royal Oak*. Not far from the wreck of the battleship, divers have recovered propellers, gears, and electric motors of German G7e torpedoes with serial numbers corresponding to those employed in 1939 (Weaver 1980, pp. 167–169) and even some nearly intact German torpedoes (BBC 2016, p. 1). H. J. Weaver noted that these discoveries "help to disprove doubts about the truth of Kapitänleutnant Prien's ship's log." (Weaver 1980, pp. 167–169).

The astronomical and hydrographic results likewise indicate that Prien was telling the truth about three aspects subject to scientific analysis: the planning for an astronomical configuration that would produce exceptionally high tides, the visibility in the direction of the brilliant auroral display, and the encounter with a strong west-going tidal stream.

Winston Churchill himself, in his capacity as First Lord of the Admiralty during 1939, ordered that the eastern entrances be blocked by the construction of large structures now known as Churchill Barriers (Fig. 7.6). The bell of the *Royal Oak* has been recovered and now serves as part of a memorial (Fig. 7.7), but the battleship itself lies on the bottom of Scapa Flow, with the position marked by a green buoy (Fig. 7.8).

Churchill did not doubt that the HMS *Royal Oak* was sunk as a result of U-boat action. Only days after the Scapa Flow events, Churchill offered the following evaluation:

> *When we consider that during the whole course of the last war this anchorage was found to be immune from such attacks, on account of the obstacles imposed by the currents and the net barrages, this entry by a U-boat must be considered as a remarkable exploit of professional skill and daring.* (Churchill 1939, p. 4)

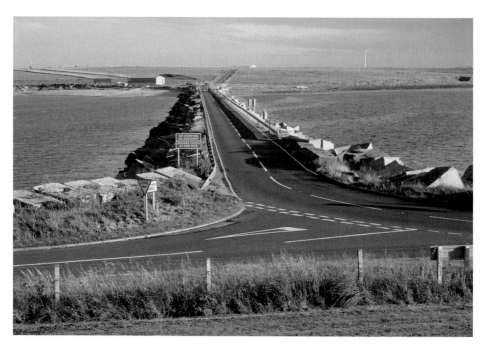

Fig. 7.6 This photograph from August 2015 shows Churchill Barrier Number One, which now completely blocks the Kirk Sound channel through which the U-47 entered Scapa Flow (Photograph by the author)

Fig. 7.7 Recovered from the seabed of Scapa Flow, the ship's bell from HMS *Royal Oak* is now part of a memorial at St. Magnus Cathedral in the town of Kirkwall (Photograph by Marilynn Olson. Used with permission)

Fig. 7.8 This buoy marks the location in Scapa Flow where HMS *Royal Oak* lies on the bottom. The text reads: "This marks the wreck of HMS *Royal Oak* and the grave of the crew. Respect their resting place. Unauthorised diving prohibited" (Photograph by the author)

D-Day 1944: Moon Over Pegasus Bridge

In the early morning hours of June 6, 1944, the complex operation code-named Overlord began to unfold. The Allies had assembled the largest seaborne invasion force in history, with an armada of 5000 ships and landing craft carrying 130,000 soldiers across the English Channel to the Normandy beaches. Airborne operations involved the American 82nd and 101st Divisions and the British 6th Airborne Division, with 24,000 troops carried into the night skies over Normandy by more than 1000 transports and gliders.

The first unit to go into action was a small British glider-borne force that embarked on a daring and spectacular night assault, code-named Operation Deadstick, more than 6 h before the amphibious craft reached Utah Beach and Omaha Beach. Each of the six Airspeed Horsa gliders carried a pilot, copilot, and approximately 30 soldiers. The troops that raced forward from the gliders included six platoons of the 2nd Battalion Oxfordshire and Buckinghamshire Light Infantry and sappers from the Royal Engineers, tasked with capturing and holding two crucial bridges inland from Sword Beach.

In order from west to east, the five landing beaches had the code names Utah (American forces), Omaha (American), Gold (British), Juno (Canadian), and Sword (British).

Importance of the Bridges

Sword Beach itself was bounded on the east by the natural obstacles formed by two parallel waterways: the Caen Canal and the River Orne. The two bridges closest to the coast were located on a half-mile-long stretch of road between the towns of Bénouville, where a bridge crossed the Caen Canal, and Ranville, where a bridge spanned the River Orne. The planners realized that seizing and holding these two bridges was one of the most critical aspects of the entire Overlord operation.

Fig. 7.9 Exhibits at the Memorial Pegasus museum in Bénouville commemorate the assault on D-Day, June 6, 1944. TOP: British troops rush from gliders to surprise and overwhelm the German defenders of the Caen Canal bridge. The building partially visible at the far right is Café Gondrée, often described as the first building in France to be liberated on D-Day. The full Moon shines among broken clouds in the southeastern sky. LOWER LEFT: The original 1944 Caen Canal bridge, now known as Pegasus Bridge. LOWER RIGHT: A small scale model of an Airspeed Horsa glider (Photographs by the author)

The German defenders could not be given any time to destroy the bridges by demolition charges, because such destruction would isolate the British 6th Airborne paratroopers east of the River Orne, would contain the Allied beachhead, and would impede a break-out inland by the seaborne forces. An essential element, therefore, was complete surprise by a glider-borne force descending silently from the night skies. In order that the German garrisons guarding the bridges not be alerted in any way, the glider assault had to be the first action taken on the morning of D-Day (Fig. 7.9).

Fig. 7.10 The shoulder patches worn by British airborne troops featured a mythological scene with the "airborne warrior" Bellerophon riding the winged horse Pegasus. The artist Edward Seago created this image, following a suggestion by the novelist Daphne du Maurier, wife of the commander of the 1st Airborne Division. Shortly after its capture, the Caen Canal Bridge became known as "Pegasus Bridge." This modern sign outside the Café Gondrée includes the design with Bellerophon and Pegasus (Photograph by the author)

The Bénouville Bridge became known by the name Pegasus Bridge because of the British airborne insignia, which featured a mythological scene with the "airborne warrior" Bellerophon riding the winged horse Pegasus (Fig. 7.10).

If the Germans retained control over the bridges, they could use the crossings to send reinforcements and armored divisions to attack the vulnerable Allied eastern flank, with perhaps "the ultimate catastrophe of panzer formations loose on the beaches, rolling them up, first Sword, then Juno, then Gold, then onto Omaha … failure at Pegasus Bridge might have meant failure for the invasion as a whole, with consequences for world history too staggering to contemplate." (Ambrose 1985, pp. 178–179).

General Richard Gale, commanding the British 6th Airborne Division, summarized the situation: "Our first task in order of priority was to seize intact the bridges over the Canal de Caen and the River Orne at Bénouville and Ranville." (Barber 2014:1).

Planning for Moonlight

The invasion planners later made it clear that they selected the specific date for D-Day based on astronomical reasons involving moonlight, the time of sunrise, and the effects of the lunar phase on the tides. The configuration of Sun and Moon determines both the strength of the tides and the times of high and low waters. The Allies required a low tide near sunrise, and, on this part of the Normandy coast, such a tide occurs only near the times of either new Moon or full Moon. A section in the author's previous *Celestial Sleuth* book discussed the D-Day tides. (Olson 2014, pp. 252–262).

General Dwight D. Eisenhower, Supreme Commander of the invasion forces, mentioned the importance of moonlight: "… the next combination of moon, tide, and time of sunrise that we considered practicable for the attack occurred on June 5, 6, and 7. We wanted to cross the Channel with our convoys at night…. We wanted a moon for our airborne assaults." (Eisenhower 1948, p. 239).

Prime Minister Winston Churchill explained the astronomical factors in his memoirs:

> *It was agreed to approach the enemy coast by moonlight, because this would help both our ships and our airborne troops …. Then there were the tides …. Only on three days in each lunar month were all the desired conditions fulfilled. The first three-day period … was June 5, 6, and 7…. If the weather were not propitious on any of those three days, the whole operation would have to be postponed at least a fortnight—indeed, a whole month if we waited for the moon.* (Churchill 1951, p. 591)

Admiral Chester W. Nimitz, in his account of the U. S. Navy during World War II, emphasized the tide times but also noted that the Moon was considered when the invasion planners

> *… began to look for the combination of natural conditions most favorable for the landing. They desired a moonlit night preceding D-day so that the airborne divisions would be able to organize and reach their assigned objectives before sunrise …. The crucial requirement, to which the others would have to be geared, was the tide. It must be rising at the time of the initial landings so that the landing craft could unload and retract without danger of stranding …. Yet the tide had to be low enough that underwater obstacles could be exposed for demolition parties. The final choice was 1 h after low tide for the initial landings … Eisenhower accordingly selected June 5 for D-day, with H-hours ranging from 0630 to 0755 to meet the varying tidal conditions at the five assault beaches.* (Nimitz 1960, p. 166)

The Allies initially intended to invade on June 5th, but bad weather forced a postponement of one day, to the morning of June 6, 1944.

Calculating the Moon and Sun

Computer calculations show that a full Moon fell on June 6th, so the bright moonlight occurred just as planned (Fig. 7.11). (Olson and Doescher 1994, p. 85; 2012, p. 8).

According to our astronomical calculations for the Caen Canal Bridge near Bénouville (49° 15′ North Latitude, 0° 16′ West Longitude), the Moon had already risen into the sky about 1½ h before sunset on the preceding day (June 5th). The Moon then arced across the sky during the night of June 5th to 6th and reached its highest point in the sky for that night at 1:19 a.m.

The slanting moonlight was sufficient to illuminate the ground for the British glider forces as they began to land at 12:16 a.m. and for the parachute troops of the British 6th Airborne and the American 82nd and 101st Airborne as they started dropping from the sky between 12:50 a.m. and 1:30 a.m., following pathfinders who had jumped about the same time as the glider landings. Table 7.2 gives the timetable of events near both the bridges and the invasion beaches.

Fig. 7.11 As the airborne assault began in the early morning hours of June 6, 1944, a bright full Moon illuminated the scene (Photograph by Russell Doescher. Used with permission)

Table 7.2 Tide calculations for Omaha Beach and astronomical calculations for the Caen Canal Bridge near Bénouville, France (49° 15′ North Latitude, 0° 16′ West Longitude)

June 5, 1944	
8:30 p.m.	moonrise, Moon is 99% lit
10:01 p.m.	sunset
June 6, 1944	
12:16 a.m.	Horsa glider #91 lands at the canal bridge, bright Moon in southeastern sky
12:26 a.m.	Major Howard sends the radio message: both bridges captured intact
1:19 a.m.	lunar transit, Moon at its highest point in the sky for the night
5:15 a.m.	beginning of civil twilight
5:23 a.m.	low water exposes the beach obstacles on Omaha Beach
5:50 a.m.	naval bombardment of Omaha Beach begins
5:57 a.m.	sunrise
6:02 a.m.	moonset
6:30 a.m.	H-Hour for the first assault wave on Omaha Beach, on a rising tide
7:25 a.m.	H-Hour for the first assault wave on Sword Beach, on a rising tide
10:12 a.m.	high water covers Omaha Beach almost to the sea wall
1:00 p.m.	approximate time when Lord Lovat leads commandos inland from Sword Beach and they link up with the airborne forces at the canal bridge

The times are given in British Double Summer Time, 2 h ahead of Greenwich Mean Time, as employed by the Allied invasion forces

Fig. 7.12 The British employed six Airspeed Horsa gliders to land the assault forces near the Caen Canal and River Orne bridges. This full-size Horsa replica, built according to the original wartime plans, was unveiled at the Memorial Pegasus museum in 2004 for the 60th anniversary of D-Day (Photograph by Amanda Slater. Used with permission)

Training in the Moonlight on Salisbury Plain

Prior to D-Day, the members of the British Glider Pilot Regiment had practiced their skills for several months in the open land of Salisbury Plain. The planners selected Staff Sergeant James Wallwork for the important job of piloting the Airspeed Horsa glider (Fig. 7.12) that was expected to land first and closest to the canal bridge. Wallwork later described the progressive difficulty of the training flights, each of which began with the gliders pulled into the air by bombers based at Tarrant Rushton airfield and ended as they descended to landing zones at a wood called Holmes Clump near the town of Netheravon, north of Salisbury:

> *Tugs, gliders and D Company had trained for three months so by June we were all rather good and knew it. Glider and tug training started in March, graduating from 4,000 feet in daylight to daylight with night-goggles, night with flares, then to 6,000 feet and moonlight only. From Tarrant Rushton airfield to Holmes Clump outside Netheravon, night after night, through complete moon periods. With the least sliver of moon we could see enough to land. Doesn't take much moonlight to make earth look like daylight from 6,000 feet.* (Wallwork 1999, p. 2)

By early May they were "flying by moonlight, casting off at six thousand feet, seven miles from the wood … They did forty-three training flights in Deadstick altogether, more than half of them at night." (Ambrose 1985, p. 62).

The glider training flights used cement blocks as ballast instead of carrying soldiers, because of the risk that a crash landing might injure the elite troops undergoing special

training for the bridge assaults. Wallwork recalled one exception made, probably near the full Moon of May 8, for a high-ranking officer:

> *Air Vice-Marshal Sir Leslie Hollinghurst, who exercised overall command of the Air Transport Groups, had expressly forbidden any live-load or passengers on Deadstick for any reason whatsoever. He was the only one to break the rule, jumping into my glider a moment before take-off time one lovely full-moon night. He enjoyed the trip, standing in the cockpit until seconds before touchdown, so that night we managed a 'perfect' for him.* (Barber 2014, p. 32)

For a newspaper story published on the 65th anniversary of D-Day, Wallwork again emphasized the importance of the training: "The outstanding thing was how bloody good we were at night. With a slight bit of moon we could put a glider anywhere you wanted, simply because of practice." (Owen 2009, p. 3).

Wallwork recalled that they "flew as long as there was any moon at all … Our time off was the few days between moon periods." (Barber 2014, pp. 30–31) One such hiatus in night training would have been for several days near the new Moon of May 22, 1944. The glider crews made their last practice flight on May 29th. (Barber 2014, p. 46).

D-Day: Moon Over Pegasus Bridge

At 10:56 p.m. on June 5th at Tarrant Rushton airfield, the engines of the massive Halifax bombers serving as tugs changed from a steady hum to a deafening roar, and by 10:59 p.m. the lead glider #91 had been pulled into the air (Barber 2014, p. 66). Gliders #92 through #96 followed at short intervals, with the first three craft intended to assault the Caen Canal Bridge and the last three gliders assigned to the River Orne Bridge. In the moonlight over England, the groups formed up and headed out for the one-hour flight over the Channel to Normandy. James Wallwork, pilot of glider #91, realized when his tug had reached France and he then "anticipated casting off, because in the light of the full moon through the clouds he had glimpsed the surf breaking on the Normandy coastline." (Fowler 2011, p. 28).

During the descent, glider #91 had to execute three legs to reach the canal bridge: first a downwind leg nearly south for almost 4 min, then a right turn to proceed crosswind and nearly west for about 2 min, and finally another right turn to head north toward the landing zone near the bridge. At first broken clouds covered the Moon, and James Wallwork and his co-pilot John Ainsworth could not see the landmarks on the ground below. With the benefit of the long months of training, they navigated with a compass and stopwatch. (Fowler 2011, pp. 30–31) Then the Moon shone from between the clouds, as Wallwork later described the scene: "And there are the river and canal like silver ribbons in the moonlight." (Wallwork 1999, p. 2).

Wallwork remembered the near-total silence in the glider: "The men had been singing, but as soon as we reached the French coast everything went quiet. There was silence for the last few minutes. It was a lovely night. In full moon we could see every twig, every cow. The waterways were like streaks of silver." (Owen 2009, p. 3).

Wallwork no longer needed to rely on only dead reckoning by compass and stopwatch: "Halfway down the crosswind leg, I could see. I could see the river and the canal like strips of silver and I could see the bridges; visibility was awfully good." (Barber 2014, p. 78).

With pardonable exaggeration, Wallwork later described the moonlit scene as glider #91 approached the canal bridge objective: "I could see the target. The Moon was on it. I could see the bridge. I could see the whites of their eyes almost." (James Wallwork interview in the short film shown at the Memorial Pegasus museum.)

Wallwork's glider was the first to land. His remarkable feat of flying removed some of the barbed wire defenses only about 150 feet from the canal bridge:

> *I can see my target now … There it is, straight ahead, but it's not Holmes Clump tonight. It's by guess and by God from here. Too high, half-flap and steady at 90. Still too high, so full-flap, and now we're coming in a bit quick. Touch down at the edge of our field removing what must have been a fence, then a hedge which didn't slow us down either … By now we are rolling head and nose down as the front wheel was removed … We are now heading at what is possibly the right speed straight for the embankment. The right speed to breach the wire and be far enough up the field to leave room for numbers two and three which are following.* (Wallwork 1999, p. 2)

The sudden stop pitched Wallwork forward out of the cockpit, and he thereby became possibly the first member of the Allied forces to touch French soil on D-Day (competing claims could come from pathfinders landing at about the same time to set up beacons in the drop zones for the paratroopers). Gliders #92 and #93 followed quickly into this landing zone (Fig. 7.13), and the British soldiers quickly overwhelmed the German defenders of the canal bridge.

The group at the River Orne Bridge had similar success, with their descent likewise aided by the moonlight. Describing the view from his vantage point in glider #95, Lieutenant Henry Sweeney recalled: "You could see the moon shining on the river as we went down along the river … saw the bridge in front of me …" (Barber 2014, p. 97).

Staff Sergeant Roy Howard, the pilot of glider #96, remembered: "As we made our third change of course and were down to 1200 feet, I could suddenly see the parallel waterways of the Caen Canal and River Orne glistening silver in the diffused moonlight glowing from behind the clouds." (Barber 2014, p. 74).

Within about 10 min after landing, Major John Howard was able to transmit the famous coded message "Ham and Jam," signifying that both bridges had been captured intact. The difficult task now became holding the bridges against determined German counterattacks. Memorable scenes from the 1962 film *The Longest Day* include Major Howard (played by Richard Todd) recalling his order to "Hold until relieved," and the seaborne commandos of Lord Lovat (played by Peter Lawford) landing at Sword Beach, fighting their way inland, and linking up with Howard's men at the bridge (Fig. 7.14). With a flair for the dramatic, Lovat had his commandos preceded by bagpiper Bill Millin playing "Blue Bonnets over the Border."

A "Late-Rising" Moon?

The statements quoted above from Eisenhower, Churchill, and Nimitz make it clear that the planners insisted on the requirement for bright moonlight during the entire night, as the glider groups and parachute divisions first formed up in the air above England, then crossed the Channel, and finally descended onto French soil. As described in the preceding

Fig. 7.13 These photographs from June and July 1944 show the three Horsa gliders that landed near the Caen Canal bridge in the early morning hours of D-Day. In the photograph at the upper right, the bridge is barely visible behind the trees on the right, and Café Gondrée appears in the distance behind the line of trees on the left. The photograph at the lower right shows the reverse view, with the Horsa gliders in the landing zone beyond the trees on the right. (© IWM B 7033, IWM B 7033, IWM B 5232, and IWM B 5288) (Photographs courtesy Imperial War Museum, London. Used with permission)

sections of this chapter, the Moon was near its highest point in the sky, exactly as planned, at the times when the gliders and paratroopers were approaching their landing zones and drop zones in Normandy.

Yet somehow many of the books and articles about D-Day got this point completely backwards. These authors mistakenly imagined that the planners wanted a dark night as the airborne divisions approached their targets. Many of these authors used almost identical language in asserting erroneously that the Moon was "late-rising." The astronomical calculations in Table 7.2 show the Moon actually rose very *early*—moonrise occurred about 1½ h before sunset on the preceding day (June 5th), and the Moon remained in the sky during the entire night of June 5th to 6th, 1944.

As an example of this misconception regarding the time of moonrise, Cornelius Ryan stated in his classic book *The Longest Day*: "The paratroopers and glider-borne infantry who would launch the assault ... needed the moonlight. But their surprise attack depended on darkness up to the time they arrived over the dropping zones. Thus their critical demand was for a late-rising moon." (Ryan 1959, p. 57).

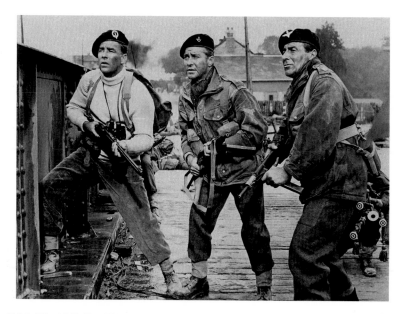

Fig. 7.14 The 1962 film *The Longest Day* includes memorable scenes of the glider assault at Pegasus Bridge. This publicity photograph depicts Lord Lovat (played by Peter Lawford), Major John Howard (Richard Todd), and Private Coke (Frank Finlay) defending the bridge from a German counterattack

Edward Ellsberg made the same mistake and offered an incorrect estimate for the time of moonrise in his discussion of a "late rising moon ... Eisenhower wanted no moon at all till well after midnight, thus to mask from the enemy the approach to the drop zone of the troop-carrying planes and gliders ... on June 5 (and June 6 also) we got what we wanted ... a moon rising about 0130, which was just what the paratroopers wanted to allow darkness to shield their approach and then moonlight to light their drop." (Ellsberg 1960, pp. 181–182).

A *Life* magazine story in 1969 agreed that D-Day was "an invasion timed by Eisenhower to give his troops full advantage of a late-rising moon." (Silk 1969, p. 36) John M. Collins wrote in 1998 that the airborne assaults were timed "to take full advantage of a late-rising moon that would allow transport pilots to approach in darkness." (Collins 1998, p. 361).

Willem Ridder in 2007 described the factors involved for the invasion and asserted erroneously that the planners wanted a "late moonrise ... the paratroopers who would lead the assault had to arrive above their diving site during a perfectly dark night in order to preserve the effect of surprise ... there were only 6 days in June when the tide would be low at the right time, and of these 6 days, only 3 would have moonless nights." (Ridder 2007, p. 413).

Bruce Parker in 2011 surveyed the scientific constraints for D-Day and used similar language: "the paratroopers had to land in darkness ... there had to be a late-rising Moon." (Parker 2011, pp. 38–39).

National Geographic in 2012 co-sponsored an expedition to France that included a visit to the invasion beaches. A Daily Expedition Report included: "Normandy Beaches, France … There was also a need for a dark moonless night so that the paratroopers could land behind the German lines, as well as a late rising full moon." (National Geographic 2012, p. 1).

A teacher's guide prepared in 2013 by the National Math + Science Initiative advised science instructors to use D-Day as a "historical, real-world scenario in a cross-curricular context" combining history and astronomy. The students should learn the reasons why "there had to be a late-rising Moon." (NMSI 2013, p. iii).

Jonathan Mayo in 2014 published a detailed timeline for the D-Day events and mentioned that the "minimum requirements were for the paratroopers a late-rising moon." (Mayo 2014, p. 23).

The BBC in 2014 introduced an online archive of D-Day accounts with text that asserted "The Normandy landings … required specific meteorological conditions: a late-rising full moon, a receding tide." (BBC 2014, p. 1) The BBC here used its authoritative voice to make the additional erroneous claim that the planners wanted a "receding tide." As the quote above from Admiral Nimitz himself makes clear, it was a "crucial requirement" that the tide "must be rising at the time of the initial landings so that the landing craft could unload and retract without danger of stranding." (Nimitz 1960, p. 166) The BBC also employed the language about a "late-rising" Moon.

We wondered not only why so many authorities could be wrong about the astronomical requirements and the time of moonrise, but also why they used almost identical language claiming that there was a "late-rising" Moon. Many of the later authors may have simply copied from the passage in the best-selling book, *The Longest Day*, published in 1959 by Cornelius Ryan. But Ryan was not the first to make this mistake.

Eventually we located the primary source for this error in the memoirs of one of General Eisenhower's closest aides during World War II. Walter Bedell Smith served as Chief of Staff at the Supreme Allied Headquarters in 1944. Smith was a member of the select group present at the meetings on June 4th and June 5th when Eisenhower made the decisions to postpone the invasion for one day and then to proceed despite the uncertain weather. In 1946 Smith wrote a series of six magazine articles for the *Saturday Evening Post* to explain the reasoning behind the Allied actions for major events in the European theater. Smith's articles were later collected in a 1956 book entitled *Eisenhower's Six Great Decisions*. The first magazine installment, and the first chapter in the book, explained the selection of the date for D-Day:

First, we wanted low tide, so that the underwater and half-hidden beach obstacles could be seen and destroyed by our demolition crews. The low tide must be late enough in the morning for an hour's good daylight to permit the saturation bombing of defenses which would precede the landings themselves. But it must come early enough in the morning so that a second low tide would occur before darkness set in. Without the second low tide we could not land the follow-up divisions.

For the airborne landings behind Utah Beach and at road centers around Caen, timed for 0200 hours on D day, we needed a late-rising full moon, so the pilots could approach their objectives in darkness, but have moonlight to pick out the drop zones. (Smith 1946, p. 107; 1956, pp. 41–42)

Walter Bedell Smith's book was especially influential, and subsequent authors ever since have repeated this unfortunate error regarding a "late-rising" Moon.

Our astronomical calculations tabulated earlier show the Moon was definitely *not* "late-rising." Moonrise actually occurred very *early*—the Moon had already risen into the sky about 1½ h before sunset on the preceding day (June 5th). The Moon then remained in the sky during the entire night of June 5th to 6th, 1944.

Lunar Luck at Pegasus Bridge

Tidal and astronomical considerations, including moonlight for the airborne assaults, meant that the date of the Normandy invasion had to fall near a full Moon. Operation Deadstick on D-Day had lunar good fortune, with the broken clouds parting and the bright full Moon appearing just in time to direct James Wallwork and his Horsa glider to the perfect location at the barbed wire adjacent to the Caen Canal Bridge. Two more gliders followed into this landing zone, and others headed toward the nearby River Orne Bridge. The first unit to go into action in the early morning hours of D-Day raced forward from the gliders and captured intact both the river bridge, now known as "Horsa Bridge," and the canal bridge, to be known thereafter as "Pegasus Bridge."

Modern visitors to the Memorial Pegasus museum at the site can examine an impressive collection of artifacts inside, while the exhibits outside include the original 1944 bridge and a full-size replica of a Horsa glider (Fig. 7.15).

Chosin Reservoir, Korea, 1950: The Star of Koto-Ri

During the Korean War, the U. S. Marines fought a legendary campaign in bitterly cold conditions near the Chosin Reservoir, forever after known as "Frozen Chosin." In a book that surveyed the battle history of the Corps, Marine historian Colonel Joseph H. Alexander argued that "No Marines ever had to fight under worse sustained conditions" than those that prevailed near the reservoir in November and December 1950. (Alexander 1999, p. 284).

On a cold night in December 1950, they spied a single star in the sky above the mountains near the town of Koto-ri. After the war, why did the veterans group known as The Chosin Few choose this star as their logo (Figs. 7.16 and 7.17)? What was the importance of this celestial body? In what part of the sky did the star appear? Can an astronomical analysis allow the "Star of Koto-ri" to be identified?

The Chosin Reservoir Campaign

The 1st Marine Division had landed at the port of Wonsan on October 26, 1950. By November 10th the Marines had moved north into the mountains and occupied the towns of Chinhung-ni and Koto-ri facing no resistance. By November 24th they had reached Hagaru-ri and then Yudam-ni, on the western shore of the Chosin Reservoir. U. S. Army General Douglas MacArthur had the overall command of the U. N. forces, and some correspondents at his headquarters described the campaign as a "race to the Yalu" (the river

Fig. 7.15 This aerial photograph shows the Memorial Pegasus museum in the distance, the original 1944 Pegasus Bridge in its position on the museum grounds, and the full-size Airspeed Horsa glider replica in the foreground. The landing zone for the three British gliders on D-Day is just visible at the extreme upper right (Photograph by Michel Dehaye. Used with permission)

that marks the border between Korea and China) and raised false optimism with phrases like "home by Christmas." The Marines had no such delusions, and Col. Alexander tells us what happened next:

> *The Chinese hiding in the eastern Taebaek Mountains waited until the night of November 27—twenty below zero, blinding snow—to spring their trap. General Sung Shih-lun, commanding 120,000 troops of the PLA [People's Liberation Army] Ninth Army Group, saw his mission as that of annihilating the crack Marine division … Red China had entered the Korean War big time.* (Alexander 1999, p. 287)

After a series of engagements along the mountain roads and on the surrounding hills, the Marines had concentrated their forces at Koto-ri by December 7, 1950, along with members of the British Royal Marine 41st Independent Commandos and U. S. Army 31st

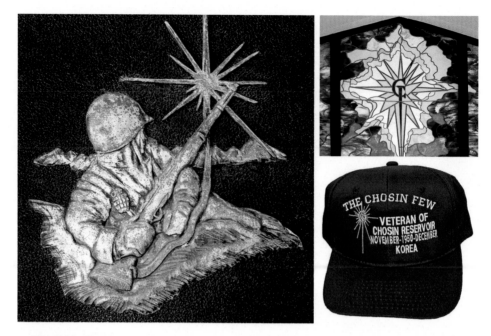

Fig. 7.16 The veterans of the Chosin Reservoir campaign emphasized the importance of the "Star of Koto-ri" by selecting it as their logo, with the letters "CF" for the Chosin Few inside the star. LEFT: This plaque on the wall of the chapel at the Marine Corps Base in Kaneohe Bay, Hawaii, depicts a Marine observing the star. UPPER RIGHT: This stained glass window in the chapel at the Marine Corps Base in Kaneohe Bay, Hawaii, includes the logo with the star. LOWER RIGHT: Hats designed for The Chosin Few display the logo with the star (Photographs by the author)

Regimental Combat Team. The small village now held more than 14,000 men, surrounded and greatly outnumbered by the Chinese army. According to Alexander, "Many officials in Washington considered the Marines a lost cause—trapped, isolated, doomed." (Alexander 1999, p. 284).

The crowded condition of the troops made them especially vulnerable to possible mortar attacks. The Marines needed to move south quickly from Koto-ri, but they had to solve major problems before they could link up with their comrades closer to the coast.

The road through the Taebaek Mountains was a single-lane rough track with sheer dropoffs on one side and cliffs and hills on the other side, with this high ground providing perfect vantage points for the Chinese to overlook the action and command the road (Fig. 7.18).

Assistance from the Air

Moreover, the enemy had destroyed a bridge at an especially treacherous section of the road in Funchilin Pass, about 4 miles south of Koto-ri. In a remarkable feat of logistics, Air Force Fairchild C-119 "Flying Boxcar" transport aircraft employed special parachute

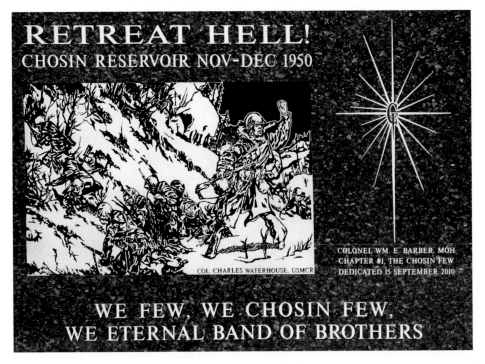

Fig. 7.17 This granite memorial was dedicated in 2010 at California's Camp Pendleton. Next to a scene from the Chosin Reservoir campaign is the logo with the letters "CF" for the Chosin Few inside the "Star of Koto-ri" (Photograph courtesy of the U. S. Marine Corps. Used with permission)

rigging to drop 2500-pound bridge sections into Koto-ri on December 7th (Fig. 7.19). Army engineers thought that they could rebuild the bridge. The spectacular bridge drop features prominently in accounts of the situation at Koto-ri. War correspondents on the scene during the Chosin campaign included Keyes Beech and Marguerite Higgins, both of whom won Pulitzer Prizes in 1951 for their Korean War reporting, and legendary photographer David Douglas Duncan of *Life*, who produced a book documenting the campaign. (Montross and Canzona 1957, pp. 309–311; Higgins 1951; Duncan 1951).

The breakout from Koto-ri down the mountain road and the reconstruction of the bridge would be possible only if Marine and Navy aircraft could provide cover. In order to drive the Chinese forces from their hilltop positions commanding the road, the Vought F4U Corsairs of the 1st Marine Aircraft Wing could employ a combination of rockets, napalm, and machine gun fire (Fig. 7.20). But air cover required clear skies.

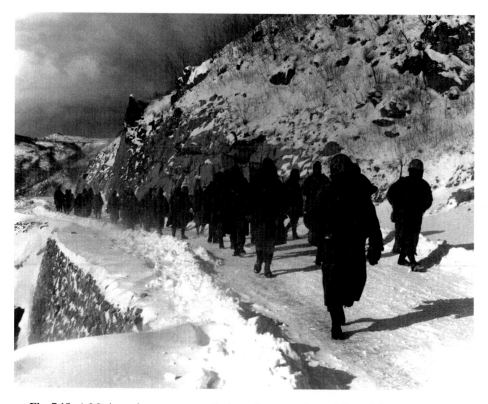

Fig. 7.18 A Marine column moves south along the mountain road through Funchilin Pass in the Taebaek Mountains during the Chosin Reservoir campaign (Photograph courtesy of the U. S. Marine Corps Archives. Used with permission)

Major General Field Harris commanded the 1st Marine Aircraft Wing. After the campaign was over, Marine General O. P. Smith thanked Harris and explained the importance of clear weather and the assistance from the Corsair pilots:

In a heartfelt message to Field Harris, Smith spoke for each of his Marines: 'During the long reaches of the night and in the snow-storms, many a Marine prayed for the coming of day or clearing weather when he knew he would again hear the welcome roar of your planes…Never in its history has Marine aviation given more convincing proof of its indispensable value to ground Marines.' (Alexander 1999, p. 300)

Fig. 7.19 TOP: Fairchild C-119 "Flying Boxcar," of the type that parachuted the vital bridge sections into Koto-ri on December 7, 1950. (Photograph courtesy of the U. S. Air Force Archives. Used with permission.) BOTTOM: Army engineers successfully bridged this gap about 4 miles south of Koto-ri and made possible the breakout south along the mountain road. The structure in the foreground is part of a hydroelectric complex using water from the Chosin Reservoir, while the rugged Taebaek Mountains form the backdrop (Photograph courtesy of the U. S. Marine Corps Archives. Used with permission)

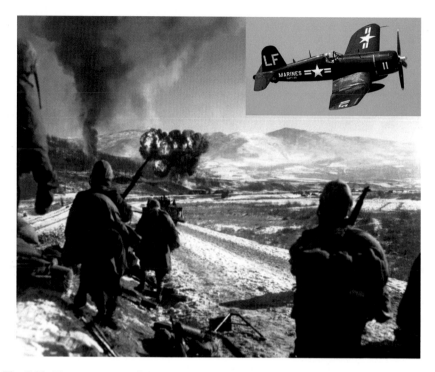

Fig. 7.20 The appearance of the "Star of Koto-ri" gave hope that clearing weather would allow crucial close air support as the Marines moved along the mountain roads. This photograph from the Chosin Reservoir campaign shows a column pausing as a Corsair drops napalm on a Chinese Army position. (Photograph courtesy of the U. S. Marine Corps Archives. Used with permission.) INSET: A restored Vought F4U Corsair seen in 2012 (Photograph by Gerry Metzler. Used with permission)

The Star of Koto-Ri

Historian Martin Russ relates how the trapped forces anxiously waited for the snowstorms to end and eventually spotted a star in the heavens above Koto-ri:

> *During the night, many Marines poked their heads outside to check the sky, hoping to see stars, which would indicate that close air support for the infantry might be available in the morning. It is recorded that at 9:37 P.M., December 7, a lone star was sighted above a mountain to the southwest of Koto-ri…remembered today by many survivors of the campaign as a symbol of hope.* (Russ 1999, pp. 398–399)

Long after the war, the Korean War veterans group known as The Chosin Few donated a plaque and a stained glass window to the chapel of the Marine Corps Base in Kaneohe Bay, Hawaii, commemorating the Chosin campaign (Fig. 7.16). The accompanying text includes lines that emphasize the importance of the star to the Marines at Koto-ri on that night in 1950:

For 11 desperate days, in sub-zero temperatures, fierce battles raged over 25 miles of treacherous icy roads in the rugged Taebaek mountains of North Korea, as units of the 1st Marine Division heroically fought their way to the small village of Koto-ri... in a blinding Siberian snowstorm...Marines and soldiers worked, waited, and prayed for the storm to abate. Shortly before 2200 hours, the winds and snow sub-sided as the dark sky opened, revealing a bright shining star. From within the entire perimeter there rose a cry, 'THERE'S A STAR,' followed by shouting, singing and prayers... in clear skies, fighter/bomber planes arrived to provide the necessary close air support.

On December 7, 2001—the anniversary of the original events at Koto-ri—Sergeant Richard W. Holtgraver, Jr., wrote a story for the *Hawaii Marine* journal. He based this account on the recollections of veteran Robert E. Talmadge and explained the importance of the star:

Star of Koto-ri: Symbol of Chosin Few

From the time they enter boot camp, until the day they die, Marines are bombarded with stories of great battles the Marine Corps has been involved in, and arguably one of the greatest battles of American military history was the Chosin Reservoir ... Many stories surround the epic 14-day battle, but one stood out clearly in the minds of the Marines ... It's the story of a lone, tiny star in a cloud-filled sky. That lonely star would provide hope and inspiration, just when the Marines would need it most ... thick, blinding snow began to fall ... They needed close air support. They needed clear skies in order to get them. As the evening wore on, the snow kept falling. Marines still looked to the skies in hopes of seeing a break in the clouds. Just when it looked like all hope for the storm to subside was about to disappear, a faint, little, white dot could be seen through the falling snowflakes around 2145. The small star provided a big beacon of hope for the Marines at Koto-ri ... That tiny star meant a lot to many of the Marines who saw it...To the men of the Chosin Few, that tiny, little star shined so brightly when they needed it most, that it would become the organiza-tion's logo in 1983 'That was a symbol of what the men in the Division went through there,' said Robert E. Talmadge, vice president for the Aloha Chapter of the Chosin Few. 'It was a key turning point in the event, or at least a psychological turn for all the Marines. Because they saw this star up there in the sky.' (Holtgraver 2001, p. 2)

Poems and Songs about the Star

Websites established to honor the veterans of the Chosin campaign include memoirs, photographs, maps, and even poems and songs. One song, co-written by Private First Class Frank Gross and Major Paul Sanders, tells the story of the star with lyrics including:

> *THE DIAMOND IN THE SKY*
>
> *…*
>
> *In ancient days God gave a sign*
>
> *To the shepherds and wise men too*
>
> *And a similar sign was seen by men*
>
> *That are known as the Chosin Few*
>
> *There is a star! There is a star!*
>
> *They shouted with a tear dimmed eye*
>
> *Oh praise in rhyme at Christmas time*
>
> *For God's diamond, God's diamond in the sky*
>
> *…*
>
> *Through the clearing skies the Corsairs came*
>
> *Flying chariots filled the air*
>
> *Like the cavalrymen to the rescue*
>
> *And the guiding star was there*
>
> *…*

Similar sentiments are found in a poem by Irvin Lindsey, with lines including:

> *THE STAR OF THE CHOSIN*
>
> *…*
>
> *If the storm does not stop, our planes cannot fly*
>
> *The Chinese will hit us where we lie.*
>
> *…the clouds parted a little*
>
> *What's that? A star! Our star! Our Star! Right in the middle*
>
> *…*
>
> *Ragged and tough Marines fell upon their knees*
>
> *And started to pray, 'Thank you God for your star today.'*
>
> *…*
>
> *The Chinese had the night, but with the day we got the light*
>
> *… I will never forget the wonderful star that night.*

Identifying the Star of Koto-Ri

Understandably, given the difficult conditions, the various survivor accounts have some discrepancies regarding dates, times, and the sequence of events. For example, the drop of the bridge sections into Koto-ri took place on December 7th (Higgins 1951, pp. 192–193; Montross and Canzona 1957, p. 309; Mossman 1990, p. 141; Simmons 2002, p. 98), but some memoirs of the Koto-ri events place the bridge drop on December 8th or even December 9th. Some accounts place the sighting of the star on the evening of December 7th, with others suggesting December 8th.

The account by Martin Russ may be the most reliable, with mention of both the precise time and the compass direction: "It is recorded that at 9:37 P.M., December 7, a lone star was sighted above a mountain to the southwest of Koto-ri." (Russ 1999, p. 398).

The time zone employed during this period of the Korean War can be deduced from the "Special Action Report" for the 1st Marine Division during the period October through December 1950. The report, available online at www.koreanwar.org, includes a chronology of daily operations with the clock times expressed in "Zone I," 9 h ahead of Greenwich Mean Time. The name "Zone I" is employed because "I" is the 9th letter of the alphabet. (Some communications also used "Zone Z" or "Zulu," indicating Greenwich Mean Time itself, that is, the time system "Zero" hours from Greenwich.)

Astronomical planetarium computer programs can recreate the sky of December 7, 1950, at 9:37 p.m. (2137I in military timekeeping) above the village of Koto-ri, which lies at 127° 18′ East Longitude and 40° 17′ North Latitude. The calculations show that the brightest object in the sky was not a star at all—it was the brilliant planet Jupiter, standing 14° above the horizon to the southwest. Jupiter was brighter than any star, and all the other naked-eye planets were below the horizon. (The same celestial scene occurred on December 8th at 9:37 p.m., and it is possible that some may have witnessed the "star" then.)

Remembering the "Forgotten War"

The Korean conflict is sometimes referred to as the "Forgotten War," with books and Hollywood movies more likely to focus on World War I, World War II, Vietnam, and more recent events. However, some things have changed in recent decades. In 1995 a Korean War Veterans Memorial was dedicated on the National Mall in Washington, D. C. (Fig. 7.21). In 2017 a ceremony at the National Museum of the Marine Corps in Triangle, Virginia, dedicated a memorial specifically for the Chosin Reservoir campaign. At the top of this monument are the letters "CF" for The Chosin Few and the iconic symbol: the Star of Koto-ri (Fig. 7.22).

The identity of the "star" is a relatively minor detail of the Korean War and the Chosin Reservoir campaign—nothing of significance to military history would change if it had turned out to be Venus or Mars, or a bright star like Sirius or Rigel. But looking back on that cold night in 1950 has value. The members of the veterans group The Chosin Few hoped that future generations would remember and commemorate the celestial scene because the "star stands as a permanent reminder of the courage, duty, honor, sacrifice, hardship and commitment experienced during this epic campaign—a battle unparalleled in modern military history." (Text on the plaque in the chapel at the Marine Corps Base in Kaneohe Bay, Hawaii.)

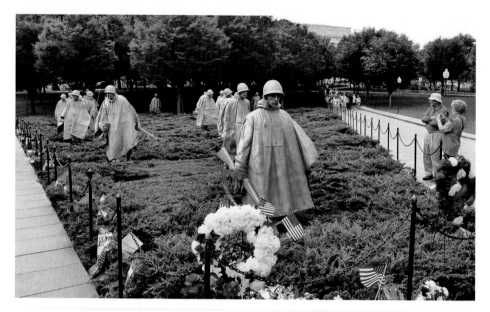

Fig. 7.21 The Korean War Veterans Memorial on the National Mall in Washington, D. C., includes 19 statues representing a platoon on patrol (Photograph by the author)

Fig. 7.22 On May 4, 2017, a group gathered for the ceremony dedicating the Chosin Few Memorial, adjacent to the National Museum of the Marine Corps in Triangle, Virginia. The marker has an octagonal shape, with inscriptions and bronze reliefs on the eight faces devoted to the important events of the Chosin Reservoir campaign. At the top of the monument are the letters "CF" for the Chosin Few in a stainless steel sculpture of the iconic symbol: the Star of Koto-ri (Photograph courtesy of the Department of Defense. Used with permission)

Perhaps readers of this chapter will be inspired to find online (www.koreanwar.org, www.chosinreservoir.com) some of the memoirs of the participants or to turn to the volumes by eminent Marine historians. (Alexander 1999, Simmons 2002).

The final words here come from a poem posted online by Lieutenant Colonel Richard L. Kirk with memorable lines about Korea—and the Star of Koto-ri:

I AM NOT FORGOTTEN
I have walked these Korean hills before, crossed these rivers

...

I am here in the hearts of those who were with me

On the Perimeter, at Inchon, at the Reservoir and the River

And in the hearts of those who waited...

...

I am a tear in the eyes of mothers, sisters, fathers,

Brothers, wives, friends, lovers...

...

I have known a distant star on a cold December night...

And I have known the love of a friend who would die for me

And I for him...

I am never forgotten.

References

Admiralty (1939) *Reports Concerning Royal Oak, Admiralty 119/1939.* London: Secretary of the Admiralty.

Alexander, Joseph H., with Don Horan, and Norman Stahl (1999) *The Battle History of the U.S. Marines: A Fellowship of Valor.* New York: HarperPerennial.

Ambrose, Stephen E. (1985) *Pegasus Bridge: June 6, 1944.* New York: Simon and Schuster.

Barber, Neil (2014) *The Pegasus and Orne Bridges.* Barnsley, South Yorkshire, UK: Pen & Sword Military.

BBC (2014) WW2 People's War, an archive of World War Two memories, introductory text posted on October 15, 2014.

BBC (2016) Torpedo on seabed linked to sinking of Royal Oak in Scapa Flow. March 2, 2016.

Churchill, Winston S. (1939) Royal Oak Torpedoed at Anchor, Tribute to German "Skill and Daring." *The Times* [London], October 18, 1939, 4.

Churchill, Winston S. (1951) *Closing the Ring.* Boston: Houghton Mifflin.

Collins, John M. (1998) *Military Geography for Professionals and the Public.* Washington, DC: National Defense University Press.

Dönitz, Karl (1958) *Zehn Jahre und Zwanzig Tage*. Bonn: Athenäum-Verlag.

Duncan, David Douglas (1951) *This is War! A Photo-Narrative in Three Parts*. New York: Harper & Brothers.

Eisenhower, Dwight D. (1948) *Crusade in Europe*. Garden City, NY: Doubleday.

Ellsberg, Edward (1960). *The Far Shore*. New York: Dodd, Mead & Company.

Fowler, Will (2011) *Pegasus Bridge: Bénouville, D-Day 1944*. Oxford: Osprey Publishing.

Haarr, Geirr H. (2013) *The Gathering Storm: The Naval War in Northern Europe, September 1939–April 1940*. Annapolis, MD: Naval Institute Press.

Higgins, Marguerite (1951) *War in Korea: The Report of a Woman Combat Correspondent*. Garden City, NY: Doubleday & Company, Inc.

Holtgraver, Jr., Sgt. Richard W. (2001) Star of Koto-ri: Symbol of Chosin Few. *Hawaii Marine* **50** (No. 48), December 7, 2001, 2.

Hydrographic Department (1934) *North Sea Pilot, Part I, comprising the Faeröes, Shetlands, and Orkneys*. London: His Majesty's Stationery Office.

Hydrographic Office (1925) *British Islands Pilot, H. O. No. 149*. Washington, DC: Government Printing Office.

Komstam, Angus (2015) *U-47 in Scapa Flow, The Sinking of HMS Royal Oak 1939*. Oxford: Osprey Publishing Ltd.

Korganoff, Alexandre (1974) *The Phantom of Scapa Flow*. London: Ian Allan Ltd.

Mayo, Jonathan (2014) *D-Day: Minute by Minute*. New York: Simon and Schuster.

McKee, Alexander (1959) *Black Saturday*. New York: Holt, Rinehart and Winston.

Montross, Lynn and Nicholas A. Canzona (1957) *U. S. Marine Operations in Korea, 1950–1953, Volume III, The Chosin Reservoir Campaign*. Washington, DC: Historical Branch, USMC.

Mossman, Billy C. (1990) *Ebb and Flow, November 1950–July 1951*. Washington, DC: Center of Military History, United States Army.

National Geographic (2012) National Geographic and Lindblad Expeditions, National Geographic Explorer in Europe, Daily Expedition Report 154,647, September 27, 2012.

New York Times (1939) Berlin Hails Crew That Sank Warship, Commander and Men of U-Boat Called Heroes for Attack on Royal Oak at Scapa Flow. October 19, 1939, 4.

Nimitz, Chester W. (1960) *The Great Sea War*. Englewood Cliffs, NJ: Prentice-Hall.

NMSI (2013) *Moon Watch, "The Tides of War."* Dallas, TX: National Math + Science Initiative.

Olson, Donald W., and Russell L. Doescher (1994) D-Day: June 6, 1944. *Sky & Telescope* **87** (No. 6), June, 84–88.

Olson, Donald W., and Russell L. Doescher (2012) Tides, moonlight, machines, and D-Day. *Physics Today* **65** (No. 1), January, 8.

Olson, Donald (2014) *Celestial Sleuth: Using Astronomy to Solve Mysteries in Art, History and Literature*. Springer Praxis: New York.

Owen, Jonathan (2009) Heroes of Pegasus Bridge. *The Independent*, Saturday, May 30, 2009.

Parker, Bruce (2011) The tide predictions for D-Day. *Physics Today* **64** (No. 9), September, 35–40.

Prien, Günther (1939) *U-47 Kriegstagebuch* [Daily War Diary], uboatarchive.net/KTBList.htm

Prien, Günther (1940) *Mein Weg nach Scapa Flow*. Berlin: Im Deutschen Verlag.

Ridder, Willem (2007) *Countdown to Freedom*. Bloomington, Indiana: AuthorHouse.

Russ, Martin (1999) *Breakout: The Chosin Reservoir Campaign, Korea*. New York: Fromm International.

Ryan, Cornelius (1959) *The Longest Day*. New York: Simon and Schuster.

Schaefer, Bradley E. (1994) World War II and the Moon. *Sky & Telescope* **87** (No. 4), April, 87.

Schaefer, Bradley E. (2005) The Moon and the U-47 in Scapa Flow. *Bulletin of the American Astronomical Society* **37**, 1151.

Silk, George (1969) Grip on the Tides. *Life* **67** (No. 1), July 4, 1969, 32–41.

Simmons, Edwin H. (2002) *Frozen Chosin: U.S. Marines at the Changjin Reservoir*. Washington, D.C.: History and Museums Division, Headquarters, U.S. Marine Corps.

Smith, Walter Bedell (1946) Eisenhower's Six Great Decisions, 1, The Invasion Gamble. *Saturday Evening Post* **218** (No. 49), June 8, 1946, 9–11, 104–110.

Smith, Walter Bedell (1956) *Eisenhower's Six Great Decisions*. New York: Longmans, Green & Co.

Snyder, Gerald S. (1978) *The Royal Oak Disaster*. San Rafael, CA: Presidio Press.

Wallwork, James Harley (1999) handwritten manuscript dated November 17, 1999, titled "James Harley Wallwork & The Taking of Pegasus Bridge," and published on April 20, 2013, on the blog of Alex Waterhouse-Hayward.

Weaver, H. J. (1980) *Nightmare at Scapa Flow: The truth about the sinking of H.M.S. Royal Oak*. Peppard Common, Oxfordshire, UK: Cressrelles Publishing Company Ltd.

Wood, Lawson (2000) *The Bull & the Barriers: The Wrecks of Scapa Flow*. Stroud, Gloucestershire, UK: Tempus.

Part III
Astronomy in Literature

8

Literary Skies Before 1800

In "The Merchant's Tale," one of Chaucer's *Canterbury Tales* from the fourteenth century, the poet uses the motion of the Moon to describe the passage of time. The story tells us that the Moon moved from Taurus to Cancer and traveled about 58° in 4 days measured from "noon to noon." Is this possible, given that the Moon's average motion is only about 13.2°/day? At this rate our satellite travels less than 53° in 4 days, not 58°. Chaucer was an expert in astronomical matters and skilled enough to write a *Treatise on the Astrolabe*. But did he make a mistake here? Several modern authors asserted that this lunar motion is impossible and that Chaucer must have made an error. But are these learned commentators themselves mistaken? Did an event with unusually rapid lunar motion from Taurus to Cancer actually occur in Chaucer's lifetime?

Miguel de Cervantes published the novel *Don Quixote* in 1605. In an enigmatic passage from Chap. 20, Sancho Panza tells the time at night by the position of stars in the northern sky. Sancho expresses the details of his calculation with these words: "by the little science that I learned when I was a shepherd, it must be less than three hours until dawn, because the Mouth of the Horn is above the head, and it makes midnight in the line of the left arm." Did star charts in Cervantes' time include a star grouping in the shape of a Horn? What modern constellation corresponds to this celestial Horn? And which way does the "line of the left arm" point? Toward the west? Toward the east? In dozens of *Don Quixote* editions for the last four centuries, commentators have attempted to explain this astronomical passage. Could all of these erudite Cervantes scholars have failed to understand the motions of the northern sky? Can we find the correct explanation of this method of timekeeping by consulting sixteenth-century navigation manuals?

Shakespeare, in Act Two, Scene One, of *Henry IV, Part One*, has a character deduce that the time is four o'clock in the morning by observing the position of a group of stars that he calls "Charles' Wain." The word "wain" is a synonym for "wagon." Did star charts in Shakespeare's time include a group of stars in the form of a wagon? And who was Charles? Some authors associate these stars with Britain's King Charles I. Can we find literary references to "Charles' Wain" that pre-date Shakespeare's mention of this star

© Springer International Publishing AG 2018
D.W. Olson, *Further Adventures of the Celestial Sleuth*, Springer Praxis Books,
https://doi.org/10.1007/978-3-319-70320-6_8

group and pre-date the reign of Charles I? What is the modern name for the group of stars called "Charles' Wain" in Shakespeare's time?

Shakespeare, in Act Two, Scene One, of *Macbeth* has two characters conclude that the time must be after midnight because the "Moon is down ... And she goes down at twelve." This passage gives the clock time of moonset on the night when Macbeth murders King Duncan. How could we use the play's clues to season of the year and time of night to determine the lunar phase that matches this description? How does the absence of moon-light in this scene fit with the play's other mentions of darkness? Later in the same scene the characters refer to the absence of starlight with the poetic words: "There's husbandry in heaven; Their candles are all out." Could we find other passages from the works of Shakespeare in which he describes the stars as "night's candles"?

Chaucer and the Moon's Speed

The English poet Geoffrey Chaucer (Fig. 8.1, Right), author of *The Canterbury Tales*, was well-versed in the celestial science of the day and often wove astronomical references into his narratives. In fact, these passages are probably the most sophisticated and interesting uses of astronomy in all of English literature. The author's previous *Celestial Sleuth* book devoted a section to "The Franklin's Tale" and Chaucer's complex descriptions of a lunar calculation from astronomical tables, a rare configuration of the Sun and Moon, and the exceptionally high tides produced on the coast of Brittany (Olson 2014, pp. 282–293).

Another intriguing reference occurs in the tale told by the Merchant (Fig. 8.1, Left), who describes the marriage of a knight dubbed January to his young bride, May. Chaucer uses the Moon's motion through the zodiac to express the passage of time:

> *The moone, that at noon was thilke day*
> *The Moon, that was at noon that same day*
>
> *That Januarie hath wedded fresshe May*
> *That January has wedded fresh May*
>
> *In two of Taure, was into Cancre glyden;*
> *In two of Taurus, was into Cancer glided;*
>
> *So longe hath Mayus in hir chambre abyden.*
> *So long has May in her chamber abided.*
> (Chaucer, "The Merchant's Tale")

According to custom, after a wedding the bride remained in her chambers for a certain period. Chaucer scholar J. C. Eade has suggested that the above lines present a puzzle: how long a time passed before May returned to the hall of the palace? (Eade 1984, p. 133).

Motion in Four Days

Chaucer followed the accepted practice of medieval astronomy and specified the Moon's position in celestial longitude, a coordinate measured along the line in the sky called the ecliptic. The ecliptic marks the fundamental plane of the Solar System, with the Sun

Fig. 8.1 Left: The teller of "The Merchant's Tale": "A Merchant was there with a forked beard, in motley, and high on his horse he sat." This illustration of the Merchant is from the Ellesmere manuscript of *The Canterbury Tales*, circa 1400–1410. (The Huntington Library, San Marino, California, mssEL 26 C 9, detail. Used with permission.) Right: The poet Geoffrey Chaucer was born about 1340 and died in 1400. This illustration of Chaucer dates from the eighteenth century. (British Library, 167.c.26, frontispiece, folio 2 recto. Used with permission)

always exactly on the ecliptic and with the Moon and the planets always found on or near the ecliptic (Fig. 8.2). The origin of ecliptic longitude corresponds to the position of the Sun at the vernal equinox. Aries extends from 0° to 30°, Taurus from 30° to 60°, Gemini from 60° to 90°, Cancer from 90° to 120°, and so on for the rest of the zodiacal signs.

In the verses quoted above, Chaucer is describing a motion of our satellite from near longitude 32°, or "two of Taurus," through Gemini to just beyond longitude 90°, which marks the beginning of Cancer. The total motion is therefore at least 58°. How long would it take? A few lines later the poet gives the answer that exactly 4 days have elapsed:

The fourthe day compleet fro noon to noon,
The fourth day completed from noon to noon,

Whan that the heighe masse was ydoon,
When the high mass was done,

In halle sit this Januarie and May....
In hall sit this January and May....
(Chaucer, "The Merchant's Tale")

Fig. 8.2 "The Merchant's Tale" describes the motion of the Moon, starting in the zodiacal sign of Taurus, passing through Gemini, and then just entering into Cancer. Elijah H. Burritt in 1835 published this chart showing the stars of the constellations of Taurus, Gemini, and Cancer along the path known as the ecliptic, indicated here by the dashed curve that arcs through these three zodiacal constellations

However, the average speed of the Moon through the zodiac is 13.176°/ day, a figure well-known to medieval astronomers. At this rate our satellite travels less than 53° in 4 days, not 58°. Therefore, some scholars have stated that the lunar motion as described in the story is impossible and have claimed that it would require more than 4 days.

For example, eighteenth-century commentator Thomas Tyrwhitt argued that the "time given" of 4 days "is not sufficient for the Moon to pass from the second degree of Taurus into Cancer." Tyrwhitt's edition of Chaucer went so far as to change the words "two of Taure" to "ten of Taure." Tyrwhitt judged that if the Moon "set out from the 10th degree of Taurus, as I have corrected the text, she might properly enough be said, in 4 days, to be *gliden into* Cancer." (Tyrwhitt 1798, p. 461)

John David North, writing in 1969 about Chaucer's astronomy, likewise insisted that the Moon's motion as described in "The Merchant's Tale" could not be achieved in 4 days. North asserted that the "Moon had moved at least 58°, for which purpose it would have required five days." (North 1969, p. 274).

However, a closer look shows that Chaucer did not make an error here. Instead, these comments by Tyrwhitt and North both made the same mistake of thinking that the Moon always moves through the constellations at its average speed.

The Moon's Speed

Several factors affect the rate of the Moon's motion. For example, our satellite speeds up as it approaches perigee, the point in its orbit that is closest to Earth. To a lesser extent, the Moon also speeds up near new or full Moon. The maximum possible speed of the Moon is

15.40°/day, and the maximum motion in longitude over four consecutive days is 61.06°, more than enough to carry the Moon from the second degree of Taurus into Cancer.

The nineteenth-century scholar Andrew Edmund Brae pointed out Tyrwhitt's error and characterized the altering of the lines in "The Merchant's Tale" as one of Tyrwhitt's "blunders of astronomical interpretation." Brae correctly observed that the Moon's speed can often exceed its mean motion (Brae 1870, pp. 93–94).

John David North himself, writing almost two decades after his 1969 analysis, acknowledged that his initial comments were incorrect and that Chaucer might be making an intentional allusion to this phenomenon of variable lunar velocity (North 1988, pp. 447–449).

We agree with Brae's conclusion that the lunar motion, exactly as given in the tale, is possible. We also agree with North's 1988 suggestions that Chaucer would have been aware of variable lunar speed and that the tale's mention of precise positions in Taurus and Cancer may not have been random choices.

The Alfonsine Tables

Did Chaucer base his lines on an actual event when the Moon moved unusually swiftly through this part of the sky? Could we identify a year and a 4-day period when this rapid motion occurred?

Our Texas State University group used computer planetarium programs to investigate every passage of the Moon through Taurus, Gemini, and Cancer from 1385 to 1395, the probable period during which Chaucer wrote "The Merchant's Tale." We tried to find a month when the Moon actually moved from near longitude 32° to at least 90° in 4 days, noon to noon. (We used noon in Greenwich Mean Time, not significantly different from Chaucer's local time.)

We found that the Moon showed the most rapid motion through this part of the zodiac during the fall of 1388 and the spring of 1389, but that no event corresponded precisely to the passage in the tale. The motion closest to Chaucer's description occurred in 1389 between April 25th and 29th, when modern computer programs show that our satellite moved from 30.83° (near "one of Taurus") to 90.50°.

However, Chaucer could not rely on modern lunar theory, much less computers, in medieval days! Instead, he would have consulted almanacs and calendars based on the Alfonsine tables, compiled in Toledo, Spain, in the thirteenth century under the direction of King Alfonso X. In the introduction to his *Treatise on the Astrolabe*, Chaucer promises to include a section with a detailed table of the Moon's motion through the signs of the zodiac and refers to the *Kalendarium* of Nicholas of Lynn. (Unfortunately, Chaucer never completed this part of his work.)

The phrasing of the lines from "The Merchant's Tale" strongly suggests that the poet relied on astronomical tables or a lunar almanac. Few observe the Moon or planets at midday, but it was a common practice in medieval tables to give lunar and planetary positions at noon. For example, in the prolog to his calendar for 1387 to 1462, Nicholas of Lynn states:

This calendar, moreover, is made for the longitude and latitude of the city of Oxford, in which, according to the practice of astrologers, the natural day is computed from noon of the preceding day until noon of the following day. (Eisner 1980, p. 58)

Using medieval methods, we calculated by hand the Moon's positions from a copy of the Alfonsine tables, which we corrected to the longitude of Oxford. Between April 25 and 29, 1389, noon to noon, the computed longitude of our satellite changed from 31.61° to 90.49°. (Olson and Jasinski 1989, p. 377) During this interval, the Moon reached a calculated speed of 15.04°/day, only slightly less than the maximum possible 15.07°/day in the lunar model used to construct the Alfonsine tables. To the nearest degree, this motion is from longitude 32° ("two of Taurus") to just beyond 90° ("gliding" into Cancer)—precisely the event described in the story.

Therefore, according to the best astronomical information available to Chaucer, the unusually rapid lunar motion in "The Merchant's Tale" is possible and, in fact, did occur in April of 1389.

Eclipse in May and Solstice in June

Chaucer also seems to have alluded to two other astronomical events in May and June of that same year.

First, the character January goes blind, and his bad fortune in suddenly losing his sight is compared to being stung by a scorpion with venom in its tail. Interestingly, on the evening of May 10, 1389, observers in Oxford or London would have witnessed a total lunar eclipse (Fig. 8.3) in Scorpio, with the eclipsed Moon rising at sunset.

Fig. 8.3 A lunar eclipse on May 10, 1389, may figure in "The Merchant's Tale." This photograph was taken during the total lunar eclipse on June 15, 2011. (Photograph by George Tucker. Used with permission)

Medieval astrologers, following the precepts of Ptolemy, associated the stinger of Scorpio with afflictions of the eyes. Blindness could be induced when the Moon was in Scorpio and approaching the star clusters then called Aculeus and Acumen (known to modern astronomers as M6 and M7, according to their numbering in the Messier catalog of star clusters and nebulae). This was especially true when the Sun and the opposed Moon were on the western and eastern horizons—exactly the conditions on May 10, 1389.

Second, in the tale's concluding scene, Chaucer states that the Sun is in the sign of Gemini, near Cancer. The poet describes the approach of summer by telling us that the Sun:

...hath of gold his stremes doun ysent
...has his streams of gold sent down

To gladen every flour with his warmnesse.
To gladden every flower with his warmness.

He was that tyme in Geminis, as I gesse,
He was that time in Gemini, as I guess,

But litel fro his declynacion
But little from his declination

Of Cancer....
Of Cancer....
(Chaucer, "The Merchant's Tale")

This solar position indicates a date just before the summer solstice, which occurred when the Sun entered Cancer on June 13th (by the Julian calendar) in 1389.

Chaucer's Astronomical Expertise

The constellations and even the specific degrees of the zodiac mentioned in "The Merchant's Tale" were apparently not Chaucer's random choices. Instead, they seem to refer to real celestial events with significance to those of his readers with knowledge of medieval astronomy.

The astronomical puzzle in "The Merchant's Tale," with the Moon starting from the second degree of Taurus and entering Cancer exactly 4 days later, can be understood on at least three levels.

First, a general audience would notice only that Chaucer was employing colorful language to describe the passage of time by references to a celestial body and to the zodiacal band in the heavens.

Second, those with some knowledge of astronomy might take note of the detailed ecliptic positions in Taurus and Cancer specified by Chaucer. From quick calculations based on the Moon's average daily motion, or based just on 4 days as a fraction of a month, this part of the audience could think (as did Tyrwhitt in 1798 and North in 1969) that the described motion is impossible and that Chaucer must have made some error.

Third, a deeper understanding of the passage would be available to those sophisticated about astronomy. They would know that the Moon speeds up near perigee and near the new or full Moon and that Chaucer is not making a mistake.

Complex, multi-layered astronomical references like those in "The Merchant's Tale" remind us of the poet's expertise in astronomy. Chaucer, knowledgeable enough to write a *Treatise on the Astrolabe*, also enriched his *Canterbury Tales* with sophisticated allusions to the heavens.

Don Quixote, Telling Time by the Stars

Miguel de Cervantes (1547–1616) (Fig. 8.4) published *Don Quixote* in 1605. The *Wikipedia* page for the novel describes it as "the most influential work of literature from the Spanish Golden Age and the entire Spanish literary canon." A survey of modern authors went even further and ranked Cervantes's creation as "the best book in the history of literature." (Yates 2002, p. 1) The tale follows the adventures of Don Quixote, who imagines himself to be on a knightly quest, and Sancho Panza, who acts as his squire (Fig. 8.5). The two are among the most memorable characters in literature over the last four centuries.

Fig. 8.4 This portrait of Miguel de Cervantes (1547–1616) was engraved in the eighteenth century by Jacob Folkema, based on a drawing by William Kent

Fig. 8.5 Don Quixote and Sancho Panza sally forth on a summer's day in this illustration created by Jules David for the cover of an 1887 French edition of *Don Quixote*

Sancho and a Celestial Clock

An intriguing astronomical passage in Chap. 20 refers to a method for telling time by the position of the stars. During a nighttime scene, Don Quixote wants to continue on the quest but Sancho argues that they should get a few hours of rest before their next adventure:

> *… dilátelo, a lo menos, hasta la mañana; que, á lo que á mí me muestra las ciencia que aprendí cuando era pastor, no debe de haber desde aquí al alba tres horas, porque lo boca de la bocina está encima de la cabeza, y hace la media nocte en la línea del brazo izquierdo.* (Don Quixote, Part I, Chapter XX)

> *… put it off, at least, until morning; for, by the little science that I learned when I was a shepherd, it must be less than three hours until dawn, because the Mouth of the Horn is above the head, and it makes midnight in the line of the left arm.* (Don Quixote, Part I, Chapter XX)

Sancho described a Horn in the sky. Did star charts in Cervantes' time include such a constellation? What modern star grouping corresponds to this celestial Horn?

Did Sancho correctly recall and apply the astronomical lore that he learned as a shepherd? Or, do Sancho's words describe a situation which is astronomically impossible? Could Cervantes be making some kind of joke that might be better understood by the audience in his time, compared to modern readers of the novel? Could it even be the case that Cervantes himself failed to understand the celestial clock in the northern sky?

Horn in the Sky

A dictionary published in 1611 by Sebastián de Covarrubias provides the answer for the modern constellation—Ursa Minor—corresponding to the Horn. The definition for *bocina* ("horn") included the explanation: "*Bocina*: A constellation in the starry sky, the Northern or Arctic stars which we call the Horn; Ursa Minor, by whose movement the people who walk in the field know the hours of the night. We say this, because the stars of which it is constituted appear to form a horn." (Covarrubias 1611, p. 143).

The seven most prominent stars of Ursa Minor are now well-known in America as the Little Dipper. These same seven stars appeared on sixteenth-century star charts as either the Horn (*Bocina*) or the Little Bear (*Ursa Minor*) (Fig. 8.6). Polaris, the brightest of these stars, was also known the North Star or the Pole Star and marked the narrow end of the Horn.

The rural method for telling time required observing the position of the two stars at the Mouth of the Horn (the head of the Little Bear) and farthest from Polaris. This pair of stars were also known as the Guards of the Pole, or, simply, the Guards (*Guardas*). During the course of a night, Earth's rotation made the Guards appear to rotate around Polaris (Fig. 8.7). The Horn therefore could act as the hand of a celestial clock.

Which Way Is "Left": West or East?

Sky lore in the sixteenth century described how an observer could determine the time of night by facing toward the north and noting the position of the stars. One version of the method imagined a celestial figure of a man whose center was at or near the Pole Star (Fig. 8.8). The head of the man in the sky was above Polaris, his feet were below Polaris, one of his arms extended above the horizon on the west side of Polaris, and the opposite arm extended above the eastern horizon. Understanding Sancho's statement that "the Mouth of the Horn is above the head" appears to be straightforward: the two stars known as the Guards stand above Polaris in the sky.

However, there is a perplexing and fundamental ambiguity regarding the meaning of "left" in Sancho's statement that the Mouth of the Horn "makes midnight in the line of the left arm." Does this refer to the left arm of the man in the sky who is depicted as facing the observer? The left arm of this celestial figure extends out over the eastern horizon. Or does this refer to the observer standing on Earth and facing north, with the observer's left arm extended toward the western horizon? These two interpretations are completely opposite!

Fig. 8.6 The seven stars known in America as the Little Dipper appeared on sixteenth-century star charts as *Ursa Minor*, the Little Bear (Petrus Apian, *Quadrans Astronomicus*, 1532, Top) and alternately as *Bocina*, the Horn (Martín Cortés, *Arte de Navegar*, 1551, Bottom). The two stars at the Mouth of the Horn were identified as *Guardas*, the Guards of the Pole. From the Pole Star a straight line runs to the member of the *Guardas* called the "time-keeping star" and known to modern astronomers as Kochab or Beta Ursae Minoris

Fig. 8.7 The *Guardas*, or Guards of the Pole, are the two bright stars near the head of Ursa Minor, the Little Bear. This diagram showing the rotation of the Guards around the Polar Star appeared in William A. Smyth's *A Cycle of Celestial Objects* in 1844. The added clock times are those appropriate for summer

Fig. 8.8 Sancho Panza claimed that he could determine the time of night because "the Mouth of the Horn is above the head, and it makes midnight in the line of the left arm." One version of sixteenth-century sky lore imagined the giant figure of a man among the stars of the northern sky. This illustration of the Man of the North appeared in a Portuguese navigational treatise in the section entitled *Regimiento Dell Norte* ("The Rules of the North"). (© National Maritime Museum, Royal Museums Greenwich, London, D2151. Used with permission)

Can we find sixteenth-century sources to identify the direction of the "left arm"? Can we then determine the season of the year when the Horn "makes midnight in the line of the left arm"? Does this happen in spring, summer, autumn, or winter? Did Sancho correctly describe the astronomical method for telling time at night?

Medina in 1545

The scholar Pedro Medina (1493–1567) published several treatises on the use of astronomy in navigation, most notably his *Arte de Navegar* in 1545. This volume included a figure depicting the seven stars of the Horn. (Medina 1545, p. 71) We hoped that Medina would explain unambiguously the correct direction of the "left arm," but we were surprised to learn that this Spanish authority employed both of the conflicting interpretations!

Medina first discussed and illustrated how observers could look in the northern sky and "imagine the figure of a man near the Arctic Pole … and being so located, his left arm shall be toward the east, and the right arm toward the west." A diagram (Fig. 8.9, top) indicated the position of the North Star at the center, with a line above labeled *Cabeza* ("head"), a line below labeled *Pie* ("feet"), and lines marking the two arms, with *Braço izquierdo* ("left arm") extending over the horizon toward the east, and *Braço derecho* ("right arm") extending over the horizon toward the west (Medina 1545, p. 76).

Medina then discussed and illustrated the convention that the left arm belonged to the observer standing on Earth and facing north. This diagram (Fig. 8.9, bottom) showed the line of *Braço izquierdo* ("left arm") extending over the horizon toward the west, and *Braço derecho* ("right arm") extending over the horizon toward the east (Medina 1545, p. 77).

These two conflicting interpretations meant that Sancho's words about "the line of the left arm" would be difficult to interpret.

Another of Medina's illustrations, especially helpful for understanding the celestial passage in *Don Quixote*, showed the position of the Mouth of the Horn at midnight throughout the months of the year. In this diagram Medina abandoned the notion of left and right and simply labeled each of the arms as *Braço* ("arm") (Medina 1545, p. 78).

Cortés in 1551

Another celebrated Spanish scholar, Martín Cortés (1510–1582), published in 1551 a treatise on navigation entitled *Breve Compendio de la Sphera y de la Arte de Navegar* (Cortés 1551). An English translation by Richard Eden appeared in 1561 with the title *The Arte of Navigation* (Eden 1561), and the popular work was reprinted five more times in England before 1600. The illustrations published by Cortés and Eden showed the northern sky with *Braço izquierdo* ("The Lefte Arme") always extended over the horizon to the west of Polaris (Fig. 8.10).

Cortés offered precise instructions explaining how to use an instrument called the nocturnal, designed to determine the time of night by the position of the Guards relative to Polaris. He even provided diagrams intended to be traced onto round plates to construct a nocturnal (Figs. 8.11 and 8.12).

Fig. 8.9 Sancho Panza stated that the Mouth of the Horn at midnight was "in the line of the left arm." Relative to the North Star at center of these diagrams, which way was left? As explained in this chapter, Pedro de Medina in 1545 illustrated two conflicting interpretations. One version (Top) imagined *Braço izquierdo* ("the left arm") extending over the horizon to the east of Polaris, and the other (Bottom) had the left arm extending over the horizon to the west

Commentary Over Four Centuries

Returning our attention to the novel, we surveyed the commentary by scholars during the four centuries since the first publication in 1605. Many editions of *Don Quixote* have appeared with notes added to explain the text. The most influential of these commentators appear to have been Juan Antonio Pellicer in 1797, Diego Clemencín in 1833, Francisco Rodríguez Marín in 1911, Rufo Mendizábal in 1945, and Marín again with his revised edition in 1947. Other editions of the famous novel often copy the erudite remarks of these four eminent scholars.

Fig. 8.10 Sancho Panza stated that the Mouth of the Horn at midnight was "in the line of the left arm." These two diagrams in Spanish by Martín Cortés in 1551 (Top) and in English translation by Richard Eden in 1572 (Bottom), showed *Braço izquierdo* ("The Lefte Arme") extending over the horizon to the west of Polaris

Fig. 8.11 Readers could construct a nocturnal by copying onto paper, wood, or brass these diagrams included by Martín Cortés in his *Arte de Navegar* of 1551. The three required parts included the background circle of months and days (Top), the 24-h time dial (lower left), and the figure of the Horn (lower right). The nocturnal was assembled and operated first by rotating the time dial so that the midnight marker "12 TPO" pointed at the desired date. Then, after rotating the Horn into the position observed in the sky, the time could be read off from the time dial at the position of the time-keeping star at the Mouth of the Horn

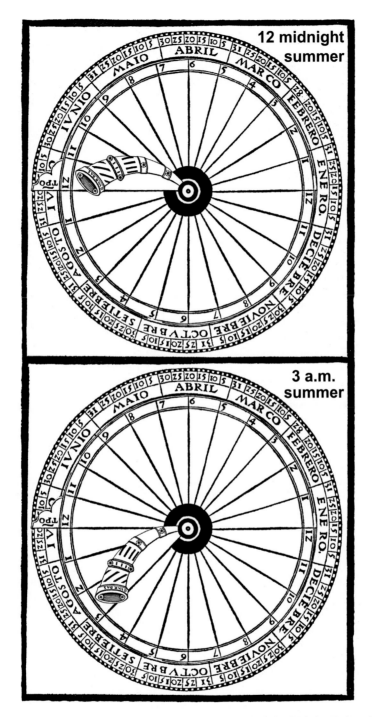

Fig. 8.12 This illustration shows a nocturnal correctly set for 12 midnight (Top) and 3 a.m. (Bottom) in the summer. The Mouth of the Horn makes midnight in the line of left arm, in agreement with that part of Sancho's speech. But in the hours after midnight in summer the counter-clockwise rotation of the heavens carries the Mouth of the Horn to lower altitudes, *not* "above the head," as Sancho claims

As our Texas State group considered the various commentaries in various editions, we became aware that scholars not familiar with astronomy could make various mistakes regarding the working of the stars in the northern sky.

Possible Error #1: Direction of Sky Rotation. The figure of the Horn acts like the hand of a celestial clock in the heavens. But there is an important difference between the hour hand of an ordinary clock on Earth and the motion of this star grouping. The hour hand of a terrestrial clock rotates clockwise—by definition of the word "clockwise"! But, as readers can observe by watching the northern sky over the course of several hours, the sky rotates counterclockwise around Polaris. (Technically, the rotation is around an imaginary point called the North Celestial Pole, near Polaris in the sky.) Commentators on *Don Quixote* could imagine, mistakenly, that the northern sky rotates in a clockwise manner exactly like the hands of a terrestrial clock.

Possible Error #2: Time for a Quarter Turn. Another important difference between the hour hand of a terrestrial clock and Sancho's celestial clock is the time required for a full rotation and, therefore, the time for a quarter turn from an "arm" to the "head" of the celestial figure in the northern sky. Astronomers know that the stars require about 24 h to complete a circuit about Polaris, and therefore about 6 h to make a quarter turn (Technically, a full rotation about the North Celestial Pole requires a sidereal day of 23 h and 56 min, with a quarter turn occupying 5 h and 59 min.).

Some of the commentators on Don Quixote confused the speed of rotation of the celestial clock in the northern sky with the speed of rotation of the hour hand of a terrestrial clock. Notes by these scholars show the significant mistake of thinking that the sky turns through a complete rotation in only 12 h and through a quarter turn from "arm" to "head" in 3 h, instead of the correct values of about 24 h and 6 h, respectively.

Possible Error #3: Horn at Midnight in Summer. Sancho tells us that the stars of the Horn "make midnight in the line of the left arm." As noted in a preceding section, one interpretation has the "left arm" extending toward the western horizon and refers to the left arm of the observer standing on Earth and facing north. The opposite interpretation has the "left arm" extending toward the eastern horizon and refers to the left arm of the imaginary giant figure facing the observer from a position among the northern stars. Computer planetarium programs could help to resolve this ambiguity, if we knew the month in which the action takes place.

Fortunately, clues in the novel definitely specify the season of the year. In Chap. 2, Cervantes tells us that Don Quixote first sallied forth on "one of the hot days of the month of July." In Chap. 25, Quixote signs a document with the date of "August 22" in the same year. Therefore all of the action in the first 25 chapters, including the use of the pastoral clock to tell the time of night in Chap. 20, must occur in a summer month of either July or August.

Whether Cervantes employed the Julian or Gregorian calendar is not clear. Spain changed calendar systems in the year 1582, prior to the publication of the novel. But Cervantes may have relied on astronomical or navigational treatises, or even his own memories of the pastoral clock from before 1582. Fortunately, the 10-day difference between the Julian and Gregorian systems does not significantly affect the interpretation. In either calendar system, astronomical calculations (or reference to the sixteenth-century

diagrams prepared by Pedro Medina and Martin Cortés) clearly demonstrate that the stars of the Horn extended toward the western horizon at midnight in the summer months of July and August.

A significant error, made by several Cervantes scholars, is to imagine that the stars of the Horn extended toward the eastern horizon at midnight in summer.

Explanation by Pellicer in 1797

Juan Antonio Pellicer (1738–1806), a scholar of Spanish history and literature, published an edition of the novel with commentary in 1797. Pellicer described the celestial figure of the man in the sky, correctly identified the Horn with Ursa Minor, and placed the adventure in August. Pellicer accepted Sancho's calculation as correct for the position and motion of the Horn in August but did not offer any details regarding the calculation (Pellicer 1797, pp. 80–81).

Explanation by Clemencín in 1833

Diego Clemencín (1765–1834), a politician and royal librarian, edited *Don Quixote* in a series of volumes first published in 1833. Clemencín described the "time-keeping star" (Spanish: *la estrella horological*), which is "the brighter of the two that form the mouth of the Horn" and noted that in "early August it makes midnight *in the line of the left arm*, as Sancho says." Clemencin repeated the assertion that "it was not lacking three hours until dawn, as Sancho himself had said," but the learned commentary did not include a detailed explanation of how the time calculation could be done (Clemencín 1833, p. 119).

Explanation by Marín in 1911

Francisco Rodríguez Marín (1855–1943), a lexicographer, poet, folklorist, and expert regarding the writings of Cervantes, published a series of editions of the famous novel in 1911, 1916, 1927, and posthumously in 1947.

Marín in 1911 had read the previous attempts at commentary and lamented that "the rule for knowing the time by Ursa Minor is complicated, and only half explained by Pellicer and Clemencín; at least, they do not explain it clearly." However, Marín himself did not provide any additional details regarding how a rural observer could actually do the calculation. Marín also did not offer an opinion whether Sancho's words were correct or incorrect (Marín 1911, pp. 132–133).

Explanation by Mendizábal in 1945

The Jesuit scholar Padre Rufo Mendizábal in 1945 apparently made the first attempt to explain Sancho's time calculation in detail, and he included diagrams intended to clarify the important points. Mendizábal placed the adventure in the month of August and correctly identified the Horn with Ursa Minor. He also correctly realized that the Horn rotated

in a counterclockwise manner during the course of a night. However, he made at least two significant mistakes.

Mendizábal imagined that the "two stars that form the mouth of the Horn" rotated around the Pole in "a circle comparable to a clock whose hours were in the reverse direction (one instead of eleven, the two instead of ten …)." As this sentence suggests, and as his illustration (Fig. 8.13) makes clear, his analysis mistakenly assumed that the Horn completed a full rotation around Polaris in 12 h, when the actual time required for a complete rotation of the northern sky is about 24 h (Mendizábal 1945, pp. 190–191).

Mendizábal made a second serious error when he positioned the Horn over the northeastern horizon at midnight in the month of August. Readers with access to computer planetarium programs can verify that the stars of the Horn (the Little Dipper) stand over the northwestern horizon at midnight in the summer months of July and August. (The calculations are more appropriately done in local solar time, not in modern daylight savings time.)

Mendizábal's diagram with the label *Verano* ("summer") depicted the Horn beginning at midnight over the incorrect horizon (in the northeast instead of the correct northwest)

Fig. 8.13 Padre Rufo Mendizábal made several significant mistakes when he created these illustrations in 1945 in an unsuccessful attempt to understand Sancho's celestial clock. Despite the subsequent praise by later commentators, Mendizábal's erroneous diagrams and analysis rendered his explanations and conclusions invalid

and then proceeding to a position at *Cabeza* (the "head") above the Pole Star in the incorrect number of hours (the illustration showed three hours to rotate through a quarter turn instead of the correct six hours) (Mendizábal 1945, pp. 190–191).

Mendizábal judged that Sancho's calculation was accurate, but the significant mistakes in both the comments and the diagrams demonstrate that Mendizábal himself did not understand the astronomy and that the analysis and his conclusions are entirely invalid.

Explanation by Marín in 1947

Francisco Rodríquez Marín, in an edition published posthumously in 1947, accepted the explanation provided by Mendizábal and quoted the entire text of the explanatory footnote from Mendizábal's 1945 edition. Marín mistakenly praised the diagrams and endorsed the analysis with the judgment: "Of the many rules I have seen explaining how to know the nocturnal hours by Ursa Minor, I think that the clearest is that in the edition of *Quijote* by Padre Mendizábal, and in addition it is illustrated with three diagrams." (Marín 1947, p. 92) However, as detailed in the previous section, Mendizábal's analysis in 1945 made several significant astronomical errors.

Marín's 1947 edition made another comment of some interest by judging that Cervantes himself was expert in the lore of the night sky and the timekeeping stars of the north. Marín argued that: "Cervantes, who often had to walk at night, especially in the summers spent in Andalusia going back and forth to get grain for the provision of the royal galleys, no doubt had much information about these sidereal clocks." (Marín 1947, p. 92).

Explanation in El Reloj de Sancho in 2010

A Spanish group known as *Asociación para la Enseñanza de la Astronomía* ("Association for the Teaching of Astronomy") published in 2010 a booklet entitled *El Reloj de Sancho* ("The Clock of Sancho"). The booklet can be downloaded from the association's website (www.apea.es) or can be located via a Google search using the Spanish title.

The booklet originated as part of a workshop describing activities that teachers could carry out with students. Chapter 20 of *Don Quixote*, with its astronomical passage, was "one of Cervantes' most entertaining chapters and that which gave rise to this workshop." (Arias, *El Reloj de Sancho* 2010, p. 20).

The lavishly illustrated booklet described the history of the nocturnal, the instrument that could be used to determine the time of night from the position of the Horn (Ursa Minor). Just as Martin Cortés had done more than four centuries earlier, the makers of the booklet included plans intended to be printed and traced so that students could construct their own nocturnals and use them to determine the time of night following Sancho's method. The text ascribed to Sancho much accurate knowledge about the workings of the heavens. The booklet concluded with a dozen activities to be carried out by students in the classroom and in the field.

As expected for a workshop created by teachers of astronomy, the booklet described the basic science accurately. The text of *El Reloj de Sancho* correctly explained the direction

of rotation of the northern sky, the time required for the rotation of the sky, and other relevant astronomical factors. The booklet confidently asserted that the analysis had avoided the mistakes and "misunderstandings by other authors." (Arias, *El Reloj de Sancho* 2010, p. 22).

However, the booklet's final conclusions were compromised by the choice of a winter calendar date. The booklet hinted at winter as the season for the timekeeping scene in Chap. 20 with the introductory comments: "The stage setting of this chapter could be summed up as a date possibly in winter, whose night was soon dark, with hardly visible stars, but enough so that Sancho knew how to orient himself and knew the time that it was and the hours that were lacking until dawn." (Arias, *El Reloj de Sancho* 2010, p. 20) A few pages later, the booklet's analysis arrived at a specific period in winter by concluding that "only on February 1 does the horolagial star cross by the left arm" at midnight, and the text went on to assert that "we can conclude with little margin of error that the phrase of Sancho, the origin of this workshop, had to happen in the first days of February." (Arias, *El Reloj de Sancho* 2010, p. 22).

The booklet's conclusions therefore completely conflicted with the summertime scheme definitely employed in the novel. As explained in a previous section, explicit statements in the novel demonstrate that all of the action in the first 25 chapters, including the use of the pastoral clock to tell the time of night in Chap. 20, must occur in a summer month of either July or August. The booklet's winter result cannot provide the correct explanation of Sancho's calculation.

Sancho's Errors

The analysis by our Texas State group resulted in our judgment that all the various "explanations" detailed in the six preceding sections are either incomplete, incorrect, or inconsistent.

The existing literature exhibits a consensus that Sancho's statements are correct and sophisticated in the use of pastoral knowledge. We conclude instead that this passage in *Don Quixote* is astronomically impossible.

Our judgment does not depend on whether Sancho intended the "left arm" to belong to the observer on Earth or to the celestial man facing us from his position in the northern sky. Sancho stated that the stars of the Horn made "midnight in the line of the left arm" and then noted that the stars are "above the head." The correct time for the mouth of the Horn to rotate from the eastern "arm," to pass through one-fourth of a circle, and then to reach the vertical line above the "head" is about 6 h. The correct time for the stars at the mouth of the Horn to rotate from the western "arm," to pass through three-fourths of a circle, and then to reach the vertical line above the head is about 18 h. Counting from midnight, it follows from this calculation that the time of Sancho's speech with the Horn "above the head" must be close to either 6 a.m. or 6 p.m. In either case, the Sun would be above the horizon in a summer month of July or August. But Sancho emphasized the darkness of the night.

The much-debated astronomical passage in Chap. 20 is itself inconsistent and incorrect.

Explanation by Casasayas in 1986

In the course of our literature search, our Texas State group found one Cervantes expert who did understand the astronomy of the pastoral clock. José María Casasayas (1927–2004) published a journal article in 1986 in the *Bulletin of the Cervantes Society of America* and reached conclusions essentially equivalent to the results of our analysis. As we did, Casasayas surveyed the previous commentators, found most of them incomplete, and judged regarding Mendizábal "that the only explanation that we encounter among all the erudite Cervantes scholars on the calculation of Sancho is not successful." (Casasayas 1986, p. 163).

Sancho, Cervantes, and the Sky

Regarding the astronomical passage in Chap. 20 of *Don Quixote*, the learned commentaries by Juan Antonio Pellicer in 1797, Diego Clemencín in 1833, Francisco Rodríguez Marín in 1911, Rufo Mendizábal in 1945, and Marín in 1947, are all either incomplete or incorrect. These scholars, though expert in the Spanish language and the writings of Cervantes, did not understand the astronomy of the northern sky. The booklet devoted to *El Reloj de Sancho* ("The Clock of Sancho") in 2010 is astronomically correct so far as it goes, but the chronology conflicts with the summertime scheme of the novel.

Our Texas State analysis concludes that the astronomical passage as related by Sancho Panza is astronomically impossible and inconsistent. Our results are in agreement with the conclusions offered by José María Casasayas in 1986.

We will probably never know whether Cervantes himself had a good understanding of the pastoral system for telling time by the stars. If so, he may have placed nonsense words in Sancho's speech for comedic effect. However, the erudite commentators for four centuries judged that Sancho exhibited accurate knowledge about this celestial calculation. The fact that these eminent scholars generally failed to recognize this passage as astronomically incorrect supports the possibility that Cervantes himself did not have a deep understanding of the northern sky.

Shakespeare: *Henry IV* and the Wagon in the Sky

Although most of the astronomical passages in the plays of William Shakespeare (1564–1616) (Fig. 8.14) refer to the heavens in a general way, a more precise celestial allusion occurs in the opening lines of a scene from *Henry IV, Part One*, written in about 1597. A character describes using the position of the stars to determine the time of night:

Rochester. An inn yard.
Enter a Carrier with a lantern in his hand.
First Carrier: Heigh-ho! an it be not four by the day, I'll be hanged:
Charles' wain is over the new chimney, and yet our horse not packed.
What, ostler!
(Henry IV, Part One: Act Two, Scene One)

Fig. 8.14 This illustration imagines William Shakespeare (1564–1616) reading his works to his family and friends

Carriers transported letters and various goods along England's roads; ostlers cared for the horses of those staying at roadside inns. The word *wain* means "wagon." Interested readers will search modern star charts in vain if they attempt to find a group of stars identified as a wagon in the sky. However, the works of sixteenth-century authors show that contemporaries of Shakespeare would recognize "Charles' wain" as a reference to stars of the constellation Ursa Major, also known as the Great Bear.

Richard Eden, Thomas Fale, and Charles's Wain

In 1577 a volume of travel writing collected by the scholar Richard Eden (ca. 1520–1576) appeared in print. He mentioned that residents of the northern lands of Europe and Asia could observe "the North starres, called charles wayne, or the great Beare." (Eden 1577, p. 292).

In 1593 the mathematician Thomas Fale published a treatise explaining the design of sundials to tell time during the daytime hours. He also described the construction of related instruments called nocturnals to tell time at night by the position of Ursa Major (the Great Bear) and Ursa Minor (the Lesser Bear). Fale mentioned that alternate names could be applied to these star groups, with "the greater beare called also Charleswaine." (Fale 1593, p. 56).

Fig. 8.15 The Wagon in the Sky. This diagram appeared in the 1564 edition of *Cosmographia* by Petrus Apian (1495–1552) and illustrated two alternate ways to figure seven bright northern stars: as a horse-drawn wagon (Latin: *Plaustrum*) and also as the Great Bear (*Ursa Maior*). Apian's charts also showed the Lesser Bear (*Ursa Minor*), the North Celestial Pole (*Polus*), and the north star Polaris (*Stele Polaris* or *Stella Polaris*)

A Wagon in Ursa Major

Star charts published in the sixteenth century by Peter Apian (1495–1552) and by Caspar Vopel (1511–1561) confirm the presence of a celestial wagon, formed from the seven stars of Ursa Major well-known to modern Americans as the Big Dipper. The four stars of the Big Dipper's bowl make up the wagon and its wheels, while the three stars of the Big Dipper's handle form the tongue to which the horses or oxen are yoked (Figs. 8.15 and 8.16). A star map by Thomas Hood (1556–1620) showed Ursa Major, the Great Bear, with accompanying text that pointed out the seven stars known "to us as Charles' waine" (Fig. 8.17).

Consensus: The Great Bear

The evidence from sixteenth-century authorities and star charts confirms that Shakespeare's passage about Charles' Wain definitely refers to the stars that are part of the Great Bear, as many commentators have concluded (for example, Knight 1867, p. 184; Rolfe 1880, p. 156; Hudson 1899, p. 83).

The Bear and Wagon in Ancient Skies

The identification of the Great Bear as a wagon or wain goes back to ancient times. More than two millennia before Shakespeare, Book XVIII of Homer's *Iliad* described

Fig. 8.16 The Wagon in the Sky. This detail from a star chart published in 1536 by Caspar Vopel (1495–1552) shows a horse-drawn wagon (Latin: *Plaustrum*) formed from the same seven stars now well-known as the Big Dipper in Ursa Major, the Great Bear. Vopel intended the blank sections to be cut away, with the remaining curved sections known as "gores" to be bent together and glued to the outside of a sphere to form a celestial globe. Because such a globe is viewed from the outside, the constellations are reversed left-to-right compared to what is seen in Earth's sky

how Hephaestus forged armor for Achilles, with terrestrial and celestial scenes adorning the shield:

> *There he depicted the Earth, the sea, and the sky,*
> *There the tireless Sun, and the full Moon,*
> *All the constellations that crown the heavens,*
> *Pleiades and Hyades were there and the mighty Orion,*
> *There the revolving Bear, that men also call the Wain.*
> (Iliad, Book XVIII)

Fig. 8.17 Only a few years before Shakespeare wrote *Henry IV, Part One*, the mathematician Thomas Hood (1556–1620) published this star chart showing the stars of Ursa Major, the Great Bear. The text on the right side includes the Latin word *Plaustrum* and the Greek word *Amaxa*, both translated as "wagon." Hood then pointed out that the stars are known "to us as Charles' waine"

As the alternate name for the Bear, Homer in the original Greek of the *Iliad* used the word ἄμαξαν, which translates as "wagon," "wain," "coach," or "carriage."

An almost identical passage appeared in Book V of Homer's *Odyssey* and described how Odysseus employed celestial navigation. To return home by sailing eastward, he kept the northern stars of the Great Bear on his left at night:

Odysseus spread his sail to the wind with joy, and he sat and steered his raft skill-fully with the steering-oar, nor did he close his eyes in sleep at night, as he watched the Pleiades, and slow-setting Boötes, and the Bear, that men also call the Wain ... For Calypso, the beautiful goddess, had bidden him to keep this constellation on his left hand as he sailed over the sea. (Odyssey, Book V)

Charlemagne's Wain

The ancient lines by Homer mentioned only the "Wain," while Shakespeare used the phrase "Charles' Wain." Who is Charles?

Although some later commentators associated the phrase with British King Charles I, this cannot be the original meaning. Richard Eden in 1577, Thomas Fale in 1593, and Shakespeare in 1597 all referred to Charles's Wain, and the reign of Charles I did not begin until 1625.

As explained by Richard Hinckley Allen in his book on star names, references prior to Shakespeare's time linked the phrase "Charles's Wain" with Charlemagne (ca. 742–814), the medieval ruler also known as Charles the Great (Allen 1899, p. 428). The *Oxford English Dictionary* lists sources as early as the fourteenth century with this group of stars described as Charlemagne's Wain. Shortly after Shakespeare's time, the physician and scholar Robert Vilvain (ca. 1575–1663) recorded the lore regarding how "7 Stars … shine in the North … Which in the great Bear far off cast their light … Which with bright beams most cleerly shine by night … Which are by vulgar term *Charlmaigns wain* named." (Vilvain 1654, p. 71).

Charles Dickens and a Rochester Inn

Returning our attention to Shakespeare's description that "Charles' wain is over the new chimney," our Texas State University group realized that an essential first step for astronomical analysis involved determining the direction of view toward "the new chimney." The stage directions for this scene specify the setting as "Rochester. An inn yard." Did Shakespeare base this setting on an actual inn?

Another of England's most celebrated authors thought so. Charles Dickens lived for many years in a house on Gad's Hill, overlooking Rochester. According to a friend's memoir, Dickens himself

> *… used to declare his firm belief that Shakespeare was specially fond of Kent, and that the poet chose Gad's Hill and Rochester for the scenery of his plays from intimate personal knowledge of their localities. He said he had no manner of doubt but that one of Shakespeare's haunts was the old inn at Rochester, and that this conviction came forcibly upon him one night as he was walking that way, and discovered Charles's Wain over the chimney just as Shakespeare has described it, in words put into the mouth of the carrier in King Henry IV.* (Fields 1874, p. 229)

This Dickens anecdote does not specifically name the "old inn at Rochester," but some local historians have identified it as the Crown Inn. (Halliwell 1859, p. 341; Aveling 1895, p. 315) The Crown Inn had a reputation as the finest inn in Rochester and could boast that Queen Elizabeth I had stayed there for several days in 1573.

However, Shakespeare has a character describe the play's inn in a manner inconsistent with a lodging suitable for royalty:

Second Carrier: *I think this be the most villainous house in all*
 London road for fleas.
(*Henry IV, Part One*: Act Two, Scene One)

For this reason, another local authority therefore expressed skepticism that Shakespeare could be alluding to the Crown Inn:

> *Shakespeare laid a vivacious scene of the First Part of Henry IV in the yard of a Rochester Inn … Gadshill, which overlooks the town, had an unenviable reputation as the haunt of highway robbers, before, during, and after Shakespeare's day …. The place is thus hallowed not alone by the shade of Charles Dickens, who set up his last home on the summit of Gadshill: the ghosts of Shakespeare and of Falstaff still hover about it. In the dramatist's day the Crown Inn, with its ample courtyard, was the leading inn at Rochester … In its pristine glories it was reckoned by Elizabethans a house fitted for the accommodation of princes; doubtless it must be distinguished from the anonymous house of call which Shakespeare's carriers frequented and rated low.* (Lee 1905, p. 516)

We therefore could not identify with certainty the correct inn and the correct direction to its "new chimney."

2 o'clock or 4 o'clock?

The First Carrier initially uses the position of "Charles' wain" to determine that the time is four o'clock. Later in the scene, the same character complicates the situation by giving a different time of night when he speaks to the highwayman named Gadshill.

> *Enter Gadshill.*
> *Gadshill: Good morrow, carriers. What's o'clock?*
> *First Carrier: I think it be two o'clock.*
> (*Henry IV, Part One*: Act Two, Scene One)

At least one of the clock times must be wrong, and many commentators have noted this discrepancy. A typical explanation "suggests that he suspected Gadshill and meant to mislead him." (Rolfe 1880, p. 157). However, the First Carrier could have exaggerated the time when initially speaking to the ostler in an effort to hasten the preparation of the horses.

Further Astronomical Analysis?

Beyond identifying the stars of "Charles' wain," a more detailed astronomical analysis of this passage becomes problematic because we cannot be certain of the identity of the inn, the direction to the "new chimney," and even whether the time is 2 o'clock or 4 o'clock in the morning. These seven stars of Ursa Major could be rising up in the sky to the northeast, passing high above Polaris in the north, sinking lower down in the northwest, or (perhaps less likely) passing low in the sky below Polaris in the north.

Tennyson and Charles's Wain

One more literary reference is worth mentioning. In 1833 Alfred Tennyson (1809–1892) published a poem entitled *The May Queen*. This composition includes lines possibly inspired by the Shakespearean scene, with an almost identical celestial image:

> *Last May we made a crown of flowers; we had a merry day;*
> *Beneath the hawthorn on the green they made me Queen of May;*

And we danced about the May-pole and in the hazel copse,
Till Charles's Wain came out above the tall white chimney-tops.
(Tennyson 1833, p. 96)

Wain, Wagon, and Bear

For Shakespeare's astronomical passage in *Henry IV, Part One*, without more information that would help to identify the Rochester inn and the compass direction of its "new chimney," we cannot make a convincing calculation of the calendar date corresponding to this scene. However, primary sources from Shakespeare's time allow us to conclude that his words "Charles' Wain" definitely described the star group now known as the Big Dipper in the constellation of Ursa Major, the Great Bear.

Shakespeare: The Moon and Stars in *Macbeth*

As a homework exercise for the author's Texas State University honors class, the students were asked to find as many references as possible to darkness in Shakespeare's *Macbeth* (Figs. 8.18 and 8.19). The ultimate purpose was to use one passage as a motivation for learning about the relationship between lunar phase and the times of moonrise and moonset.

Fig. 8.18 William Shakespeare (1564–1616)

Fig. 8.19 Poster for a production of *Macbeth* featuring Thomas W. Keene, a famous American actor of the late nineteenth century (Illustration courtesy of Library of Congress. Used with permission)

Most of the celestial references in this play describe heavenly scenes in a general way. For example, Macbeth alludes to his reasons for desiring a dark night:

Stars, hide your fires!
Let not light see my black and deep desires.
(*Macbeth, Act One*, Scene Four)

In the next scene, Lady Macbeth expresses the same sentiment:

Come, thick night,
And pall thee in the dunnest smoke of hell,
That my keen knife see not the wound it makes,
Nor heaven peep through the blanket of the dark,
To cry, "Hold, hold!"
(*Macbeth*, Act One, Scene Five)

A recent essay by John Mullan explains these passages as "conjuring darkness" and points out that "Macbeth and Lady Macbeth separately call on darkness not just to assist their plans but to hide their deeds from 'Heaven' or their own consciences." (Mullan 2016, p. 1)

The stage directions for Act One, Scene Seven, and Act Two, Scene One, instruct that the characters should enter carrying torches, and this action makes it clear to the audience that night has fallen.

Our Texas State group was especially interested in the opening lines of Act Two, Scene One, which specifically mention the exact hour of moonset in a conversation between Banquo and his son Fleance:

Banquo:	How goes the night, boy?
Fleance:	The Moon is down; I have not heard the clock.
Banquo:	And she goes down at twelve.
Fleance:	I take't, 'tis later, sir.
Banquo:	Hold, take my sword. There's husbandry in heaven;
	Their candles are all out....

(*Macbeth*, Act Two, Scene One)

Shakespeare's metaphoric references to thrift ("husbandry") regarding the stars (the "candles of heaven") prove that even the starlight has become obscured, which matches the desires of Macbeth and Lady Macbeth.

Later in Act Two, Scene One, Macbeth himself discusses the darkness just before he murders King Duncan:

Now o'er the one half-world
Nature seems dead, and wicked dreams abuse
The curtain'd sleep; witchcraft celebrates
Pale Hecate's offerings; and wither'd murder.
(*Macbeth*, Act Two, Scene One)

The "one half-world" refers to the dark night side of Earth.

The later scenes of *Macbeth* include many more mentions of darkness (Mullan 2016). For example, Macbeth describes the approach of the night when he has ordered the murder of Banquo:

Light thickens, and the crow
Makes wing to the rooky wood;
Good things of day begin to droop and drowse,
While night's black agents to their preys do rouse.
(*Macbeth*, Act Three, Scene Two)

Our Texas State group was especially intrigued by the passage quoted above from Act Two, Scene One, in which Banquo states that the Moon "goes down at twelve," that is, that moonset occurred at midnight. Because the relationship between lunar phase and the time of moonset exhibits seasonal variations, we wondered—in what season of the year does this part of the play take place?

Summer Season

Shakespeare revealed the season of the year in Act One, Scene Six, by means of a conversation between King Duncan and Banquo. They notice the summer birds nesting on the walls of the castle:

Duncan: *This castle hath a pleasant seat; the air*
 Nimbly and sweetly recommends itself
 Unto our gentle senses.
Banquo: *This guest of summer,*
 The temple-haunting martlet, does approve
 By his loved mansionry that the heaven's breath
 Smells wooingly here; no jutty, frieze,
 Buttress, nor coign of vantage, but this bird
 Hath made his pendent bed and procreant cradle;
 Where they most breed and haunt, I have observ'd
 The air is delicate.
 (*Macbeth*, Act One, Scene Six)

Lady Macbeth's mention of "the crickets cry" in Act Two, Scene Two, is likewise consistent with a summer setting.

Summer Moonrises and Moonsets

Table 8.1 lists the visibility of the various lunar phases during the summer season. Banquo's description in the play matches only one lunar phase: the first quarter Moon (Figs. 8.20 and 8.21).

Interested readers can verify this in the months near the summer solstice. On the date of a first quarter Moon, moonset will occur near local midnight—subject to several complications! Midnight in local "apparent solar time" will correspond to a time closer to 1 a.m. on clocks and watches set to daylight savings time. Differences of roughly

Table 8.1 Times of moonrises, best visibility, and moonsets near the summer solstice

Waxing crescent Moon	Visible in the evening, sets before midnight
First quarter Moon	Visible in the evening, sets at 12 midnight
Full Moon	Rises at sunset, visible all night long, sets at sunrise
Last quarter Moon	Rises at 12 midnight, visible in the early morning hours
Waning crescent Moon	Rises after midnight, visible in the early morning hours

Fig. 8.20 First quarter Moon (Photograph by Russell Doescher. Used with permission)

plus or minus half an hour can also occur depending on a given city's position in its time zone.

Seasonal variations in the northern hemisphere cause the first quarter Moon to set somewhat after local midnight near the spring equinox, and to set before local midnight near the autumn equinox.

Fig. 8.21 This sequence of photographs shows how the effects of Earth's atmosphere near the horizon can make a setting First Quarter Moon appear to turn blood red—an especially appropriate color for *Macbeth*! (Photograph by Giuseppe Petricca. Used with permission)

Stars as Candles in Shakespeare

Perhaps the most poetic touch in Banquo's speech describes the absence of starlight with the words: "There's husbandry in heaven; Their candles are all out." Shakespeare also refers to stars as the "candles" of heaven in several other plays. An especially memorable example occurs in *Romeo and Juliet*:

> *Juliet:* *Wilt thou be gone? It is not yet near day:*
> *It was the nightingale, and not the lark,*
> *That pierced the fearful hollow of thine ear;*
> *Nightly she sings on yon pomegranate-tree:*
> *Believe me, love, it was the nightingale.*
> *Romeo:* *It was the lark, the herald of the morn,*
> *No nightingale: look, love, what envious streaks*
> *Do lace the severing clouds in yonder east:*
> *Night's candles are burnt out, and jocund day*
> *Stands tiptoe on the misty mountain tops.*
> (*Romeo and Juliet*, Act Three, Scene Five)

Juliet hopes that the night is not over, but the stars disappear ("Night's candles are burnt out") when their light is overwhelmed by the brightening glow of morning twilight as the Sun approaches the eastern horizon.

Elsewhere in Shakespeare's works, the poet alludes to stars as "those gold candles fix'd in heavens air" in Sonnet 21, and the character Bassanio describes stars as "these blessed candles of the night" in *Merchant of Venice*, Act Five, Scene Two.

Moonset at Midnight

Although many of Shakespeare's astronomical references are general allusions to Sun, Moon, stars, planets, comets, and meteors, the specification of the time of moonset in *Macbeth* is unusually precise. The information that the Moon "goes down at twelve," along with clues to the season of the year, allows us to imagine the first quarter Moon sinking toward the western horizon as Macbeth and Lady Macbeth prepare for the murderous events at the heart of the "Scottish Play."

Further Reading

Several authors have surveyed the astronomical passages in Shakespeare's works (Harmon 1898; Dean 1924; Chappell 1945; McCormick-Goodhart 1945; Guthrie 1964; Olson, Olson, and Doescher 1998; Levy 2011; Olson 2014; Falk 2014).

References

Allen, Richard Hinckley (1899) *Star Names and Their Meanings*. New York: G. E. Stechert.

Arias, Enrique Aparicio (2010) *El Reloj de Sancho (Publicaciones de Asociación para la Enseñanza de la Astronomía, No. 20)*. Barcelona, Spain: Antares Producción & Distribución.

Aveling, S. T. (1895) Rochester Inns. *Archaeologica Cantiana* **21**, 315-326.

Brae, Andrew Edmund (1870) *The Treatise on the Astrolabe of Geoffrey Chaucer*. London: John Russell Smith.

Casasayas, José María (1986) La edición definitiva de las obras de Cervantes. *Cervantes: Bulletin of the Cervantes Society of America* **6** (No. 2), 141-90.

Chappell, Dorothea Havens (1945) Shakespeare's Astronomy. *Publications of the Astronomical Society of the Pacific* **57** (No. 338), October, 255-259.

Clemencín, Diego (1833) *El Ingenioso Hidalgo Don Quijote de la Mancha*, Volume 1. Madrid: D. E. Aguado.

Cortés, Martín (1551) *Breve Compendio de la Sphera y de la Arte de Navegar*. Sevilla: Antón Álvarez.

Covarrubias (1611) *Tesoro de la Lengua Castellana, o Española*. Madrid: Luis Sanchez.

Dean, John Candee (1924) The Astronomy of Shakespeare. *The Scientific Monthly* **19** (No. 4), October, 400-406.

Eade, John Christopher (1984) *The Forgotten Sky*. Oxford: Clarendon Press.

Eden, Richard (1561) *The Arte of Navigation*. London: Richard Jugge.

Eden, Richard (1577) *The History of Trauayle in the West and East Indies*. London: Richard Jugge.

Eisner, Sigmund, ed. (1980) *The Kalendarium of Nicholas of Lynn*. Athens, GA: University of Georgia Press.

Fale, Thomas (1593) *Horologiographia, The Art of Dialing*. London: Thomas Orwin.

Falk, Dan (2014) *The Science of Shakespeare: A New Look at the Playwright's Universe*. New York: Thomas Dunne Books, St. Martin's Press.

Fields, James T. (1874) *Yesterdays with Authors*. Boston: James R. Osgood and Company.

Guthrie, W. G. (1964) The Astronomy of Shakespeare. *Irish Astronomical Journal* **6** (No. 6), 201-211.

Halliwell, James O. (1859) *The Works of William Shakespeare, Volume IX*. London: J. E. Adlard.

Harmon, Orrin E. (1898) The Astronomy of Shakespeare. *Popular Astronomy* **6** (No. 4), 232-241; **6** (No. 5), 263-268; **6** (No. 6), 321-326.

Hudson, Henry N. (1899) *Shakespeare's Henry IV. Part First*. Boston: Ginn & Company.

Knight, Charles (1867) *The Pictorial Edition of the Works of Shakspere. Histories, Vol. I*. London: George Routledge & Sons.

Lee, Sidney (1905) The Johnson Club, A Literary Pilgrimage to Rochester. *Pall Mall Magazine* **36** (No. 150), October, 513-521.

Levy, David H. (2011) *The Sky in Early Modern English Literature: A Study of Allusions to Celestial Events in Elizabethan and Jacobean Writing, 1572-1620*. New York: Springer.

Marín, Francisco Rodríguez (1911) *El Ingenioso Hidalgo Don Quijote de la Mancha, Volume 2*. Madrid: Edicions de La Lectura.

Marín, Francisco Rodríguez (1947) *El Ingenioso Hidalgo Don Quijote de la Mancha*. Madrid: Ediciones Atlas.

McCormick-Goodhart, Leander (1945) Shakespeare and the Stars. *Popular Astronomy* **53** (No. 10), 489-503.

Medina, Pedro (1545) *Arte de Navegar*. Valladolid: Francisco Fernandez de Córdoba.

Mendizábal, Rufo (1945) *El Ingenioso Hidalgo Don Quijote de la Mancha*. Madrid: Razón y Fe.

Mullan, John (2016) Conjuring darkness in Macbeth. Online at the British Library website: https://www.bl.uk/shakespeare/articles/conjuring-darkness-in-macbeth.

North, John David (1969) Kalenderes Enlumyned Ben They: Some Astronomical Themes in Chaucer, Part II. *Review of English Studies* **20** (No. 79), August, 257-283.

North, John David (1988) *Chaucer's Universe*. Oxford: Clarendon Press.

Olson, Donald (2014) *Celestial Sleuth: Using Astronomy to Solve Mysteries in Art, History and Literature*. Springer Praxis: New York.

Olson, Donald W., and Laurie E. Jasinski (1989) Chaucer and the Moon's Speed. *Sky & Telescope* **77** (No. 4), April, 376-377.

Olson, Donald W., Marilynn S. Olson, and Russell L. Doescher (1998) The Stars of Hamlet. *Sky & Telescope* **96** (No. 5), November, 68-73.

Pellicer, Juan Antonio (1797) *El Ingenioso Hidalgo Don Quijote de la Mancha, Tomo II*. Madrid: Gabriel de Sancha.

Rolfe, William J. (1880) *Shakespeare's History of King Henry the Fourth, Part I.* New York: Harper & Brothers.

Tennyson, Alfred (1833) *Poems.* London: Edward Moxon.

Tyrwhitt, Thomas (1798) *The Canterbury Tales of Chaucer, Vol. II.* Oxford: Clarendon Press.

Vilvain, Robert (1654) *Enchiridium Epigrammatum.* London: R. Hodgkinsonne.

Yates, Emma (2002) Don Quixote tops authors' poll. *The Guardian*, May 7, 2002.

9

Literary Skies After 1800

The British Romantic poet Lord Byron, in three stanzas of a poem entitled "Childe Harold's Pilgrimage," described an Italian twilight scene with spectacular colors filling the sky. Byron noted that the Moon was visible and that a "Single Star is at her side." How could we use biographical information, letters, diaries, and other clues to determine that an actual event in 1817 inspired these stanzas? Where in Italy did this occur? On what date did Byron observe this scene? Can we identify the "Single Star" near the Moon? And what is the connection between the remarkable twilight hues observed by Byron in Italy and a volcanic eruption half a world away in Indonesia?

Edgar Allan Poe, in the 1838 short story "The Conversation of Eiros and Charmion," described an apocalyptic event that destroys all life on Earth when a comet's atmosphere mingles with that of Earth. What were Poe's sources for this story? What nineteenth-century scientific books did he consult? How can we deduce that Poe's reading must have included volumes by the scholars Thomas Dick, Elijah Burritt, and John Herschel? What actual comets followed paths that made close approaches to Earth's orbit? The characters in the story also discuss a comet that traveled very near to the planet Jupiter, so close that the comet actually passed through the system of Jupiter's moons. What actual comet made this remarkable close approach to Jupiter? Have previous scholars correctly identified the comets that inspired Poe's story?

The Woman in White by Wilkie Collins caused a sensation in nineteenth-century England. Before publication as a novel, the story appeared in serial form over the course of 40 weeks between November 1859 and August 1860. Readers awaited each weekly installment with anticipation comparable to that seen at the modern release parties for the Harry Potter novels. No less of an authority than Charles Dickens himself judged that the moonlit encounter that ended the first installment of *The Woman in White* was one of the "two scenes in literature which he regarded as being the most dramatic descriptions." In this passage, a full Moon illuminates the landscape where a young man is walking after midnight on a rural road north of London. Suddenly a mysterious woman dressed entirely in white startles him. Collins correctly judged that the cliffhanger ending of this sequence would induce readers to buy the next installment. Modern scholars attempted to deduce

© Springer International Publishing AG 2018

D.W. Olson, *Further Adventures of the Celestial Sleuth*, Springer Praxis Books,

https://doi.org/10.1007/978-3-319-70320-6_9

the date of a similar moonlit event in the life of the author Wilkie Collins, but they obtained contradictory results in a wide range of years. Can we combine calculations of the Moon's phase, analysis of nineteenth-century meteorological records, biographical information, and other clues to determine a precise date for the actual event when Wilkie Collins himself encountered a woman in white on a full Moon night? How does this date compare with the results of previous researchers? What is the connection to the Pre-Raphaelite artist John Everett Millais and to his celebrated paintings of *Ophelia* and *The Proscribed Royalist, 1651,* from the 1850s? And who was the actual "woman in white"?

Byron: "The Moon Is Up…A Single Star Is at Her Side"

The poet George Gordon Byron (1788–1824), better known as Lord Byron (Fig. 9.1, left), achieved fame in the early nineteenth-century comparable to the celebrity of Elvis Presley or the Beatles in the twentieth century. The work that first brought recognition and renown to Byron was a lengthy poem entitled "Childe Harold's Pilgrimage," published in four sections called cantos. The first two cantos appeared together in 1812 to great acclaim, and Byron later recalled: "I awoke one morning and found myself famous." (Moore 1830, p. 255) The third and fourth cantos appeared in 1816 and 1818, respectively.

Fig. 9.1 Left: Lord Byron (1788–1824) in a nineteenth-century colored engraving based on a portrait by Thomas Phillips (1770–1845). RIGHT: John Cam Hobhouse (1786–1869), a good friend of Byron's, in an engraving based on a drawing by Abraham Wivell (1786–1849)

Byron wrote the fourth canto in Italy during the summer of 1817. An intriguing astronomical passage in three of the stanzas described a spectacular scene just after sunset, as the glow of twilight produced dramatic colors. The poet noted that the Moon was visible and that a "Single Star is at her side."

Childe Harold's Pilgrimage, Canto IV

Stanza XXVII
The Moon is up, and yet it is not Night –
Sunset divides the sky with her – a Sea
Of Glory streams along the Alpine height
Of blue Friuli's mountains; Heaven is free
From clouds, but of all colours seems to be
Melted to one vast Iris of the West,
Where the Day joins the past Eternity;
While, on the other hand, meek Dian's crest
Floats through the azure air – an island of the blest!

Stanza XXVIII
A Single Star is at her side, and reigns
With her o'er half the lovely heaven; but still
Yon sunny Sea heaves brightly, and remains
Rolled o'er the peak of the far Rhaetian hill,
As Day and Night contending were, until
Nature reclaimed her order – gently flows
The deep-dyed Brenta, where their hues instil
The odorous Purple of a new-born rose,
Which streams upon her stream, and glassed within it glows,

Stanza XXIX
Filled with the face of Heaven, which, from afar,
Comes down upon the waters; all its hues,
From the rich sunset to the rising star,
Their magical variety diffuse:
And now they change; a paler Shadow strews
Its mantle o'er the mountains; parting Day
Dies like the Dolphin, whom each pang imbues
With a new colour as it gasps away –
The last still loveliest – till – 'tis gone – and All is gray.
(Byron 1818, pp. 16–17)

These stanzas made three topographical references to locations in Italy and two mythological references of astronomical interest.

The mention of the waters of the "deep-dyed Brenta" referred to a canal between Padua and the lagoon of Venice. Wealthy families constructed more than 200 grand villas along the banks of the Brenta Canal to serve as summer homes. During the summer of 1817 Byron rented the Villa Foscarini in the town of La Mira, about 7 miles west of the Venetian lagoon. (DeVal 1978–1979, p. 21)

The phrase "blue Friuli's mountains" indicated peaks in a region to the northeast of La Mira and Venice, while the "far Rhaetian hill" referred to the Rhaetian Alps along the Italy-Switzerland border to the northwest of Byron's location. Iris was the goddess of the rainbow in Greek mythology, and Byron's phrase "Iris of the West" therefore provided a poetic description of the vivid colors in the twilight sky.

In addition to the explicit lunar reference ("The Moon is up"), the phrase describing how "meek Dian's crest/Floats through the azure air" indirectly referred to the same celestial body by the mention of Diana, the goddess of the Moon. Byron's readers would be familiar with paintings and sculptures identifying the Roman goddess Diana by attributes that can include hunting dogs or a deer, a crescent-shaped bow, a quiver of arrows, and her diadem or crest in the shape of a crescent Moon above her forehead (Fig. 9.2).

Fig. 9.2 Byron's readers in the nineteenth century would immediately recognize "Dian's crest" as a poetic reference to the Moon. Paintings and sculptures often depicted the Roman goddess Diana with her diadem or crest in the shape of a crescent Moon above her forehead. Upper left: Fresco by Antonio Correggio (1489–1534). Upper right: Painting by Guillaume Seignac (1870–1924). Lower left: Statue by British sculptor Joseph Nollekens (1737–1823). (Photograph by the author.) Lower right: Painting by Jules Joseph LeFebvre (1834–1912)

An especially intriguing astronomical reference came after the mythological allusion to "Dian's crest" (the Moon) when Byron then noted that a "Single Star is at her side." Our Texas State group wondered whether it might be possible to identify the "Single Star" near the Moon in this dramatic and colorful twilight sky. Can we determine the date of this spectacular celestial scene? Could biographical information, letters, diaries, and other clues allow us to confirm that an actual event inspired these stanzas?

Summer in La Mira

Byron's letters establish a range of possible dates for the memorable evening sky. The poet moved to the Villa Foscarini (Fig. 9.3) on the Brenta Canal in La Mira on June 14, 1817, and he began writing the fourth canto of "Childe Harold's Progress" by June 26th. Byron's close friend, John Cam Hobhouse (Fig. 9.1, earlier, right), joined him as a houseguest on July 31st, and the two began a custom of almost-daily rides together at sunset along the Brenta. Byron and Hobhouse left La Mira on November 13th to spend the winter season in Venice. On January 8, 1818, Hobhouse departed for England and carried the manuscript of the fourth canto to John Murray, Byron's publisher in London. (Marchand 1957, pp. 696–720) The letters show that the celestial scene must have occurred between June and November of 1817.

Fig. 9.3 The Villa Foscarini today is the wide white building behind the end of this foot-bridge spanning the Brenta Canal in La Mira. A plaque on the villa's wall reads *LORD BYRON ABITO 1817* ("Lord Byron lived here in 1817.") (Photograph by the author)

Byron's Note in Print and Manuscript

In the first edition published by John Murray, a note written by Byron appears to provide a precise date of August 18th for the spectacular twilight when:

> *A single star is at her side, and reigns*
> *With her o'er half the lovely heaven.*

However, this date may *not* be precisely correct. Byron scholars have published facsimile reproductions of the poet's manuscripts, and the corresponding page shows that he was uncertain regarding the exact date. The original manuscript, in Byron's handwriting, reads:

> *The above description may seem fantastical or exaggerated to those who have never seen an Oriental or an Italian sky – yet it is but a literal – and hardly sufficient delineation of an August evening (the ~~19~~ 18th) as contemplated during many a ride along the banks of the Brenta – near La Mira.* (Erdman and Worrall 1991, p. 325)

After first identifying the date as August "19," Byron then crossed out that number and changed his recollection by writing "18th."

Hobhouse's Diary

Remarkably, an even better source for the correct date exists. As mentioned in a preceding section, Byron and Hobhouse frequently rode together along the Brenta and made round trips from La Mira to the town of Dolo and back (Fig. 9.4). A biography of Byron noted regarding the fourth canto that: "Stimulated by his rides at sunset along the Brenta, Byron added more stanzas." (Marchand 1957, p. 706) Hobhouse himself later recalled that "part of it was begot as it were under my own eyes … some of the stanzas owe their birth to our morning walk or evening ride at La Mira." (Coleridge 1899, p. 315) Hobhouse kept a diary in the summer of 1817, and the relevant entry proves that the memorable twilight occurred on August 20th:

> *Wednesday August 20th 1817: Ride with Byron. Return over the other side of the river from Dolo … Riding home, remarked the moon reigning on the right of us and the Alps still blushing with the gaze of the sunset. The Brenta came down upon us all purple – a delightful scene, which Byron has put in three stanzas of his "Childe Harold."* (Hobhouse 1909, p. 77)

The Moon and Jupiter

We set our planetarium computer programs for August 20, 1817, and a location between Dolo and La Mira along the Brenta Canal path (12° 06′ East Longitude, 45° 26′ North Latitude). At sunset the Moon stood 20° above the southern horizon, and it was still 18° high an hour later, when deep twilight would have matched Byron's description. And the poem's "Single Star…at her side" was not a star at all. The planet Jupiter shone brilliantly, only 10° to the right of the Moon in the twilight sky—close enough that the Moon-Jupiter pair would be memorable (Fig. 9.5).

Fig. 9.4 Don and Marilynn Olson in 2010 retraced the route of Lord Byron and John Cam Hobhouse along the south bank of the Brenta Canal between La Mira and Dolo—but on bicycles rather than horses (Photograph by the author)

Fig. 9.5 Two centuries ago the poet Lord Byron observed the Moon with Jupiter nearby in an evening twilight sky. On August 23, 2014, astrophotographer Jeff Sullivan captured the Moon with Venus and Jupiter nearby in a morning twilight sky, as glitter paths reflect in the waters of California's Mono Lake. Venus, at lower left, has just risen above the distant hills. Jupiter stands higher in the sky. The faint glow of earthshine illuminates the "dark" part of the waning crescent Moon. Automobile headlights illuminate the tufa rocks on the shore of Mono Lake in the foreground (Photograph by Jeff Sullivan. Used with permission)

Volcanic Twilights

Byron's twilight passage has one more aspect of scientific interest. The spectacular colors he observed were likely to have been genuinely abnormal, stemming from the greatest volcanic eruption in recorded history.

A chapter in the author's previous *Celestial Sleuth* book identified the blood-red sky in Edvard Munch's most famous painting, *The Scream*, as a depiction of a "Krakatoa twilight." (Olson 2014, pp. 67–82) For several years after the 1883 eruption of Krakatoa, dust, gas, and aerosols in the upper atmosphere produced remarkable hues in twilight skies worldwide.

Even more powerful than the Krakatoa event was the April 1815 eruption of Tambora (Fig. 9.6). Richard Stothers wrote in the journal *Science* that the Tambora "eruption stands out as being an order of magnitude bigger in volume of discharged pyroclastics than the Krakatau eruption in 1883 …. In fact, it exceeds any other known eruption, historical or otherwise, during the past 10,000 years." (Stothers 1984, p. 1197) Regarding optical effects, Stothers noted that in 1815 "prolonged and brilliantly colored sunsets and twilights were frequently seen … the twilight glows appeared orange or red near the horizon, purple or pink above" and that "Two and a half years after the eruption, some haze still remained." (Stothers 1984, pp. 1194–1195).

Fig. 9.6 The summit caldera of Mount Tambora on Sumbawa Island, Indonesia, is clearly visible in this USGS Landsat satellite image captured in 2005. The Tambora eruption of April 10–11, 1815, had worldwide effects on Earth's atmosphere for 3 years (Photograph courtesy of the U. S. Geological Survey. Used with permission)

Fig. 9.7 The 1991 eruption of Mount Pinatubo in the Philippines ejected enough material into the stratosphere to redden twilights around the world for 2 years. This photograph, taken on June 12th, shows a preliminary eruption of Pinatubo 3 days before the main one began (Photograph courtesy of the U. S. Geological Survey. Used with permission)

Similar worldwide volcanic twilights followed the 1991 eruption of Mount Pinatubo in the Philippines (Fig. 9.7), a much lesser event that, even so, turned clear twilight skies around the world into a spectacular mixture of purple and bright red.

Tambora in Literature and Art

Recent authors describing the effects of the 1815 Tambora eruption have given a number of examples from literature and art, including the origin of *Frankenstein*, a short poem written by Byron, and "volcanic sunset" paintings (Klingaman and Klingaman 2014; Wood 2014; Zerefos et al. 2007, 2014).

Tambora's effect on the weather caused 1816 to become known as the "year without a summer." The cold and rainy conditions forced a group of authors, including Mary Shelley, to remain inside. They invented tales of horror around the fireplace of Villa Diodati, the house rented by Byron near Geneva during the summer of 1816. A chapter in the first *Celestial Sleuth* book used the position of the Moon to determine a precise date and time for Mary Shelley's "waking dream" that became the inspiration for the novel *Frankenstein* (Olson 2014, pp. 317–332).

Byron himself wrote in 1816 an apocalyptic poem called "Darkness" with a line describing how "The bright sun was extinguish'd." The American artist William Edward West transcribed a conversation with Byron about the poem: "I asked him one day how he could have conceived such a scene as he had described in his 'Darkness' – said he wrote it one day in 1816 in Geneva when there was a celebrated dark day – that the fowls went to roost at noon and the candles lighted as at night." (West 1826, pp. 246–247; Pennington 1984, p. 20).

Christos S. Zerefos and co-authors have analyzed "volcanic sunset paintings," defined as "those that were created within a period of three years that followed a major volcanic eruption." Their list of works with enhanced reddening in the sky included sunset and twilight paintings created by J. M. W. Turner and Caspar David Friedrich in the years 1817–1818 (Zerefos et al. 2007, pp. 4028–4029; Zerefos et al. 2014, pp. 3002–3004). To examples like these we can add another effect of the Tambora eruption: the spectacular sunset observed in Italy by Byron on August 20, 1817. As Byron and Hobhouse rode eastward on the bank of the Brenta Canal, a "Tambora twilight" set the stage for a close grouping of the Moon and Jupiter.

The Comets of Edgar Allan Poe

Edgar Allan Poe (1809–1849) (Fig. 9.8) is famous for his poetry and tales featuring the macabre and the grotesque. Less well-known is his interest in astronomy (Fig. 9.9) and the astronomical references that occur throughout Poe's work.

For example, Tycho's supernova of 1572 inspired the poem "Al Aaraaf" (1829). "The Unparalleled Adventure of One Hans Pfaall" (1835) tells the story of a voyage to the Moon by balloon and along the way discusses the faint glow called the zodiacal light, the inclination of the Moon's orbital plane, and possible explanations for gradual changes in the orbit of Encke's Comet. In a signature scene at the beginning of Poe's "Murders in the Rue Morgue" (1841), as the characters walk through Paris they cast their "eyes upward to the great nebula in Orion." Poe remarks on the immense distances to the stars and the related light-travel times from Sirius and 61 Cygni in his footnotes to various editions of "The Thousand-and-Second Tale of Scheherazade." (1845 and 1850).

Poe's lengthy cosmological treatise *Eureka* (1848) discusses asteroids, stars, nebulae, and even the problem known as Olber's paradox. (Croswell 2001, pp. 44–50) Poe anticipates an essential feature of the modern resolution of the paradox when he offers his explanation of the dark night sky:

Were the succession of stars endless, then the background of the sky would present us a uniform luminosity, like that displayed by the Galaxy – since there could be absolutely no point, in all that background, at which would not exist a star. The only mode, therefore, in which, under such a state of affairs, we could comprehend the voids which our telescopes find in innumerable directions, would be by supposing the distance of the invisible background so immense that no ray from it has yet been able to reach us at all. (Poe 1848, p. 100)

Fig. 9.8 Edgar Allan Poe walks again on the streets of Boston. This statue, created by artist Stefanie Rocknak and unveiled by the Edgar Allan Poe Foundation of Boston in 2014, is located near the intersection of Boylston Street and Charles Street, just south of Boston Common. At night the dramatic shadow of Poe's raven falls on the sidewalk in a manner reminiscent of lines from the last stanza of the poem: "And the lamp-light o'er him streaming throws his shadow on the floor/And my soul from out that shadow that lies floating on the floor /Shall be lifted – nevermore!" (Photograph by Sean Sweeney, www.flickr.com/ssweeney1. Used with permission)

Fig. 9.9 This telescope (left), reputed to be the instrument Poe used to study the heavens in the 1820s, is displayed at the Poe House museum (right) in Baltimore. The refractor and its pillar stand were made by the London firm of Thomas Blunt and were brought back from England by Poe's foster father, John Allan (Photographs courtesy of Poe Baltimore, Inc. Used with permission)

Poe describes the Moon, stars, and planets in the poems "Evening Star" (1827) and "Ulalume" (1847), and many other examples exist.

The Conversation of Eiros and Charmion

Especially interesting references to comets appear in "The Conversation of Eiros and Charmion," a short story first published in the December 1839 issue of *Burton's Gentleman's Magazine*. The tale takes the form of a dialog between two spirits in a heavenly realm. An apocalyptic event has destroyed all life on Earth, and the agent of destruction was a comet in a path that "would bring it into very close proximity with the earth." As the comet drew closer, scholars offered reassurance that comets were "vapory creations of inconceivable tenuity…altogether incapable of doing injury to our substantial globe, even in the event of contact." The end indeed came not by a collision, but by the comet's atmosphere mingling with that of Earth, extracting all the nitrogen, and replacing it with pure oxygen. The result was a "final destruction of all things by fire…A combustion irresistible, all-devouring, omni-prevalent, immediate…the whole incumbent mass of ether in which we existed burst at once into a species of intense flame…Thus ended all." The tale includes some very specific scientific references to the composition of Earth's atmosphere and to the orbits and physical properties of comets.

What motivated Poe to write this tale? Can we determine the books from which he derived his scientific statements? Can we identify the actual comets that inspired the astronomical passages?

Earth's Atmosphere

A pioneering study by Margaret Alterton pointed out (Alterton 1925, pp. 140–141) that Poe's passages about Earth's atmosphere and combustion were taken from *The Christian Philosopher* by Thomas Dick (Fig. 9.10, left):

> *Of 100 measures of atmospheric air, 21 are oxygen, and 79 nitrogen. The one, namely, oxygen, is the principle of combustion, and the vehicle of heat, and is absolutely necessary for the support of animal life, and is the most powerful and energetic agent in nature. The other is altogether incapable of supporting either flame or animal life … If the nitrogen were extracted from the air, and the whole atmosphere contained nothing but oxygen … combustion would not proceed in that gradual manner which it now does, but with the most dreadful and irresistible rapidity … instantly a universal conflagration would commence …. (The Christian Philosopher, Dick 1836, pp. 35, 132–133)*

Poe repeats this passage almost verbatim:

> *…the air which encircled us was a compound of oxygen and nitrogen gases, in the proportion of twenty-one measures of oxygen and seventy-nine of nitrogen in every one hundred of the atmosphere. Oxygen, which was the principle of combustion, and the vehicle of heat, was absolutely necessary to the support of animal life, and was the most powerful and energetic agent in nature. Nitrogen, on the contrary, was incapable*

Fig. 9.10 Poe used various volumes from the 1830s as the sources for his descriptions of Earth's atmosphere and the orbits of comets. Left: Thomas Dick (1774–1857), author of *The Christian Philosopher* in 1836. Center: Elijah Hinsdale Burritt (1794–1838), author of *The Geography of the Heavens* in 1838 (Courtesy of the New Britain Public Library Local History Room Collection, New Britain, CT). Right: John F. W. Herschel (1792–1871), British author of *A Treatise on Astronomy* in 1833, American edition published in 1834

of supporting either animal life or flame … What would be the result of a total extraction of the nitrogen? A combustion irresistible, all-devouring, omni-prevalent, immediate …. ("*The Conversation of Eiros and Charmion,*" Poe 1839, p. 322)

Leonids of 1833?

What astronomical phenomenon might have inspired Poe to think about fire in the atmosphere?

Biographer Arthur Quinn judged that "probable as a local source, this time for his story 'Eiros and Charmion,' was the rain of meteors visible in Baltimore in the early morning of November 13, 1833…the dread on the part of some of the beholders that the end of the world was at hand … might easily have suggested to Poe the description by Eiros of the comet which brings destruction to the world." (Quinn 1941, p. 187).

The Leonid meteor storm of 1833 was indeed a spectacular event. However, Poe wrote about a comet, and astronomers did not make the connection between comets and meteor showers until 1866 when Giovanni Schiaparelli (1835–1910) showed that the Perseid meteors and Comet Swift-Tuttle shared the same orbit. Poe would not have been able to associate a meteor shower with the approach of a comet, and the Leonids do not fit the story.

Halley's Comet? Encke's Comet?

Arthur Quinn offered as an alternate theory that Poe "probably saw Halley's Comet in 1835." (Quinn: 1941, p. 287) Several more recent commentators also endorsed the idea of Halley's Comet as inspiration for the story (Beaver 1976, p. 356; Levine and Levine 1976, p. 108; Sova 2007, p. 50).

In his notes to the tale, Poe scholar Thomas Mabbott likewise mentioned that the "famous Halley's Comet returned in 1835." Mabbott also argued that Poe might have been interested in Encke's Comet, because "its periodicity had been calculated," it had returned in 1838, and it "was expected again in 1842." (Mabbott 1978, p. 452).

Poe's astronomical references in other works demonstrate that he was aware of Halley's Comet and Encke's Comet. But neither of those celestial wanderers posed a threat to collide with Earth.

Our Texas State group wondered: Did any other comet, known in the 1830s, have an orbit that intersected or nearly intersected Earth's orbit? Eventually we realized that only one comet matched this requirement of Poe's story.

Biela's Comet

Biela's Comet was first observed in 1772 by Jacques Leibax Montaigne. The comet received its name in 1826 when Wilhelm von Biela and Jean-Félix Adolphe Gambart identified it as periodic. The comet was observed in 1832 and the next return was scheduled for 1839, the year Poe's tale appeared.

An essential point of the Eiros and Charmion story is that Poe's fictional comet approaches so close that the comet's atmosphere mingles with Earth's atmosphere. Exactly such a possibility was discussed in the scientific literature of the 1820s and 1830s for Biela's Comet.

Heinrich Olbers, the astronomer associated with "Olber's paradox," remarked about Biela's Comet in *The American Journal of Science*: "[A]t some time the comet may pass at a very small distance from us, and even so near, that its atmosphere may be in contact with our globe." (Olbers 1828, p. 190) (Fig. 9.11) Astronomer Joseph Johann von Littrow, writing in the same journal in 1833, pointed out: "Of all the comets which are known to astronomers, that of Biela is the only one whose orbit is such as to admit of its ever coming in contact with the Earth. This is a circumstance which renders that body an object of deep and peculiar interest to the inhabitants of our globe." (Littrow 1833, p. 346) (Fig. 9.12). Poe could conceivably have been familiar with these notes in a scientific journal.

To find more likely candidates for Poe's reading, we surveyed popular astronomy books from the 1830s. Probably the most famous such volumes were the multiple editions of *The Geography of the Heavens*, written by Elijah Hinsdale Burritt (Fig. 9.10 earlier, center) and issued in large printings in 1833, 1836, 1838, and later years. An article by Peggy Aldrich Kidwell surveyed the Burritt volumes and their enthusiastic public reception (Kidwell 1985, pp. 26–28).

Burritt's 1838 edition included language identifying Biela's Comet as a perfect candidate for Poe's fictional comet:

> *... the path of Biela's comet passes very near to that of the Earth ... the matter of the comet extends beyond that path Thus, if the Earth were at that point of its orbit which is nearest to the path of the comet, at the same moment that the comet should be at that point of its orbit which is nearest to the path of the Earth, the Earth would be enveloped in the nebulous atmosphere of the comet.... This is the comet which was to come into collision with the Earth, and to blot it out from the Solar System.*
> (Burritt 1838, pp. 251–252)

Fig. 9.11 The astronomer Heinrich Olbers remarked in 1828 that Biela's Comet "may pass at a very small distance from us, and even so near, that its atmosphere may be in contact with our globe." This diagram shows exactly that possibility, with Biela's Comet (C–C′) making a hypothetical close passage that allows the atmosphere of the comet to mix with the atmosphere of Earth (T = Terre = Earth). This illustration appeared in Amedee Guillemin's *The World of Comets* (1877)

Fig. 9.12 The red comet symbol and the red arrows mark the location where the orbit of Biela's Comet and the orbit of Earth nearly intersect. A misunderstanding about the 1832 apparition of the comet caused a panic in some of the press, but the comet (C) passed this intersection point on October 29, 1832, more than a month before Earth (T = Terre = Earth) arrived there on November 30, 1832, and astronomers knew that no collision would occur. This illustration appeared in Amedee Guillemin's *The World of Comets* (1877)

British astronomer John Herschel (Fig. 9.10 earlier, right) in 1833 wrote a popular book titled *A Treatise on Astronomy*. In 1834 an American edition appeared with a passage related to a recent "comet panic" caused by Biela's Comet:

The other comet of short period which has lately been discovered is that of Biela …
Its orbit, by a remarkable coincidence, very nearly intersects that of the earth; and
had the latter, at the time of its passage in 1832, been a month in advance of its
actual place, it would have passed through the comet – a singular rencontre, per-
haps not unattended with danger. (Herschel 1834 (American edition), p. 292)

Poe's own words prove that he had read John Herschel's book. One of Poe's later essays describes events in the summer of 1835: "Harpers had issued an American edition of Sir John Herschel's 'Treatise on Astronomy,' and I had been much interested in what is there said respecting the possibility of future lunar investigations … I longed to write a story embodying these dreams." (Poe 1846, p. 159) The essay goes on to say that Herschel's book inspired him to begin his 1835 story about Hans Pfaall's balloon voyage to the Moon.

Poe's inspiration for using a comet as the agent to destroy life on Earth almost certainly came from his reading about Biela's Comet, possibly in *The American Journal of Science* but more likely in the books by Elijah Burritt and John Herschel.

Lexell's Comet

However, another intriguing passage in "The Conversation of Eiros and Charmion" does not fit at all with the behavior of Biela's Comet. As Poe's fictional comet approaches Earth, scientists offer reassurances that nothing need be feared from even a direct collision:

The very moderate density of these bodies had been well established. They had been
observed to pass among the satellites of Jupiter without bringing about any sensible
alteration either in the masses or in the orbits of these secondary planets. We had
long regarded the wanderers as vapory creations of inconceivable tenuity, and as
altogether incapable of doing injury to our substantial globe, even in the event of
contact. ("The Conversation of Eiros and Charmion," Poe 1839, p. 321)

As the comet draws even closer to Earth, the reassurance is repeated:

…the harmless passage of a similar visitor among the satellites of Jupiter was a
point strongly insisted upon, and which served greatly to allay terror. ("The Conversation of Eiros and Charmion," Poe 1839, p. 322)

Poe almost certainly derived these passages from the 1834 Philadelphia edition of John Herschel's popular book. Herschel describes an encounter between Lexell's Comet and Jupiter:

In the case of the remarkable comet of 1770, which was found by Lexell to revolve
in a moderate ellipse in the period of about 5 years, and whose return was predicted
by him accordingly, the prediction was disappointed by the comet actually getting

entangled among the satellites of Jupiter, and being completely thrown out of its orbit by the attraction of that planet, and forced into a much larger ellipse. By this extraordinary rencontre, the motions of the satellites suffered not the least perceptible derangement – a sufficient proof of the smallness of the comet's mass. (Herschel 1834 (American edition), p. 292)

Elijah Burritt's 1838 edition quotes Herschel's words and summarizes this passage as "sufficient proof of the aeriform nature of the comet's mass." (Burritt 1838, p. 245).

Poe's mention of a comet "observed to pass among the satellites of Jupiter" was definitely inspired by Lexell's Comet.

Lexell's Comet and Earth

In addition to the remarkable 1779 passage of Lexell's Comet through Jupiter's satellite system, nine years earlier this same comet also had an exceptional encounter with Earth. On July 1, 1770, Lexell's Comet passed by Earth at a distance only about six times the distance to the Moon. This ranks as the closest approach of a comet to our planet in recorded history. A subsequent close encounter with Jupiter tugged it into an orbit that will keep this comet from coming close to us again.

Stars Visible Through Comets

Another passage from Poe's tale offers reassurance about the low density of comets in a different way: "The exceeding tenuity of the object of our dread was apparent; for all heavenly objects were plainly visible through it." ("The Conversation of Eiros and Charmion," Poe 1839, p. 322).

Once again Poe was apparently influenced by John Herschel, who discussed the tenuous nature of comets:

Stars of the smallest magnitude remain distinctly visible, though covered by what appears to be the densest portion of their substance; although the same stars would be completely obliterated by a moderate fog, extending only a few yards from the surface of the earth It will then be evident that the most unsubstantial clouds which float in the highest regions of our atmosphere ... must be looked upon as dense and massive bodies compared with the filmy and all but spiritual texture of a comet. (Herschel 1834 (American edition), pp. 285–286)

The primary source for this remark was an article by John Herschel himself, who described his observations of Biela's Comet on September 23, 1832:

... it passed directly over a small cluster or knot of minute stars of the 16th or 17th magnitude...the stars of the cluster being visible through the comet.

A more striking proof could not have been offered of the extreme translucency of the matter of which this comet consists. The most trifling fog would have entirely effaced this group of stars; yet they continued visible through a thickness of the cometic matter... (Herschel 1833, pp. 99–100)

Fig. 9.13 The Great Comet of 1843 developed a spectacularly long tail. This chromolith from Amedee Guillemin's *The World of Comets* (1877) shows the appearance of the comet on March 19, 1843, with the constellation of Orion above the comet and the bright star Sirius near the end of the comet's tail. Two weeks later Poe reprinted his cometary tale of Eiros and Charmion on the front page of a newspaper called the *Philadelphia Saturday Museum* for April 1, 1843

Comet of 1843

Observers in the nineteenth century witnessed the passage of a remarkable series of spectacular comets (Figs. 9.13 and 9.14). The Great Comet of 1843 reached its maximum brilliance in March. Poe took the occasion to reprint his tale of Eiros and Charmion, now with the title "The Destruction of the World [A Conversation between two Departed Spirits]."

Meteor Storms in 1872 and 1885

Although Biela's Comet itself never collided with Earth, this comet had an unusually interesting history after 1839—and fragments of Biela's Comet did strike Earth's atmosphere!

Biela's Comet was not observed during the unfavorable return in 1839. At the apparition of 1845–1846, Matthew Fontaine Maury was astonished to see that the comet had divided into two components that moved together and developed parallel tails as they approached the Sun. Both objects were recovered at the 1852 passage, but after that year they were never seen again.

Fig. 9.14 Left: This chromolith appeared in Amedee Guillemin's *The World of Comets* (1877) and showed Donati's Comet over Paris on October 5, 1858, when the head of the comet passed close to the bright star Arcturus. RIGHT: This chromolith of the Great Comet of 1881, as observed on June 26th of that year, was part of a set of 15 astronomical drawings created by Étienne Léopold Trouvelot and accompanied by *The Trouvelot Astronomical Drawings Manual* (1882)

Then, on November 27, 1872, the exact date when Earth passed closest to the comet's orbit, astronomers were again astonished as fragments of Biela's Comet produced a spectacular meteor storm (Fig. 9.15). A similar rain of meteors fell from the sky on November 27, 1885. The meteors are known as either Bielids or as Andromedids, after the constellation containing the point from which they appeared to radiate.

Kremenliev's Thesis

Our Texas State University group worked on this project and identified Poe's sources as part of a recent Honors College course. Later our literature search revealed that another scholar had drawn the same conclusions five decades earlier.

Elva Baer Kremenliev submitted her Ph. D. thesis, "The Literary Uses of Astronomy in the Writings of Edgar Allan Poe," to UCLA in 1963. She used John Herschel's 1834 American edition as a source and connected "The Conversation of Eiros and Charmion" to both Biela's Comet and Lexell's Comet (Kremenliev 1963, pp. 143–149).

A modern edition of Poe's stories includes Kremenliev's thesis in the bibliography and agrees that Poe "may well have been thinking of Biela's comet." (Beaver 1976, p. 356).

Fig. 9.15 Biela's Comet itself never collided with Earth—but fragments of the comet eventually did! A meteor storm occurred on November 27, 1872, as shown in this chromolith from Giuseppe Naccari's *Atlante Astronomico* (1904). The meteors, known as Bielids or as Andromedids, produced another storm of falling stars on November 27, 1885

Eudosia and Neander

Our search of popular astronomy books available to Poe turned up one more volume worth mentioning. The format for Poe's tale is a dialog between Eiros and Charmion. James Ferguson's *An Easy Introduction to Astronomy for Young Gentlemen and Ladies*, published in Philadelphia in 1819, takes the form of a dialog between a brother and sister

named Neander and Eudosia, respectively, with the conversation including the following reassurance about the danger of comets:

> Eudosia. *But, as we were talking about the comets, pray, are they not dangerous? We are always frightened when we hear of their appearing, lest their fiery trains should burn the world.*
>
> Neander. *That is owing to People's not knowing better...And, as to those appearances, which are called the tails of the comets, they are only thin vapours, which arise from the comets, and which could not hurt any planet, if it should happen to go through that vapour when the comet is crossing the plane in which the planet's orbit lies...*
>
> Eudosia. *This is comfortable doctrine, indeed.*
> (Ferguson 1819, pp. 41–42)

Poe's format for "The Conversation of Eiros and Charmion" may have been in part inspired by Ferguson's book for young readers.

Poe's Sources

The scientific passages in Edgar Allan Poe's 1839 story "The Conversation of Eiros and Charmion" were derived from Thomas Dick's *The Christian Philosopher*, Elijah Burritt's *The Geography of the Heavens*, and John Herschel's *A Treatise on Astronomy*, all available to him in the 1830s. The specific details about comets are based on the characteristics of Biela's Comet and Lexell's Comet.

Wilkie Collins: The Woman in White

Inspiration struck for this research project while the author was reading the following paragraphs that begin a profile of Wilkie Collins (Fig. 9.16) in a *New Yorker* article by Jonathan Rosen:

> *My elder daughter, who is in fifth grade, recently learned about cliffhangers and asked me if I knew any.*
>
> *"Here's one," I said. "A young man is walking along a deserted road in the dead of night. All of a sudden, he feels a hand on his shoulder. He whirls around and sees a young woman, dressed from head to foot in white, standing before him like a ghost. She asks him the way to London. He explains that he is headed there himself. She is clearly frightened, and tells him that she has 'met with an accident.' She will not say what it is, but she is very relieved to learn that he is not an aristocrat, only a drawing master who teaches the children of the rich. She takes his arm and they walk together, but she remains nervous and makes the young man promise that when they get to London he will not try to interfere with her going away. When they reach the outskirts of the city, the drawing master finds a cab for the woman. She jumps in, refusing all offers of further assistance. Soon, the young man sees another carriage*

race by with two men inside. They ask a policeman if he has seen a young woman dressed all in white. It is very important that they find her. 'What has she done?' the policeman asks. To which one of the men replies, 'Done! She has escaped from my Asylum!' The drawing master, hidden in the shadows, overhears this exchange, but says nothing. He watches the carriage drive off into the night."

My daughter's eyes had grown large. "That's a good one," she whispered. "What happens next?"

What indeed! A hundred and fifty years after the publication of "The Woman in White," in which this scene appears, Wilkie Collins had her. And she didn't even know what an asylum was.

Nowadays, people tend to know Collins, if they know him at all, for either "The Woman in White," published in 1860, or "The Moonstone," published in 1868. Since the former is considered the originator of the "sensation novel" – a wildly popular Victorian genre that blended gothic horror and domestic realism – and the latter is often credited with spawning the modern detective story, that's not a bad legacy. (Rosen 2011, p. 75).

Before publication as a novel in 1860, *The Woman in White* appeared as a serial with 40 weekly installments in the publications *All The Year Round* in England and *Harper's Weekly* in the United States. In the first installment, published on November 26, 1859, Walter Hartright visits a family cottage near Hampstead Heath, north of London.

Fig. 9.16 This woodcut portrait of Wilkie Collins (1824–1889) appeared on the front page of *Harper's Weekly* for March 8, 1873

Walter then describes his walk back to London by the light of a full Moon on an oppressively hot and sultry summer night:

...it was nearly midnight when the servant locked the garden-gate behind me. I walked forward a few paces on the shortest way back to London; then stopped, and hesitated.

The moon was full and broad in the dark blue starless sky; and the broken ground of the heath looked wild enough in the mysterious light to be hundreds of miles away from the great city that lay beneath it. The idea of descending any sooner than I could help into the heat and gloom of London repelled me. The prospect of going to bed in my airless chambers, and the prospect of gradual suffocation, seemed, in my present restless frame of mind and body, to be one and the same thing. I determined to stroll home in the purer air, by the most round-about way I could take; to follow the white winding paths across the lonely heath; and to approach London through its most open suburb by striking into the Finchley-road, and so getting back, in the cool of the new morning, by the western side of the Regent's Park.

I wound my way down slowly over the Heath, enjoying the divine stillness of the scene, and admiring the soft alternations of light and shade...

But when I had left the Heath, and had turned into the by-road...I had become completely absorbed in my own fanciful visions...

I had now arrived at that particular point of my walk where four roads met – the road to Hampstead, along which I had returned; the road to Finchley; the road to West End; and the road back to London. I had mechanically turned in this latter direction, and was strolling along the lonely high-road ... when, in one moment, every drop of blood in my body was brought to a stop by the touch of a hand laid lightly and suddenly on my shoulder from behind me.

I turned on the instant, with my fingers tightening round the handle of my stick.

There, in the middle of the broad, bright high-road – there, as if it had that moment sprung out of the earth or dropped from the heaven – stood the figure of a solitary Woman, dressed from head to foot in white garments; her face bent in grave inquiry on mine, her hand pointing to the dark cloud over London, as I faced her.

I was far too seriously startled by the suddenness with which this extraordinary apparition stood before me, in the dead of night and in that lonely place, to ask what she wanted. The strange woman spoke first.

"Is that the road to London?" she said.

I looked attentively at her, as she put that singular question to me. It was then nearly one o'clock. All I could discern distinctly by the moonlight, was a colourless, youthful face...

This nocturnal scene was a favorite subject for illustrators of the novel (Figs. 9.17, 9.18, 9.19, and 9.20).

Fig. 9.17 Francis Arthur Fraser created the cover artwork for the 1889 Chatto and Windus edition of *The Woman in White*. The dramatic moonlit encounter of Walter Hartright and the Woman in White was a favorite subject for illustrators of the novel

Charles Dickens himself judged that the moonlit encounter was one of the "two scenes in literature which he regarded as being the most dramatic descriptions." (The other appeared in Thomas Carlyle's *The French Revolution*.) (H. F. Dickens 1934, p. 54).

The Woman in White caused a sensation in nineteenth-century England. Readers awaited the appearance of each weekly installment with anticipation comparable to that

Fig. 9.18 The cover artwork for the 1937 Modern Library edition of *The Woman in White* featured the moonlit scene on the road north of London

seen at the modern release parties for the Harry Potter novels. Prince Albert enjoyed *The Woman in White* so much that he sent copies as gifts. William Gladstone, Chancellor of the Exchequer and a future Prime Minister, missed a theatre engagement in order to keep reading. Novelist William Makepeace Thackeray "sat up all night in order to read the exciting tale he could not put down" (Ellis 1931, p. 29). One of Wilkie Collins's biographers noted that "*The Woman in White* was probably the most popular novel written in England during the nineteenth century." (Davis 1956, p. 216).

Moonlit Encounter Near Regent's Park

Near the end of the nineteenth century an account appeared in print suggesting that the novel's moonlit encounter with a woman in white was based on a real event in the life of the author. The story appeared in a biography of the artist John Everett Millais:

> *Of Wilkie Collins … both he and his brother Charles were for many years amongst Millais' most intimate friends … Since his famous novel, The Woman in White, appeared, many have been the tales set on foot to account for its origin, but for the most part quite inaccurate. The real facts, so far as I am at liberty to disclose them, were these: –*
>
> *One night in the fifties Millais was returning home to Gower Street from one of the many parties held under Mrs. Collins' hospitable roof in Hanover Terrace, and, in*

VOL. III.—No. 152.] NEW YORK, SATURDAY, NOVEMBER 26, 1859. [PRICE FIVE CENTS.

Entered according to Act of Congress, in the Year 1859, by Harper & Brothers, in the Clerk's Office of the District Court for the Southern District of New York.

THE WOMAN IN WHITE.

By WILKIE COLLINS.

AUTHOR OF "THE DEAD SECRET," "AFTER DARK," ETC. ETC.

[From Advance Sheets, purchased direct from the Author.]

PREAMBLE.

This is the story of what a Woman's patience can endure, and of what a Man's resolution can achieve.

If the machinery of the Law could be depended on to fathom every case of suspicion, and to conduct every process of inquiry, with moderate assistance only from the lubricating influences of oil of gold, the events which fill these pages might have claimed their share of the public attention in a Court of Justice.

But the Law is still, in certain inevitable cases, the pre-engaged servant of the long purse; and the story is left to be told, for the first time, in this place. As the Judge might once have heard it, so the Reader shall hear it now. No circumstance of importance, from the beginning to the end of the disclosure, shall be related on hearsay evidence. When the writer of these introductory lines (Walter Hartright, by name) happens to be more closely connected than others with the incidents to be recorded, he will describe them in his own person. When his experience fails, his task will be continued, from the point at which he has left it off, by other persons who can speak to the circumstances under notice from their own knowledge, just as clearly and positively as he has spoken before them.

Thus, the story here presented will be told by more than one pen, as the story of an offense against the laws is told in Court by more than one witness—with the same object, in both cases, to present the truth always in its most direct and most intelligible aspect; and to trace the course of one complete series of events, by making the persons who have been most closely connected with them, at each successive stage, relate their own experience, word for word.

Let Walter Hartright, teacher of drawing, aged twenty-eight years, be heard first.

THE NARRATIVE OF WALTER HARTRIGHT, OF CLEMENT'S INN, LONDON.

I.

It was the last day of July. The long hot summer was drawing to a close; and we, the weary pilgrims of the London pavement, were beginning to think of the cloud-shadows on the corn-fields, and the autumn breezes on the sea-shore.

For my own poor part, the fading summer left me out of health, out of spirits, and, if the truth must be told, out of money as well. During the past year, I had not managed my professional resources as carefully as usual; and my extravagance now limited me to the prospect of spending the autumn economically between my mother's cottage at Hampstead, and my own chambers in town.

The evening, I remember, was still and cloudy; the London air was at its heaviest; the distant hum of the street-traffic was at its faintest; the small pulse of the life within me and the great heart of the city around me seemed to be sinking in unison, languidly and more languidly, with the sinking sun. I roused myself from the book which I was dreaming over rather than reading, and left my chambers to meet the cool night air in the suburbs. It was one of the two evenings in every week which I was accustomed to spend with my mother and my sister. So I turned my steps northward, in the direction of Hampstead.

Events which I have yet to relate, make it necessary to mention in this place that my father had been dead some years at the period of which I am now writing, and that my sister Sarah, and I, were the sole survivors of a family of five children. My father was a drawing-master before me. His exertions had made him highly successful in his profession; and his affectionate anxiety to provide for the future of those who were dependent on his labors, had impelled him, from the time of his marriage, to devote to the insuring of his life a much larger portion of his income than most men consider it necessary to set aside for that purpose. Thanks to his admirable prudence and self-denial, my mother and sister were left, after his death, as independent of the world as they had been during his lifetime. I succeeded to his connection, and had every reason to feel grateful for the prospect that awaited me at my starting in life.

The quiet twilight was still trembling on the topmost ridges of the heath; and the view of London below me had sunk into a black gulf in the shadow of the cloudy night, when I stood before the gate of my mother's cottage. I had hardly rung the bell, before the house-door was opened violently; my worthy Italian friend, Professor Pesca, appeared in the servant's place; and darted out joyously to receive me, with a shrill foreign parody on an English cheer.

On his own account, and, I must be allowed to add, on mine also, the Professor merits the honor of a formal introduction. Accident has made him the starting-point of the strange family story which it is the purpose of these pages to unfold.

I had first become acquainted with my Italian friend by meeting him at certain great houses, where he taught his own language and I taught drawing. All I then knew of the history of his life was, that he had once held a situation in the University of Padua; that he had left Italy for political reasons (the nature of which he uniformly declined to mention to any one); and that he had been for many years respectably established in London as a teacher of languages.

Without being actually a dwarf—for he was perfectly well-proportioned from head to foot —Pesca was, I think, the smallest human being I ever saw, out of a show-room. Remarkable any where, by his personal appearance, he was still further distinguished among the rank and file of mankind, by the harmless eccentricity of his character. The ruling idea of his life appeared to be, that he was bound to show his gratitude to the country which had afforded him an asylum and a means of subsistence, by doing his utmost to turn himself into an Englishman. Not content with paying the nation in general the compliment of invariably carrying an umbrella, and invariably wearing gaiters and a white hat, the Professor further aspired to become an Englishman in his habits and amusements, as well as in his personal appearance. Finding us distinguished, as a nation, by our love of athletic exercises, the little man, in the innocence of his heart, devoted himself impromptu to all our English sports and pastimes, whenever he had the opportunity of joining them; firmly persuaded that he could adopt our national amusements of the field, by an effort of will, precisely as he had adopted our national gaiters and our national white hat.

I had seen him risk his limbs blindly at a fox-hunt and in a cricket-field; and, soon afterward, I saw him risk his life, just as blindly, in the sea at Brighton. We had met there accidentally, and were bathing together. If we had been engaged in any exercise peculiar to my own nation, I should, of course, have looked after Pesca carefully; but, as foreigners are generally quite as well able to take care of themselves in the water as Englishmen, it never occurred to me that the art of swimming might merely add one more to the list of manly exercises which the Professor believed that he could learn impromptu. Soon after we had both struck out from shore, I stopped, finding my friend did not gain on me, and turned round to look for him. To my horror and amazement, I saw nothing between me and the beach but two little white arms, which struggled for an instant above the surface of the water, and then disappeared from view. When I dived for him, the poor little man was lying quietly coiled up at the bottom, in a hollow of shingle, looking by many degrees smaller than I had ever seen him look before. During the few minutes that elapsed while I was taking him in, the air revived him, and he ascended the steps of the machine with my assistance. With the partial recovery of his animation came the return of his wonderful delusion on the subject of swimming. As soon as his chattering teeth would let him speak, he smiled vacantly, and said he thought it must have been the Cramp.

When he had thoroughly recovered himself and had joined me on the beach, his warm Southern nature broke through all artificial English restraints, in a moment. He overwhelmed me with the wildest expressions of affection—exclaimed passionately, in his exaggerated Italian way, that he would hold his life, henceforth, at my disposal—and declared that he should never be happy again, until he had found an opportunity of proving his gratitude by rendering me some service which I might remember, on my side, to the end of my days. I did my best to stop the torrent of his tears and protestations, by persisting in treating the whole adventure as a good subject for a joke; and succeeded at last, as I imagined, in lessening Pesca's overwhelming sense of obligation to me. Little did I think then—little did I think afterward when our pleasant Brighton holiday had drawn to an end —that the opportunity of serving me for which my grateful companion so ardently longed, was soon to come; that he was eagerly to seize it on the instant; and that, by so doing, he was to turn the whole current of my existence into a new channel, and to alter me to myself almost past recognition.

Yet, so it was. If I had not dived for Professor Pesca, when he lay under water on his shingle bed, I should, in all human probability, never have been connected with the story which these pages will relate—I should never, perhaps, have heard even the name of the woman, who has lived in all my thoughts, who has possessed herself of all my energies, who has become the one guiding influence that now directs the purpose of my life.

II.

Pesca's face and manner, on the evening when we confronted each other at my mother's gate, were more than sufficient to inform me that something extraordinary had happened. It was quite useless, however, to ask him for an immediate explanation. I could only conjecture, while he was dragging me in by both hands, that (knowing my habits) he had come to the cottage to make sure of meeting me that night, and that he had some news to tell of an unusually agreeable kind.

We both bounced into the parlor in a highly abrupt and undignified manner. My mother sat by the open window, laughing and fanning herself. Pesca was one of her especial favorites; and his wildest eccentricities were always pardonable in her eyes. Poor dear soul! from the first moment when she found out that the little Professor was deeply and gratefully attached to her son, she opened her heart to him unreservedly, and took all his puzzling foreign peculiarities for granted, without so much as attempting to understand any one of them.

My sister Sarah, with all the advantages of youth, was, strangely enough, less pliable. She did full justice to Pesca's excellent qualities of heart; but she could not accept him implicitly, as my mother accepted him, for my sake. Her insular notions of propriety rose in perpetual revolt against Pesca's constitutional contempt for appearances; and she was always more or less undisguisedly astonished at her mother's familiarity with the eccentric little foreigner. I have observed, not only in my sister's case, but in the instances of others, that we of the young generation are nothing like so hearty and so impulsive as some of our elders. I constantly see old people flushed and excited by the prospect of some anticipated pleasure which altogether fails to ruffle the tranquillity of their serene grandchildren. Are we, I wonder, quite such genuine boys and girls now as our seniors were, in their time? Has the great advance in education taken rather too long a stride; and are we, in these modern days, just the least trifle in the world too well brought up?

Without attempting to answer those questions decisively, I may at least record that I never saw my mother and my sister together in Pesca's society, without finding my mother much the younger woman of the two. On this occasion, for example, while the old lady was laughing

"I TURNED ON THE INSTANT, WITH MY FINGERS TIGHTENING ROUND THE HANDLE OF MY STICK."

Fig. 9.19 In the United States the first installment of *The Woman in White* appeared on the front page of *Harper's Weekly* for November 26, 1859. Although John McLenan's illustration at the lower right does not depict the Moon, the dramatic shadows suggest the presence of moonlight

Fig. 9.20 Left: Frederick Walker created this striking poster to advertise a theatrical adaptation of *The Woman in White* on the London stage in 1871. The innovative design marked "the birth of modern English poster art." (Robinson 1952, p. 252). Right: Don and Marilynn Olson next to Frederick Walker's original artwork, in the format of gouache on paper, now exhibited in the Tate Britain museum in London (Photograph by Ava Pope. Used with permission)

accordance with the usual practice of the two brothers, Wilkie and Charles, they accompanied him on his homeward walk through the dimly lit, and in those days semi-rural, roads and lanes of North London.

It was a beautiful moonlight night in the summer time, and as the three friends walked along chatting gaily together, they were suddenly arrested by a piercing scream coming from the garden of a villa close at hand. It was evidently the cry of a woman in distress; and while pausing to consider what they should do, the iron gate leading to the garden was dashed open, and from it came the figure of a young and very beautiful woman dressed in flowing white robes that shone in the moonlight. She seemed to float rather than to run in their direction, and, on coming up to the three young men, she paused for a moment in an attitude of supplication and terror. Then, seeming to recollect herself, she suddenly moved on and vanished in the shadows cast upon the road.

"What a lovely woman!" was all Millais could say. "I must see who she is and what's the matter," said Wilkie Collins as, without another word, he dashed off after her. His two companions waited in vain for his return, and next day, when they met

again, he seemed indisposed to talk of his adventure. They gathered from him, however, that he had come up with the lovely fugitive and had heard from her own lips the history of her life and the cause of her sudden flight. She was a young lady of good birth and position, who had accidentally fallen into the hands of a man living in a villa in Regent's Park. There for many months he kept her prisoner under threats and mesmeric influence of so alarming a character that she dared not attempt to escape, until, in sheer desperation, she fled from the brute, who, with a poker in his hand, threatened to dash her brains out. Her subsequent history, interesting as it is, is not for these pages. (J. G. Millais 1899, Vol. I, pp. 278–281)

The reason for the discretion in the last sentence became clearer in 1931, when Stewart Marsh Ellis published rumors that "this Woman in White so gallantly rescued by Wilkie Collins was the same lady who henceforth lived with him" for decades, although they never married (Ellis 1931, p. 28). Based on "private information," Clyde K. Hyder gave her name as Caroline Graves (Hyder 1939, p. 297) Caroline is buried with Wilkie Collins in his plot in London's Kensal Green Cemetery.

Given the strictures of Victorian morality, it is not surprising that Wilkie Collins himself refrained from public statements about Caroline, with only brief passing references to her in correspondence with friends. Letters to and from Caroline (if any ever existed) have not been found. Independent confirmation of this Regent's Park encounter came from the fourth person present, Wilkie's brother Charles Allston Collins.

Kate Dickens, daughter of Charles Dickens, married Charles Collins in 1860 at the height of the mania for *The Woman in White*. Kate was therefore in a unique position to know the details about Wilkie Collins and his longtime mistress. After Wilkie Collins and Caroline Graves were both dead, Kate revealed that the moonlit event involving Caroline was indeed the inspiration for the dramatic scene in the novel. Biographer Gladys Storey interviewed Kate, who remained

… full of memories of the past … She fell into talking about Wilkie Collins who, she recollected, had a mistress called Caroline, a young woman of gentle birth, and the original of the woman in white, in his thrilling novel of that name. A curious story is attached to their dramatic meeting: one moonlight night in the 'fifties, Collins and his brother, accompanied by Millais, were walking leisurely along a road in the vicinity of Regent's Park, when suddenly they heard a piercing scream, which issued from a villa close by, followed by the appearance of a woman garbed in a flowing white dress…. (Storey 1939, pp. 213–214).

Regent's Park Encounter: 1854?

Scholars have attempted to deduce the year of that moonlit meeting near Regent's Park. For example, Wilkie Collins's biographer Nuel Pharr Davis realized that "Millais indicates only that the incident occurred on a summer night in the fifties," but Davis argued that "Fixing the date is not impossible." Davis surveyed letters, memoirs, and other biographical data to rule out various years. For example, he argued that the "summer of 1852, while theoretically possible, is extremely unlikely. One reason is that Millais spent the summer of that year painting like a hermit at the remote village of Hayes with his brother William."

Davis eventually concluded that the adventure near Regent's Park probably occurred in mid-July of 1854 (Davis 1956, pp. 321–322).

A later biographer, William Clarke, judged: "That Wilkie met a girl in distress in such circumstances has a ring of truth about it ... details of the friends and the place all seem authentic and, if true, can help put a reasonable date to his rather dramatic first meeting with Caroline." Clarke also decided that the most likely year was 1854 (Clarke 1988, p. 91).

Regent's Park Encounter: 1853? 1855? 1859?

Other scholars have placed the Regent's Park encounter in a variety of years from the 1850s.

Paul Lewis maintains a Wilkie Collins website (http://www.web40571.clarahost.co.uk) that includes extensive detail about *The Woman in* White, including scans of each of the installments as they originally appeared in *All The Year Round*. In the biographical pages, Lewis reviews the famous Millais anecdote related to the origin of the novel and suggests that the event occurred probably in "the summer of 1853."

Andrew Gasson drew a similar conclusion, and placed the meeting at some point "during the early 1850s." (Gasson 1998, p. 105).

Jeanne Bedell authored the Wilkie Collins entry for the *Dictionary of Literary Biography*. She settled on a different year and wrote that "in the late summer of 1855 as Collins, his brother, and John Everett Millais were walking to Millais's studio in Gower Street in north London, they were startled by a woman's scream from the garden of a nearby house." (Bedell 1988, p. 93).

Biographer Kenneth Robinson judged that it "is not possible to fix precisely Wilkie's first meeting with Caroline but there are indications that it took place in the early part of 1859." (Robinson 1952, p. 132).

Don Cox and Maria Bachmann generally agreed with Robinson and wrote that the dramatic scene in the novel "could have been drawn from a celebrated incident that allegedly occurred in the late 1850s." (Cox and Bachman 2006, p. 14).

Chronological Analysis

Our Texas State University group wanted to carry out an independent analysis that combined biographical information with astronomical calculations of lunar phases. Table 9.1 lists the five search criteria that we used in an attempt to find a date that would match the Millais account of the incident near Regent's Park.

Table 9.1 Search criteria for the moonlit encounter

1. Months: summer months of June, July, August, September
2. Years: 1850–1855
3. Lunar phases: full Moon or nearly full Moon
4. The four principals (John Millais, Wilkie Collins, Charles Collins, and Caroline Graves) must not be away from London
5. Residences: the Collins family residence must be at 17 Hanover Terrace and the Millais family must be living at 83 Gower Street to match the Millais account

Table 9.2 Full Moons in the early 1850s

1850	June 24, July 24, August 22, September 21
1851	June 13, July 13, August 11, September 10
1852	June 2, July 1, July 31, August 29, September 28
1853	June 21, July 20, August 18, September 17
1854	June 10, July 10, August 8, September 6
1855	June 29, July 29, August 27, September 25

Table 9.2 lists the full Moon dates calculated from astronomical computer programs.

Dates in early June and late September technically do not fall in the summer season but are included for completeness.

Years before 1850 need not be considered, because the Collins family did not move into Hanover Terrace until the late summer of 1850. In fact, all of the above full Moon dates in 1850 and 1851 are apparently ruled out because Caroline Graves was then still married to her first husband, George Robert Graves. The official death certificate shows that he died on January 30, 1852, at the Moravian Cottages on Weston Road in Bath (Clarke 1988, p. 92; Lewis 2013).

The full Moon dates listed in the summer of 1853 can also be ruled out. In the early part of that summer, Wilkie Collins had a serious illness that rendered him unable to work for two months. In a letter dated June 25, 1853, Wilkie Collins mentioned his "illness and long confinement" and noted that he was now recovering but was "not strong enough yet to do more than 'toddle' out for half an hour at a time with a stick." (Baker et al. 2005, p. 84) In the latter part of the summer, John Millais was absent from London on a lengthy trip; he departed first to Northumberland on June 22 and then continued to Scotland where he remained from June 29 to November 10, 1853. Wilkie Collins himself spent a holiday in Boulogne, France, between July 29 and September 6, 1853.

The full Moon dates listed in 1854, 1855, and the full Moons in all subsequent years can also be eliminated because Millais was not at Gower Street. In 1854 John Millais traveled to Scotland from May 24th through July 13th, and he then spent the period July 13th to July 27th at the Peacock Inn in Baslow, near Chatsworth, England. (Lutyens 1967, p. 214, 225–241) In a letter written from Scotland on June 16, 1854, Millais noted that the Millais family had given up the Gower Street residence, never to return, and had moved to a new home in the suburb of Kingston-on-Thames. Millais wrote that "we have left Gower St for good. Our new home overlooks the Thames and has a garden and stabling which I have turned into a painting room to be out of the way of callers in Town."

This leaves only the full Moon periods of 1852, rejected by previous authors. Recall that Nuel Pharr Davis said that the "summer of 1852, while theoretically possible, is extremely unlikely. One reason is that Millais spent the summer of that year painting like a hermit at the remote village of Hayes with his brother William." (Davis 1956, pp. 321–322). Other scholars followed Davis in ruling out 1852 for the same reason.

Our Texas State University group can show that rejecting the dates in the summer of 1852 on these grounds is definitely incorrect. Millais did spend most of that summer and early fall at Hayes near Bromley, Kent, where he worked on his masterpiece, *The Proscribed Royalist, 1651*. However, we found documents proving that Millais did not remain at Hayes during the entire summer.

Regent's Park Encounter: 1852

John Millais returned to London at least twice during the summer of 1852, and one of these visits by Millais turns out to be an excellent candidate for the adventure with Wilkie Collins, Charles Collins, and Caroline Graves on a full Moon night.

Millais was summoned from Hayes to a courtroom in Oxford in order to testify in the July 16th trial testing the validity of the late George Vandeput Drury's will and codicils. The trial was mentioned in *Jackson's Oxford Journal* for July 17, 1852, some of Millais's testimony was printed in *The Times* for July 20, 1852, and the event is mentioned in the biography by Millais's son (J. G. Millais 1899, pp. 169–170). Millais's correspondence shows that the artist, while making the roundtrip from Hayes to Oxford, spent several days in London both before and after the July 16th trial. Astronomical calculations and contemporary almanacs agree that a new Moon fell on July 17, 1852. The absence of the Moon from the night sky during this period proves that the moonlit encounter with a woman in white near Regent's Park did not occur in mid-July of 1852.

Two weeks later, a full Moon occurred on July 31, 1852, and near that time period Millais came up from Hayes to London again, on this occasion for events at the Royal Academy of Arts.

Researchers at the Royal Academy Library kindly checked the archives for 1852 and found that the summer art exhibition closed on Saturday July 24th and that the Conversazione, a gala reception for all the artists and various dignitaries, took place on the evening of Wednesday July 28th. A letter written by Millais from Hayes on August 4th proves that he definitely attended this reception: "The Royal Academy conversazione I attended alone … The Duke of Wellington made his appearance about ten, and walked through the rooms with the President, Sir Charles Eastlake. All went off as those and most things do." (J. G. Millais 1899, Vol. I, pp. 170–171).

A notice posted by the Royal Academy of Arts in *The Morning Chronicle* of July 24, 1852, announced that the exhibition was closing on that day and notified exhibitors that they could pick up their works on Thursday July 29th or Friday July 30th. John Millais had three paintings to collect, including his famous *Ophelia* now in the Tate Britain museum. Charles Collins for the 1852 exhibition had contributed three paintings, including a spring landscape entitled *May, in the Regent's Park*, painted from a window in the family home on Hanover Terrace and also now in the Tate Britain collection.

A Millais biography asserted that the artist attended the Eton vs. Harrow match in the summer of 1852 at Lord's Cricket Ground in London. (Fleming 1998, p. 89) This provides additional support for the presence of Millais in London near the end of July, because the sporting columns of *The Times* give the dates of this three-day contest as Friday, July 30, Saturday, July 31, and Monday, August 2, 1852.

The nights at the end of July and the beginning of August in 1852 appear to satisfy all five criteria as candidates for the moonlit encounter with a woman in white near Regent's Park: the months are in the summer, the year is in the 1850s, the lunar phase corresponds to a full or nearly full Moon, none of the principals appear to be away from London, and the moonlit walk would have been from the Collins family residence on Hanover Terrace to the Millais home on Gower Street. Meteorological observations in 1852 appeared every month in the *Philosophical Magazine* and *The Gentleman's Magazine*, and they were

Table 9.3 Moonlight and sky conditions in July–August 1852

1852 July 30–July 31	Moon 100% lit, sky "very fine" and cloudless before and after midnight
1852 July 31–August 1	Moon 99% lit, sky cloudy in the evening, "very fine" and cloudless after midnight
1852 August 1–August 2	Moon 96% lit, sky cloudy in the evening, "very fine" and cloudless by midnight

compiled for the entire year in *Results of the Magnetical and Meteorological Observations Made at the Royal Observatory, Greenwich*. Table 9.3 gives the sky conditions during the relevant period and indicates that the Moon would have been visible near midnight on each of these three nights.

One more astronomical note is perhaps worth mentioning. The month of July 1852 contained two full Moons, one on July 1st and another on July 31st, a phenomenon recognized in the contemporary newspapers. This makes the full Moon that helped to inspire *The Woman in White* a "blue Moon" by a modern definition (Olson 2014, pp. 226–233).

The opening installment of *The Woman in White* alludes to oppressive heat four times:

It was the last day of July. The long hot summer was drawing to a close … The evening, I remember, was still and cloudy; the London air was at its heaviest … The heat had been painfully oppressive all day; and it was now a close and sultry night … The moon was full and broad in the dark blue starless sky … The idea of descending any sooner than I could help into the heat and gloom of London repelled me. The prospect of going to bed in my airless chambers, and the prospect of grad- ual suffocation, seemed, in my present restless frame of mind and body, to be one and the same thing.

What can we find out from meteorological archives about the temperatures in July and August 1852? Was this an unusually hot period in London? Would Wilkie Collins have associated his full Moon adventure near Regent's Park with a hot and sultry night?

Record-breaking Heat in July 1852

Beginning in 1826, meteorological instruments were set up in the gardens at Chiswick, near London, and a series of regular observations each day at morning, noon, and night was initiated. The daily observations for July 1852, published in the *Philosophical Magazine*, included comments such as "Excessively hot: thermometer higher in the shade than it has been for at least twenty-six years," with multiple days described as "very hot" or "sultry."

Robert Thompson surveyed the run of Chiswick data and likewise noted for 1852: "July – This was the hottest month in the present century…On the 5th the thermometer in the shade stood as high as 97° and on the following day at 95°…August. – This was also a hot month." (Thompson 1855, p. 199).

James Glaisher extended the compilation of Chiswick meteorological observations to the period from 1826 to 1869 and still found that the month of highest mean temperature "was July 1852." (Glaisher 1871, p. 14).

Charles Leeson Prince, a veteran weather observer with measurements made from 1843 through 1885 at Uckfield in East Sussex, agreed that the heat of July 1852 was of a record-breaking character. Prince noted for 1852 that "a rapid increase of temperature occurred on July 3rd. The remainder of the month was excessively hot, and its mean temperature the highest I have ever registered for any month." (Prince 1886, p. 116).

A modern data set, known as the Central England Temperature (CET) series, extends the observations and lists the mean CET for each month. Tables of the "mean CET ranked coldest to warmest" are available at the website of the UK Met Office. For the range of years between 1800 and 1950, the warmest CET value for July occurred in the year 1852.

The analysis that identified the days near the full Moon of July 31, 1852, was based on the calendar months, the lunar phase, and biographical material in the form of letters, memoirs, and newspaper accounts. The fact that this period in 1852 happens to be one of record-breaking heat, matching the sultry weather described by Wilkie Collins in the opening pages of *The Woman in White*, helps to make a more convincing case that the Regent's Park adventure in 1852 was the inspiration for the corresponding scene near Hampstead Heath in the novel.

The Place Where Four Roads Met?

In the novel Wilkie Collins gives a detailed description of the location where Walter Hartright encountered the woman in white:

> *I determined to stroll home in the purer air, by the most round-about way I could take; to follow the white winding paths across the lonely heath; and to approach London through its most open suburb by striking into the Finchley-road, and so getting back, in the cool of the new morning, by the western side of the Regent's Park … I had now arrived at that particular point of my walk where four roads met – the road to Hampstead, along which I had returned; the road to Finchley; the road to West End; and the road back to London.* (From the opening installment as published in *All The Year Round*, November 26, 1859)

As early as 1863, interested readers attempted to identify the precise place "where four roads met." An anonymous contributor with personal knowledge of the Finchley Road mentioned specifically "the corner of the road, made celebrated by the halt of the Woman in White – namely, that diverging to Frognal and West Hampstead." (Anonymous, *London Journal* 1863, p. 303)

In 1931, Stewart Marsh Ellis independently made the same identification and wrote that in "his romance, Wilkie Collins placed the scene of the meeting with the Woman in White at that portion of the Finchley Road where it is bifurcated by West End Lane and Frognal Lane." (Ellis 1931, p. 28). In 1973, Harvey Peter Sucksmith repeated this theory about "the junction of Finchley Road, West End Lane, and Frognal Lane." (Sucksmith 1973, p. 604).

However, Paul Lewis recently has published a new suggestion, placing the novel's moonlit encounter about a half mile farther north, at the corner where Platt's Lane and Fortune Green Road intersect the Finchley Road (Lewis 2010, pp. 4–7).

Paul Lewis also pointed out the intriguing facts that an entirely different intersection was described in Wilkie Collins's handwritten manuscript and that the change must have been made at the last moment, when the first installment was in the proof stage at *All The Year Round* (Lewis 2010, pp. 3–5). The manuscript reads: "I had now arrived at that particular point of my walk where four roads met – the road to Hampstead, along which I had returned; the road to Finchley and Barnet; the road to Hendon; and the road back to London." (Road intersection as described in Wilkie Collins's handwritten manuscript.)

Paul Lewis's Wilkie Collins website included a link to a Google map display showing various points along "Walter's Walk." Lewis placed the "manuscript crossroads" on a modern thoroughfare called "Hendon Way," which runs to the northwest toward the town of Hendon after branching off the Finchley Road just north of the Platt's Lane and Fortune Green Road intersection. This identification at first may seem plausible, because Wilkie Collins's manuscript mentions the "road to Hendon." But this modern Hendon Way did not exist in the nineteenth century and does not appear on nineteenth-century maps. Local histories state that this Hendon Way was laid out during a construction project in 1924 (Baker and Pugh 1976, pp. 2–5) and confirm that the modern Hendon Way cannot be the road indicated by Wilkie Collins in the manuscript.

The Place Where Four Roads Met

Our Texas State group suggested a new identification for the place "where four roads met" as described in the manuscript; we could give evidence to support this identification, and we could offer an explanation why the last-minute change by Wilkie Collins took place.

We discovered that detailed maps from the 1850s do show a thoroughfare called "Hendon Road" that intersects the Finchley Road in the village of Golders Green, and we realized that this spot exactly matches the Wilkie Collins manuscript description. At this intersection in Golders Green in 1852 "four roads met": a road running toward the southeast and then uphill to the North End region of Hampstead Heath, the road to Finchley and Barnet leading north, the Hendon Road running to the northwest, and the main Finchley Road leading south to London (Fig. 9.21). This intersection is now adjacent to the busy Golders Green rail, bus, and tube station.

Walking for a Half Hour and More

After the moonlit encounter, the novel continues as Walter Hartright describes how he and the Woman in White "set our faces toward London, and walked on together in the first still hour of the new day." They walk at first "for some minutes." After a pause for conversation, the woman then requests that they "walk on fast," and the pair "moved forward again at a quick pace; and for half an hour, at least" before reaching the "first houses" on the outskirts of London at a location readily identifiable as the neighborhood near the North Star pub, College Crescent, and the New College (Figs. 9.22 and 9.23).

Fig. 9.21 This detail from a nineteenth-century map shows the village of Golders Green and, at the lower right, the only intersection that matches the Wilkie Collins manuscript description of the spot where the moonlit encounter of Walter Hartright and the Woman in White occurred. The manuscript mentions the "road to Hendon," and this is the only location where a thoroughfare called "Hendon Road" intersects Finchley Road

Adding "some minutes" to "half an hour, at least" provides a rough estimate for the total time elapsed as the pair walked south on the Finchley Road: about 0.6 h, or roughly 36 min.

In August 2013, our Texas State group traveled to London, and we walked the 2.15 mile distance from the Golders Green intersection to College Crescent in 35 min, in excellent agreement with the times given by Wilkie Collins (Fig. 9.24).

The *Wikipedia* article "Preferred walking speeds" includes an extensive list of references which establish that the average walking speed for adults is about 3.0–3.5 miles/h, that "brisk walking" speed is about 3.5–4.0 miles/h, and that the transition to jogging or running occurs at nearly 5 miles/h. Our Texas State group walked briskly at speeds ranging between 3.6 and 3.7 miles/h for 35 min, perhaps not much different than the speed with which Walter Hartright and the Woman in White "moved forward again at a quick pace; and for half an hour, at least."

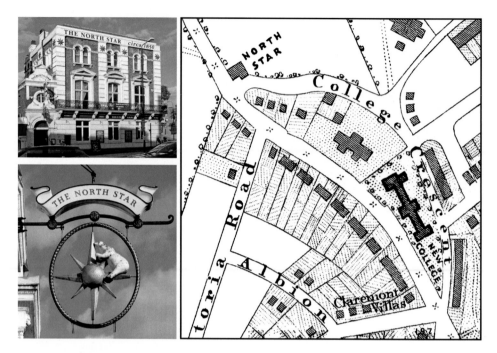

Fig. 9.22 The North Star public house (upper left) still stands today. The pub sign (lower left) features the North Star and a bear that may represent either Ursa Major (The Great Bear) or Ursa Minor (The Lesser Bear). The nineteenth-century map (right) shows the North Star pub at the entrance to College Crescent and uses a series of "X" symbols to mark the Finchley Road (Photographs by the author)

The argument based on elapsed times and walking speeds, combined with the fact that the nineteenth-century Hendon Road met the Finchley Road only in Golders Green, provides strong evidence that Wilkie Collins in his original manuscript intended to have the dramatic meeting of Walter Hartright and the Woman in White take place near the intersection in Golders Green.

From the intersection with Frognal Lane and West End Lane, the spot identified by the consensus of most previous scholars, we covered the distance to College Crescent in less than 12 min. Walking from the Platt's Lane intersection to College Crescent took us less than 19 min. Both of these times, from locations favored by previous authors, disagree significantly with the times mentioned in the novel.

We suggested that in the proof stage shortly before publication, Wilkie Collins moved the location of the important scene, the dramatic climax of the opening installment, from Golders Green to another location much farther south and much closer to College Crescent, but Collins forgot to alter the elapsed times in the text.

Fig. 9.23 The red numbers added to this detail from the 1852 edition of *Davies's New Map of the British Metropolis* illustrate Walter Hartright's "round-about" walk as described in the manuscript of *The Woman in White*. The journey begins at (1) Hampstead Heath; (2) the road leading to Golders Green; and (3) the location "where four roads met" and where Walter encountered the woman in white. The numbers continue south along the Finchley Road to indicate: (4) the toll house at The Castle pub; (5) the intersection with Pratts Lane; (6) the intersection with the lanes westward to West End and eastward to Frognal Hall; (7) the North Star pub; and (8) the toll house on the Avenue Road. At the lower right corner appears part of the green expanse of The Regent's Park

Fig. 9.24 In August 2013 members of our Texas State University group (upper left: Ava Pope, Don Olson, and Roger Sinnott) recreated the walk described in Wilkie Collins's manuscript for *The Woman in White*. We started from the Golders Green intersection, walked briskly south along the Finchley Road (lower left), and reached the landmark of the North Star pub (right) in 35 min (Photographs by Russell Doescher. Used with permission)

Why would he have made this change in location? We suggested that this change was related to a plot point as the Woman in White becomes worried that she will be noticed by the turnpike keeper at a toll house. The relevant passage reads:

… [W]e came within view of the turnpike, at the top of the Avenue-road. Her hand tightened round my arm, and she looked anxiously at the gate before us.

"Is the turnpike man looking out?" she asked.

He was not looking out; no one else was near the place when we passed through the gate. The sight of the gas-lamps and houses seemed to agitate her, and to make her impatient.

"This is London," she said. "Do you see any carriage I can get? I am tired and frightened. I want to shut myself in, and be driven away."

Fig. 9.25 The Finchley Road runs from north to south in this detail from a nineteenth-century map. A toll house stood in the Finchley Road, adjacent to The Castle Inn public house. Inset: The Castle Inn in a photograph from 2010. A blue plaque on the wall read: "Near this site was situated A TOLL GATE ABOLISHED in 1871." (Photograph courtesy of The Lost Pubs Project, http://www.closedpubs.co.uk. Used with permission)

(From the opening installment as published in *All The Year Round*, November 26, 1859.)

Maps from the 1850s show that the Finchley Road running south between Golders Green to the Avenue Road included *two* toll gates. The first toll house was adjacent to the Castle Inn at Childs Hill (Fig. 9.25), a location that is now the modern intersection with Hermitage Lane and Cricklewood Lane. The second toll house stood on Avenue Road, near the location of the modern Swiss Cottage tube station. The latter toll gate is the one mentioned in the novel's text.

This topography gives a plausible reason that explains Wilkie Collins's last-minute change of the important place "where four roads met." Perhaps when he realized that his text made no mention of passing the Childs Hill toll house, the author altered his description of the road intersection to a point south of Childs Hill, but he forgot to update the estimates for the elapsed time of the walk.

Moonlit Meetings with a Woman in White

We conclude that Wilkie Collins and John Millais provided enough details to allow iden-tifications of both time and place.

The adventure involving Wilkie Collins, John Everett Millais, Charles Collins, and Caroline Graves occurred adjacent to Regent's Park on a night near the full Moon of July 31, 1852.

Wilkie Collins's manuscript set the fictional version—the dramatic moonlit meeting of Walter Hartright and the Woman in White—at the Golders Green intersection "where four roads met – the road to Hampstead, along which I had returned; the road to Finchley and Barnet; the road to Hendon; and the road back to London."

Interested readers can visit these locations today and can even arrange to do so under the light of a full Moon. Thinking about the creative process of Wilkie Collins can enrich a reading or re-reading of the opening installment, which ends with the memorable cliff-hanger: "Don't forget: a woman in white. Drive on."

Although Collins wrote dozens of novels and stories, pilgrims to his grave in Kensal Green Cemetery, London, will observe that the inscription at the foot of the cross mentions only one title: IN MEMORY OF WILKIE COLLINS, AUTHOR OF "THE WOMAN IN WHITE" AND OTHER WORKS OF FICTION.

References

Alterton, Margaret (1925) *Origins of Poe's Critical History. University of Iowa Humanistic Studies, Volume 2 (No. 3).* Iowa City: University of Iowa.

Anonymous (1863) Ghost Club. *London Journal* **38** (No. 978), November 7, 1863, 303.

Baker, T. F. T., and R. B. Pugh, eds. (1976) *A History of the County of Middlesex: Volume 5: Hendon, Kingsbury, Great Stanmore, Little Stanmore, Edmonton Enfield, Monken Hadley, South Mimms, Tottenham.* Oxford: Oxford University Press.

Baker, William, Andrew Gasson, Graham Law, and Paul Lewis, eds. (2005) *The Public Face of Wilkie Collins: The Collected Letters, Vol. 1.* London: Routledge.

Beaver, Harold (1976) *The Science Fiction of Edgar Allan Poe.* New York: Penguin.

Bedell, Jeanne F. (1988) Wilkie Collins. *Dictionary of Literary Biography: British Mystery Writers, 1860-1919,* **70**, 85-101.

Burritt, Elijah Hinsdale (1838) *The Geography of the Heavens and Class Book of Astronomy.* New York: F. J. Huntington and Co.

Byron, George Gordon (Lord Byron) (1818) *Childe Harold's Pilgrimage, Canto the Fourth.* London: John Murray.

Clarke, William M. (1988) *The Secret Life of Wilkie Collins.* London: Allison & Busby.

Coleridge, Ernest Hartley (1899) *The Works of Lord Byron, Volume 2.* London: John Murray.

Cox, Don Richard, and Maria K. Bachman, eds. (2006) *The Woman in White.* Peterborough, Ontario: Broadview Press.

Croswell, Ken (2001) Wondering in the Dark. *Sky & Telescope* **102** (No. 6), December, 44-50.

Davis, Nuel Pharr (1956) *The Life of Wilkie Collins*. Urbana: University of Illinois Press.

DeVal, María (1978-1979) A mystery resolved: Two villas on the Brenta. *The Byron Society Newsletter* **6**, 20-21.

Dick, Thomas (1836) *The Christian Philosopher*, in *The Works of Thomas Dick*. Hartford, CT: H. F. Sumner & Co.; New York: Robinson, Pratt & Co.

Dickens, Henry Fielding (1934) *The Recollections of Sir Henry Dickens, K.C.* London: William Heinemann Ltd.

Ellis, Stewart Marsh (1931) *Wilkie Collins, Le Fanu and Others*. London: Constable & Co. Ltd.

Erdman, David V., and David Worrall, eds. (1991) *Childe Harold's Pilgrimage: A Critical, Composite Edition, Presenting Photographic Evidence of the Author's Revisions, Rearrangement, and Replacements, Stanza by Stanza, and Canto by Canto*. New York: Garland Publishing, Inc.

Ferguson, James (1819) *An Easy Introduction to Astronomy for Young Gentlemen and Ladies*. Philadelphia: Benjamin Warner.

Gasson, Andrew (1998) *Wilkie Collins, An Illustrated Guide*. Oxford: Oxford University Press.

Glaisher, James (1871) *Reduction of the Meteorological Observations Made at the Royal Horticultural Gardens, Chiswick, in the Years 1826-1869*. London: Spottiswoode & Co.

Herschel, John F. W. (1833) Observations of Biela's Comet. *Memoirs of the Royal Astronomical Society* **6**, 99-109.

Herschel, John (1834) *A Treatise on Astronomy* [American edition] Philadelphia: Carey, Lea & Blanchard.

Hobhouse, John Cam (1909) *Recollections of a Long Life, with Additional Extracts from His Private Diaries, edited by his daughter Lady Dorchester*. London: John Murray.

Hyder, Clyde K. (1939) Wilkie Collins and *The Woman in White*. *PMLA* **54** (No. 1), 297-303.

Kidwell, Peggy Aldrich (1985) Elijah Burritt and the "Geography of the Heavens." *Sky & Telescope* **69** (No. 1), January, 26-28.

Klingaman, William K., and Nicholas P. Klingaman (2014) *The Year Without Summer: 1816 and the Volcano That Darkened the World and Changed History*. New York: St. Martin's Press.

Kremenliev, Elva Baer (1963) The Literary Uses of Astronomy in the Writings of Edgar Allan Poe. Ph. D. thesis, UCLA.

Krupp, E. C. (2002) Lighter Than Air. *Sky & Telescope* **103** (No. 4), April, 78-80.

Levine, Stuart, and Susan Levine (1976) *The Short Fiction of Edgar Allan Poe: An Annotated Edition*. Indianapolis, IN: Bobbs-Merrill.

Lewis, Paul (2010) *Walter's Walk*. London: Wilkie Collins Society.

Lewis, Paul (2013) private communication, copy of George Robert Graves's death certificate dated January 30, 1852.

Lewis, Paul (2016) Wilkie Collins web site, http://www.web40571.clarahost.co.uk.

Littrow, Joseph Johann von (1833) On the Collision of two Comets, and the Comet of July, 1831. *American Journal of Science* **24**, 346-348.

Lutyens, Mary (1967) *Millais & the Ruskins*. New York: Vanguard Press, Inc.

Mabbott, Thomas, ed. (1978) *Collected Works of Edgar Allan Poe, Tales and Sketches, 1831-1842*. Cambridge, MA: Belknap Press.

Marchand, Leslie A. (1957) *Byron, A Biography*. New York: Alfred A. Knopf.

Millais, John Guille (1899) *The Life and Letters of Sir John Everett Millais, Vol. I*. New York: Frederick A. Stokes Company.

Moore, Thomas (1830) *Letters and Journal of Lord Byron: with Notices of his Life, Volume I*. New York: J. & J. Harper.

Olbers, Heinrich (1828) Olbers on the Comet of short period. *American Journal of Science* **13**, 189-190.

Olson, Donald (2014) *Celestial Sleuth: Using Astronomy to Solve Mysteries in Art, History and Literature*. Springer Praxis: New York.

Pennington, Estill Curtis (1984) Painting Lord Byron: An Account by William Edward West. *Archives of American Art Journal* **24** (No. 2), 16-21.

Poe, Edgar Allan (1839) The Conversation of Eiros and Charmion. *Burton's Gentleman's Magazine*, **5** (No. 6), December, 321-323.

Poe, Edgar Allan (1846) The Literati, Part VI. *Godey's Lady's Book* **33**, October, 157-162.

Poe, Edgar Allan (1848) *Eureka: A Prose Poem*. New York: Geo. P. Putnam.

Prince, Charles Leeson (1886) *Observations Upon the Climate of Uckfield, Sussex, and its Neighborhood*. Lewes, East Sussex, UK: H. Wolff.

Quinn, Arthur Hobson (1941) *Edgar Allan Poe, A Critical Biography*. New York: Appleton-Century Company.

Robinson, Kenneth (1952) *Wilkie Collins, A Biography*. New York: The Macmillan Company.

Rosen, Jonathan (2011) Doubles: Wilkie Collins's shadow selves. *The New Yorker*, July 25, 2011, 75-79.

Sova, Dawn B. (2007) *Critical Companion to Edgar Allan Poe: A Literary Reference to his Life and Work*. New York: Facts on File.

Stewart, John Innes Mackintosh (1966) *The Moonstone*, Introduction. Harmondsworth, UK: Penguin.

Storey, Gladys (1939) *Dickens and Daughter*. London: Frederick Muller Ltd.

Stothers, Richard B. (1984) The Great Tambora Eruption in 1815 and Its Aftermath. *Science* **224** (No. 4654), 1191-1198.

Sucksmith, Harvey Peter, ed. (1973) *Oxford Classics: The Woman in White*. Oxford: Oxford University Press.

The Times (London), Summer Assizes, Oxford Circuit. July 20, 1852, 7.

The Times (London) Cricket, The Public Schools' Matches, Harrow v. Eton. July 31, 1852, 8; August 2, 1852, 8; August 3, 1852, 5.

Thompson, Robert (1855) An Abstract of Meteorological Observations in the Garden of the Society. *Journal of the Royal Horticultural Society* **9**, 195-205.

West, William Edward (1826) Lord Byron's Last Portrait, With Records of his Conversation, &c. during his sittings. *The New Monthly Magazine and Literary Journal* **16**, 243-248.

Wikipedia, "Preferred walking speed."

Wood, Gillen D'Arcy (2014) *Tambora: The Eruption That Changed the World*. Princeton, NJ: Princeton University Press.

Zerefos, Christos S., and V. T. Gerogiannis, D. Balis, S. C. Zerefos, and A. Kazantzidis (2007) Atmospheric effects of volcanic eruptions as seen by famous artists and depicted in their paintings. *Atmospheric Chemistry and Physics* **7**, 4027-4042.

Zerefos, Christos S., and P. Tetsis, A. Kazantzidis, V. Amiridis, S. C. Zerefos, J. Luterbacher, K. Eleftheratos, E. Gerasopoulos, S. Kazadzis, and A. Papayannis (2014) Further evidence of important environmental information content in red-to-green ratios as depicted in paintings by great masters. *Atmospheric Chemistry and Physics* **14**, 2987-3015.

Part IV
The Terrestrial Sleuth

10

J. M. W. Turner and the Great Western Railway, and John Everett Millais and an Ancient Oak

The J. M. W. Turner painting *Rain, Steam, and Speed – The Great Western Railway* has a special importance as one of the earliest canvases to show how the Industrial Revolution altered the British landscape. Could nineteenth-century railroad timetables help us to understand the origin of this painting? Can we identify the railway bridge in the canvas? Turner first exhibited this work at the Royal Academy summer exhibition in 1844. Remarkably, an eyewitness account of a June 1843 trip by Lady Jane Simon on the Great Western Railway apparently described the moment that inspired Turner to create *Rain, Steam, and Speed*. Some art historians have accepted the veracity of Lady Simon's story, but others have been skeptical and regard her account as unreliable.

We wondered if the abundant specific details provided by Jane Simon could allow us to determine a precise date for her trip by consulting steamship schedules, stagecoach itineraries, railroad timetables, and meteorological observations. Would a careful analysis demonstrate that her story was impossible, as some art historians insisted, or would verification of the details lend credibility to Lady Simon's account? Did she witness the origin of *Rain, Steam, and Speed* – the moment that inspired Turner to create this masterpiece?

The nineteenth-century artist John Everett Millais painted some of the most iconic works of the Pre-Raphaelite movement. His canvas entitled *The Proscribed Royalist, 1651*, now in the collection of composer Andrew Lloyd Webber, depicts a scene from the aftermath of the English Civil War. A Puritan girl nervously looks over her shoulder as she risks her life to bring food to a young Royalist cavalier hiding in a hollow oak tree. Millais began this canvas in the summer of 1852 and first exhibited it at the Royal Academy in the summer of 1853. Knowing that Millais based his backgrounds on actual locations, scholars and admirers of the artist have been interested to find the original "Millais Oak." Books, articles, and newspaper stories for more than a century were in unanimous agreement and provided directions to a certain tree in West Wickham Common, a park southeast of London. This oak became an oft-visited tourist site. How can we be certain that this previous identification is incorrect and that visitors have been going to the wrong tree? How do the letters written by Millais provide clues that point to a different tree? Can we find the

actual "Millais Oak"? What is the surprising connection between this centuries-old tree and the dramatic moonlit scene near the beginning of the Wilkie Collins novel, *The Woman in White?*

The Origin of Turner's *Rain, Steam, and Speed*

In the nineteenth century the Industrial Revolution, with its awe-inspiring machines and imposing factories, provided new subjects for artists. Édouard Manet created *The Railway* at Paris's Gare Saint-Lazare in 1873, and Claude Monet produced a series of eleven works depicting the same station in 1877. Both Monet and Vincent van Gogh painted trains running on lines in the countryside and crossing railway bridges in France.

Another series by Monet showed trains on the bridge over the Thames near London's Charing Cross Station in 1899–1901. Rolf Sinclair recently suggested to our Texas State University group the idea of using railroad timetables in an attempt to determine precise times for these London paintings, but the large number of trains arriving and departing Charing Cross every day in those years made the project seem impossible.

We then considered applying this technique to an earlier canvas: the famous *Rain, Steam, and Speed – The Great Western Railway* (Fig. 10.1) by Joseph Mallord William Turner (1775–1851).

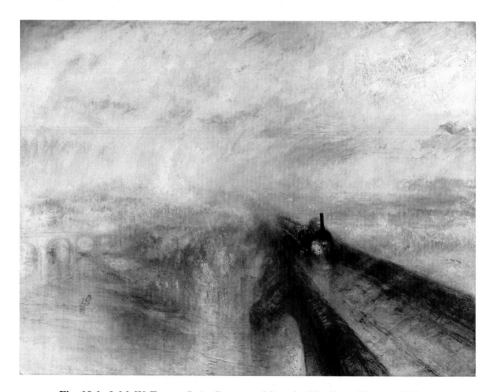

Fig. 10.1 J. M. W. Turner, *Rain, Steam, and Speed – The Great Western Railway*

Turner first showed this painting at the 1844 Royal Academy exhibition in London. The reviewer for the *Morning Chronicle* on May 8, 1844, surveyed Turner's works as a whole and called *Rain, Steam, and Speed* "the most magnificent of all these prodigious compositions." William Makepeace Thackeray asserted that the "world has never seen anything like this picture." (Thackeray 1844, p. 712).

Could railroad timetables from the 1840s help to determine the precise moment when Turner was inspired to create this masterpiece? In addition to meteorological archives, what other evidence might be useful? Could we identify the railway bridge in the painting?

Brunel's Great Western Railway

Isambard Kingdom Brunel (1806–1859) (Fig. 10.2), a mechanical and civil engineer considered one of most important figures of the Industrial Revolution, directed the construction of the Great Western Railway line that was the setting for Turner's canvas. The locomotive in the painting is probably of the type known as the Fire Fly class (Fig. 10.3) used for passenger trains in the 1840s.

Fig. 10.2 This statue of Isambard Kingdom Brunel (1806–1859), one of most important figures of the Industrial Revolution, watches arrivals and departures from a vantage point on Platform 8 of London's Paddington Station. Brunel directed the construction of the Great Western Railway and the original Paddington Station (Photograph by the author)

Fig. 10.3 The Fire Fly class of locomotives provided motive power for Great Western Railway passenger trains during the 1840s. This replica of the original Fire Fly was constructed in 2005 and is now displayed at the Didcot Railway Center, where it runs under steam on a special broad gauge line (Photograph by Peter Turvey. Used with permission)

Lady Simon's Accounts

Remarkably, an eyewitness account of an 1843 trip on the Great Western Railway apparently described the moment that inspired Turner to create *Rain, Steam, and Speed*. The story appeared in a letter written by Lady Jane Simon (1816–1901) to John Ruskin. In 1843 she was known as Jane O'Meara and was then engaged to her future husband Dr. John Simon (1816–1904), later Sir John Simon, the celebrated surgeon and pathologist.

Jane Simon's letter described a complicated return to London from a visit with friends in Plymouth. The prospect of bad weather interfered with her original plan to journey by sea, and she instead traveled on a stagecoach that connected to the Great Western Railway (Fig. 10.4). During a night of dramatic storms she shared a railway coach with a person whom she later identified as Turner himself. Jane began her account with her intention to travel by steamship:

> *In the spring of the year 1843, I went to Plymouth…on a certain day of June, it was arranged that I should return to London via Southampton; I being then very fond of the sea …. Accordingly, on the day fixed, I was duly ready, my boxes packed…awaiting the arrival of Mr. Harris, who was (as we fondly believed) securing my berth, and coming to fetch me to the boat.* (Ruskin 1899, pp. 220–221)

Fig. 10.4 Newspapers in 1843 used stock artwork, like these examples from the *Plymouth Journal* of May 25, 1843, and the *Plymouth & Devonport Weekly Journal* of June 8, 1843, to call attention to the advertisements for travel by steamship, stagecoach, and railway

Her host, William Snow "Thunder and Lightning" Harris (1791–1867), had invented the lightning rod systems for the vessels of the British Royal Navy. An expert on storms at sea, Harris absolutely refused to let her travel on the ship:

Time passed on, – no Mr. H.! At last at half-past one he appeared.

"Oh, papa, how late you are; Miss – will lose the boat!"

"She has lost it, Yes, it's blowing up for such a storm as we haven't had for long, and I'm not going to let you go up Channel to-night ..."
(Ruskin 1899, pp. 220–221)

Jane then hoped to catch the afternoon stagecoach from Plymouth to connect with the railway at a station known as Beam Bridge: "But I *must* go somehow (Now be it remembered, that in those days…the Great Western Railway itself only finished as far as Beam Bridge, a small outlying station.) I must go. So please send to tell the coach to come for me." (Ruskin 1899, pp. 221–222).

As the stagecoach passed through the town of Exeter, the storm raged in earnest (Fig. 10.5):

…the hitherto bright, breezy day began to justify Mr. Harris…a first-rate sailor and judge of the weather…. The clouds gathered, distant low whistlings of wind came from all around, and in a threatening evening, at eight, we reached Exeter…. The weather after Exeter got worse and worse; – the wind began to bluster, the lightning changed from summer gleams to spiteful forks, and the roll of thunder was almost continuous; and by the time we reached Beam Bridge the storm was at such terrible purpose, that the faithful guard wrapped me up in his waterproof and lifted me, literally, into the shed which served as a station. (Ruskin 1899, pp. 222–223)

When the train departed from Beam Bridge station, Jane shared a compartment in

…a first-class carriage, in which were two elderly, cosy, friendly-looking gentlemen, evidently fellows in friendship as well as in travel…When I had…settled myself, I looked up to see the most wonderful eyes I ever saw, steadily, luminously, clairvoyantly, kindly, paternally looking at me…I should have described them as the most 'seeing' eyes I had ever seen. (Ruskin 1899, pp. 223–224)

The next part of the trip provided a dramatic sight when the train was stopped at Bristol:

…we went on, and the storm went on more and more, until we reached Bristol; to wait ten minutes. My old gentleman rubbed the side window with his coat cuff, in

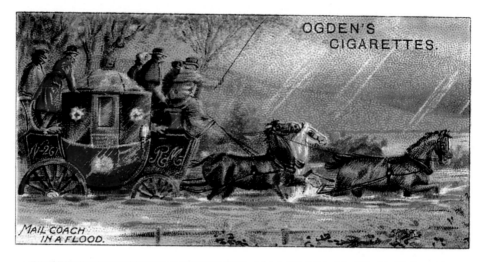

Fig. 10.5 Ogden's Cigarettes issued "Mail Coach in a Flood" in 1909 as card #8 in their Royal Mail series. The scene is reminiscent of the storm experienced by stagecoach travelers from Plymouth as they approached the Great Western Railway terminus at Beam Bridge station on the evening of June 8, 1843

vain; attacked the centre window, again in vain, so blurred and blotted was it with the torrents of rain! A moment's hesitation, and then:

"Young lady, would you mind my putting down this window?"

"Oh no, not at all."
"You may be drenched, you know."

"Never mind, sir."
Immediately, down goes the window, out go the old gentleman's head and shoulders, and there they stay for I suppose nearly nine minutes. Then he drew them in, and I said:
"Oh please let me look."
"Now you will be drenched," but he half opened the window for me to see. Such a sight, such a chaos of elemental and artificial lights and noises, I never saw or heard, or expect to see or hear. He drew up the window as we moved on, and then leant back with closed eyes for I dare say ten minutes, then opened them and said:

"Well?"

I said, "I've been 'drenched,' but it's worth it."
(Ruskin 1899, pp. 224–226)

The journey continued east from Bristol with a memorable passage through the 1.82-mile-long Box Tunnel and a pause for refreshments at Swindon before covering the last miles to London: "… the storm by then over …. I watched the dawn and oncoming brightness of one of the loveliest June mornings that have ever visited the earth …. At six o'clock we steamed into Paddington station." (Ruskin 1899, p. 226).

The significance of Jane Simon's experience in 1843 became apparent to her during the Royal Academy exhibition in 1844:

The next year, I think, going to the Academy, I turned at once, as I always did, to see what Turners there were. Imagine my feelings: – RAIN, STEAM, AND SPEED, GREAT WESTERN RAILWAY…I had found out who the 'seeing' eyes belonged to! As I stood looking at the picture, I heard a mawkish voice behind me say:

"There now, just look at that; ain't it just like Turner? – whoever saw such a ridiculous conglomeration?"

I turned very quietly round and said:

"I did; I was in the train that night, and it is perfectly and wonderfully true"; and walked quietly away. When I saw your young portrait of Turner, I saw that some of it was left in the 43 face, – enough to make me feel it always delightful to look at the picture.
(Ruskin 1899, pp. 228–229)

Lady Simon must have often repeated this story. One of Ruskin's friends, George Richmond, recorded a version that was shorter but had a few additional details:

Lady Simon, wife of Sir John Simon, when young, had to travel by coach to catch the train …. The weather was very wild, and by-and-by a violent storm swept over the country …. The old gentleman seemed strangely excited at this, jumping up to open the window, craning his neck out, and finally calling to her to come and observe a curious effect of light. A train was coming in their direction, through the blackness, over one of Brunel's bridges, and the effect of the locomotive, lit by crimson flame, and seen through driving rain and whirling tempest, gave a peculiar impression of power, speed, and stress.

Some time afterwards in London she got an invitation to the Private View of the Royal Academy, and in the big room she was struck by the picture "Rain, Steam, and Speed" by Turner. In a flash she realized that the subject of the picture was what she had been called upon to admire out of the window of the coach, and that the eccentric old gentleman could have been no other than Turner himself!
(Stirling 1926, pp. 55–56)

Some art historians, notably Kenneth Clark, accepted the veracity of Lady Simon's story (Clark 1950, p. 102). Others were skeptical, with Martin Davies calling it "an apparently unreliable anecdote" (Davies 1959, p. 99). Andrew Loukes likewise described Jane's account as "possibly dubious" (Loukes 2001, p. 253).

We wondered if the abundant specific details provided by Jane Simon could allow us to determine a precise date for her trip by consulting steamship schedules, stagecoach itineraries, railroad timetables, and meteorological observations. Was there a major storm near Bristol in June of 1843? Relatively few GWR trains ran at night in those days. Would railroad timetables for 1843 reveal any instances when two trains, running in opposite directions, could meet at night? Would this happen near Bristol? Would a careful analysis demonstrate that her story was impossible, or would verification of the details lend credibility to Lady Simon's account?

John Gage: Single Track?

John Gage, author of an influential monograph devoted entirely to *Rain, Steam, and Speed*, was one of the skeptics regarding Jane Simon's story. Gage judged that "Lady Simon's account to George Richmond is full of impossibilities, and her better-known report to Ruskin even more so." (Gage 1972, p. 18).

For example, Gage described the pictured section of the Great Western Railway as a single track line and claimed that Jane Simon and Turner therefore could not have witnessed a meeting of trains from their window. Gage asserted that "the train…in Turner's picture, is running on a single track line, and certainly cannot have been seen from a railway carriage passing in the opposite direction." (Gage 1972, pp. 18–19).

Although John Gage made valuable contributions to art history, including the collection and publication of Turner's letters (Gage 1980), his apparent lack of railway expertise caused him to make some errors regarding the Great Western Railway.

Authoritative railway histories make it abundantly clear that Brunel designed and constructed the entire Great Western Railway main line as double track throughout. The layout had two tracks each with "gauge of way" 7 feet, the intermediate space of 6½ feet, and the two side-spaces each 4¾ feet, making the total width 30 feet. The same dimensions applied to the entire line, and bridges had clear width between parapets of 30 feet (Whisaw 1842, pp. 150–151; MacDermot 1927, p. 49).

Gage's claim of a single track line is mistaken, and Lady Simon's vivid description of trains meeting at night is certainly possible.

Steamship: Plymouth to Southampton

To check other details of Jane Simon's account, we consulted Devonshire newspapers. The advertisements in June of 1843 mentioned only one steamship running from Plymouth to Southampton. The "Splendid and Powerful Steamer" *Brunswick* departed twice a week, on Monday and Thursday afternoons at 1 p.m. Jane Simon must have planned her trip for one of those days.

Accordingly, we wondered whether a major storm had affected Bristol on either a Monday or Thursday.

Storm at Bristol

The *Bristol Mercury* newspaper published a column titled "Meteorological Register" with daily reports from the weather observer George Muston, who sold chronometers, watches, and clocks at his shop on Small Street. His remarks for June 1843 mention only one storm.

The wind direction shifted and the barometer began to drop precipitously on Wednesday, June 7th. Muston described the weather as "Cloudy, rain, stormy" on Thursday, June 8th – a day of the week consistent with Jane Simon's vivid description of the storm at Bristol.

Jane noted that the bad weather eventually ended and that she experienced a beautiful dawn on her arrival in London at about 6 a.m. the next morning. A newspaper article described the London weather in exactly the same way: "On Thursday night [June 8th] the wind…increased to a hard gale, with very heavy squalls and rain, which continued with

unabated violence until about three o'clock yesterday morning [Friday June 9th], when it moderated considerably." (*Morning Chronicle* (London), Saturday, June 10, 1843.)

The archives of the Royal Observatory at nearby Greenwich include similar reports, with "a gale of wind" on Thursday, June 8, 1843. On the morning of Friday, June 9, 1843, the wind had "much abated" by 4 a.m., and breaks in the clouds to the east appeared immediately after 4 a.m.

W. Snow Harris's refusal to allow Jane to travel by sea proved dramatically correct. Another newspaper story described the outcome of the storm as particularly severe in Ireland, Wales, and the southwest of England on both June 8th and 9th:

> *THE STORM OF FRIDAY LAST. – During the night of Thursday last* [June 8th], *and the greater portion of the following day (Friday)* [June 9th], *the southern portion of the coast was visited by a tremendous gale of wind, almost a hurricane, accompanied by hail and rain, which fell in torrents, causing a heavy sea, and driving several large and valuable vessels on shore, where they were soon shattered to pieces, and many lives were lost.* (*The Times* (London), Tuesday, June 13, 1843)

The combination of the steamship schedules and the meteorological observations show that Jane Simon's trip began in Plymouth on the afternoon of Thursday, June 8, 1843.

Beam Bridge Station in 1843

We can also verify another part of Lady Simon's account by her remark about boarding the train at Beam Bridge. Railway historians consider this the most short-lived of all stations on the Great Western.

Beam Bridge station opened on May 1, 1843, as a temporary terminus ("end of the line") while Brunel directed construction of the nearby Whiteball Tunnel. Beam Bridge station closed on May 1, 1844, when the tunnel opened and the rail line was completed to Exeter (MacDermot 1927, p. 190).

A June departure from Beam Bridge was possible only in the year 1843. This confirms that Jane's story is accurate and consistent on this point.

Late in the evening of June 8, 1843, Jane departed from Beam Bridge on an "up" train heading to London. Would her train meet with any "down" trains coming from London? If so, where would that occur?

Bradshaw Guides

The company of George Bradshaw (1801–1853) published *Bradshaw's Monthly General Railway and Steam Navigation Guide for Great Britain and Ireland* throughout the 1840s. Great Western Railway timetables for June 1843 list Beam Bridge as the end of the line, 171½ miles by rail from London's Paddington Station (Fig. 10.6).

Only a handful of trains ran after dark on the GWR line. The schedules include only one possibility for a night-time "meet," which would occur near Bristol, exactly as Jane Simon described. Table 10.1 lists excerpts from the timetable, with the lines marked in bold identifying the only place where two trains running in opposite directions could meet at night.

GREAT WESTERN.—171½ Miles in length.

Dis-tance	UP TRAINS. STATIONS.	7¼ a.m.	9 a.m.	7¼ a.m.	7 a.m.	7 40 a.m.	8 40 a.m. mail.	7¼ a.m.	9 a.m.	12 noon.	11 a.m.	12¾ p.m. mail.	1 p.m.	3 p.m.	5 p.m.	11 p.m. mail.
	Beambridge....	7 15	9 0	..	11 0	12 15	1 0	3 0	5 0	11 0
1¾	Wellington	7 20	9 3	..	11 4	12 19	1 5	3 4	5 5	..
8½	Taunton	7 40	9 15	..	11 18	12 32	1 25	3 18	5 22	11 15
20¼	Bridgewater	8 12	9 35	..	11 40	12 52	1 50	3 40	5 48	11 40
26¾	Highbridge	8 29	9 49	1 4	2 10	3 52	6 5	..
36½	West. Su. Mare	8 25	9 35	..	11 25	1 10	2 15	4 0	6 8	..
37¾	Banwell	8 58	12 15	6 35	..
41¼	Clevedon R. (Yat.)	9 10	10 20	..	12 22	1 38	2 50	4 20	6 45	..
45¼	Nailsea............	9 20	10 28	1 46	..	4 28	6 55	..
53¼	Bristol, arrival	9 50	10 50	..	12 50	2 10	3 50	4 50	7 30	12 50
	„ departure	7 0	7 40	8 40	10 0	11 0	12 0	1 0	2 30	4 0	5 0	7 40	1 0
58	Keynsham	7 50	..	10 10	..	12 10	..	2 40	4 10	..	7 50	..
60	Saltford	10 16	..	12 16	4 16
63	Twerton	8 0	12 22	4 22	..	8 0	..
64¾	Bath	7 25	8 5	9 5	10 30	11 25	12 30	1 25	2 57	4 30	5 25	8 10	1 20
69¾	Box	7 36	..	9 18	..	11 40	..	1 4	3 8	..	5 37
73½	Corsham	7 49	..	9 28	..	11 52	..	1 50	3 22	..	5 50
77¾	Chippenham	8 2	..	9 40	..	12 5	..	2 2	3 34	..	6 2	..	1 50
88½	Wootn. Basset	10 4	..	12 30	3 58
112	Cirencester..	7 50	..	9 30	..	12 0	..	1 35	3 20	..	5 50	..	1 40
102½	Minety	8 15	..	9 55	..	12 22	..	2 0	3 50	..	6 10
98¾	Purton........	8 23	..	10 5	2 10	4 0	..	6 20
94¼	Swindon Jn. arri.	8 37	..	10 18	..	12 45	..	2 30	4 10	..	6 30	..	2 25
	„ depart.	.	..	7 30	8 47	..	10 28	..	12 55	..	2 40	4 20	..	6 40	..	2 35
100¼	Shrivenham......	7 42	10 40	..	1 8	4 32
107¾	Faringdon Road	7 58	10 55	3 5	7 8	..	3 0
115¾	Steventon......	8 12	9 27	..	11 10	..	1 37	..	3 20	5 0	..	7 23	..	3 18
124	Wallingford Rd.	8 30	9 46	1 55	5 18	3 36
127	Goring............	8 38	11 32	5 25
130¼	Pangbourne	8 46	9 57	3 50	7 52
135¾	Reading	7 30	..	9 0	10 10	..	11 50	..	2 20	..	4 5	5 43	..	8 8	..	4 0
140¾	Twyford	7 40	..	9 10	10 20	2 35	5 55	..	8 20
149	Maidenhead ..	7 55	..	9 30	10 34	..	12 20	3 45	4 35	6 12	7 30	8 36	..	4 29
153¾	Slough..........	8 6	9 0	9 40	10 44	11 30	12 30	..	3 5	4 0	4 45	6 22	7 45	8 48	..	4 40
158¾	West Drayton	8 18	9 10	9 53	..	11 40	4 10	7 55	4 52
162¾	Southall	8 28	9 19	10 3	..	11 49	4 19	8 5
164¾	Hanwell	8 33	9 24	10 9	..	11 54	4 24	8 10
166	Ealing	8 38	9 28	10 14	..	11 58	4 28	8 15
171¼	Paddington	8 55	9 45	10 30	11 25	12 15	1 10	..	3 50	4 45	5 30	7 5	8 30	9 30	..	5 25

Fig. 10.6 Bradshaw timetables in the period between May 1843 and April 1844 showed the Great Western Railway extending 171½ miles from London's Paddington station to a temporary terminus at Beam Bridge, the station where Lady Jane Simon began her journey. Her trip on the last passenger train of the day, called here the "11 p.m. mail," included a 10 min pause at Bristol

If both trains were running precisely on time, the meet would occur a short distance east of Bristol. If Jane Simon's train were slightly delayed, perhaps by the storm, then the meet could take place near Bristol's Temple Meads station.

Jane's account, as recalled by George Richmond, included the description that a "train was coming in their direction, through the blackness, over one of Brunel's bridges." An 1839 guidebook described the Brunel Bridge immediately adjacent to the Bristol Temple Meads station as a "Gothic Bridge of Two Arches over the Harbour." (Wyld 1839, p. 275). An authoritative modern study by John Binding used a slightly different name for the same bridge in a chapter devoted to "The Approaches to Bristol," with maps and plans including

Table 10.1 Great Western	Up train: 11 p.m. mail	
Railway timetable for the	11:00 p.m.	Beam Bridge
summer of 1843	…	…
	12:50 a.m.	**Bristol, arrival**
	1:00 a.m.	**Bristol, departure**
	…	…
	1:20 a.m.	Bath
	…	…
	2:25 a.m.	Swindon Junction, arrival
	2:35 a.m.	Swindon Junction, departure
	…	…
	5:25 a.m.	Paddington
	Down train: 8:55 p.m. mail	
	8:55 p.m.	Paddington
	…	…
	11:35 p.m.	Swindon Junction, arrival
	11:45 p.m.	Swindon Junction, departure
	…	…
	12:45 a.m.	Bath
	…	…
	1:10 a.m.	**Bristol, arrival**
	1:20 a.m.	**Bristol, departure**
	…	…
	3:15 a.m.	Beam Bridge

Brunel's original sketches for this "Floating Harbour Bridge…a stone bridge…of two main arches each of 56ft span…" (Binding 2001, pp. 19–20).

The 1843 schedules therefore confirm the accuracy of another detail of Lady Simon's story: the night-time meet had to be near Bristol, where her train paused for ten minutes, just as she described in her letter to John Ruskin.

Express Curve

To expedite through service for Beam Bridge traffic to and from London, the Great Western Railway had constructed an "Express Curve" at Bristol so that these trains could bypass the Brunel-designed Temple Meads terminus (Binding 2001, pp. 138–139). This curve is the location where the train carrying Jane Simon and J. M. W. Turner would have stopped for ten minutes, and where the passengers could watch an approaching train coming across the "Floating Harbour Bridge" through the storm (Fig. 10.7). The Express Curve lay outside the Bristol Temple Meads train shed, so it was exposed to the weather. This is consistent with Jane's description that both of them, craning their necks outside the carriage window, became "drenched."

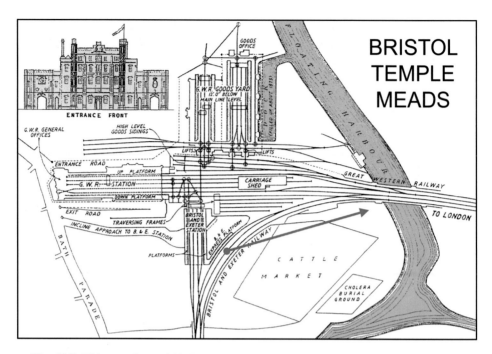

Fig. 10.7 This map from 1845 shows the Bristol Temple Meads complex. The red arrow indicates Turner's direction of view from the Express Curve toward Brunel's Floating Harbour Bridge. The Express Curve lay outside the Bristol Temple Meads train shed, so it was exposed to the weather. We argue that Turner, at about 1:00 a.m. on June 9, 1843, observed the scene that inspired him to paint *Rain, Steam, and Speed*. This map appeared in the Great Western Railway Special Centenary Number, Supplement to *The Railway Gazette*, on August 30, 1935 (Map copyright *Railway Gazette International*. Used with permission)

One more puzzle remains—the bridge in Turner's painting does not resemble the bridge in Bristol. Turner may have been inspired in Bristol, but he may have used a different bridge as the model for the finished canvas

Abingdon Bridge? Cefn Mawr Viaduct?

One author suggested that Turner "borrowed from the viaduct of the Great Western Railway over the Thames at Abingdon," and another writer agreed that the "scene represents a train running at full speed across the viaduct of the Great Western Railway over the Thames at Abingdon (Anonymous, *Art-Journal* 1860, p. 228; Anonymous, *Masters in Art* 1902, p. 38).

Yet another correspondent offered that Turner's "picture represents the Great Western train crossing the Cefn Viaduct" near the town of Cefn Mawr in North Wales (J. J. P. 1907, p. 58).

Both of these assertions must be incorrect. The Abingdon Bridge on the branch line from Didcot to Oxford did not open to traffic until June 12, 1844, and the Cefn Mawr viaduct over the River Dee on the Shrewsbury & Chester Railway, later absorbed into the Great Western, opened on October 16, 1848 (MacDermot 1927, pp. 180, 340–346).

Both of these dates occurred after the painting was already on display at the Royal Academy exhibition, which opened to the public on Monday, May 6, 1844.

Maidenhead Bridges

We agree with the majority of modern scholars that the painting depicts the crossing of the Thames known as the Maidenhead Railway Bridge. This impressive structure still stands at one of Turner's favorite stretches of the Thames in an area long familiar to the artist. The nearby Maidenhead road bridge, visible on the left edge of Turner's canvas, provides the key to the identification (Figs. 10.8 and 10.9).

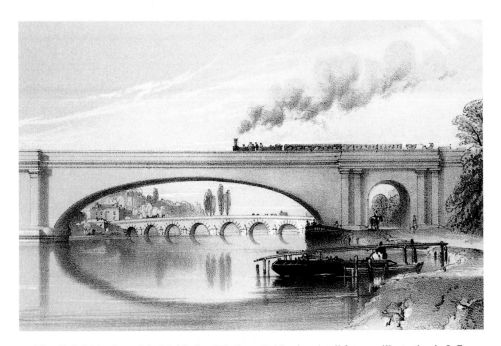

Fig. 10.8 This view of the Maidenhead Railway Bridge is a detail from an illustration in J. C. Bourne's *The History and Description of the Great Western Railway* (1846). Although Turner was apparently inspired to depict a railway subject by the dramatic scene that he witnessed on a stormy night at Bristol, the artist based the railway bridge in the finished canvas on the Maidenhead crossing of the Thames (Illustration courtesy of the Institution of Civil Engineers, London. Used with permission)

Fig. 10.9 Steam trains still occasionally cross the Maidenhead Railway Bridge. This April 2010 scene shows Great Western Railway locomotive # 5043, named *Earl of Mount Edgcumbe*, pulling the coaches of a special excursion train to Bristol. The Maidenhead road bridge is visible on the left edge of Turner's canvas and in the distance of this photograph (Photograph by Peter Zabek. Used with permission)

Martin Davies wrote in 1959 that the painted "scene may be identified with reasonable certainty as Maidenhead railway bridge, across the Thames between Taplow and Maidenhead…The view…would be to the east, or towards London; the bridge seen in the distance would be Sir R. Taylor's road bridge." (Davies 1959, p. 99).

John Gage endorsed this same location, but he made another error when he stated regarding Maidenhead that the "bridge seems to have first been identified by M. Davies" in 1959 (Gage 1972, p. 85).

In fact, this correct identification goes back at least to 1888, when Edward Tyas Cook wrote: "RAIN, STEAM, AND SPEED…the bridge is perhaps a recollection of Maidenhead." (Cook 1888, p. 645). Other scholars prior to 1959 repeated the Maidenhead Bridge identification (Frith 1895, p. 226; Goodall 1902, p. 59).

The Stormy Night of June 8–9, 1843

Turner based the bridges in the finished canvas on Brunel's Maidenhead Railway Bridge and the nearby road bridge. The artist was apparently inspired to depict a railway subject by the scene that he witnessed at Bristol near 1 a.m. on June 9, 1843.

Our analysis, comparing the details in Jane Simon's letter against steamship schedules, stagecoach routes, railway timetables, and meteorological observations, supported the idea that she provided a generally accurate account. The dramatic events on that stormy night, seen through the "most wonderful eyes" of her "old gentleman," provided the inspiration for Turner's famous painting: *Rain, Steam, and Speed – The Great Western Railway*.

John Everett Millais and the "Millais Oak"

John Everett Millais (1829–1896), a leading British artist of the nineteenth century, created some of the most iconic paintings of the Pre-Raphaelite movement. A modern writer described his *Ophelia*, now in the Tate Britain collection, as Britain's favorite painting (Secher 2014, p. 1). Millais began work on *Ophelia* in the summer of 1851 and exhibited the canvas at the Royal Academy in the summer of 1852. As detailed in Chap. 9, determining the precise dates of the artist's trips to and from London in 1852 provided the key to solving a literary mystery. On a summer full Moon night the trio of John Everett Millais, Wilkie Collins, and Charles Collins encountered a woman dressed in white near Regent's Park in London, and that adventure inspired the dramatic moonlit scene near the beginning of the famous Wilkie Collins novel, *The Woman in White*.

Millais in 1852: The Proscribed Royalist, 1651

Millais spent most of the summer of 1852 at the George Inn in the town of Hayes, about ten miles southeast of central London. In June 1852 Millais began work on another masterpiece: *The Proscribed Royalist, 1651*. The canvas depicts a scene from the aftermath of the English Civil War. A Puritan girl nervously looks over her shoulder as she risks her life to bring food to a young Royalist cavalier hiding in a hollow oak tree (Fig. 10.10).

Millais selected this unusual arboreal setting as a reference to a famous incident in 1651 when King Charles II hid in an oak tree to escape his pursuers. To commemorate this event, pubs throughout England bear the name "Royal Oak" and feature oak trees on their pub signs. The astronomer Edmond Halley in 1678 created a constellation called *Robur Carolinum*, Latin for "Charles's Oak" (Figs. 10.11 and 10.12). At least a dozen cities and towns worldwide are named Royal Oak, and eight ships of the British Royal Navy have carried the name HMS *Royal Oak*. Regarding one of these vessels, Chap. 7 details how astronomical factors played an important role in the sinking of the battleship HMS *Royal Oak* at Scapa Flow in 1939.

During the summer of 1852 Millais worked directly from nature, as was his custom, and based his painted oak on a tree that he found in a park called West Wickham Common, just south of the town of Hayes. One of the artist's letters described the George Inn in Hayes as "a delightful little inn near a spot exactly suited for the background." (J. G. Millais 1899, pp. 164–165). The modern brochure for this park helps to explain why Millais chose this site:

> There are 15 ancient oak pollards on West Wickham Common, found in a small area
> at the western end of the site in broadleaved woodland. Many are over 600 years old

Fig. 10.10 John Everett Millais, *The Proscribed Royalist, 1651*

and the majority have hollowed trunks packed with decaying wood One of the pollards was made famous by Victorian artist J. E. Millais, who used the Common as a setting for his painting The Proscribed Royalist, 1651. One of the older, large oak pollards at the western periphery of the site is believed to be that very tree. Sadly, this tree died several decades ago.

A pollard is a tree that has been cut at or above head height, so that it sends up new branches. Pollarding has the effect of retarding vertical growth and prolonging the lifespan of the tree.
(City of London 2011, p. 11)

Fig. 10.11 English astronomer Edmond Halley in 1678 honored the event of Charles hiding in an oak tree by creating a constellation called *Robur Carolinum*, Latin for "Charles's Oak." This constellation no longer appears on modern star charts but can be seen here on a map of the heavens published by John Seller in 1680. Nearby constellations include Piscis Volans (the Flying Fish), the Chamaeleon, Musca (the Fly), and, unnamed at the upper left, the four bright stars of Crux (the Southern Cross)

Millais finished the landscape background by November 1852. After his return to London the artist employed the Irish beauty Anne Ryan as the model for the young woman, and his fellow artist Arthur Hughes posed for the cavalier (J. G. Millais 1899, pp. 172–175).

The completed painting appeared in the Royal Academy exhibition during the summer of 1853. Following an enthusiastic reception by the public, the painting "was transformed into a steel engraving to take advantage of the burgeoning market for prints, and it spawned a tourist site – the 'Millais Oak' on West Wickham Common, a place of pilgrimage for Millais admirers throughout the late 19th century." (Rosenfeld 2003, p. 47).

Consensus Location for the "Millais Oak"

Our Texas State University group traveled to London in August of 2013 for a research trip related to Wilkie Collins and John Everett Millais, and we wanted to make our own pilgrimage to visit the "Millais Oak."

Fig. 10.12 A tree in the sky, in the form of the archaic constellation *Robur Carolinum* (Latin for "Charles's Oak), appeared on celestial charts for more than 1½ centuries. These two examples are details from star maps created by James Barlow in 1790 (left) and Elijah Burritt in 1835 (right). Barlow's chart includes a cross colored red and with the title *Crosiers* (Crux, the Southern Cross), near the back legs of Centaurus (the Centaur). The upper right corner of Burritt's map features part of Argo Navis, the ship of Jason and the Argonauts

The existing literature was unanimous regarding the location and even included photographs of the site. According to the published authorities, we would easily find the original "Millais Oak" near the bottom of a hill and standing only a few feet from a public path that runs along the south side of West Wickham Common. For more than a century, guidebooks, newspaper articles, and local authorities directed interested visitors to this spot. Photographs from 1892, 1899, and the modern day all showed the same tree. Based on the abundant literature, it seemed a straightforward matter to have an imaginative experience in the exact place where the artist created the landscape of this spectacular painting.

Thomas Fisher Unwin in 1882 wrote a guidebook for hikers and bicyclists and noted that West Wickham Common included "Coney Hall Hill; an eminence." Unwin advised these tourists to look in a "group of oak trees at the base … it was at one of the hollow old oaks in this wood that Mr. Millais painted his celebrated picture of 'The Proscribed Royalist.'" (Unwin 1882, p. 71).

An article in a gardening journal in 1891 described how visitors could easily find the "famous Oak tree from which the great painter Millais took his *Proscribed Royalist*" because the tree stood in the lower part of the park "on the edge of the public path" (A.D.W. 1891, pp. 353–354).

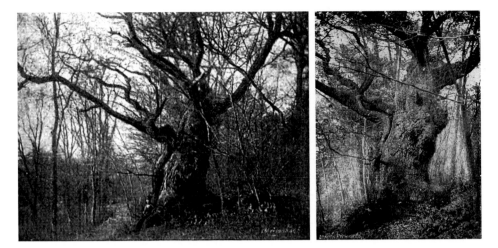

Fig. 10.13 For more than a century this tree was mistakenly identified as the "Millais Oak." A letter written by John Everett Millais in the summer of 1852 proves that this cannot have been the model for the ancient oak in his celebrated painting. Left: This 1892 photograph by Thomas Athol appeared in *The Graphic*, with text incorrectly describing the tree as "the original for the hiding-place depicted in the *Proscribed Royalist*." Right: This photograph of the same tree appeared in an 1899 biography of the artist written by his son, John Guille Millais, who followed the erroneous identification promoted by Athol

A story titled "West Wickham Common" appeared in 1892 in *The Graphic*, a weekly illustrated paper with wide circulation. Thomas Athol Joyce, the son of the editor of *The Graphic*, provided a photograph with the caption "HOLLOW OAK IN CONEY HILL WOOD" (Fig. 10.13, left). The text described this tree near the public path as "the original for the hiding-place depicted in the *Proscribed Royalist*" (Anonymous, *The Graphic* 1892, p. 607).

Probably the most influential source to offer an identification of the same tree appeared in 1899 in a two-volume biography of the artist by his son, John Guille Millais. Volume I included a lengthy section describing how the artist resided in Hayes, near "the big trees on Coney Hall Hill, where still stands the giant oak that he painted." The book included a new photograph (Fig. 10.13, right) with caption "The Millais Oak, Hayes, Kent, 1898" and depicting, from a slightly different angle, the same tree photographed 6 years earlier for *The Graphic* (J. G. Millais 1899, pp. 165–166).

Many later authors uncritically adopted the tree identification endorsed by J. G. Millais. J. Eadie Reid, in a 1909 monograph about the artist, mentioned the same location (Reid 1909, p. 36). A group of geologists conducted an excursion to observe "Millais' Oak" (Dibley and Kennard 1909, p. 34). W. Baxter advised bicycle tourists passing the Common to stop at the "foot" of the "beautiful hill" to see the tree pictured by the artist (Baxter 1912, p. 123).

An essay by Donald Alister Macdonald in 1933 discussed an ancient embankment at the highest point of the Common and speculated that the earthworks might be the remnants of a Roman fort. Macdonald described the position of the famous oak by noting that at "the foot" of the slope below the earthworks "was a grand and ancient oak who had perhaps sheltered Druids; certainly Roman legionaries as well as cavaliers, for Millais had painted it in one of his most famous pictures." (Macdonald 1933, p. 129).

Andrew Cowan, an expert in arboriculture management, published in 2004 an essay about ancient trees in the UK. Cowan included a modern photograph of the tree next to the West Wickham Common public path and asserted that this "ancient natural sculpture, in its younger years, was painted by the artist Millais ... in his portrait of *The Proscribed Royalist, 1651*, which is now owned by Andrew Lloyd Webber" (Cowan 2004, p. 11).

For a major Millais exhibition at Tate Britain in 2007, art historian Alison Smith wrote a catalogue entry that accepted the photographs published by J. G. Millais in 1899 and Andrew Cowan in 2004 as depictions of the correct tree, which "inspired a tourist site known as the 'Millais Oak' on West Wickham Common" (Smith and Rosenfeld 2007, pp. 96, 252)

In an essay that also appeared in 2007, Andrew Lloyd Webber described his acquisition of the famous painting. The composer had traveled to see the tree identified as the inspiration for the canvas:

> *Among the paintings that I am lending to the Tate's fantastic Millais exhibition is The Proscribed Royalist, 1651, which Millais painted in 1852 and 1853. It is a typical example of the 'every picture tells a story' historical style that the Pre-Raphaelites loved so much. It is set in the aftermath of the English Civil War and shows a Cavalier on the run being aided by his lover, a Puritan girl whose severe black and white bonnet, collar and cape, contrasts astonishingly with her shimmering, sensual, gorgeous russet brown skirt. Quite how she thought that this outfit was not going to bring attention to herself is curious He is hiding in a hollow oak tree, just like Charles II did when he was on the run after the Battle of Worcester ... It's a sort of Romeo and Juliet story, with star-crossed lovers whose love is stronger than the cause that still divides their families I bought it in 1983. It was probably the last major Millais to come on the market. When I was researching the picture's provenance, I went down to Kent where the oak tree can still be seen on West Wickham Common – it is known as Millais' oak* (Webber 2007, p. 26).

On September 10, 2016, the Civil Engineers Club of London conducted a walk that passed through West Wickham Common on the footpath that runs along the south side of the park. The detailed itinerary instructed the members to "Watch out for the Millais Oak on the right." A photograph later posted online showed the group by the oak located near the base of the hill and about 10 feet from the path (Barber 2016, p. 1).

The *Wikipedia* page for *The Proscribed Royalist, 1651,* makes the same identification and links to the photograph taken by Andrew Cowan in 2004.

The existing literature about the "Millais Oak" therefore exhibits a unanimous consensus that seems especially impressive. All of the authorities agree that the oak stands near the southwestern corner of the park, at the base of a hill and only a few feet from the public path. Individuals and groups have visited and photographed this same tree from at least the 1880s up until the present day.

However, a complication emerged as our Texas State University group prepared for the August 2013 research trip to England. We were somewhat skeptical of the consensus identification when we compared the published photographs of the tree to the details of Millais's canvas. Before our visit we exchanged emails with Luke Barley, the ranger assigned to West Wickham Common. From a variety of angles he had already carefully studied the trunk and the pattern of the branches and advised us of his opinion that the consensus tree, identified by every authority for more than a century, had almost no resemblance at all to the painted oak!

We knew that the park contained more than a dozen ancient oaks, many with hollow trunks, and we wondered whether the writers in the late nineteenth century had settled on the wrong tree. Perhaps every other author since then had just copied this mistaken identification.

The Streetlight Effect

We suspected that the original error was of the type that has its own *Wikipedia* page and has earned a name in the scientific literature: the Streetlight Effect.

An old joke exists in various versions and typically runs something like this:

Late at night, a police officer sees a drunken man intently searching for something on the ground under a streetlight and asks what he has lost. The man says that he is looking for his car keys. The officer helps for a few minutes without success and then asks whether the man is certain that he dropped the keys near the streetlight. "No," comes the reply, "I lost the keys over in the park." The puzzled officer asks why he is searching here, and the intoxicated man answers with aplomb, "The light is much better here."

The nineteenth-century authors may have made a mistake for similar reasons. They may have identified the "Millais Oak" as they did in part because they could so easily visit this tree's location—near the base of a hill and only a few feet from a public path that was well-traveled and nearly level.

Letter from Millais

As we continued our trip preparations, we wondered whether we could locate any comments regarding the tree from Millais himself. What we found in the artist's letters totally contradicted the consensus of the authorities and proved that visitors had been going to the wrong tree for more than a century.

The key discovery came when we read Jason Rosenfeld's biography of the artist. Rosenfeld discussed a letter in which "Millais made light of the difficulties of terrain and climate in painting the background to his next major picture, *The Proscribed Royalist, 1651*." The letter included a "humorous sketch ... that shows the painter on the wooded Coney Hall Hill, his chair slipping from below him, his book propped on a tree, his gangly form perched precariously above a canvas on an easel" (Rosenfeld 2012, pp. 71–72).

Rosenfeld reproduced a page from this letter in facsimile and also transcribed the text written by the artist. Millais's own words described the actual location of the "Millais Oak":

> *Yesterday I made a commencement under the most disheartening circumstances, wind & rain, but the lasting grievance is the impossibility of my ever managing a comfortable position to sit in, my situation is nearly the summit of a serious declivity, some people's lives have depended upon a thread, but mine depends upon the weight of an eyelash … At the bottom of the slope there is a duck pond which (should I sneeze) I might reach after having come in contact with some dozen relentless tree stumps.* (Letter from John Everett Millais at the George Inn, Hayes near Bromley, Kent, Friday afternoon (summer 1852) to Mrs. Collins, Pierpont Morgan Library, New York, Bowerswell Papers, MA.1338, PQ 31.)

This letter by Millais definitively rules out the consensus oak tree because of its position only a few feet from a nearly level path near the bottom of the park's hill. The correct "Millais Oak" must be near the summit of the hill in a precarious position above a steep slope leading down to a duck pond.

Duck Pond

With assistance from Arthur Holden at the Bromley Local Studies Library and Archives, we found two early photographs of the duck pond. Holden also helped in checking the map collection, and we determined that the duck pond appeared on maps from 1862, 1895, 1933, and 1936, but that the pond had been filled in by 1955.

Using Photoshop™ we superimposed the nineteenth-century maps over a modern map and carefully added the duck pond to the modern chart. We could now see the precise position of the duck pond relative to the ancient oaks of West Wickham Common. Our map illustration (Fig. 10.14) shows only two trees as possible candidates for the "Millais Oak" because these two stand near the top of a steep hill that slopes down toward the modern Gates Green Road and the duck pond site.

Research Trip to the Actual Millais Oak

To verify and extend the map analysis, our Texas State group made a research trip to Hayes in August 2013 and examined all of the ancient oaks in the southwestern corner of West Wickham Common.

The lower red circle on the map (Fig. 10.14) marks the ancient oak that was the mistaken consensus preference of all previous authors. We first visited this tree, only a few feet from a nearly level path near the bottom of the park's hill (Fig. 10.15). Millais's description in his letter does not fit this location at all.

The upper red circle on the map (Fig. 10.14) marks the correct tree—the only ancient oak that was both near the top of the slope above the site of the nineteenth-century duck pond and also in a position where the topography of the ground immediately surrounding the tree matched the landscape depicted in the painting. This map does not show elevation

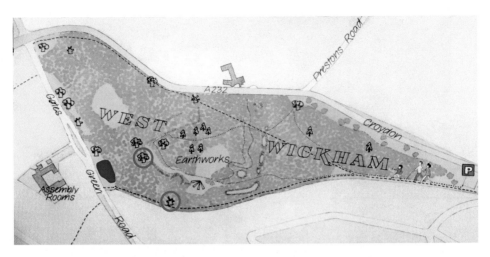

Fig. 10.14 This illustration shows the positions of the ancient oaks at West Wickham Common. The region labeled "Earthworks" is on the top of the park's highest hill. The blue shape marks the position of the nineteenth-century duck pond. The lower red circle marks the ancient oak that was identified as the "Millais Oak" according to the mistaken consensus preference of all previous authors. This tree is definitely ruled out because of its position at the foot of the hill and only a few feet from the public path. The upper red circle marks the actual "Millais Oak," near the top of the steep and treacherous slope that faces west (to the left) toward Gates Green Road (Illustration by the author)

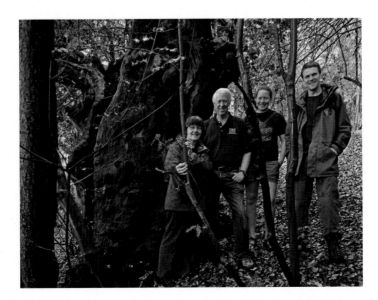

Fig. 10.15 Members of our Texas State University group (Marilynn Olson, Don Olson, and Ava Pope, along with ranger Luke Barley) visited the ancient oaks of West Wickham Common during a research trip to Hayes in August 2013. This tree, which stands only a few feet from a path on the south side of the park, was mistakenly identified for many years as the "Millais Oak" (Photograph by Russell Doescher. Used with permission)

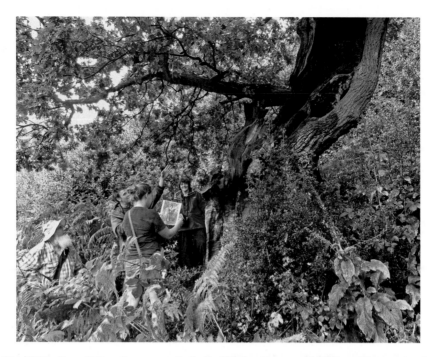

Fig. 10.16 Russell Doescher, ranger Luke Barley, Ava Pope, and Marilynn Olson at the site of the actual "Millais Oak," near the top of a steep slope on the west side of West Wickham Common. The steepness of the slope can be inferred from the position of Russell Doescher on the left, noticeably lower in elevation despite being only a few feet away from the rest of the group (Photograph by Roger Sinnott. Used with permission)

contours, but our measurements at the site showed that this ancient oak was elevated about 55 feet above the level of the road and duck pond site. Visiting this oak was arduous and would have been almost impossible without assistance from ranger Luke Barley, who brought pruning tools that were necessary to clear the holly and other underbrush that now cover the area (Figs. 10.16 and 10.17). Footing was difficult on the steep hillside near this tree, and several times members of our group fell and began to slip down the hill—just as Millais described in his letter!

For more than a century books and articles identified a certain tree in West Wickham Common as the "Millais Oak"—but all those authorities were definitely mistaken. A letter written by the artist in the summer of 1852 contained topographic clues that allowed us to find the actual tree. Identifying and visiting this site helped us to appreciate the effort and dedication of the artist when he worked to depict this ancient oak in the landscape of *The Proscribed Royalist, 1651*.

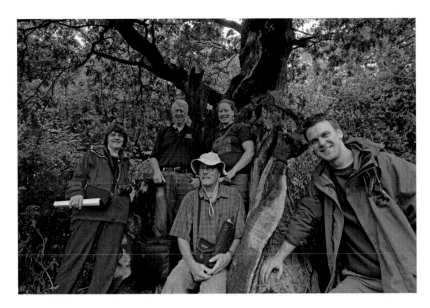

Fig. 10.17 Marilynn Olson, Don Olson, Roger Sinnott, Ava Pope, and ranger Luke Barley at the site of the actual "Millais Oak." Reaching this location was difficult and laborious, with treacherous footing that threatened our group with the possibility of falling and slipping down the hill—just as Millais described in his letter (Photograph by Russell Doescher. Used with permission)

References

A. D. W. (1891) Trees at Wickham Court. *The Garden, An Illustrated Weekly Journal* **40** (No. 1039), October 17, 1891, 353-354.

Anonymous (1860) The Turner Gallery: Rain, Steam, and Speed. *Art-Journal* **6** (new series), 228.

Anonymous (1892) West Wickham Common, with photographs by Thomas Athol Joyce. *The Graphic* **46** (No. 1199), November 19, 1892, 607.

Anonymous (1902) J. M. W. Turner. *Masters in Art* **3** (Part 35), November, 1-40.

Barber, Tony (2016) Civil Engineers' Club Walk across Hayes, West Wickham and Keston Commons, September 10, 2016. London: Institution of Civil Engineers, report and photographs posted online at: http://www.ceclub.net/walking.

Baxter, W. (1912) *Cyclists' Touring Club, British Road Book, New Series, Vol. I, South-East England.* London: Thomas Nelson and Sons.

Binding, John (2001) *Brunel's Bristol Temple Meads.* Hersham, UK: Ian Allan Publishing, Ltd.

City of London (2011) *West Wickham Common Local Plan 2011-2021.* London: City of London Corporation.

Clark, Kenneth (1950) *Landscape Painting*. New York: Charles Scribner's Sons.

Cook, Edward Tyas (1888) *A Popular Handbook to the National Gallery*. London: MacMillan and Co.

Cowan, Andrew (2004) Protecting our ancestors legacy for the generations of the future. *ArborEcology* **12**, Summer 2004, 1-10.

Davies, Martin (1959) *The British School*. London: The National Gallery.

Dibley, G. E., and A. S. Kennard (1909) Excursion to Hayes and Keston, Saturday, June 27th, 1908. *Proceedings of the Geologists' Association* **21** (No. 1), 33-35.

Frith, Henry (1895) *The Romance of Engineering*. London: Ward, Lock & Bowden, Ltd.

Gage, John (1972) *Turner: Rain, Steam and Speed*. New York: Viking Press.

Gage, John (1980) *Collected Correspondence of J. M. W. Turner*. Oxford: Oxford University Press.

Goodall, Frederick (1902) *The Reminiscences of Frederick Goodall*. London: Walter Scott.

J. J. P. (1907) Turner's "Rain, Steam and Speed." *Bye-Gones* **10** (new series), May 1, 1907, 58.

Loukes, Andrew (2001) Railways, in *The Oxford Companion to J. M. W. Turner*, Evelyn Joll, Martin Butlin, and Luke Herrmann, eds. Oxford: Oxford University Press.

MacDermot, Edward Terence (1927) *History of the Great Western Railway, Volume 1, 1833-1863*. London: Great Western Railway Company.

Macdonald, Donald Alister (1933) *The Brooks of Morning: Nature and Reflective Essays*. Sydney, Australia: Angus & Robertson.

Millais, John Guille (1899) *The Life and Letters of Sir John Everett Millais, Volume I*. New York: Frederick A. Stokes Company.

Reid, J. Eadie (1909) *Sir J. E. Millais, P.R.A.* London: Walter Scott Publishing Co., Ltd.

Rosenfeld, Jason (2003) John Everett Millais, in *Pre-Raphaelite and Other Masters, The Andrew Lloyd Webber Collection*. London: Royal Academy of Arts.

Rosenfeld, Jason (2012) *John Everett Millais*. New York: Phaidon Press.

Ruskin, John (1899) *Praeterita, Volume III*. London: George Allen.

Secher, Benjamin (2014) Ten things you never knew about Ophelia. *The Telegraph*, August 7, 2014.

Smith, Alison, and Jason Rosenfeld, eds. (2007) *Millais*. London: Tate Publishing.

Stirling, Anna M. W. (1926) *The Richmond Papers*. London: William Heinemann Ltd.

Thackeray, William Makepeace (1844) May Gambols, or Titmarsh in the Picture Galleries. *Fraser's Magazine*, June, 712-713.

Unwin, Thomas Fisher (1882) *Round Bromley and Keston: A Handy Guide to Rambles in the District. With a Map, Illustrations and Bicycle Route*. London: T. Fisher Unwin.

Webber, Andrew Lloyd (2007) Why I'm mad about Millais. *Daily Mail Weekend Magazine*, October 20, 2007, 25-26.

Whisaw, Francis (1842) *The Railways of Great Britain and Ireland*. London: John Weale.

Wyld, James (1839) *The Great Western, Cheltenham and Great Western, and Bristol and Exeter Railway Guides*. London: James Wyld.

Index

© Springer International Publishing AG 2018
D.W. Olson, *Further Adventures of the Celestial Sleuth*, Springer Praxis Books,
https://doi.org/10.1007/978-3-319-70320-6